DATE DUE		
OCT 0 6 1989		
MAR 2 8 1991		
12/14/95		
3-26-97		
1-0-98		
12-15-98		
4-15-00		
4-17-03		
6-17-03		

Late Picasso

SPONSORED BY GLOBAL ASSET MANAGEMENT LIMITED

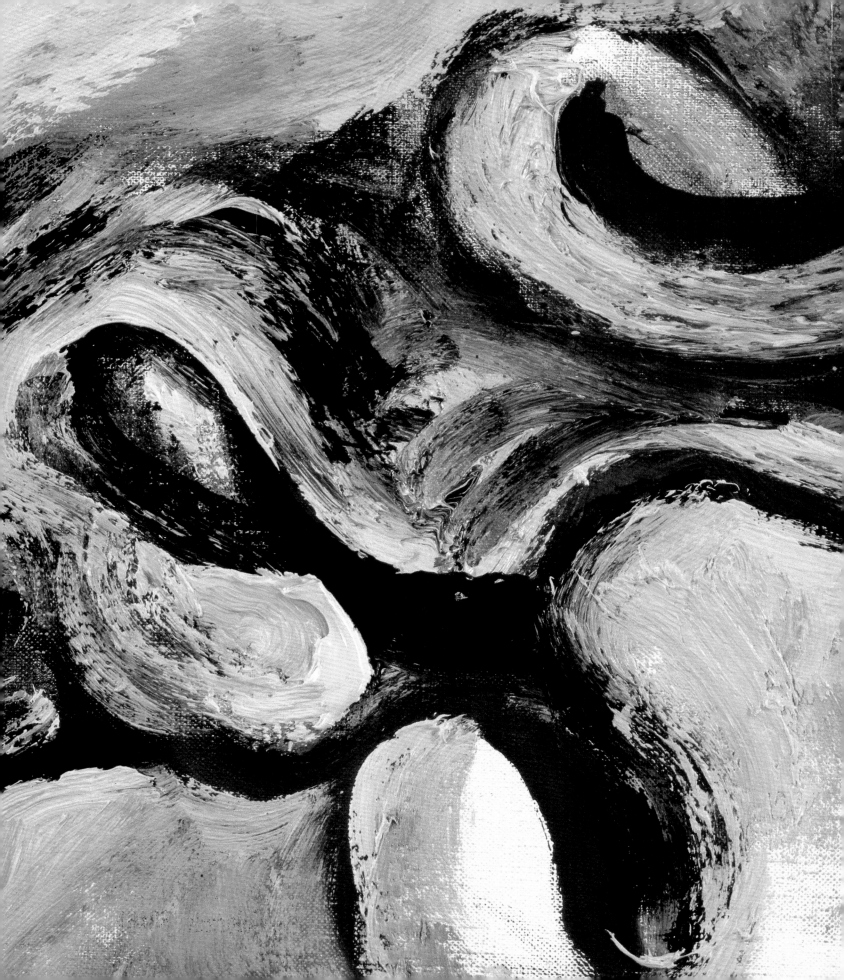

Late Picasso

Paintings, sculpture, drawings, prints 1953-1972

The Tate Gallery

Musée National d'Art Moderne, Paris 17 February–16 May 1988
The Tate Gallery, London 23 June–18 September 1988

cover/jacket
Pablo Picasso
'Woman Pissing' (detail)
16 April 1965 (cat. 33)

frontispiece
Pablo Picasso
'The Kiss' (detail)
24 October 1969 (cat.49)

ISBN 0 946590 89 3 (paper)
ISBN 0 946590 90 7 (cloth)
Published by order of the Trustees 1988
for the exhibition of 23 June–18 September 1988
Original French edition © Editions du Centre Pompidou, Paris 1988
Copyright © 1988 The Tate Gallery and the authors. All rights reserved
Published by Tate Gallery Publications, Millbank, London SW1P 4RG
Designed by Caroline Johnston
Printed and Typeset by Balding + Mansell UK Limited, Wisbech, Cambs
Colour Origination by Clair Offset, Paris, and Balding + Mansell UK Limited
Black and White Origination by Francephotogravure, Lyon,
and Balding + Mansell UK Limited
Typeface: 11/16 pt Monophoto Photina
Paper: Parilux JOB, Toulouse

All Picasso and Braque works © DACS 1988

for Jacqueline Picasso

Executive Committee

Marie-Laure Bernadac

Isabelle Monod-Fontaine

David Sylvester

Foreword

The exhibition of the Picasso Legacy at the Grand Palais in 1979 brought back to light some of the works shown at the Palais des Papes, Avignon, in 1970 and 1973, and so provided an opportunity to take a new view of this subsequently neglected late work. In 1981, at the Kunstmuseum, Basle, Christian Geelhaar devoted an entire exhibition to Picasso's work of 1964–72; in 1984 Gert Schiff produced a similar exhibition in New York. Meanwhile, David Sylvester and Dominique Bozo, who at that time was both Director of the Musée National d'Art Moderne and responsible for the Musée Picasso, were also keen to organize such an exhibition, and it was decided that those two museums should work together, and that the Tate Gallery should work with them, on the conception and realization of this project, the scope of which was later expanded to cover Picasso's last twenty years, the 'époque Jacqueline'.

Responsibility for the project was undertaken by David Sylvester, on behalf of the Tate Gallery, and Marie-Laure Bernadac, for the Musée Picasso, later joined by Isabelle Monod-Fontaine, for the Musée National d'Art Moderne. We are most grateful to them.

We are delighted that an exhibition of such exceptional quality and significance has resulted from a collaboration between our three museums.

Alan Bowness
Director, Tate Gallery

Pierre Georgel
Chief Curator
Musée Picasso

Jean-Hubert Martin
Director, Musée National
d'Art Moderne

The English version of the catalogue has been produced to accompany the second showing of the exhibition, at the Tate Gallery. With its publication I should like to take the opportunity of thanking our French colleagues at both museums most sincerely for all their hard work on our joint behalf. Showing the exhibition first and having a close contact with the heirs of Picasso's Estate, they have inevitably borne the brunt of the administrative work. I should like to express particular thanks to Nathalie Brunet, the exhibition assistant at the Musée National d'Art Moderne.

Finally our thanks go to Global Asset Management Ltd for their sponsorship of the exhibition at the Tate. For a second time we are deeply grateful to them.

A.B.

Acknowledgements

First and foremost our thanks are due to the members of the Picasso family for their whole hearted co-operation. Claude Picasso was a great support throughout. Maya Ruiz-Picasso, Paloma Picasso-Lopez, Marina Picasso and Bernard Ruiz-Picasso were unstintingly generous in their loans. The Vilato family were likewise extremely helpful. At a time of mourning Catherine Hutin made an indispensable contribution to a project which her mother, Jacqueline Picasso, had strongly supported from the outset.

Special thanks are also due to Louise Leiris and Maurice Jardot who, with their outstanding knowledge of Picasso's work, gave invaluable help over selecting and assembling the works. We should like also to thank their colleagues at the Galerie Louise Leiris, Quentin Laurens, Bernard Lirman and Jeanette Druy.

Assembling such a number of works, now so widely dispersed, would not have been possible without the support of Ernst Beyeler, Arnold B. Glimcher, Jan Krugier and Angela Rosengart, who loaned, or helped to procure loans of, vital material.

We should also like to record our debt of gratitude to all the other people who helped in a variety of ways: Mali Antoine Funakoshi, Michele Archambault-Dulman, Heiner Bastian, Bernd Dütting, Kate Ganz, Christian Geelhaar, Carmen Gimenez, Martine Jolibois, Sandor Kuthy, Carolyn Lanchner, Peter Ludwig, Marilyn McCully, Alex Maguy, Angelica Zander Rudenstine, Gert Schiff, Werner Spies, Simon Studer, Sixtine Tripet, Diane Upright, and all those who assisted in the compilation of this catalogue.

For the photographs, David Douglas Duncan, André Gomès, André Villers, Edward Quinn, Laurence Berthon, Marie-Hélène Breuil, Anna Kafetsi, Claude Laugier, Brigitte Vincent; also Mme Alter (Agence Roger-Violett), Ludovic de Ginguay-Beaugendre (Service photographique de la Réunion des Musées Nationaux), Nicole Massard (Editions Cercle d'Art).

Sadly, we have to salute the memory of that great Picasso collector Victor Ganz. He was involved from the outset in the planning of the exhibition and his sudden death last autumn has cast a shadow over the final stages of its preparation.

Marie-Laure Bernadac, Isabelle Monod-Fontaine, David Sylvester

Contents

Photograph: Edward Quinn

A Genius without a Pedestal

MICHEL LEIRIS

A sort of leitmotiv in Picasso's very diverse oeuvre: mountebanks, circus performers, musicians, bullfighters in the ring or during a break, painters from the old days or from the present (sometimes a fictitious studio-scene showing a character we can take to be Pablo himself, sitting at an easel opposite a woman in the nonchalant pose of a model who is none other than Jacqueline), sculptors with classical profiles. Artists of every kind abound in his work and there is no period hardly when they do not make an appearance, as if, while alternating with other subjects, they illustrated a privileged subject, to which he felt fraternally drawn whatever the form of activity in question: of art, without any rationale beyond the song that it sings, and seen less as a system for seizing intuitively hold of the world as it in truth is than as the most marvellous of games, a game which is evidence that man, an animal disloyal to his origins, is a renegade from nature, with which he is engaged in a ceaseless contest of hide-and-seek.

Picasso. Rather than a genius with the flowing locks of a hero or bearded like God-the-Father, solemnly saying his Mass, in the style of a Wagner or a Rodin, a genius, true, who was well aware of the seriousness of life, to the point of having an acute sense of the tragic (the note of *cante jondo* to which 'Guernica', a scream torn from him by a public calamity, bears such brilliant witness, as does, in the register of a private pathos, the drawing which shows a sightless minotaur being led by an adolescent Antigone), yet a genius which can lacerate our hearts without having to lacerate its own toga, which gladly proceeds by the series, as if pursuing some good fortune or was simply carrying on to the end of a subject or a manner before wearying of it: a profoundly playful genius, it would seem. If he appears, almost from the start, to have been eager to experiment in everything (to extend to the limit the gamut of ways of forging images which are self-sustaining and whose truthfulness convinces the moment we first see them, whatever their structure), was this not because he was in flight, as if from the plague, from that dread messenger, boredom, and pledged to constant change (an appeal to the most diverse languages, some times almost wholly of his own invention, at others more or less traditional, languages which he employed by turns less out of perfectionism as out of an inability to persist in whatever is no longer bringing in a return), as if the spirit ceased to be the spirit once it is no longer on the alert and and ready at any moment to commit itself, by a throw of the die, in some new direction. In which connection one may well wonder whether, in the ordinary course of his working day, Picasso ever let up: forever occupied, whether observing through that keen eye of his, or working positively, or confecting one of those knick-knacks of which he manufactured a considerable number on the margins of his oeuvre properly so called as painter, sculptor, draughtsman,

engraver, ceramicist, and, in the literary sphere, as poet in French and in Spanish, but above all in Picassian.

Picasso. Too unbridled a genius not to have had his moments of facetiousness and who, one may well believe, found amusement in the clash between two pictorial genres which are not always separate but have never been so starkly conjugated, as when he unhesitatingly set an edible still life for a hat on the head of the girl-friend whose portrait he was painting, or enclosed the wrist of a woman making love in a watch-strap, in evocation of a moment when everything, and time most of all, should be forgotten; a genius in truth both lucid enough and sufficiently untrammelled to allow mockery its head (an incisive way to reopen a question) and bring it to bear on his own activities. This is shown – in an artist more than one of whose works relies openly on satire, as, among others, the violently sardonic engravings in the series entitled 'Dream and lies of Franco', or the friendlier, more or less caricatural graphic compositions in which one sees, for example, a procuress introducing a girl to a client – in a number of works where humour self-evidently has a part, like the sculpture in which – a burlesque metaphor, realized not in words but concretely, like the one elsewhere in which a kitchen fork becomes the foot of a bird, of a crane to be exact – a toy motorcar chosen from among his son Claude's playthings becomes, while remaining perfectly recognizable, the jaw of a baboon, a particularly striking example of his ironic use of the most unexpected materials, in a sort of montage. A humour that we meet with again in other such sculptural promotions of everyday objects, which thus take on the meaning of parts of the human body, or, elsewhere, in the arrangement of two items of scrap such as a pair of handlebars and a bicycle saddle to form the head of a bull – startling ways of doing what you want to do – just as in the paintings, by virtue of this same raging and inextinguishable need to invent signs (a desire to renew the vocabulary which takes precedence over any properly aesthetic quest), one finds the most paradoxical types of writing being fearlessly exploited, types all the more eloquent for being divorced from their routine. But then, to overturn and to blow the dust from, was that not after all the stated purpose of each of those sumptuous entertainments he seems to have treated himself to, when he so freely revised some of the great, universally recognized masterpieces?

Picasso. An enemy of war who assumed with dignity his world role as the man of the Dove, but who cared nothing for social gradations and treated everyone alike, and was so little puffed up by his own fame that he took advantage of the opportunities it offered him in daily life for outbursts of comic demystification, as if he had been very careful not to allow an undoubted awareness of his own worth go to his head.

Picasso. Give or take a few years a child prodigy, yet who was far from resting on his laurels since his whole life was spent cocking a snook – not at all as an iconoclast, but as the discoverer of other ways effectively to represent human beings and objects – at that academic manner he had mastered early in his youth. Picasso. One of those weightless geniuses who constitute a species alas all too rare, among which – a name that comes

naturally to my mind, without need for critical reflection – I would class Mozart, who also far exceeded his past as a child prodigy, as the abundance and quality of his later efflorescence prove. Pablo Ruiz Picasso, the son of a painter just as young Wolfgang Amadeus was the son of a musician, and who continued as a prodigy right up until his last breath, just like Salzburg's unforgettable native-son, the author of lighthearted works as well as of serious ones, and whose *Don Giovanni*, an opera that foreshadows Romanticism, richly justifies the label of *dramma giocoso* attaching to the theatrical genre to which it belongs. And for me this is the best term, the very essence of ambiguity, at once sombre and cheerful – 'merry drama', translated literally – by which to describe what is represented to so high a degree in the final phase of the oeuvre of the *malageño* our contemporary, a huntsman after quite other prey but fully as ardent and as insatiable as the vanquisher of the 'mil e tre' – a phase full of contrasts of form and of feeling (in blue romances, cubist fugues and other movements of a sometimes titanic sweep yet still immune from stiffness, and positively, directly transmitted. And working thus, at double the tempo, does Picasso – who, unlike the legendary composer of two centuries ago, lived to a great age – not seem to have let off a wonderful last set-piece, in a spectacular affirmation, thanks to the boldness of a line freed from all stylistic constraints and to the intensity of his colours, that although death was drawing near, he was more alive than ever?

translated by John Sturrock

fig. 1 'Large Nude', 20–22 February, 5 March 1964,
140 × 195 cm, *Kunsthaus Zurich*

L'Epoque Jacqueline

JOHN RICHARDSON

Jacqueline Hutin entered Picasso's life in the summer of 1952, shortly after she went to work in the Galerie Madoura. This gallery – in the rue d'Antibes at Cannes – was the retail outlet for the artist's Vallauris potters, the Ramiés.[1] Over the next two years Picasso saw more and more of this attractive young divorcée, but he did not introduce her into his work until summer, 1954. On 2 and 3 June, Picasso executed two paintings of Jacqueline (Zervos XVI.324–25) which are among the most exultant of his later portraits. Two years was far longer than Jacqueline's predecessors had had to wait before manifesting themselves in the artist's imagery. However, as the sitter said many years later, these works were more reassuring than any declaration of love: 'How could I have had any reservations about Pablo's intentions?'

When I first saw these formidable sphinx-like images shortly after they were painted, it was difficult to equate them with Jacqueline's demure and gentle presence. But what accurate characterizations they proved to be! Trust Picasso to unveil the peculiar combination of childlike innocence and guile, masochism and demonic possessiveness that lay at the core of Jacqueline's character. And then the features in these hieratic portraits were so much more emphatic than the real thing. Jacqueline's neck was short whereas in the paintings it is columnar; and her eyes were more often cast submissively down than fixed in an aggressive stare. As Picasso once said of a portrait of his penniless friend, Angel de Soto in white tie and tails, he liked 'to improve his sitters' circumstances for them'.

The biographer, Patrick O'Brian, who harbours a grudge against Jacqueline, claims that the artist must have had Sylvette David or Geneviève Laporte in mind when he painted these portraits.[2] Granted, there are reverberations of Jacqueline's predecessors in them, but the truth is more complex. Picasso, whose visual recall was phenomenal, had instantly spotted Jacqueline's resemblance to the right-hand figure in Delacroix's 'Women of Algiers' – hence the crouching orientalist pose. However, he also claimed that Jacqueline was the image of Alice Toklas. 'I'm not joking. I mean it as a compliment,' he said. 'I always wanted to do a portrait of her. Alice was not always bent over and mustachioed as she is now; she was once very striking, just like Jacqueline. Take her hat off and you'll see what I mean.' And next time Alice appeared in the studio, that's just what Picasso did: he grabbed the huge black hat trimmed with osprey feathers, which hid the old lady's face, and teased the dog with it while mockingly pointing out her resemblance to Jacqueline. Despite the moustache and the king-size cigarette, it was possible to see what the artist meant, why he had endowed Jacqueline with Toklas's hieratic look.

In the course of the next few months a typically Picassian transformation took place. Just as, half a century earlier, Gertrude Stein had grown more and more to look like Picasso's famous portrait of her, Jacqueline was to prove the accuracy of Picasso's foresight by coming to resemble the new persona that he had ordained. And the countless paintings, drawings, sculptures and prints of Jacqueline that Picasso executed over the next two decades remain remarkably faithful to the original formulation, except that her former serenity is often clouded with pain or worry, often suffused with *Angst*.

Three more months were to elapse after the execution of the first two portraits before 'l'époque Jacqueline' officially began. It was not until Picasso returned from his holiday in the Roussillon – he had stayed first of all with his friends the Lazermes in Perpignan, then in Collioure at the Auberge des Templiers – that he and Jacqueline moved in together. The house at Vallauris had been bought in Françoise's name; Jacqueline's Villa Ziquet at Golfe-Juan was too small, so they moved to Paris to the studio on the rue des Grands-Augustins. And there Picasso painted a succession of Jacquelines, based on the two great prototypes done in June. These once and for all confirm that '*la petite Roque*' had become the new inamorata – one who, as she later claimed, would never leave the artist's side for more than a few hours at a time until his death. Reciprocal tenderness is the hallmark of these early portraits: tenderness tinged with melancholy, as if painter and sitter felt intense compassion for each other. The one, dated 11 October 1954, of Jacqueline in a head scarf (Zervos XVI.331) harks back, via the drawing he had done of Rosita Manolo a month or two earlier, to the etiolated girls of the Blue Period. Some of these images suggest that Jacqueline was already suffering from the ill-health which overshadowed her early years with the artist; also that, although she was abjectly, ecstatically in love, there were problems to life with the artist, not least the way his hitherto unfriendly friends were all of a sudden making up to her. 'I had better beware of them', she said to me, 'they're bearing gifts.'

In Paris, Picasso embarked on a series of variations on Delacroix's 'Women of Algiers' (the later Montpellier version as well as the more famous Louvre one), which he had long had in mind. Picasso 'had often spoken to me (Françoise Gilot wrote) of making his own version of the "Women of Algiers" and had taken me to the Louvre on an average of once a month to study it.' However, Françoise had not been the Delacroix type. Jacqueline, on the contrary, epitomized it – and not just in physiognomy. All three of Delacroix's 'Women of Algiers' have the same squat, short-waisted torso that we find in numerous paintings of Jacqueline, especially later ones, where the artist makes the worst of her dumpy body: protuberances gashed with orifices. All three 'Women of Algiers' likewise manifest Jacqueline's submissiveness towards that absent but ever present pasha, the painter. And then, there is the African connection: Jacqueline had lived for many years as the wife of a colonial official in Upper Volta, now called Burkina. As Picasso remarked, 'Ouagadougou may not be Algiers, nonetheless Jacqueline has an African provenance'.

The outbreak of Orientalism had another sadder aspect. On 3 November, Matisse, the

only artist Picasso regarded as a serious rival, died at Nice. 'Au fond il n y a que Matisse,' Picasso had been in the habit of saying, echoing Matisse's remark to one of the nuns at his chapel: 'Don't let anyone criticise my chapel except Picasso.' For Picasso, irony was the easiest way to deal with grief. 'Il est mort, et moi, je continue son travail,' he said. And to Penrose, he joked that Matisse had 'left me his odalisques'. Matisse was the only other artist since Delacroix (Picasso told Cooper) to have exorcized the 'picturesque sentimentality that is the curse of most Orientalism'. Certainly there is nothing picturesque or sentimental about Picasso's 'Women of Algiers'; besides Delacroix and Matisse, they epitomize Cubism: for instance, the way legs are plaited.

The day after Picasso brought the series to an end (14 February) his hated wife, Olga – they had been estranged for twenty years – died at Cannes. To escape ex-mistresses who were eager to marry him now that he was free, the artist fled Paris. He and Jacqueline returned to the south to look for somewhere to live. Sure enough, the house they found, the grandiose Villa La Californie (which had been rented for some years to Queen Geraldine of Albania), had an Orientalist air. He had put so much thought into the 'Women of Algiers', Picasso told Daix, that he ended up with a house that, as it were, matched them. 'It's always like exploratory painting. Besides, Delacroix had already met Jacqueline . . .' And the war with Algiers, he might have added, was at its height.

As always when the mistress changed, everything else in the artist's life changed: not just the house but the poet laureate, the circle of friends, the dog and last but not least the style. He now saw more and more of Jean Cocteau, his affection for whom was all the stronger for being tinged with age-old contempt; less and less of Parisian intellectuals and Communists, although he remained a party member until his death. Instead he took up with an assortment of bullfighters, photographers, collectors, printers and potters. He also came into possession of a dachshund called Lump and a goat called Esmeralda. Picasso's *train de vie* matched his new surroundings. The only trouble was that increased fame meant that the house was often under a state of siege. Fortunately Jacqueline provided rock-like security and support.

Jacqueline's 'Women of Algiers' resemblance continued to have an Orientalizing effect on Picasso's style, witness paintings of her in a Turkish jacket, or *djellaba* against a background of palm trees and the Mauresque fenestration of La Californie. Pride in his new house and new mistress is reflected in numerous decorative paintings of Jacqueline in the studio. Largely because the artist was more contented, or less discontented, than he had been in some years, this was one of his less demonic – hence less exploratory periods. However, clouds soon began to gather. A seventy-fifth birthday was most unwelcome. At the same time the Hungarian revolution soured Picasso on the USSR, though not enough to undermine his faith in Communism. Meanwhile Jacqueline was recurrently ill. Far from being sympathetic, the artist resented these lapses. 'Whenever women are ill, it's their fault,' he once said in front of his ailing mistress. And just as he had improved her circumstances in earlier portraits, he was no less capable of doing the reverse. Subtle adjustments to her image enabled Picasso to worship or humiliate or test

Jacqueline, indicate love or anger or desire and even on occasion predict one of her frequent bouts of illness. This prediction might take the form of a drawing like one (Zervos XVII.330) done on Saint Valentine's Day, 1957, in which her anguished features are superimposed on a shocking-pink network of lines like a fever-chart. When, a day or two later, Jacqueline obligingly ran a temperature, the artist took pride in having foreseen it. 'You see, I'm a prophet,' he claimed, not entirely in jest. Once Picasso showed me a particularly agonized portrait of the period and joked rather cruelly that a good doctor could base a diagnosis on it.

Despite private and public problems Picasso steeled himself, a year later, to wrestle with Velázquez's masterpiece, 'Las Meniñas'. Although from earliest days he had exploited El Greco to great advantage, Picasso had hitherto fought shy of Velázquez (as he had of Goya). With good reason: much of the master's genius resided in the sheer glory of his paint; and Picasso was out to appropriate Velázquez's *alma española*, not his facture. The titanic tussle lasted four months, from 17 August until 30 December 1957. Night after night Picasso shut himself away in one of La Californie's attics – formerly used as a pigeon-loft – where no one was allowed but Jacqueline. So self-absorbed and temperamental did the artist become that Jacqueline and the Pignons dubbed him 'the abominable snowman'. In the end he devoted fifty-eight paintings (subsequently given to the Museu Picasso, Barcelona) to the 'Meniñas'. The series starts with a tremendous bang: a huge (6 × 9 foot) and highly equivocal exercise in Cubist space, which turns the figure of Velázquez into a faceted giant towering over the 'Meniñas' and their attendants. 'Look at it and try to see where each of [the figures] is actually situated', Picasso told Penrose. No question about it, 'Variation I' is a triumph of probing. By comparison the other fifty-seven variations merely beat around the bush. However, many sparks are struck, and they pave the way for Picasso's preoccupation with the studio as the setting for the creative act; with the equivocal rapports between artist, model and spectator; and the no less equivocal rapports between art and illusion. They are also the first signs of Picasso's return in extreme old age to his roots in southern Spain, for Velázquez was also Andalusian.

By the following summer high-rise buildings and *paparazzi* were encroaching on Picasso s privacy. It was time to move away from Cannes. In 1958, Douglas Cooper and I put the artist on to buying the Château de Vauvenargues on the slopes of Cézanne's Mont Sainte-Victoire. He used this primarily as a country retreat, but some of his finest paintings of 1959–60 – easily recognizable for their heraldic combination of viridian and carmine – were done there. As for the Mont Saint-Victoire, he depicted it in the form of a gigantic nude ('Nude under a Pine Tree' cat.10), like a piece of sculpture which follows the long line of the range. On one or two of his mock state portraits of Jacqueline in the manner of Spain's golden age, Picasso wrote in large letters 'Jacqueline de Vauvenargues'. The title, as it were, 'took'. Jacqueline enjoyed being *la châtelaine*. And it was very much her idea that Picasso, not to speak of herself, be buried at the foot of the steps leading up to the château's main entrance.

fig.2 'Las Meniñas, after Velázquez', 15 September 1957,
129 × 161 cm, *Museu Picasso, Barcelona*

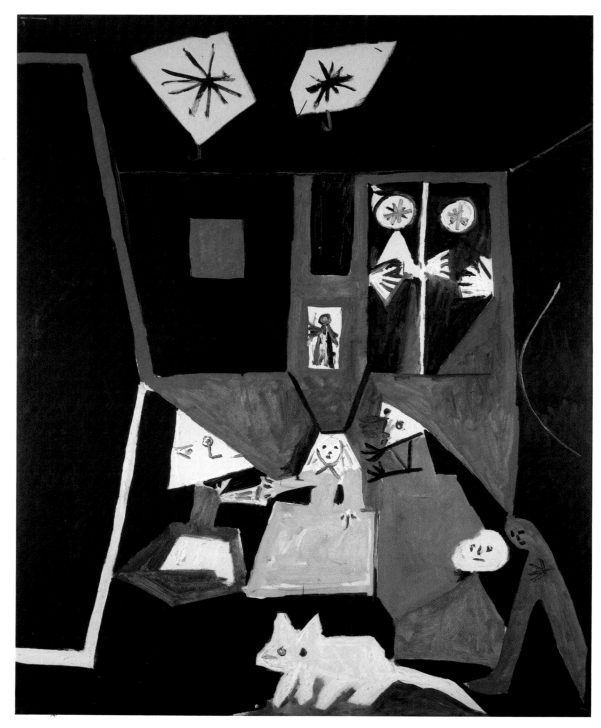

fig. 3 'Las Meniñas, after Velázquez', 19 September 1957,
162 × 130 cm, *Museu Picasso, Barcelona*

Finally, on 2 March 1961, Picasso and Jacqueline celebrated their marriage in great secrecy and, in June, installed themselves in a handsome, well-protected villa idyllically set on a terraced hillside near Mougins.[3] A former *mas*, the house had been transformed before the war into a luxurious villa by Benjamin Guiness. It had been named after a neighbouring pilgrimage chapel, Notre-Dame-de-Vie, and this no doubt commended it to someone whose eightieth birthday was about to be celebrated, and whose greatest fear was death. The house lived up to its auspicious name. Picasso spent the last twelve years of his life there, working on what amounted to a whole new oeuvre. Although derided by most pundits of the period, this has now emerged – thanks largely to two pioneer exhibitions (organized by Christian Geelhaar at the Kunstmuseum, Basle in 1981; and Gert Schiff at the Guggenheim Museum, New York, in 1984) – as a phenomenal finale to a phenomenal oeuvre.

<p style="text-align:center">* * *</p>

Starting with the 'Déjeuner sur l'Herbe', the major themes of the last decade develop out of each other with a zig-zag logic that is peculiarly Picassian. Off and on over two and a half years (1959–62) the artist did more than a hundred variations on Manet's masterpiece; ultimately going round and round in circles trying to figure out how to bring the series to a climax and once and for all exorcize Manet's bothersome ghost. What more appropriate and ironical than a rape scene, or rather a series of rape scenes (1 August 1962) (see *Je Suis Le Cahier*, no.165) in which Manet's bearded picnickers menace callipygous ladies with their large pink erections? At the end of this sketchbook Picasso executed a further rape series (29 August 1962): projects for the *l'Après Midi d'un Faune* drop curtain which had been commissioned by the Paris Opera's *maître de ballet*, Serge Lifar, but declined by its director, Georges Auric. The subject of rape still preoccupied the artist a month or two later when he spent an evening – 'dans le délire de peinture et l'enthousiasme' – projecting on to the wall of one of the studios at Notre-Dame-de-Vie slides of David's 'Rape of the Sabines' (Louvre) and Poussin's 'Massacre of the Innocents' (Chantilly) which Jacqueline had asked the Pignons[4] to bring from Paris. The Pignons' visit coincided with Picasso's eighty-first birthday (25 October), but, more to the point, with the Cuban missile crisis – a crisis which evoked the artist's anti-Americanism, where Cuba was concerned.[5] And these great neo-classical evocations of violence, combined with memories of his own earlier rape scenes, inspired Picasso to embark on yet another denunciation of war.

The new series dates from 24 October, when Picasso painted a version of the 'Rape of the Sabines', which 'conflates motifs from Poussin's version with borrowings from David's work'.[6] He also filled a sketchbook with drawings: some after Poussin's 'Rape', some of a girl falling off her bicycle, and some which combine those two images. Over the next ten days the artist poured forth a profusion of paintings which jumble up these motifs and the periods to which they should by rights belong: Ancient Rome, the France of Louis XIII and Napoleon as well as the present day. On 25 October the girl who falls off

her bicycle and impales herself on it (as in Georges Bataille's *Histoire de l'œil*: a favourite book of Picasso's) has her breasts squashed into her face by the large sandalled foot of a centurion. Then, between 2 and 4 November, she gets what can only be described as 'hoofed' to death by a phallic-headed warrior on a phallic-headed horse. (Note the outrageous pictorial pun between the horse's testicles and the victim's breasts.) The very same day (4 November) Picasso embarked on a huge free-for-all (cat.22), in the course of which not only the Sabines get raped, but also, in a manner of speaking, Poussin and David, likewise the artist's own earlier self. The only trouble with these paintings is that, as so often when Picasso sets out to castigate violence, he ends up appearing to relish it. In his masterly analysis of this group of paintings Schiff admits this 'painful ambiguity. Victims and assailants . . . are all treated with equal cruelty by the painter . . . [However] on February 7 he finished a large canvas which resolved the contradiction. As if he had exorcized the cruelty in his own soul, Picasso was now capable of creating one of the most moving statements against war and violence ever painted.' True, this exuberantly baroque vision of 'The Rape of the Sabines' (Museum of Fine Arts, Boston) is Picasso's most effective war painting since 'Guernica'. But with all respect for Schiff, doesn't the artist, as Wilde wrote of Swinburne, 'deafen us with his clangours'? And doesn't the principal villain of the piece – the warrior on the right who brandishes a sword and tramples the mother and child underfoot with such gusto – have a look of the artist? Much of the strength of Picasso's late work surely derives from the fact that he *never* 'exorcized the cruelty in his own soul'; that, on the contrary, this late convert to the principles of homeopathy perceived that the only cure for violence was violence.

The 'Warrior' paintings nearly did him in, Picasso said. But in the end they served as a catharsis for his political and personal anxieties: for the Cuban missile crisis and, one suspects, some private missile crisis of his own. Far from subsiding, however, violence engendered even more violence. Although he remained *engagé*, Picasso would never again indict war.[7] Instead, as Parmelin reports, he 'declared himself ready to kill "modern" art – and hence art itself – in order to rediscover painting. It [was] art, accursed facile art, that in the final analysis had made those warriors so painful to come by . . . And so down with all that has been done! Down with Picasso too! Because . . . it [was] Picasso and Picasso's style of painting that he [was] attacking.' And Parmelin concludes, 'in the month of February, 1963 [in fact the day after he finished the final "Rape of the Sabines"], Picasso lets loose. He paints "The Artist and his Model". And from this moment on he paints like a madman, perhaps never before with such frenzy.' As Picasso wrote inside the back cover of a sketchbook (no.17 in *Je Suis Le Cahier*), an inscription which he had meticulously dated 27 March 1963 – 'La peinture est plus forte que moi/elle me fait faire/ce qu'elle veut' (Painting is stronger than I am; it makes me do whatever it wants).

The fact that most of the work done after 1963 revolves around the studio reflects the reclusive life that great fame and great age obliged the old artist and his young wife to

lead. The burdens of fame and age were compounded by the problem of being a figurative painter in an era of non-figurative painting. Parmelin summed up Picasso's dilemma: 'When one draws figures in an age when no one else is doing it', she wrote, 'one must be more solitary than ever and – quite different to what people say – the painter . . . must be a painter first of all and live the life of a painter. Everything else is secondary.' And so, the quasi-regal audiences that had been a ritual at La Californie dwindled to visits by a few close friends and associates. Apart from a secret trip to Paris in November 1965 for an operation at the American Hospital, Picasso gave up travelling. Indeed, except for a few *corridas* at Fréjus (the last in 1970), he seldom left the immediate neighbourhood even to go to Vauvenargues. Notre-Dame-de-Vie and more especially his studios became Picasso's entire world, a microcosm of the universe: what Schiff has called Picasso's *Teatrum Mundi*.

Picasso could, indeed often did, generate an atmosphere of sardonic good will around him, but age had not mellowed his black side, and in the last ten years of his life he often had reason to be gloomy. The Papini 'confession', for instance. Pierre Daix – the most perceptive and accurate of the artist's biographers[8] – has once and for all condemned as false this statement that Picasso was supposed to have made to Giovanni Papini[9] (a former Futurist and editor of *Lacerba*), confessing that his art was a joke on the public. From time to time philistine elements on either side of the Iron Curtain would trot out this spoof to discredit modern art or for their own devious reasons. In the early sixties, for example, when the Russians wanted to get back at the French Communist party, they arranged for this 'confession' to resurface in a Yugoslav magazine. This time Picasso finally lost his temper and, with the help of Daix, then editor of *Les Lettres Françaises*, denounced Papini's handiwork as a forgery. Unfortunately, this wretched fake continues to deceive gullible people, witness a recent book, *What's Bred in the Bone* by the Canadian novelist, Robertson Davies, which uses it as a punch-line.

At the height of the Papini affair, Picasso had even greater cause for outrage. His ex-mistress, Françoise Gilot, came out with an embarrassingly frank book, *Life with Picasso*[10] (first published in America in 1964), which he tried, and failed, to prevent from appearing in France. To make matters worse, Picasso was bitter that much of his former constituency was drifting away from him, bitter because he felt he was making a colossal breakthrough. Instead of sitting back and churning out 'Picassos', he was doing work of great innovative power. He was bitter, too, that young artists had forsaken him for new gods, false gods, he felt, Marcel Duchamp in particular. Picasso had never taken Duchamp seriously, his camp followers even less so. 'They've looted Duchamp's store', he said of the Neo-Dadaists, 'but all they've done is change the wrapping paper.' As for the Abstract Expressionists: 'When somebody wants to say something good about [abstract art], he talks of music . . . I think that's why I don't like music.' Picasso should perhaps have paid more heed to advice Matisse once gave him: 'We cannot judge what comes after us.'

No less upsetting, some of those closest to him were lukewarm in their support, at

worst treacherous. Picasso's dealer, the faithful Kahnweiler, may have been way ahead of the game before 1914, but by the 1960s, the artist felt that this impresario of Cubism was no longer as understanding as he should have been. And then Douglas Cooper, who had served with such honour as Picasso's Falstaff, fell foul of his idol. According to Jacqueline, Cooper forced his way into Notre-Dame-de-Vie one evening and broached the forbidden subject of the artist's litigious children. Picasso ordered his old friend out of the studio. Cooper avenged himself, the moment the artist was dead, by writing a letter to *Connaissance des Arts* (July, 1973) in answer to an article describing the enthusiasm with which Picasso's 'admirers' had welcomed the exhibition at Avignon's Palais des Papes. 'With what admirers might you have spoken? I believe I am entitled to count myself among the serious admirers of Picasso's work and to be capable of judging it. I have also spent a long time looking at the paintings in question. These are incoherent doodles done by a frenetic dotard in the anteroom of death. That's what has to be said.' Jacqueline never spoke to Cooper again.

If they weren't defecting, old friends seemed to be dying: that, too, was unpardonable. And then there was the onset of impotence, the imminence of his own death. Despite these dark clouds the artist's work went from strength to strength. The early sixties were strong but the late sixties were even stronger. Meanwhile Jacqueline was proving the ideal wife – patient, perceptive, formidable and ruthless in protecting his interests. And Picasso was proving amazingly vigorous for a man of his great age – hard of hearing but sharp as ever in mind and eye and spirit. And although much of the avant garde had drifted away from him Picasso could still count on some devoted supporters. Chief among these were Edouard Pignon, with whom he ceaselessly talked about painting, and his Polish wife, Hélène Parmelin, whose books about Picasso *dans l'intimité* from the late forties up to his death are of the greatest value as records of a period too recent to have been fully chronicled.[11] Parmelin is 'the only person to catch Pablo's turn of phrase', Jacqueline said with justice, the only person to record the paradoxes and pyrotechnics, the fits and starts of his talk, the only person to evoke the *Sturm und Drang* no less than the fun-and-games of the artist's everyday life.

Among the other principal habitués of Notre-Dame-de-Vie were the Crommelynck brothers, Piero and Aldo – master engravers whom Picasso had first known in Lacourière's studio where Aldo had been apprenticed. They not only worked on the sets of prints, which are among the glories of the artist's last phase, they were like a second family to him. The Crommelyncks, their wives and children, figure in numerous prints[12] and drawings of the period. Aldo's looks inspired the aquiline appearance of some of the musketeers and those kissing couples (late sixties) whose profiles and tongues lock into each other as tightly as pieces of a puzzle. Besides their Paris atelier, the Crommelyncks set up an engraving studio (autumn, 1963) in an old bakery at Mougins, and most days, when they were in the Midi, they would call on Picasso around teatime to see if their services were required. More often than not they were, and they would stay on, preparing the plates, pulling trial proofs, helping with corrections until well into the

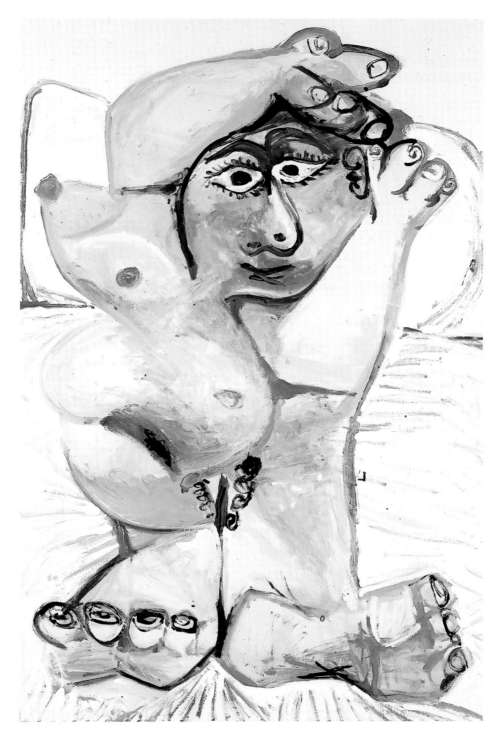

fig.4 'Reclining Nude', 14 June 1967,
114 × 146 cm, *Musée Picasso, Paris*

night. One cannot overestimate the role that these young printers and their attractive wives played not just in Picasso's art – witness the '347' series – but in his daily life. There were of course other old friends who continued to visit the studio until shortly before Picasso died, not least that painfully great writer Michel Leiris, and his wife, Zette (Kahnweiler's partner); David Duncan, the artist's court photographer; Swiss dealers like the Cramers and Rosengarts; art historians like Pierre Daix from Paris, Roland Penrose from London, Jean Leymarie from Geneva and William Rubin from New York; and Spanish cronies – Rafael Alberti, Luis Miguel Dominguin, and above all, Manuel Pallarés, a comrade from art-school days in Barcelona – who kept the artist in touch with his Spanish roots and past.

<center>* * *</center>

On a visit to Notre-Dame-de-Vie in the mid-sixties, I found Picasso in a talkative mood – talkative about the mundane things that affected his work. He said that anyone who bothered to check the dates would discover that his bullfight subjects were usually executed on a Sunday, the traditional day of the *corrida*. As compensation for not being at the bullring, he would find himself enacting on paper the spectacle he was missing. And because Picasso's imagination was always harnessed to the facts of his life ('I paint the way some people write their autobiography', he told Françoise Gilot), the scenes would usually be specific, often set in the Roman arena at Arles; and the silhouette of the toreador – tall, elegant, poised to kill – would usually correspond to Luis Miguel Dominguin. 'He materializes in my drawings whether I want him there or not,' although, as Picasso told Cocteau, 'his real bullring is the Place Vendôme. One thinks he is not like the others, but he is exactly the same.' Cocteau had a way of evoking the artist's malice.

This compensatory pattern no longer applied to bullfighting, Picasso said, for the simple reason that he had virtually ceased going to *corridas*. True, there are tauromachic references, but mostly in the form of portraits of *toreros* – kin to his musketeers – dressed in the style of Goya's *Tauromachia*. The bull, that symbol of sexual potency, has all but vanished from Picasso's work. Nor does the bullring figure in the artist's last tauromachic painting: the large seated figure, done after a bullfight at Fréjus in October 1970, of a black matador from Mozambique. This haunted and haunting masterpiece, on which he worked 'obsessively' (according to Jacqueline), represented a conscious farewell to the bullring. Picasso thought so highly of it that he hung it in a place of honour at Notre-Dame-de-Vie, close to his great Matisse, 'Still-life with Oranges', and presented it with much ceremony to Jacqueline. 'You are the only person capable of understanding it,' he said. Do you think he had Van Gogh's 'Zouave' in mind when he painted it, I asked her? The answer was, yes.

In the absence of outside stimuli, Picasso drew more and more on his incomparable memory – especially his memory of early days in Spain – also on what he himself

described as his 'novelist' side: 'I spend hour after hour while I draw', he told Otero, 'observing my creatures and thinking about the mad things they're up to; basically it's my way of writing fiction.' Fiction, too, was a recurrent source of inspiration. He owned several editions of Fernando de Rojas's bawdy *Tragi-Comédia de Calisto y Melibea* (1499), whose villain, the procuress Celestina, is the protagonist of a magnificent series of picaresque engravings (1968) – illustrations to Rojas as if rewritten by Picasso. Besides the Spanish classics, the artist's library included most of French literature, English authors such as Swift and Sterne (he also had a particular penchant for Douglas Jerrold's *Mrs Caudle's Curtain Lectures*), Americans such as Hawthorne and Melville, any number of thrillers, and of course art books of every kind – books that accumulated in piles all over the floor, seldom on shelves. A goldmine of iconographical clues lies hidden in this eclectic library.

Even television played a role in the development of Picasso's late style. To distract herself during the long hours when her husband was working, Jacqueline had bought a television set. The two of them developed a taste for old movies. One film in particular, *The Lives of the Bengal Lancers*, triggered a series of drawings – a sultan surrounded by big-bosomed odalisques (1968) – inspired not so much by the lancers as some Orientalist concept of their foe. He may also have derived ideas from Hollywood extravaganzas of Roman life like *Spartacus*. As he told Otero, 'I don't know what's happening to me lately. I do nothing but lancers, musketeers, warriors, bullfighters.' But what the artist most enjoyed watching on TV was *Catch*. (*Catch* is short for 'catch-as-catch-can', 'Franglais' for all-in wrestling.) To some extent its rituals parody the rituals of the bullring. There is violence but it is more farcical than solemn; there are fetishistic costumes but they are more comic-strip than hieratic; and there are sexual overtones, but they are more honky-tonk than darkly sacrificial. Picasso, who had always been a devotee of the circus, especially enjoyed the clowning aspects of *Catch*. The more grotesque the antics, the more pleased he would be, especially if there were more than two entangled participants. To Jacqueline's surprise, Picasso got hooked on *Catch*. *Catch* was the only thing that could keep him from the studio. Pignon was also a *Catch* fan, and the two artists would keep each other abreast of forthcoming bouts. Hence all those seemingly wrestling figures who turn out to be making love. But it is not just the tangled limbs of the lovers, it is the general air of burlesque violence – the *Three Musketeers* as seen by Mack Sennett – that flavours the late graphics with a surreal hint of *Catch*.

But let me go back to Picasso's statement about drawings compensating him for missed pleasures, because this has an obvious relevance to the artist's sex life, or lack of one. Picasso admitted to Brassai, 'whenever I see you, my first impulse is to . . . offer you a cigarette, even though I know that neither of us smokes any longer. Age has forced us to give it up, but the desire remains. It's the same thing with making love. We don't do it any more but the desire is still with us!' The eroticism of the late works can thus be seen partly as compensation for an inability to have sex. But it does not follow, as Douglas Cooper claimed, that Picasso's baleful nudes flaunting their sexual parts are allegories of

impotence. This negative view leaves out of account some very positive aspects of Picasso's final works.

For while Picasso's sexual powers may have waned, his artistic ones had done nothing of the sort. Whatever he may have felt about the onset of impotence, the compensatory pattern that the artist diagnosed enabled him to see sex and art as metaphors for each other. The tools of the artist's trade – his brushes – became surrogates for sexual parts to be used on a canvas that was a surrogate for the model. Apropos his work for the Diaghilev ballet, Picasso told Clive Bell in 1960 that 'when it comes to the point, one generally has to paint the dress on the dancers'. And he recalled the first night of *Tricorne*, when he wanted to make some last-minute alterations to Lopokova's costume. 'Little Lydia was abominable. She couldn't sit still for a moment. She wriggled and giggled and messed everything up,' he told Bell, who checked the story with Lopokova. 'Oh, yes, I should think so,' she said, 'he tickled my nipples with his brush.' Lopokova apparently told Picasso to behave, that she wasn't one of his canvases or one of his girls.

Forty years later Picasso was still doing much the same thing, only on canvas: for example, numerous studio scenes (1963–64) in which an artist uses his brushes on the painted image of a model as if he were making love to her; and in which he blurs the distinction between the 'real' model and the 'painted' model. Time and again a phallic thumb or bunch of brushes stuck through the hole in a scrotum-shaped palette makes a pun on the artist's sexual parts. Time and again the artist literally pokes the model with his brush. Instead of seeing these paintings as allegories of impotence, one could say that impotence had shown the artist how the creative and procreative processes can be seen as standing for each other.

Picasso's obsession with genitalia, which takes its most extreme and comic form in the frolicking phallus – people who figure in a series of prints (cats.109–112) done in November–December 1966 – have an atavistic source. Picasso, we should never forget, was born in Málaga, and he remained deeply Andalusian at heart. Just how deeply will be apparent to anyone who consults David Gilmore's recently published study of Andalusian aggression (*Aggression and Community, Paradoxes of Andalusian Culture*, Yale University Press, 1987). In his enlightening analysis of *machismo*, Gilmore sees Andalusia as a 'phallocentric society'. 'The Andalusian view of sexuality stresses the functional primacy of the penis in both arousal and orgasm. The male organ is the instrument of instruction and the gonads are the brains. Sex is a masculine monopoly. Man the furrowing plough, woman the fertile soil . . . [The Andalusian man's] phallic aggression restores his endangered integrity, his masculine dignity . . . this aggression fused with sexual love and with a curious sexual hate born of centuries of defeat, unites him to the world as it protects him from the world.'

Besides *machismo*, Gilmore cites another characteristic of Andalusian aggressiveness: the *mirada fuerte* (literally strong gazing). 'If you mention something valuable to an Andalusian, he wants to see it, wants to eye it. To express that something is good or true,

he points to his eye, tapping the side of his head [a characteristically Picassian gesture]; he needs to see it and in seeing to experience it, feel it . . . When the Andalusian fixes a thing with a stare, he grasps it. His eyes are fingers holding and probing . . . the *mirada fuerte* has elements of curiosity, hostility . . . and envy. But the sexual element is present also . . . The light of the eyes is highly erotic . . . In a culture where the sexes are segregated to the point of mutual invisibility, the eye becomes the erogenous zone par excellence. In Andalusia the eye is akin to a sexual organ . . . looking too intently at a woman is akin to ocular rape.' And Gilmore cites a voyeurs' club in the village of Fuenmayor: the members would go to the church and check on the marriage banns, then peep in at night on the newly weds, who are supposedly 'somewhat careless about the normal precautions'. Nowhere does Picasso's name crop up in Gilmore's study, but isn't the artist a striking embodiment of these theories – the *mirada fuerte* especially – above all in old age, when his imagination reverted to the Andalusian roots which were as much his pride as his shame? 'You should wear a black dress', he had once told Françoise Gilot, 'with a kerchief over your head so that no one will see your face. In that way you'll belong even less to the others. They won't even have you with their eyes.'

<p style="text-align:center">* * *</p>

'Works of art beget works of art'
(W. B. Yeats)

Just as the sexuality of Picasso's late work (especially when it was exploited by unscrupulous publishers out to titillate a prurient public) discouraged its serious acceptance, so did the artist's flagrant borrowing from the old and not-so-old masters – Velázquez, Rembrandt, Delacroix, Van Gogh, Manet, Ingres among them. Another symptom of failing powers and an impoverished imagination, we were told. In fact it was nothing of the sort.

Why did Picasso lock horns with one great painter after another? Was it a trial of strength like arm wrestling? Was it out of admiration or mockery, irony or homage, Oedipal rivalry or Spanish chauvinism? Each case was different, but there is always an element of identification, an element of cannibalism involved – two elements that, as Freud pointed out, are part of the same process. Indeed Freud described the process of identification as 'psychic cannibalism': you identified with someone; you cannibalized them; you assumed their powers. How accurately this describes what the predatory old genius was up to in his last years.

Picasso also cannibalized his friends. He would switch on the magnetism and let his ego feed on whatever emotional response – critical understanding or silly starstruck *Schwärmerei* – could be extracted from his companions. A day spent with the great man would thus induce spiritual exhaustion. Picasso cannibalized great artists in much the same way. He engaged them in mortal, or immortal, combat, and devoured them one

after another. With their powers added to his, this very small, very frail, very old man felt himself more powerful than any other artist in history, so powerful indeed that he embarked on a one-man apotheosis of post-Renaissance painting. The irony is that although Picasso was the most famous artist in the world, and a regular exhibitor, hardly anyone understood, let alone appreciated what he was doing.

Of all the artists with whom Picasso identified, Van Gogh is the least often cited but probably the one who meant most to him in later years. He talked of him as his patron saint, talked of him with intense admiration and compassion, never with any of his habitual irony or mockery. Van Gogh, like Cézanne earlier in Picasso's life, was sacrosanct – 'the greatest of them all', he said. Parmelin has described how Picasso badgered the director of the museum in Arles to get him a photostat of a press-cutting, the only documentary record of Van Gogh chopping off his ear and giving it to Rachel, the prostitute. He, who seldom framed anything, was going to frame it, he said. Parmelin also touches on another incident that I witnessed. Apropos a certain dealer who coerced his artists, or their widows, into exchanging a painting for a Rolls-Royce, Picasso said rather bleakly, 'Can you imagine Van Gogh in a Rolls-Royce?' It became a standing joke: 'Can you imagine Velázquez in a Rolls?' The answer I seem to remember was, yes. But Van Gogh never – not even a *deux-chevaux*.

At first glance Van Gogh does not manifest himself very overtly in Picasso's work, certainly not as overtly as Manet or Velázquez. But that is largely because his influence is not a superficial stylistic question of borrowed compositions or anecdotal trappings, but a matter of deep spiritual identification. True, some of the landscapes or seascapes of 1967 recall the tornado turbulence, if not the ominousness, of Van Gogh's terminal 'Cornfields'. However, it is the paintings of a red-bearded, straw-hatted artist at his easel (1963–64), with their generic resemblance to Van Gogh's self-portraits (one of which Picasso used to project, floor to ceiling, on the studio wall) that reveal the extent of the old Spaniard's debt to the doomed Dutchman.

Why, one wonders, should a great artist want to paint self-portraits in the guise of another great artist? Had Picasso lost some sense of his own identity? The answer is surely that in losing your identity to someone else you gain a measure of control over them. These proxy self-portraits suggest that Picasso was out to assume something of Van Gogh's identity and by osmosis something of the Protestant *Angst*, which is what makes northern Europeans sometimes so attractive, sometimes so unattractive, to southern ones.

In his self-pitying Blue Period days Picasso had thought of Van Gogh as a kindred spirit – the quintessential *peintre maudit*. At the end of his life Picasso's attitude to the Dutchman was less sentimental. What he wanted was to enlist Van Gogh's dark spirits on his side, to make his art as instinctive and 'convulsive' as possible – something that African art had helped him achieve in 1907, something that the Surrealists had helped him do in the twenties. I suspect that Picasso also wanted to galvanize his paint surface –

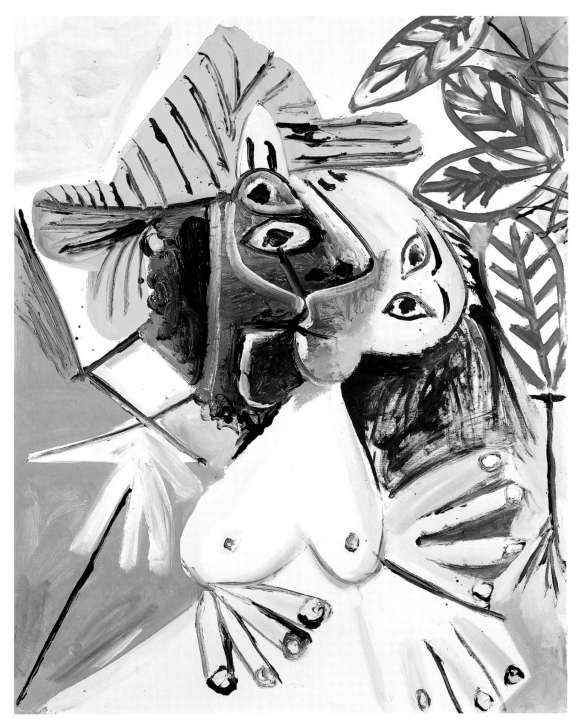

fig. 5 'The Kiss', 28 November 1969,
116 × 89 cm, *Private Collection*

not always the most thrilling aspect of the epoch before Jacqueline's – with some of the Dutchman's Dionysian fervour. It worked. The surface of the late paintings has a freedom, a plasticity, that was never there before; they are more spontaneous, more expressive and more instinctive, than virtually all his previous work. The imminence of his own end may also have constituted a link with Van Gogh. The more one studies these late paintings, the more one realizes that they are, like Van Gogh's terminal landscapes, a supreme affirmation of life in the teeth of death.

If Van Gogh became an explosive spirit lurking in the depths of Picasso's psyche, how should we see Rembrandt, the other great Dutchman whose presence presides over the late work? More, I think, as an all-powerful God-the-father figure whom Picasso had to internalise before he died. Since Gert Schiff and Janie L. Cohen have both analyzed the impact of Rembrandt on Picasso,[13] I will not go over the same ground again except to comment on Cohen's suggestion that Picasso must have worked from Ludwig Munz's book on Rembrandt's etchings. She is doubtless correct, although I couldn't find a copy of Munz when I went through Picasso's books at Notre-Dame-de-Vie in 1985. What I did find was a set of Otto Benesch's six-volume catalogue of Rembrandt's drawings.[14] And these are apparently what engaged the artist's attention during his convalescence from his operation in November 1965. Benesch's catalogue opens up some interesting leads, but I am less interested in the art-historical game of hunting down stylistic parallels than in determining the nature of Picasso's obsession with Rembrandt.

The artist has supplied us with a clue in the form of his famous Oedipal boast – first published by Jaime Sabartès (Picasso's secretary) and unquestioningly accepted by every subsequent biographer except Daix – that, when he was thirteen, his father 'gave me his paints and his brushes and never went back to painting'.[15] That Don José equipped his prodigy of a son with the tools of his trade goes without saying; as for the rest of the claim, it is the more interesting for being false – wishful thinking on the artist's part. For there is incontrovertible evidence that, far from abdicating in favour of his son, Don José continued to paint: for instance, he always portrayed the pigeon of the year for Barcelona's Colombofila, of which he was president. Given Picasso's fantasy – a fantasy he came to believe – about this symbolic paternal gift, it is surely possible that he entertained a similar fantasy about a far more formidable antecedent, Rembrandt, and that he was out to appropriate the Dutchman's 'brushes'. Just as Picasso used to joke that he had repaid his debt to his pigeon-fancying father 'millions of times over' in kind – that is to say, in pigeons or doves – were not his late works a way of paying Rembrandt back in musketeers? For Picasso's ubiquitous musketeers have an undoubtedly Rembrandtian provenance.[16] The artist used a slide machine to project 'The Night Watch' in all its vastness on his studio wall – thus enabling the musketeers to step straight out of seventeenth-century Amsterdam into the time-warp of Picasso's *teatrum mundi*.

'Every artist takes himself for Rembrandt,' Picasso once told Françoise Gilot, and this is truer of nobody than of himself. He repeatedly inscribed books, especially ones to his

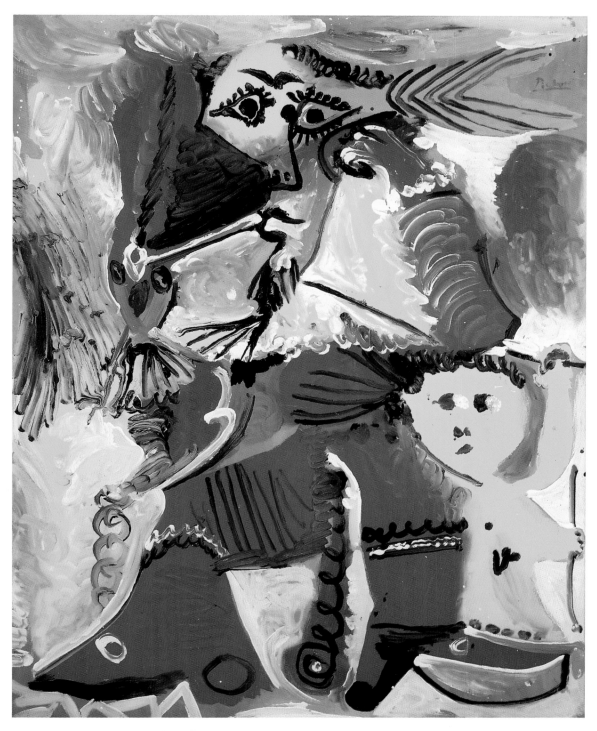

fig.6 'Rembrandtesque Figure and Cupid',
19 February 1969, 162 × 130 cm, *Picasso Collection,*
la Ville de Lucerne, Rosengart Bequest

friends the Rosengarts, with a sketch of a self-portrait of Rembrandt over his signature as if to advertise the degree of this identification. And long before Rembrandtian references became a regular feature of his work, Picasso used to say that the Dutchman was *his* kind of painter, that he infinitely preferred the Dutch to the Italian masters, whom he regarded as too *pompier*, too 'artistic' (a pejorative word in his vocabulary). The Dutch knew how to rub people's noses in real life. It was also my impression that Picasso identified with Rembrandt because they had both suffered a similar fate in old age. From being enormously popular *chefs d'école* both had turned reclusive; both were accused of not finishing their work; both lost out to new gods.

And then, as Cohen suggests, Picasso identified with Rembrandt 'as an ageing artist. Rembrandt's pictorial identification of his own ageing process as seen in his self-portraits was surely not lost on the ageing Picasso.' True, but let us go a step further and see Picasso's identification with Rembrandt in the light of art-historical concepts of a great late period. Picasso knew all about the almost religious awe which certain art historians feel for the late works of certain artists. And he must have suspected that his own late work was seen by critics as a decline and fall rather than an apotheosis. This was the view that John Berger advanced in his *Success and Failure of Picasso* (1965): compared to 'Bellini, Michelangelo, Titian, Tintoretto, Poussin, Rembrandt, Goya, Turner, Degas, Cézanne, Monet, Matisse, Braque', whose work 'gained in profundity and originality as [they] grew older', Picasso 'became a national monument and produced trivia.' His late work (Berger claimed) 'represents a retreat . . . into an idealized and sentimental pantheism . . . Picasso is a startling exception to the rule about old painters.' These words were the more wounding coming from a supposedly sympathetic Marxist pen.

In the circumstances what more natural than that Picasso should identify with a master whose late work was rejected by his former followers, then vindicated by posterity, and ultimately revered for being centuries ahead of its time? And what more natural than that Picasso, who saw himself as the greatest artist of his time, should lay claim, as if by right, to the mantle of one of the greatest artists of all time?

As for the various nineteenth-century masters included in Picasso's pantheon, the most consistent favourite for more than seventy years was Ingres. Since Robert Rosenblum has demonstrated the full extent of Ingres's influence on Picasso's vision, I will not go into that again;[17] or into the many Ingresque references in the late work, such as the ingenious variations done in 1968 on Ingres's 'Turkish Bath'; or into the way Picasso, who fifty years earlier had invoked Ingres to preside over his change from Cubism to Neoclassicism, used Ingres in order to get even with Raphael (cats. 124–129). These iconographic parallels are interesting, but they do not explain why, only a month before he died, Picasso talked so obsessively to Pignon about Ingres. 'One must paint like Ingres,' he said. 'We must be like Ingres.' Picasso certainly wasn't referring to the artist's academicism, or the Neoclassicism that had once beguiled him, even less to Ingres's preposterous airs as *chef d'école*. And since Picasso specifically mentioned painting, he

presumably had more than Ingres's passion for drawing in mind, although the conviction that drawing was, as it were, the armature of painting had been a lifelong link. What exactly did Picasso mean?

A partial answer is to hand, thanks to a recent Ingres exhibition[18] that was conceived along new lines. Hitherto Ingres had been thought of as a great painter who had an unfortunate habit of watering down the historical figure compositions for which he was famous by churning out replica after replica – in the case of his wonderful Paolo and Francesca composition, some twenty paintings, drawings, and prints executed over thirty-five years. Historians thus tended to regard all but the earliest versions as mechanical recapitulations of lesser merit. Marjorie B. Cohn, who wrote the catalogue preface, turned this traditional view upside down. She demonstrated that, far from involving successive stereotypes – copies of copies of copies – Ingres's approach was often a means of perfecting, of distilling his original image, of making it more expressive, formally, stylistically, anecdotally. When Miss Cohn says Ingres's 'canvas might be completed but the picture never was', couldn't she be referring to late Picasso? And the same goes for her statement that 'the aged Ingres committed himself to himself, in a grand disregard of the conventional expectations of the "original" artist.' How true of the aged Picasso whose originality lay in the power to recycle the history of art in terms of his own ever-questing self.

Historians might have lost sight of the simultaneous backwards and forwards movement in Ingres's development. Not, however, Picasso, who knew Ingres's work by heart and would have been instinctively aware of how it applied to himself, of how much of his own oeuvre, like much of Ingres's, has to be seen not as a succession of finished works but as a series of series, an open-ended process. So open-ended that, according to Picasso, 'in finishing a work you kill it' – those are his very words – and you also kill something in yourself.

The nature of this ongoing process became clear to me when Picasso showed a group of friends, including myself, the impressive series of large ink-wash drawings of Jacqueline he had done a day or two earlier (12 November 1960). As usual he displayed his work as if it were by someone else, analying the drawings with detachment that bordered on alienation. Which was *le plus fort*? This one? Why not that one? We had to weigh our words, because Picasso, whose memory was phenomenal, might well taunt us with our answers, months, even years later. The artist's preferences were of course the only ones of interest. What were they? 'Almost always the first in any series,' he said, 'and then the penultimate one, the one that was still open-ended, the one before the *coup de grâce*.' But what fascinated him most was to study them sequentially; this way he could follow the – even to him – mysterious workings of his genius, the evolution and transformation of an idea. Hence the meticulous dating and numbering which enabled him to establish what Braque called *les jalons de la recherche* (the stages in his quest), the same *recherche* we can follow in much slower motion in Ingres's work. Hence, too, some of the late sketchbooks (e.g. *Je Suis Le Cahier*, no. 165) in which Picasso takes advantage

of the semi-transparent paper so that he can trace and simultaneously ring successive changes on an image – a way of keeping track of his thought processes.

Other parallels between Ingres and Picasso: both artists transformed their subjects into sculptures and then painted them; and both regarded their own past in the same light as they regarded the historical past, as an unending source of inspiration. For Ingres and Picasso their own pasts *were* history. Thus we find Ingres dipping into the repertory of his own work in the same spirit as he dipped into antiquity or the Renaissance. Picasso did much the same but of course went much further. We only have to compare Picasso's famous self-portrait of 1907 in the National Gallery, Prague, with the death's head self-portrait of June 1972 (cat.102) to understand how – often unconsciously – he bounced late works off earlier ones, not because, like Chirico or Dali, he had become a burnt-out case, but in order to beat himself at his own game. The Prague picture is in the nature of a manifesto: behold Picasso, the new Messiah of art, it seems to say, Matisse watch out! Sixty-five years later, when Picasso prepared to take leave of the world, how appropriate that he should revert in spirit and style to this symbol of his early breakthrough. The enormous eyes of the ninety-year-old artist still blaze forth defiantly from a mask that is, if anything, even more intransigent than the early one. Daix has movingly described how Picasso showed him this magnificent drawing. 'I did a drawing yesterday', he said, 'I think I have touched on something. It doesn't look like anything I have hitherto done.' And he held the portrait up to his face to demonstrate that the fear in the drawing had been invented. Three months later, Picasso showed Daix the self-portrait again. What did he feel about it? Daix said that the colours – grey-green, pink, mauve and black – reminded him of 'The Still-life with a Bull's Skull' which Picasso had painted on hearing the news of Gonzalez's death in 1942. 'He heard it without flinching. Suddenly I had the feeling he was facing death point-blank like a good Spaniard.'

Just as he felt free to appropriate whatever he liked from the most disparate sources, Picasso felt free, at the end of his life, to play as many tricks with the time warp as a science-fiction writer. He had no compunction about confronting famous artists and their famous subjects, regardless of century, with one another as well as figures from his past, his own life or fiction. Rembrandt's 'Night Watch' – or is it the 'Stahlmeesters'? – have an evening out with a mixed bunch of Degas's prostitutes and the artist's girlfriends at Guy de Maupassant's 'Maison Tellier', or is it Lola La Chata's Malagueño whorehouse, or the studio at Notre-Dame-de-Vie? Sometimes Celestina, the procuress, looks on inscrutably; also on occasion the Pope and Michelangelo. At the very end of his life (1971) the watcher is Degas, and this brings me to another figure who haunts Picasso's late work.

Gert Schiff and Christian Geelhaar have written perceptively about Picasso's rapport with Degas.[19] Nevertheless, since Douglas Cooper and I helped in a small way to rekindle Picasso's interest in this artist's monotypes, I propose to add a few facts to the record. In

1958 Maurice Exteens sold the magnificent group of Degas monotypes, that his father-in-law, Gustave Pellet, had purchased at the Degas sale, to two Parisian dealers, Hector Brame and César de Hauke (publisher of Lemoisne's *catalogue raisonné* of Degas's work). Among the many brothel scenes in the collection was a particularly graphic one, entitled 'On the Bed' (Janis, no.109), which I bought for a pittance in view of its subject. Shortly after I acquired it, Picasso came to dinner. The monotype immediately caught his eye. 'Degas's paintings have never really interested me,' Picasso confessed, 'but the monotypes are another matter – the best things he ever did.' He credited them with the black-and-white immediacy of a photograph and the *éclat*, the impact, of a Rembrandt drawing. Picasso said he had always wanted to own some, but Vollard never wanted to sell any. What could I do but give him mine? – a gift he characteristically repaid with a no-less-remarkable drawing. This little monotype whetted Picasso's appetite and, with Cooper's help, he set about acquiring whatever was left of the Exteens' collection from Hector Brame, and Reid and Lefèvre in London. *Only* the brothel scenes, Picasso insisted, none of the colourful landscapes, which he disdained as too 'artistic', too 'abstract'.

Picasso took the greatest pride in his new acquisitions and frequently displayed them to friends, once joking that Degas was his contemporary (true to the extent Picasso was thirty-six when Degas died). However, he did not exploit them in his work for ten years, that is to say not until 1968, when the Fogg Museum at Harvard mounted an exhibition of Degas monotypes. The exhibition was commemorated by Eugenia Parry Janis's well illustrated catalogue, a copy of which I found at Notre-Dame-de-Vie.[20] The fact that the first tentative references to Degas in Picasso's work (in some of the '347' series) do not relate to any of the monotypes in his collection but to illustrations in Janis confirms that the Fogg catalogue was his source of inspiration – at least at first.

Three years later, that is to say early in 1971, Picasso brought out his monotypes to show William Rubin and left them around for further study. He also had a framed photograph of Degas in the studio – a photograph which bore a certain resemblance to Picasso's father. In the course of the next weeks, the monotypes and the photograph inspired Picasso to engrave a series of brothel scenes (cats.151–53) in which Degas figures as a voyeur, not so much of sexual acts as of whores relaxing or on parade. 'Do you think [Degas] only came to take notes?' Picasso asked Daix. 'Nobody knows exactly what he did with women . . .'! And the artist went on to fantasize about Degas's sex-life, whether he was a closet homosexual or addicted to some vice. Picasso could not rid his engravings of Degas's presence, he said.

For all that these prints date from Picasso's ninetieth year, there is an amazing youthfulness, irony and wit to them, also a paradoxical combination of detachment from and identification with Degas. Picasso plays one significant trick on this father-like figure: in one of the prints he adds a network of wrinkles to Degas's face so that he looks even older than the ninety-year-old artist who is portraying him. And why not? As Picasso said to Brassai, 'Every time I draw a man, automatically I think of my father . . . I

see all the men . . . with his features.' Indeed, so striking is the resemblance between Degas and Picasso's father that O'Brian has mistaken the former for the latter in references to these prints – a confusion which is for once enlightening.

Degas was once dubbed by George Moore 'the master of the keyhole', and this is the aspect with which Picasso identified. Degas's keyhole preoccupation enabled Picasso to comment on his own similar case. When questioned on this point by Daix, he admitted that for him engraving was a voyeuristic medium. 'In front of your copper plate you are always the voyeur. That is why I have engraved so many embracing couples.' And when Daix cited the famous 1936 engraving of a faun unveiling a woman, Picasso said, 'I am the voyeur who watches the faun being the voyeur. That is the point of engraving. Whereas painting, that is actual love-making.' This neat distinction brings us back once again to the *mirada fuerte*. In the last resort this is what the 1971 brothel prints are about: the way, the Andalusian way, the artist (or his surrogate) takes possession of things and people with his eyes, makes love with his eyes, manipulates people with his eyes. Even when he was over eighty, Picasso still exploited the power of his magic eyes. He would fasten his huge pupils on some enthralled victim and will him or her to rhapsodic response – tears if possible. No, there was nothing senile or surreptitious about Picasso's voyeurism; on the contrary it was rapacious and sadistic, but that is the nature of the *mirada fuerte*. How apt of Hélène Parmelin to categorize the late phase as *une période-regard*.

As for the girls, Félix Fénéon's contemporary description of the whores in Degas's monotypes applies equally to Picasso's prints a century later: 'There's a collapse of hair on to shoulders, bosom on to hips, stomach on to thighs . . . The girls look like a series of bulging jointed cylinders.' Picasso even follows Degas in frizzing their hair into fringes over criminally low foreheads. He borrows from Degas the classic whore's outfit: the ribbon around the neck, the black stockings, the galumphing boots, and shifts cut to reveal rather than conceal.

But despite these similarities, Picasso opens up subjects that Degas had kept narrowed down, and closes down the space that Degas had opened up. The similarities and dissimilarities are immediately apparent if we compare a Degas monotype (fig.143), used as an illustration to Maupassant's 'Maison Tellier', which Picasso owned, with the witty variations that he perpetrated (cats.151–54). The madam, for instance. Whereas Degas depicts a snug old soul in black bombazine, Picasso comes up with a baroque harridan out of the eighteenth rather than the nineteenth century. In some prints her face disintegrates in a tangle of arabesque-like wrinkles, warts and facial hair; in others her wig, surmounted by ostrich feathers and a huge jewelled butterfly, threatens to go off like a firework; and the complacently clasped hands with which Degas had endowed his madam are transformed by Picasso into a vaginal sign made by joining outstretched thumbs and forefingers – typical of his visual puns. The Degas/Maupassant *tranche de vie* ends up as theatre of the absurd.

If many of the girls in this series derive from Degas, others have their origins in

Picasso's earlier work. As I said apropos Ingres, Picasso has a way of dipping into his own past, his own repertory of characters. And so we find the aforementioned 'Celestina' of 1903 rubbing shoulders with 'The Man with the Lamb' of 1943 and figures from the Vollard series of 1934, the *Antipolis* series of 1946, and the *Verve* series of 1953. Picasso also inserts people from real life – former mistresses for example – into his brothel. The glimpses that we get of girls who resemble Marie-Thérèse Walter, Dora Maar and Geneviève Laporte remind us that he once identified figures in the 'Demoiselles d'Avignon' as Fernande Olivier and Marie Laurencin. As for the artist's wife, she is portrayed as shamelessly and unprettily as any of the whores. This flagrant exposure of Jacqueline can of course be attributed to the husband's black sense of humour, his Spanish irony, or his misogynistic Andalusian view of women as orifices. Once again, however, Picasso is equating sex with art; the beloved Jacqueline becomes *l'éternel féminin*; not just model and wife, but hooker, monster, dream-girl, muse. Thus brothel and studio end up as metaphors for each other – arenas where fantasies can be realized, where women can be exalted and degraded, loved and hated, and in the last resort sacrificed on the altar of art.

Picasso singled out the physicality of Degas's 'pig-faced whores' for admiration. 'You can smell them', he said. This physicality is what so much of Picasso's art is about. Just as in his twenties he and Braque had devised Cubism as a way of rendering reality more palpably than ever before, so in his eighties, as he told Hélène Parmelin, he aimed to do a painting of a woman on a chair that would be as *real* as the woman herself – so real that it would contain everything pertaining to the woman and yet would resemble nothing in our experience. So real that people seeing her would say 'Bonjour, Madame'. And Picasso described how he had once shown his great 'Woman in a chemise in an Armchair' of 1913 (Ganz Collection, New York) to Braque: 'Is this woman *real?*' Picasso had asked. 'Could she go out in the street? Is she a woman or a picture?' Picasso went on at Braque. 'Do her armpits smell?' And the two artists proceeded to use the armpit quotient as a test of *real* painting. 'This one smells a bit but not that one . . .' I remember hearing Picasso listing other intimate attributes that a painting of a woman should convey – attributes I will spare the reader.

The physicality with which Picasso endowed his late works is one of the reasons why they met with such scorn. People were shocked, and as shocked people often do, they took refuge in disdain; Picasso's notion of femininity was infantile, senile, vulgar. Ironically, these accusations were much the same that an uncomprehending public had made against another artist who had a place of honour in Picasso's pantheon and with whom he identified, Manet. The only difference was that Second Empire Philistines had the excuse of ignorance in the face of the 'Déjeuner sur l'Herbe' or 'Olympia', whereas a hundred years later critics were supposed to be proof against the shock of the new.

This shared feeling of rejection at the hands of an uncomprehending public goes a long way toward explaining Picasso's continuing identification with Manet. Given that Picasso had an instinctive grasp of art history, and a very clear idea of where he, Picasso,

stood in relation to the past and the present, he had no problem identifying with Manet as the first modern artist, one who had set out to shock the bourgeoisie and had been pilloried for his pains, one who had been denounced for 'shamelessness' and 'vulgarity', for painting 'a yellow-bellied courtesan', 'a female gorilla made of india-rubber'. Had Manet painted 'Olympia' in the guise of a Circassian slave or coquettish Bathsheba, he would have given no offence. It was her blatant nakedness as opposed to artistic nudity that was a threat. Picasso admired 'Olympia' and the girl in the 'Déjeuner' for all the things that the Second Empire had found so shocking, not least the outdoors juxtaposition of a naked woman and fully clothed men. And he set out to paint nudes who would be far more threatening, far more shocking than Manet's.

<p style="text-align:center">* * *</p>

No doubt about it, Picasso's 'super-real' (his word) women *are* threatening. Had they been pretexts for celestial Mozartian painting like Matisse's Odalisques, or – on a much lower level – perverse spectres of sex appeal like Dali's or Bellmer's rubbery anthropoids, they would have been artistically acceptable. But these hefty, smelly creatures who scratch their parts and pick their terrible toes with banana-sized fingers, and expose themselves in a matter-of-fact, unerotic way, threatened a generation nurtured on art that had been deodorized and sanitized, a generation that had mostly turned away from reality except in the gimmicky or eye-fooling forms of pop art or photo-realism.

A further obstacle to liking these late works is the deceptive clumsiness of their technique. People who should have known better suggested that the artist had become senile and sloppy and that his hand had lost its cunning. Picasso played into their hands by boasting that 'chaque jour je fais pire'. What of course he meant was that 'chaque jour je fais mieux'; that he was out to eradicate artistic clichés (including Picassian ones) and all trace of fine painting or virtuosity from his work. Did Picasso, who had been aware of Oscar Wilde and his work from student days, know of his great dictum? 'I have solved the riddle of Truth. A truth in Art is that whose contrary is also true.'

No, far from losing any of his cunning, Picasso still had to make things as difficult as possible for himself and, by extension, for the viewer. True, in the past, dexterity, or rather his ingenious attempts to conceal dexterity, had on occasion got the better of him. Seldom, however, in the last paintings. The technique is very much there, above all the infinite variety of the formal invention and the wonderful plasticity of the paint, but it is never an end in itself.

In fact, the clumsiness of Picasso's very late paintings is disingenuous to the point of deceptiveness. Technique, said Picasso, is important, 'on condition that one has so much . . . that it completely ceases to exist'. There is nothing hit-or-miss about his seemingly hit-or-miss style. The point was to preserve the directness and spontaneity of his first rush of inspiration, to be as free and loose and expressive as possible. In old age Picasso had finally discovered how to take every liberty with space and form, colour and light, fact and fiction, time and place, not to mention identity.

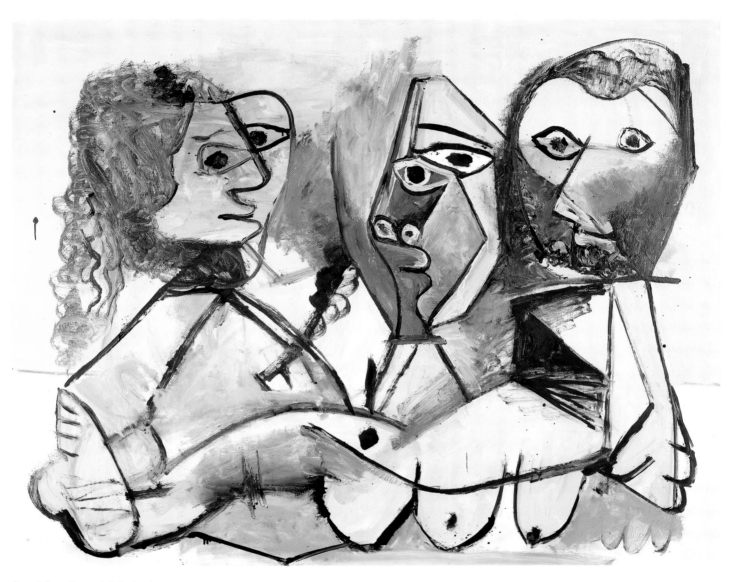

fig.7 'Three Figures', 6 September 1971,
130 × 162 cm, *Kunstmuseum, Berne*

A year or so before he died, Picasso embarked on an amazing, mostly monochrome composition (cat. 70) – one of his two or three last paintings. It is dated 25 May 1972, but according to Jacqueline, was worked and reworked over a longish period, hence the unusually thick Braque-like impasto. And it is to my mind the masterpiece of Picasso's last phase: a distillation of everything (not least Cubism and sculpture) that had gone before, a cryptic last testament a 'chef d'oeuvre inconnu'. 'Reclining Nude and Head' is the title, but even Jacqueline, who developed a demon eye for the finer points of the artist's work, found it difficult (or maybe painful) to decipher. With its emphatic cross, the rectangular configuration at the bottom of the canvas put her in mind of a coffin, she said; but it also represents a recumbent figure, albeit an ominous one. The other elements read like parts of an armature. But there can be no mistaking the Jacqueline-like figure at the centre: two *mirada fuerte* eyes supported on a plinth balanced on a wedge of a nose, balanced on a tiny mouth, balanced in turn on a rudimentary vagina. Jacqueline did not know for sure whether Picasso had Balzac's *Le Chef d'Oeuvre Inconnu* in mind, but given his preoccupation with the character of Frenhofer, and his illustrations to Vollard's 1931 edition of the novella, she thought it likely. 'Pablo knew he was going to die,' she said, as we studied the painting, 'I, too, know I'm going to die,' Might Picasso also have derived inspiration from Braque's 'Studios' – paintings whose profundities had once left him baffled to the point of resentment? I suspect that he had finally deciphered their ambivalent metaphysical message. In Jacqueline's lifetime, there used to be another canvas of the same size (130 × 195 cms) stacked next to the 'Reclining Nude and Head' in the studio. It was blank except for a signature: Picasso's last work. Another *Chef d'Oeuvre Inconnu*, or a way of leaving things open-ended.

Shortly after Picasso died (8 April 1973) in his ninety-second year, the great exhibition of 201 of his recent paintings opened at the Palais des Papes in Avignon (23 May–23 September, 1973). It attracted crowds of tourists and curiosity seekers but received little critical attention on either side of the Atlantic. Pierre Daix was a noble exception. For the most part Picasso's former admirers took refuge in lavishing faint praise on his recent drawings and prints, especially '347' series, which it would have been difficult to denigrate. As for the paintings of cavaliers, musketeers, lovers and painters, they were either denounced (by Douglas Cooper *et al.*) or ignored. 'Hardly discussed in scholarly literature [Gert Schiff has written], poorly represented in exhibitions, commercially unpopular . . . The works of Picasso's last period . . . were all but hushed up since no one found answers to the questions they raised.'

<div align="center">* * *</div>

Picasso's death triggered successive fights between Jacqueline and the various heirs. The situation was complicated by the adamant stand that the widow took on practically every point at issue, and by the sense of identification that she had developed with the monumental accumulation of work that her husband had left behind him.[21] Jacqueline could not abide the thought of appraisals and inventories, let alone the obligatory

fig.8 *Picasso 1970–1972, 201 peintures* exhibition
at the Palais des Papes, Avignon, 1973

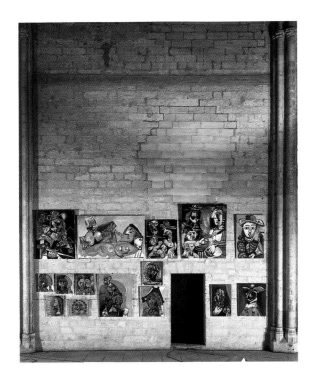

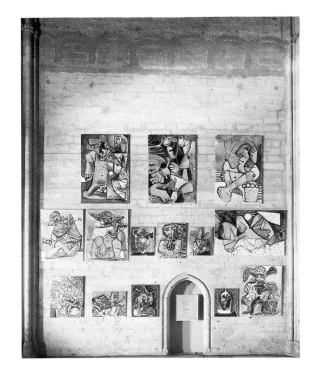

fig.9 *Picasso 1970–1972, 201 peintures* exhibition
at the Palais des Papes, Avignon, 1973

shareout, and she became more and more distraught. Hadn't she been the perfect wife for Pablo? she would angrily ask visitors to Notre-Dame-de-Vie. Hadn't she sheltered him from the world (specifically his children) so that he could work in peace until his ninety-second year? Hadn't she figured in his work more often (as many as 160 times in 1963 alone) than any of the other women? Look at the adoring *dédicaces* on the countless works he gave her. And look at the skills she had been obliged to develop: she had acted in turn as interpreter, secretary, agent, cook, poet, driver, nurse, photographer, not to speak of model. Why, given the sacrifices she had made, were people so antagonistic?

According to Jacqueline, Picasso obliged her to take much of the blame for the rejection of his illegitimate children, an act that darkened his last years with litigation. 'Pablo gave me no choice,' she said. Moreover, recognizing his children would have involved recognizing the fact of his own death, and this he was constitutionally unable to do. Even making a will was out of the question. 'I know I would die the next day,' he said.

Given the enormity of her sacrifice, the least we can do is denote the last two decades of the artist's work as *l'époque Jacqueline*. It is her image that permeates Picasso's work from 1954 until his death, twice as long as any of her predecessors. It is her body that we are able to explore more exhaustively and more intimately than any other body in the history of art. It is her solicitude and patience that sustained the artist in the face of declining health and death and enabled him to be more productive than ever before and to go on working into his ninety-second year. And lastly it is her vulnerability that gives a new intensity to the combination of cruelty and tenderness that endows Picasso's paintings of women with their pathos and their strength. The artist's children may have seen her as a Kali-like figure, but for Picasso, Jacqueline was, in a very literal way, Notre-Dame-de-Vie.

Notes

1 Jacqueline was no relation of Madame Ramié, as most biographers have assumed, but a casual acquaintance of her daughter-in-law, Hugvette.

2 Patrick O'Brian, *Pablo Ruiz Picasso: A Biography*, Putnam, 1976.

3 No longer as well protected as it was. The artist made the mistake of not buying the land below his property. Jacqueline was horrified when this became the site of a flashy development.

4 Pignon had asked Picasso to contribute a painting to the 1963 Salon de Mai, based on Delacroix's 'Entry of the Crusaders into Constantinople'. Picasso said that the choice of Delacroix was 'difficult', however he would participate in the show: 'I have received a command from Pignon. I must carry out that command.'

5 Picasso's anti-Americanism dated from the days of the Cuban War in 1898, which spelt the end of the Spanish Empire. Barcelona prepared for an American invasion. 'Do the Yankee companies still control Cuba,' Picasso asked David Douglas Duncan, 'as they did in the days of Maquinli and the Maan? [sic]'. He was referring to President McKinley and the Maine, the American warship that caused the war between the United States and Spain.

6 Gert Schiff, 'The Sabines', *Je Suis Le Cahier*.

7 Daix, who has understood Picasso's political stance better than anybody, states that the artist had been a passionate follower of the troubles that broke out in Prague and Paris in Spring, 1968, that he read *L'Aveu*, and shuddered with indignation at what was happening in Spain as much as at what the USSR had in common with France's despotism.

8 Pierre Daix, *Picasso Créateur: la vie intime et l'oeuvre* (Editions Seuil, 1987).

9 Originally published in a book entitled *Il Libro Nero*, consisting of spoof interviews and confessions, purportedly by Kafka and Stendhal as well as Picasso, in celebration of Papini's 70th birthday in 1951.

10 Françoise Gilot, *Life with Picasso*, written with Carlton Lake, art critic on the *Christian Science Monitor*.

11 Hélène Parmelin, *Picasso: Women; Cannes and Mougins, 1954–1963* (orig. published in 1964); *Picasso: The Artist and his Model* (1965); *Picasso Says* (orig. published in 1966); *Picasso at Nôtre Dame de Vie* (1966); *Voyage en Picasso* (1980).

12 'Eh oui, j'ai gravé mon graveur et toute sa famille . . .' Picasso told Daix. And in one of the erotic engravings of Raphaël having sex with La Fornarina, the papal voyeur is given the features of Aldo Crommelynck.

13 'Picasso's Exploration of Rembrandt's Art', October 1983, *Arts Magazine*, vol.58, no.2.

14 Phaidon Press, London 1954.

15 *Picasso: An Intimate Portrait*, London 1949.

16 A further derivation of these musketeers has been suggested by José L. Barrio Garay, who has pointed out (see his introduction to *Picasso in Milwaukee*, Milwaukee Art Center, 1970–71 that the Spanish work '*mosquetero*' also described the non-paying play-goers who stood at the back of seventeenth-century Spanish theatres. It is 'as if Picasso were now himself a spectator of his life and oeuvre,' Barrio Garay writes.

17 Robert Rosenblum, 'Picasso and Ingres', first delivered for the International Foundation for Art and Research, 10 January 1983.

18 *In Pursuit of Perfection: The Art of J.-A.-D. Ingres*. The J.B. Speed Art Museum, Louisville, Kentucky (December 1983–January 1984); The Kimbell Art Museum, Fort Worth, Texas, March-May 1984.

19 Christian Geelhaar, review of *Austellung Pablo Picasso: 156 Graphische Bläter, 1970–72*, Kunsthaus, Zurich, March-May 1978, *Pantheon*, vol.36; July/August/September 1978. See also Geelhaar's preface to the catalogue of *Das Spätwerk – Themen 1964–1972*, Kunstmuseum, Basle, September-November, 1981.

20 Eugenia Parry Janis, *Degas Monotypes: Essay Catalogue and Checklist* (Fogg Art Museum, Harvard University, 1968).

21 According to Daix, the estate included 1876 paintings, 7089 individual drawings, 4659 drawings divided between 149 sketchbooks, 1355 sculptures, 2880 ceramics, 18,000 prints, without counting the illustrated books, copper plates, etc.

Picasso 1953-1972: Painting as Model

MARIE-LAURE BERNADAC

Through the painting of painting, in his paraphrases of Delacroix, Velázquez and Manet, and through the enactment of its ritual in 'The Artist and his Model' series, Picasso effectively created an alternative painting, a new painterly language. In the last twenty years of his life, Picasso literally took painting as his model, his subject, or his example, just as 'the writer as he grows old takes writing as his subject' (Paul Valéry). Whether in variations on the old masters, or in depictions of the place of creation (the studio), or of the model (the woman, the nude), or of the painter (young or old, bearded, with or without palette, costumed or stripped bare), all the works of this period have to do with a single theme, that of painter and model. This theme enables him to illustrate the mechanics of creation through the relationship between the three principal participants, the artist, the model and the canvas, i.e. the subject, the object and the verb, with all the thousand ways in which it can be conjugated. In this hand-to-hand struggle with painting, in this violent endeavour to resolve the eternal conflict between art and life, reality and illusion, it seems as if Picasso has found himself on the other side of the canvas, through the looking-glass, and identified himself with his object.

Painting ruled supreme during these last years, so absolutely indeed that the artist declared, in an amazing and utterly lucid act of capitulation: 'Painting is stronger than I am; it makes me do whatever it wants.'[1] To personify a mere means, an expedient, an intermediary, to this degree is to reverse the relationship between the artist and his work to the point where the man is totally absorbed into the painting. The work takes on a life all its own and becomes self-generating. All this defines the scope and the issues of his last period and simultaneously casts light on the psychic structures of Picasso the creator.

The aesthetic and formal revolution that took place in those last years, which was as fundamental in its own way as the Cubist revolution, was little understood at the time. In the 1980s, however, it began to have its repercussions in contemporary art, and it is now becoming possible to see that it holds a key to the evolution of art at the end of the century. Picasso, someone has said, opens and closes the twentieth century. Hence the necessity to put 'Late Picasso' on show, not so much in order to rehabilitate an unjustly maligned period (the exhibitions in Basle[2] and New York[3] have already done that) as to set it within the artistic context of the present day and to establish Picasso, finally, as a *contemporary* painter.

The phrase 'Late Picasso', like its rather inept French variant 'Le dernier Picasso', puts the emphasis on the lateness of the work, as a final revision of a painterly style. Is this an apotheosis, a leap into the future, or is it decadence and regression? The late styles of the

great painters tend to fall into one or other of these categories. Is Picasso like Titian, Rembrandt, Cézanne and Matisse; or is he like Picabia, De Chirico or Derain? Is the very last phase of his life a time of maturity and transcendence, or of decline and obsession?

The reviews at the time were ferocious: 'daubs', 'senility', 'impotence'. The fact was that Picasso in his eighties was still continuing to irritate, to overturn the conventional wisdom. It was not until the exhibitions of 1979[4] and 1980[5] that this last period (repeatedly ignored in retrospectives) could really be seen at all.

The 'late style' that was revealed in the two big exhibitions at the Palais des Papes in Avignon (1970 and 1973) had its inception in 1964 (according to Christian Geelhaar) or in 1963 (according to Gert Schiff). Dominique Bozo, who, with David Sylvester, was the prime mover of the present exhibition, chose to go back to the source of this renewal, in order to show the necessary, and as it were initiatory, stages that led to the final leap. And so the exhibition begins with 1953.

November 1953 witnessed a crisis in Picasso's personal life, when Françoise Gilot left him, and also the continuation of the 180 *Verve* drawings on the theme of the artist and his model. Then, in 1954, there came a change of place (La Californie); a change of woman (Jacqueline Roque); the beginning of the old-master paraphrases the 'Women of Algiers'; and a political and cultural context that isolated Picasso from the outside world and turned him back upon his own creative resources. He had reached an age (seventy-two) which gave him a new perspective on his own life, and on his work, and which forced him to embark in earnest on a last battle with time. Circumstances combined to make this the point of departure for the final phase in his career.

In those last twenty years, the first ten took the form of a recapitulation, a synthesis of his past, through a reappropriation of old master painting which led to a rereading of Cubism in the light of the representational distortions of the 1930s. The final ten years can be seen as a crossing of barriers, a liberation of knowledge and technique, a return to nature, spontaneity, the 'childhood' of art and a savage, primal immediacy in painting. After reviewing his past, absorbing the 'alternative' presented by his 'fathers', Picasso seems to have cut the Gordian knot of creativity and found a new life-force – the power of eroticism – which was to bring him to a final ecstasy.

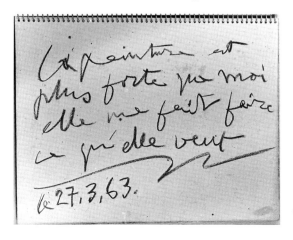

fig. 10 From the 3rd page of Picasso's notebook, dated 10.2.63, 21.2.63. *Musée Picasso, Paris.* MP 1886

1953–1963: The Painting of the Past

A 'DETESTABLE' SEASON IN HELL

November 1953: after the departure of Françoise and the children, Picasso was left alone at La Galloise. Whatever misunderstandings and other causes may have led to this separation, the fact is that a woman, a young and beautiful woman who was the mother of his children, had left him: he was an old man, alone with the burden of his fame. This private crisis, with all the upheavals it brought with it, unleashed a profound artistic crisis (as had happened when he separated from Olga in 1935) and led to 'everything being called into question'.[7]

Between 18 November 1953 and 3 February 1954, Picasso shut himself away in the deserted villa and produced, at a dizzying pace, 180 drawings which have as their central theme that of the painter and his model (cat.76). Some of them additionally summon up and incorporate themes from the past: the circus, clowns, acrobats and monkeys. Others anticipate the future: masks, old age, eroticism, jokes at the expense of the painter's trade, the comedy of the art milieu. Coloured crayons, india ink, wash, graphite pencil: all these techniques are enlisted to illustrate this journal of a 'season in Hell' which sums up bitterly, cruelly, sarcastically, implacably, the absurd drama of creativity and the irresoluble duality of art and life, art and love. Woman is there to be painted but must also be loved, and whatever his genius the artist is still a man, subject to age, illness and death.

Quite apart from its unquestionable merit and its unprecedented freedom as drawing, this series is of prime importance in the painter's life. Michel Leiris has brilliantly pinpointed its importance by comparing it to Goya's 'Caprichos', with their burlesque comedy which juxtaposes satire and personal record, tragedy and comedy. Swinging between Baudelaire's *Vieux Saltimbanque* and Charlie Chaplin, between *commedia dell'arte* and picaresque novel, Picasso unmasks in his own way the myth of the artist, who becomes a laughing-stock, and the hollow mockery of art, its senseless aspiration to emulate real life and carnal beauty. Painters of all kinds are there – romantics, academics, naïfs, egotists, individualized to the point of caricature – while woman remains the model, ideal and timeless.

These drawings for *Verve*, in their diversity and their unity, serve in a sense as the overture to the opera that is to come. All his future themes are announced, and the keynote, which is that of comic tragedy, is sounded from the start. Picasso introduces his technique of series and variations, his narrative style, his mingling or alternation of genres, switching from a nervous, incisive, summary line to a pure, classic outline, or to a geometrical schema. In the circus or carnival scenes there appears the correlation between art and the theatre, as well as the role-swapping – young and old, man and woman – that conveys the deceptive nature of art and of appearances. The constant presence of the model and the studio reveals the artist's obsession with creation and the

agonizing fear of impotence, both creative and sexual, which goes together with the erotic unveiling of the female.

This intimate series takes the form of a descent into the lower depths of the unconscious; the Blue Period of his youth rises to the surface, and with terrifying lucidity Picasso lays bare his own situation as an artist and as a man. All the paths that he is to explore in the remainder of his work are already adumbrated in these 180 profoundly disturbing images. After this, where was a new impulse to be found?

The two paintings that set the scene for the following period were produced concurrently with the *Verve* drawings. They are 'The Shadow' (cat. 1) and 'Nude in the Studio' (cat. 2), dated 29 and 30 November 1953 respectively. 'The Shadow' is a view of the bedroom at La Galloise, with a nude woman lying on the bed and the shadow of a man who is looking at her: the silhouette, in a rectangle of light, of a painter who is a phantom but is nevertheless present, facing a woman who is seen as the model but who is nevertheless absent. Another version of this painting (Zervos XVI.99) fuses the shadow with what is seen, so that the woman's body is made of the very substance of the painting. When David Douglas Duncan asked him the meaning of this enigmatic work, Picasso replied: 'That was our bedroom. You see my shadow? I had just moved away from the window. You see my shadow and the sunlight falling across the bed and the floor? Do you see the toy cart on the chest of drawers and the little vase on the mantelpiece? They came from Sicily, and they're still in the house.'[8]

The next day, Picasso moves from the intimacy of the bedroom to the bright light of the studio. He gives the artistic relationship precedence over private life by placing his model in a sumptuous setting where different spaces, windows, doors, canvases and the easel overlap in an unprecedented wealth of colour. The complex structure of the space, and of the depth rhythmically articulated by the pieces of furniture, prefigures the 'Studios' painted at La Californie; and the decorative chequering, the mosaic of the carpets, and the warmth of the colours, anticipate 'Women of Algiers'. This seminal painting is close in its composition to a later drawing, dated 21 January 1954 (cat. 76): beside the easel, brush in hand, stands a woman painter; the seated nude model is set within an all-encompassing decor. This nude no longer has the slender curves, nor the morphology, of the nudes inspired by Françoise; and in a drawing of the same date (no. IV, Zervos XVI.203) there appears for the first time the long-necked profile of Jacqueline Roque.

INTERMEZZO

A short intermezzo served to prepare for the work to come. On the one hand, out of affection, and in a Matissian, extremely decorative style, he painted his children, Claude and Paloma, drawing and playing, with and without their mother: they had come to spend the Easter holidays. On the other, he tackled a neutral model, with whom he had no emotional relationship, Sylvette, whose face and whose celebrated ponytail he

fig. 11 Visit to the Studio (drawing for *Verve*),
19 January 1954 VII

fig. 12 In the Studio (drawing for *Verve*),
3 February 1954 I

fig. 13 'The Masks' (drawing for *Verve*),
25 January 1954 I

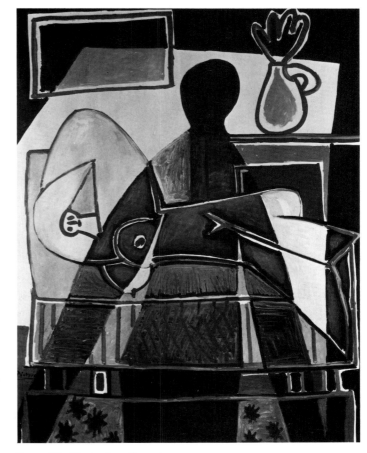

fig. 14 'The Shadow', 29 December 1953,
Zaks Collection, Art Gallery of Ontario, Toronto

fig. 15 'Sheet of Studies' (drawing for *Verve*),
21 January 1954 IV

scrutinized, analysing them into interlocking rectangular planes which made it possible to see her both frontally and in profile at the same time. Passing from a graceful realism to a severe geometry, the series of portraits of Sylvette anticipates his sheet-metal sculpture and foreshadows the triumphant entry into his painting of Mme Z, the 'Modern Sphinx', of whom he was to make two celebrated portraits in June 1954.

THE PAINTING OF PAINTING

The period from 1954 to 1963 is entirely dominated by the painting of the past, and by a review of his own painterly resources and those of his contemporaries, Matisse and Braque. Picasso ceaselessly analysed, decomposed and recomposed other men's masterpieces, digesting them to make them his own. This pictorial cannibalism is unprecedented in the history of art. True, painters – including Picasso – have always had recourse to images from the past, taking their motifs and their forms from the lexicon of universal art, and producing pastiches, copies, paraphrases and quotations. But the operation embarked on by Picasso in the great exploratory cycles of works on Delacroix, Velázquez and Manet is on a totally different scale. From one painting he makes a hundred, feverishly exploring all the possibilities on offer in the endeavour to validate his own handiwork, to test the power of his painting on given subject matter.

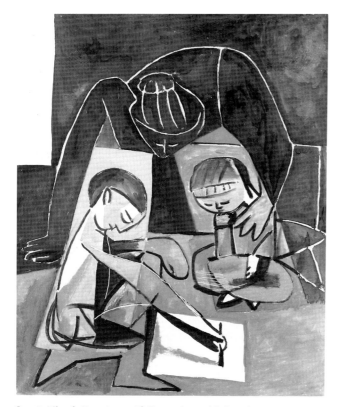

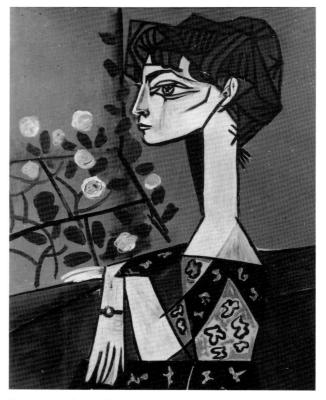

fig. 16 'Claude Drawing, with Françoise and Paloma', Vallauris, 17 May 1954. *Musée Picasso, Paris*

fig. 17 'Jacqueline with Flowers', Vallauris, 2 June 1954. *Private Collection*

Why, at this stage in his artistic evolution, did he feel this need to go back to the old masters, to revert to tradition? The reasons are manifold: a chance resemblance, the suggestive power of a place, and, above all, the need to confront 'great painting', the urge to challenge the past, and the consciousness of a duty to be done and an inheritance to be entered upon and transcended in order to launch painting on new paths. These are the personal motives. There is also the historical context to consider: it was the heyday of abstract art, which Picasso always resisted although he had been partly responsible for it in the first place; and above all it was just after the death of Matisse, the friend and rival with whom, since the turn of the century, he had carried on an uninterrupted and fruitful dialogue. Picasso was now the sole representative of a tradition of painting which traced its origin to the Renaissance, which had been revolutionary at the dawn of the twentieth century, and which had thenceforth remained obstinately figurative.

'WOMEN OF ALGIERS'

It all started with Delacroix, and the 'Women of Algiers' (fig. 19). The work had been on Picasso's mind for a long time. Françoise Gilot tells us that he often used to take her off to the Louvre to see it. Then, in a sketchbook used at Royan in 1940,[9] he drew the first sketches: the composition and the figures in their respective poses, then the colours (figs. 18, 20, 21). In June 1954 there came another sign: the Delacroix self-portrait, in a sketchbook that also includes the sketches of Manet's 'Déjeuner sur l'Herbe'.[10] In December 1954 seven more drawings appear in another sketchbook (fig. 24).[11] The ground seems to have been well laid.

Then he met Jacqueline, who in her physique, in her strange likeness to one of the women in the painting, in her temperament, her calm, her sensuous nature, represented the ultimate odalisque. After the storms, Picasso found in her a serenity and openness that gave him back his desire and appetite for life, for love and for painting. This emotional upheaval was followed in November 1954 by a still more decisive event, the death of Matisse. 'When Matisse died,' said Picasso, 'he left his odalisques to me as a legacy.'[12]

To D.-H. Kahnweiler he said of the 'Women of Algiers': 'I tell myself that it is Matisse's legacy. After all, why shouldn't one inherit something from one's friends?'[13] Matisse's odalisques represent not only the myth of the Orient – the harem, with its highly coloured sensual delights – but also the problem of integrating a figure with an ornamental background. Picasso was taking up the same task that Matisse had been engaged on in the 1920s; and he was also developing the idea, adumbrated by Delacroix, of doing two versions of the same painting. He shut himself away in the bleak studio in the Rue des Grands-Augustins for three months and painted two variants of the same vision, straight off.

It was an opportunity for him to explore the language of Cubism in depth, and to develop the simultaneous perception of a body from different points of view, forcing it to

display itself both prone and supine at the same time while respecting its anatomical cohesion: this was something he had never done in earlier works, which operate through a succession of planes. Numerous preparatory drawings analyse the poses of the women, superimpose them, overlap them within a decorative pattern of squares. Picasso enters into the game with huge gusto, giving rein to a joyously aggressive eroticism far removed from the cushioned sensuousness of the harem. He kneads the springy flesh, bends it with his agile brush into twists and arabesques, then slams it into a rigorous geometric pattern of acute angles and faceted volumes that has its origin in Cubism. As he goes along, he transforms the composition into his favourite theme of a seated female figure watching over a sleeping one. He concludes the process with two opposite solutions on canvas, one sumptuously coloured and decorative (cat.5) and the other spare and monochromatic (cat.4): one painted, the other drawn.

Picasso's work on the 'Women of Algiers' enabled him to exploit his own pictorial resources to the full without concerning himself with the subject, and to think of his work as a whole rather than a succession of single paintings. What interests him here is what goes on between one version and the next, the modifications, the metamorphoses, the comings and goings, the constant factors. 'You see,' he said to D.-H. Kahnweiler, 'this is not time recovered but time to be discovered.'[14] The 'Women of Algiers' is a tribute to Matisse only in its iconography: the way it is painted is wholly Picasso's own. He was to pay a more specifically painterly tribute with a quintessentially Matissian theme; that of the artist's studio.

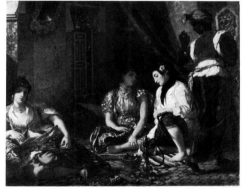

fig. 19 Eugène Delacroix, 'Women of Algiers', 1833. *Musée du Louvre, Paris* *left and far left*

figs. 18, 20 Two 'Studies for "Women of Algiers, after Delacroix"', 1940 (page from Royan sketchbook). *Musée Picasso, Paris.* MP 1879

fig.21 'Colour Study for "Women of Algiers, after Delacroix"', 1940 (page from Royan sketchbook). *Musée Picasso, Paris*. MP 1879

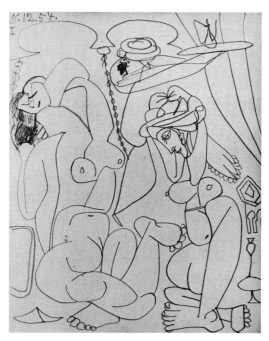

fig.24 'Study for "Women of Algiers, after Delacroix"', 1954 (page in sketchbook dated 5.12.1954 (I)). *Musée Picasso, Paris*. MP 1883

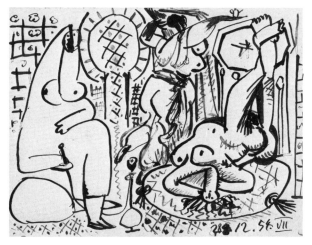

fig.22 Drawing of 'Women of Algiers, after Delacroix', 28.12.1954, VII. *Musée Picasso, Paris*

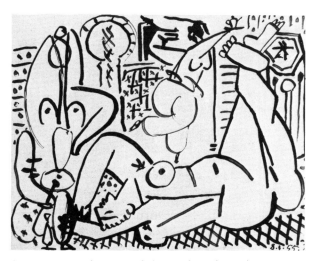

fig.23 Drawing of 'Women of Algiers, after Delacroix', 8.1.1955. *Musée Picasso, Paris*

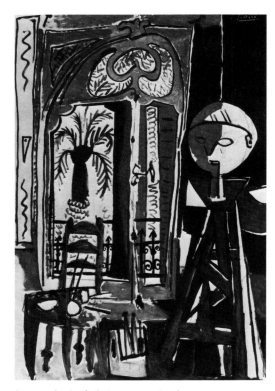

fig.25 'The Studio', Cannes, 23 October 1955. *La Ville de Lucerne, Rosengart Bequest*

THE STUDIO

Moving into La Californie was a momentous event. It was the first time Picasso had moved into a house big enough to enable him to send for all the old canvases that were still in Paris, and to accumulate in artful disorder the traces and memories of his past. As soon as he arrived, Picasso took possession of the entire ground floor of the huge turn-of-the-century house, set in its luxuriant garden. A new stage in his life began there, with Jacqueline.

He quickly responded to the stimulus of the place in a series of what he called *paysages d'intérieur*: interior landscapes.[15] For Picasso, his studio is a self-portrait in itself. Sensitive to its ritual, its secret poetry, he marks with his presence the environment and the objects in it, and makes his territory into his own 'second skin'. The work falls into two phases. A first phase in 1955 (from 23 October to 12 November) favours an upright format, a light touch, a transparent space bathed in vibrant light. The handling is supple and illustrative, and the tracery of the window blends with the tangle of vegetation, uniting the interior and the exterior in a single space. Then the vision becomes denser. Picasso reduces depth to uniform, flat coloured surfaces. A large horizontal painting plays with both manners. In a dense linear structure that forms a heavily charged, Baroque space, one can nevertheless discern, enmeshed in the decor, the constants of studio furniture: the palette-chair, the ceramic head on a stool, the low table with three trays.

The second phase begins in March 1956. Between the two comes a postscript to the 'Women of Algiers' in the shape of the series 'Jacqueline Seated in Turkish Costume' (fig.26), which maintains Delacroix's sensuous, erotic atmosphere. Translated into formal ideograms, or rendered in a more classical style, sometimes close to that of Matisse (cat.6), the subject once more affords the opportunity to try out a range of ways of applying paint. 'Jacqueline,' he said, 'possesses to an unimaginable degree the gift of turning into painting.'[16] Two cardinal works, 'Women at their Toilet'[17] and 'Two Women on the Beach' (fig.30),[18] summarize the research into the formal potential of human bodies that had been undertaken in the 'Women of Algiers'. The women in 'Women at their Toilet' (fig.27), contorted, sombre, dramatic, recall the distortions of the bathers of the 1920s,[19] while at the same time the freedom of their handling foreshadows the late period. Those in 'Two Women on the Beach' – monumental, petrified as if turned to stone in a limpid, transparent light – reassert the solidity of Cubist volumes.

For the time being there was nowhere left to go in this direction, and Picasso returned to the subject of the studio in 'The Studio at La Californie', the most Matissian of all his works. The format has changed to a horizontal one, and the painter has turned to look into the centre of the room. The surface is rhythmically punctuated by three high panelled doors, a cupboard, a Moroccan dish, the easel in the centre (just as in the reference-image, which is Courbet's 'Studio'); and a number of canvases standing on the

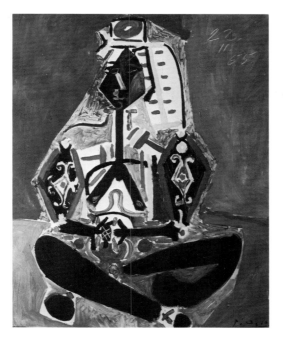

fig.26 'Woman Seated in Turkish Costume',
Cannes, 22 November 1955

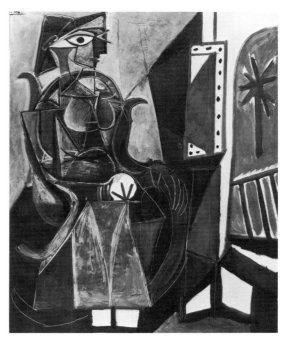

fig.28 'Woman Seated by a Window', Cannes,
11 June 1956. *Museum of Modern Art, New York,
Mrs Simon Guggenheim Fund*

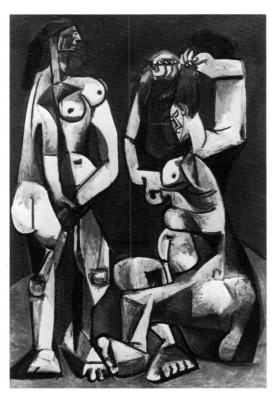

fig.27 'Women at their Toilet', Cannes,
4 January 1956. *Musée Picasso, Paris*

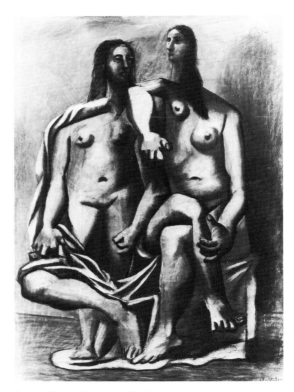

fig.29 'Two Bathers', 24 October 1920.
Musée Picasso, Paris

floor. There are contrasts of black and white and of positive and negative forms; flat, lightly painted and even unpainted areas; and a profusion of decorative elements: Picasso is engaged in 'verifying Matisse's language . . . cataloguing his pictorial signs'.[20]

Then the colours turn to browns, blacks, ochres and greys (cat.8). The atmosphere takes on a Spanish tang: 'a Mozarabic chapel', said Antonina Vallentin;[21] 'Velázquez', said Picasso to Alfred H. Barr.[22] After dismantling the space and trying out different ways of suggesting it, Picasso cannot resist bringing back into the studio the model, Jacqueline, seated in an armchair, facing the easel. The drawing becomes simplified, geometrical; the colours become bright and gay. The confrontation between the seated model and the easel leads to the majestic, classical 'Jacqueline Seated' (fig.28).[23]

This endeavour, spread over a whole year, enabled Picasso to explore the pictorial space, to verify some of the experimental results of Cubism in respect of pictorial depth, to work them out in practice in terms of the paintings of studios by Matisse and by Braque, and to school himself in the use of a spare, economical language made up of brushstrokes which outline and form at the same time, a language that is as clear as children's paintings. One year after Delacroix, one year before Velázquez, his inventory triumphantly concluded, the figure of the painter was set for a resounding comeback.

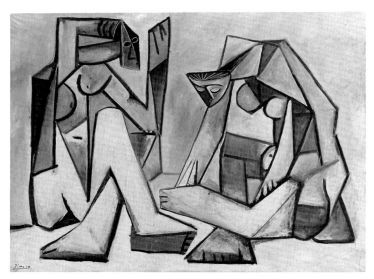

fig.30 'Two Women on the Beach', 6 February –
26 March 1956. *Musée National d'Art Moderne, Centre
Georges Pompidou, Paris, Marie Cuttoli Bequest, 1963*

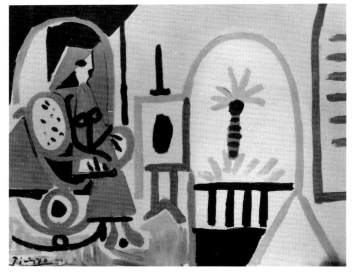

fig.31 'Woman Seated in the Studio', Cannes,
11, 18, 19 May–10 June 1956

'LAS MENINAS'

And not just any painter, either: the painter in question was his compatriot Velázquez, whom Picasso had always revered: 'Velázquez, first class,' he had written to a friend in 1897, after visiting the Prado.[24] Not just any painting, either: he set out to tackle the ultimate masterpiece, the most disturbing picture in the history of painting, a veritable 'theology in pictorial form' which unveils the mystery of the very roots of painting: 'Las Meniñas' (fig. 37).

This painting is a mirror, a trap, an interplay of reflections, an inversion of roles between the viewer and the viewed; it could not fail to fascinate a painter who had taken painting as his subject. In painting his own 'Meniñas', Picasso was inserting himself as the last refinement in the hall of mirrors constructed by Velázquez. He paints a painting of a painting representing a painting that is empty of those who are being painted (the king and queen) and full of those who are on the other side (the painter and the attendants or *meniñas* themselves). The theme is the ambiguous relationship between external reality and pictorial reality: the coexistence of two worlds, that of art and that of life.

In his series based on the work (figs. 32–6), Picasso interprets this double interplay in his own way, by incorporating views of the world outside, a window with pigeons, the

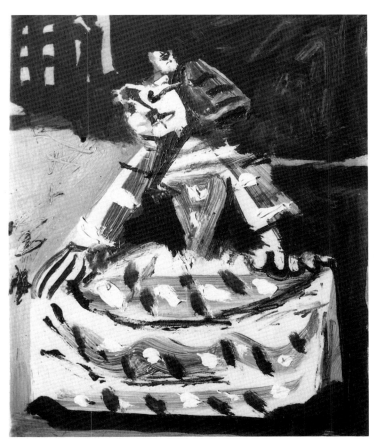

fig. 32 'Las Meniñas,
after Velázquez, "Dona Isabel
de Velasco"', Cannes,
17 November 1957 (v).
Museu Picasso, Barcelona

sea, landscapes, objects from everyday reality – such as his own dachshund Lump, who stands in for the noble Spanish hound – and then, ultimately, Jacqueline. Between 17 August and 30 December, shut away in the empty second-floor rooms at La Californie, which had been specially converted into a studio, Picasso painted fifty-eight pictures, including forty-four 'Meniñas', nine 'Pigeons', 'The Piano', three landscapes and a portrait of Jacqueline.

The first version of 'Las Meniñas', unlike that of the 'Women of Algiers', is the most faithful and the most complete. He starts out by posing the problem, then descends into workings-out of detail, proceeding by association or by digression. Apart from the format – which has changed from horizontal to vertical in order to expand the space – and the use of monochrome, all the elements of the original painting are there. The painter, on the left, a towering figure who has become indistinguishable from his easel, is handled in the same tight graphic style as the 'Portrait of a Painter' after El Greco or the 'Young Ladies of the Banks of the Seine' after Courbet (1950). The closer one gets to the right-hand side of the painting, the more schematic and insubstantial the figures become, ending up with a crude blank silhouette. Picasso here combines, on a single canvas, a number of different pictorial styles which he develops one by one, giving the final preference to a simple, bare handling based on flat areas of paint and heavy geometric outlines: it is an extrapolation of Synthetic Cubism. The choice of black and white enables him to structure space and explore the placing of the figures.

The colours come later, and when they do they are bright, vivid, based on strong reds, greens and yellows, sometimes against black, sometimes against red. Very soon, Picasso concentrates on the Infanta, who becomes the principal figure. Alone, half-length or full-length, and escorted by her *meniñas*, she is treated alternately in simplified forms, flat colour areas, and thick, sinewy, superimposed lines. The handling is sometimes hasty and allusive: a few patches of colour on which forms are drawn. Picasso presses the variety of styles still further, passing from overlapping multicoloured facets to Matissian simplicity, constructing space through flat coloured planes.

What Picasso retains from this enigmatic scene is that of its being an exercise in painting. From Velázquez's sumptuous handling he retains the rendering of flesh and silk, the subtle light that falls on the Infanta's dress, and which he renders by patches of white and yellow against green, as in the last little painting of the Infanta which drops a final curtsey to close the series on 30 December. The laboratory work in which Picasso analyses, dissects and recomposes his subject lends him an extraordinary freedom of brushwork, an unquenchable enthusiasm, and the licence to manipulate his figures as he chooses. Humour and irony are never far away, as in the piano which makes a sudden and hilarious appearance because of the way the little page on the right is holding his hands.

Some of the bases of Picasso's later style are established here: the schematic signs for hands and feet, the childlike drawing style that reappears in the series 'The Artist and his Model', and the bold, sinewy scrawl that appears in the 17 November version of 'Las

fig.33 'Las Meniñas, after Velázquez', Cannes, 17 November 1957 (I). *Museu Picasso, Barcelona*

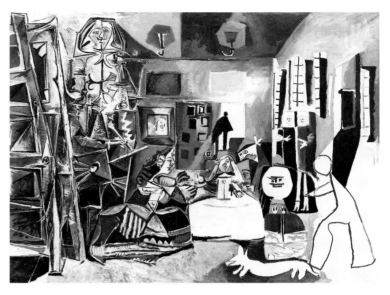

fig.36 'Las Meniñas, after Velázquez', Cannes, 17 August 1957, *Museu Picasso, Barcelona*

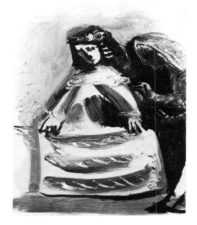

fig.34 'Las Meniñas, after Velázquez, "Dona Isabel de Velasco"', Cannes, 17 November 1957 (VI). *Museu Picasso, Barcelona*

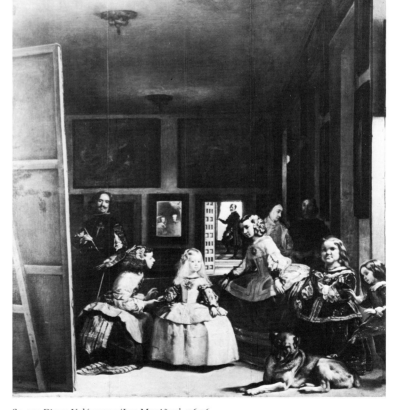

fig.37 Diego Velázquez: 'Las Meniñas', 1656. *Prado, Madrid*

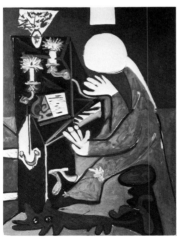

fig.35 'Las Meniñas, after Velázquez', Cannes, 17 October 1957. *Museu Picasso, Barcelona*

Meniñas' (no.VI).[25] The 'Meniñas' series is the first manifestation of Picasso's mental return to Spain, which became more and more marked throughout the period at Vauvenargues and culminated triumphantly in the 'Siglo de Oro' noblemen of the Avignon period, which also marked a profounder exploration of the system of variation, in which, freed from the preordained subject, Picasso allowed painting to speak for itself.

'Las Meniñas', like the 'Women of Algiers', is a composition with several figures, something he rarely tackled. Here he rapidly reduced the number of protagonists. At long last, he had found a way of verifying Cubist space and depth: an undertaking for which the 'Studio' series had been a preparation. 'Las Meniñas' had represented a review of pictorial techniques and the invention of new ones: a settling of accounts with his great predecessor. He was continuing on his way, with one foot in the past, the other in the future. At this stage in his train of thought, he needed a springboard; and this was supplied, fortuitously, by 'The Fall of Icarus'.

SCULPTURE AS MODEL: 'THE FALL OF ICARUS'

The preparatory work for the large panel on the Unesco Building (fig.45) gave Picasso an opportunity to go back over the problems that concerned him most; it marks a crossroads in his work, a pause before the final stage. In December 1957 – starting before he finished work on 'Las Meniñas' – and January 1958, Picasso accumulated a store of sketches and preparatory drawings in two sketchbooks (figs.40, 42–3).[26] An immense surface to be covered, an unrewarding architectural setting, a humanitarian project, an official commission: these were the obstacles that Picasso set himself to overcome. After 'Guernica' and 'War and Peace', this was his third monumental decorative project. The starting-point, the genesis of the work – as with 'Guernica'[27] – is once again the 'primal scene': the studio, the artist and the model. But from the outset he added a new element, that of sculpture (as represented by the painted bathers), which served in a way as a fuse to set the whole huge composition ablaze.

As so often in his career, Picasso turned once again to sculpture. In the constant dialogue between two and three dimensions that characterizes his work as a whole, sculpture represents a measure of detachment, a different viewpoint, a crosscheck and an enrichment for painting. The first sketch of 6 December 1957 (fig.39) shows the studio, the nude model who seems to have emerged from the canvas propped on the easel, a large painting representing bathers which functions like an open window (are these sculptures, or is this a painting of sculptures?), and, finally, the tall, ghostly outline of the painter.

Along the way, in the complex succession of steps, leaps, and dizzying changes of tack that is described by Gaëtan Picon in *La Chute d'Icare*,[28] Picasso integrated and summed up the progress made in the preceding five years. The resumption of the studio theme sent him back to two paintings of 1953, the 'Reclining Nude' and 'The Shadow', which are combined in two drawings dated 7 January 1958 (III and IV) (fig.41).[29] He even

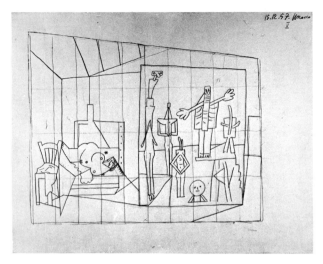

fig.38 'The Studio: Woman Reclining and Picture' (study for UNESCO panel), Cannes, 15 December 1957 (V). *Musée Picasso, Paris*

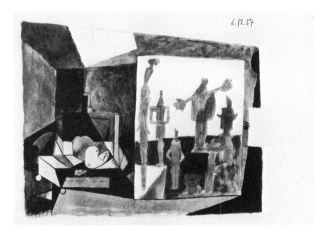

fig.39 'The Studio: Woman Reclining, Picture and Artist' (study for UNESCO panel), Cannes, 6 December 1957

fig.40 'Reclining Nude' (page from UNESCO sketchbook), Cannes, 19 December 1957 (VIII). *Musée Picasso, Paris*. MP 1885

fig.41 'Studio Interior' (study for UNESCO panel), Cannes, 7 January 1958 (III)

fig.42 'Nude in Studio' (page from UNESCO sketchbook), Cannes, 23 December 1957 (II). *Musée Picasso, Paris*. MP 1885

fig.43 'Reclining Nudes' (page from UNESCO sketchbook), Cannes, 4 January 1958 (VI). *Musée Picasso, Paris*. MP 1885

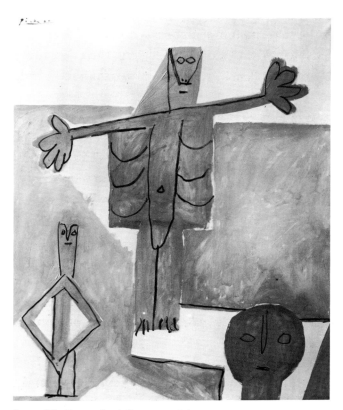

fig.44 'The Trampoline', Cannes, 22 July 1957

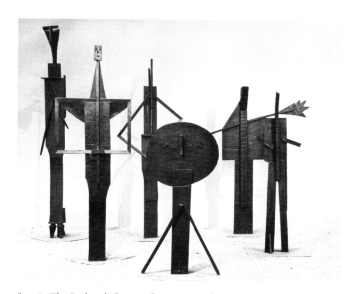

fig.46 'The Bathers', Cannes, Summer 1956.
Musée Picasso, Paris

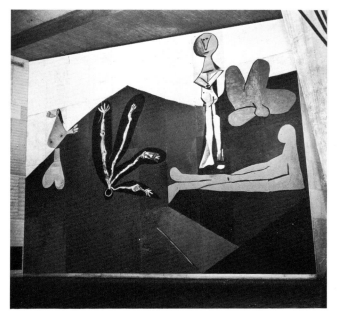

fig.45 'The Fall of Icarus', UNESCO, Paris, 1958

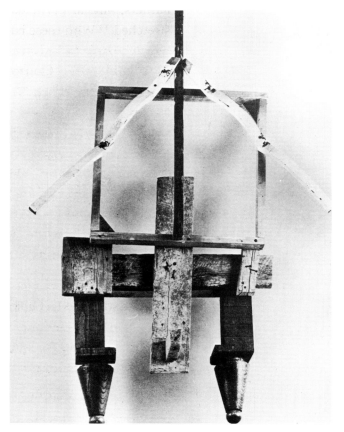

fig.47 'Man', Cannes, 1958. *Private Collection*

evokes the room at Vallauris, through the presence of the little Sicilian horse on the shelf;[30] 'because from time to time,' he said, 'a bit of sculpture is needed.'[31] Studies of reclining female nudes reappear, derived from the 'Women of Algiers'; their distortions sometimes seem to result from their plastic malleability and sometimes from the folding of stiff cut-out forms.[32]

In other drawings he studies the geometry of the studio, and this structured space recalls the studio at La Californie or the one in 'Las Meniñas'. The resemblance to the first version of 'Las Meniñas' is striking: the same arrangement of figures, a tall figure with a small head on the left, a little one with a big head in the centre, the same frontal arrangement, and so on. But what these successive studies represent above all is Picasso's transposition into his own terms of a problem posed by Velázquez, that of the ambiguity of pictorial space and its anomalous relation to reality. Picasso multiplies the conundrums; painting of a sculpture or painted sculpture, window or canvas, real model or model painted on canvas: the ambiguities culminate in the outline of the painter, who becomes the subject of a painting. This is just one more sign of the fusion, the identification of the painter with his object. The painter in painting, painting in painting: the plot constantly thickens.

Curiously enough, after piling up all these illusionary effects, Picasso plunges back into the central canvas, the nub of his subject, and chooses as his principal motif the bathers, and in particular the one who stands on a diving-board with arms out-stretched.[33] With these bathers Picasso reverts to a theme which was dear to him and which he had worked on at Dinard in 1928 and subsequently at Boisgeloup. This is also the central scene of Clouzot's film *La Plage de la Garoupe*, the scene of everyday life that he observes on the beach. The sculpture 'The Bathers' (fig.46), an assemblage of wood, frames and planks, is a monumental work, a model for a fountain, and the first sculptural group in the sequence; it had a number of successors,[34] and served to open the way to planar sculpture and thus to the sheet-metal cut-outs of the 1960s. Most of these figures, by their form, which recalls a stretcher, and their original material, pieces of wood, frames, planks, are 'bodies that are paintings; bodies that are easels'.[35]

In 1957 Picasso made three heads made up of profiles which intersect at 90 degrees along a vertical line (cat.73).[36] Sculptures in cardboard and sheet-metal, derived from his work on the 'Heads' of Sylvette, enabled him to combine painting and sculpture. He told Pierre Daix:

> In the studio at La Californie I lit these cut-out heads very strongly and tried to get them into my painting. I did the same thing with 'The Bathers'. I painted them to start with, then I sculpted them, and then I painted them again in a picture of the sculptures. Painting and sculpture had a real debate.[37]

As Pierre Daix remarks, these new sculptures were to be a point of departure for painting: 'and rightly so, because they came out of painting; they were materializations of painting in three dimensions'.

fig.48 'Cannes Bay', Cannes, 19 April–9 June 1958.
Musée Picasso, Paris

fig.50 'Bullfight' (page from sketchbook),
2 March 1959 (IX)

fig.49 'Still Life with Bull's Head', Cannes,
25 May–9 June 1958. *Musée Picasso, Paris*

fig.51 'Still Life with Demijohn', Vauvenargues,
14 June, 1959. *Private Collection*

In the final composition Picasso keeps nothing of 'The Bathers' apart from one standing figure, derived from the diver, and the vast blue sea. The other figures are stretched out or seated, and one, a female bather, takes on the inflated forms of the Dinard 'Women Bathing'. He carries simplification and abstraction to the ultimate, sidesteps his initial subject, and adds, at the last moment, the enigmatic figure of the bird-man who falls from the sky into the sea. The theme of the diver and the diving-board does not appear by chance. As both Daix and Picon point out, this attitude of risk-taking, taking a dive, a leap into the unknown, exactly corresponds to Picasso's state of mind at that moment: 'The painting, the springboard. It all happens between these two things. . . . A diver is surely like the painter, facing the danger and the aching void of his chosen element.'[38]

The myth of Icarus, which superimposed itself on the initial conception, and which was suggested by Georges Salles, is certainly there in the work, whether consciously or not, and in spite of the official title of 'The Forces of Life and the Mind Triumphing over Evil'. The Father's lesson cannot be learnt, as Picasso knew from his experience with the old masters. At this stage in his career, disillusioned with ideology, Picasso found himself face to face with himself, with creation pure and simple. Poorly understood at the time and often decried since, this work marks, as Daix writes, a stage in a 'reconquest of the self'.[39]

VAUVENARGUES

In 1958 Picasso painted two characteristic but isolated pictures, 'Cannes Bay' and 'Still-life with Bull's Head',[40] which mark the transition towards external space, the move out of the confinement of the studio. The heavily impastoed Ripolin, the runs, the materiality of the thick paint, are echoes of contemporary art; at the same time they define Picasso's late style.

In March 1959 the *corrida* was back in force, with a series of drawings in which Picasso mingled the themes of bullfight and Crucifixion.[41] Christ as a matador, cast into the Spanish bullring, expresses the bloody sacrifice of the victim and also, by his tragic presence, the magnitude of the risk that Picasso was taking as a painter.

The decisive event of 1959, however, was his move to Vauvenargues, in Cézanne country. 'I've bought the Montagne Sainte-Victoire, the real thing,' he told Kahnweiler. A new place, an austere and lordly dwelling, brought with it a new kind of painting, strongly influenced by Spain, and dominated by dark red, deep green and ochre. Picasso painted still-lifes with mandolines and jugs,[42] and above all the famous, ornate Henri II sideboard that he had just bought. In 1959 two magisterial paintings done in homage to Cubism expressed the classical mastery and maturity of Picasso's style of the late 1950s: 'Nude under a Pine Tree' (cat. 10) and 'Seated Nude' (cat. 17). In these Picasso allies the geometrical and constructional rigour derived from 'Two Women on the Beach' to a newly acquired graphic fluency and a newly recovered plasticity of form. There is

humour in them, too, as is shown by the prosaic high-heeled shoes in 'Seated Woman'.

Finally, it was at Vauvenargues, in August 1959, that Picasso embarked on the cycle of works based on 'Le Déjeuner sur l'Herbe', the last cycle of its kind, which was to come to an end at Mougins, in July 1962, after 27 paintings, 140 drawings, 3 linocuts and numerous cardboard maquettes.

'LE DEJEUNER SUR L'HERBE'

Why Manet? For a number of excellent reasons. Manet embodies a certain kind of preoccupation with Spain; he specializes in quotations; he is the leader of a pictorial revolution; and he is the acknowledged father of modern art. Manet had been on Picasso's mind for a very long time.[43] In 1903 there was the parody of 'Olympia'; in 1919 'The Lovers' (an allusion to *Nana*); in 1950 there was 'The Massacres in Korea', a pastiche of the 'Execution of the Emperor Maximilian' (in itself a pastiche of Goya's 'Third of May'): the omens run through Picasso's whole career. In 1929 he wrote on the back of an envelope a sentence heavy with foreboding: 'When I see Manet's "Déjeuner sur l'Herbe" I say to myself: trouble in store'[44] (fig. 52). Like the 'Women of Algiers', the 'Déjeuner' was present as early as 1954, in a sketchbook[45] that establishes the heads of the figures and studies the composition (figs. 53–5). Then, in 1955, he drew Jacqueline as 'Lola of Valencia'.[46]

The preliminary stage, before Picasso tackles an old master painting, is always the same: Picasso seems to be obsessed by the work and works hard on it at different periods and in utterly different ways. 'Le Déjeuner sur l'Herbe' represents an opportunity to handle an open-air scene after so many indoor settings in harems and studios. Indirectly, it pays tribute to Cézanne's 'Grandes Baigneuses' and Matisse's 'Joie de vivre': he takes from one the endeavour to integrate the body in the landscape, and the structural solidity, and from the other he takes the idyllic pastoral atmosphere. It is also, for him, a way of studying the female nude. The specific pose assumed by Victorine Meurent, which leads Manet to flatten the articulations and superimpose the arms and legs, and also that of the woman who leans forward, are transcribed in the numerous drawings of nudes that form part of the cycle. Picasso shows the two women in every conceivable posture, manipulating them as he needs. The ample forms of Manet's figures, 'stamped out with a pastry-cutter',[47] are translated by Picasso into rounded bean shapes. Working on 'Le Déjeuner' brings Picasso to the point of inventing a new morphology. It is these same forms, all curves, that reappear cut out in sheet metal in the 'Footballers' of 1960.[48]

As always, Picasso slants the initial theme in the direction of his own personal preoccupations: the stooping woman in the background brings him back to the coiled postures that he had been studying since 1944,[49] and the two central figures, the seated nude and the man talking, take up a dialogue which imperceptibly turns into the

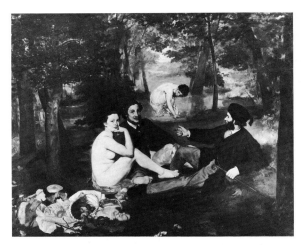

fig.52 Edouard Manet, 'Le Déjeuner sur l'Herbe', 1863. *Musée d'Orsay, Paris*

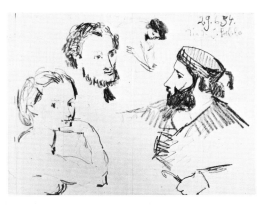

fig.55 'Le Déjeuner sur l'Herbe, after Manet' (page from sketchbook), 29 June 1954. *Musée Picasso, Paris.* MP 1887

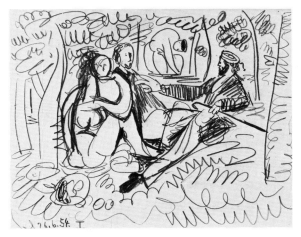

fig.53 'Le Déjeuner sur l'Herbe, after Manet' (page from sketchbook), 26 June 1954 (I). *Musée Picasso, Paris.* MP 1882

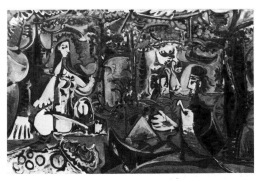

fig.56 'Le Déjeuner sur l'Herbe, after Manet', Vauvenargues, 3 March – 20 August 1960. *Musée Picasso, Paris*

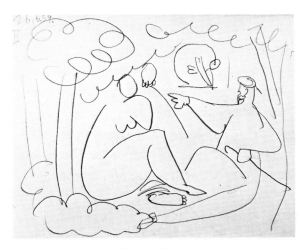

fig.54 'Le Déjeuner sur l'Herbe, after Manet' (page from sketchbook), 26 June 1954 (II). *Musée Picasso, Paris.* MP 1882

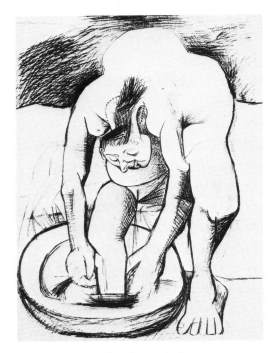

fig.57 'Woman Washing her Feet', May 1944. *Art Institute of Chicago, Chicago*

interaction between the artist and his model. By a curious paradox, Manet's flat, silent painting has given birth, after its rape by Picasso, to loquacity and three-dimensional form.[50]

The sylvan scene, which intermittently turns itself into a bathing party, leads him to evoke the half-light under the trees, and the deep, shady greenness of a forest clearing. This kind of setting is unusual in his work and recalls the 'Nudes in the Forest' and the landscapes of the Rue des Bois (1908). For each successive image, Picasso changes his idiom. Starting with flat areas of colour, he goes on to a style draped and festooned with detail and then to a linear style made up of swirling vortices, and then to wide, sinewy brushstrokes.

The 'Déjeuners' differ from previous series in that they give Picasso scope not only to test out a succession of different layouts and styles of brushwork, but to step out of the 'Déjeuner' theme altogether and do something that is wholly his own. This transition is eased by the fact that this theme introduces figures and poses that had long been favourites of his (a woman reclining or sitting, a nude bending forward, and so on). The transfers of images and the associations take place in every direction. All the phases of this exploration are visible in the countless drawings that accompany the series and make up what Douglas Cooper calls the 'image laboratory'. There are in fact many more drawings than paintings, and the drawings are very free interpretations of the theme.

This cycle was pursued for longer than any of the others, and it is structured differently. Picasso came back to it several times, as if he could not tear himself away from a subject that was vital to him, as if he were conscious of the importance of this series, and of its significance for his creativity. In leaving Manet behind and producing new works of his own, he was playing for high stakes: by appointing himself as the continuer of a tradition, he was undertaking to go further with Manet than Manet had gone with Giorgione: 'Picasso has embraced the whole of nineteenth-century painting, and his greatest triumph is that he has gone beyond that pictorial tradition and established his own independence and supremacy.'[51]

Manet's concern was to relate a painting to a painting: Picasso's was to relate a painter to a painter. What was at stake was not only his own power as a painter but his power as a demiurge: the power to metamorphose certain objects in the world of reality which are also, and equally, paintings in a museum. Manet had freed him from the past and given him a new creative impulse. This was the last of Picasso's sets of variations; it was also the richest and most fruitful.

'THE RAPE OF THE SABINES'

The episode of the 'Sabines' was of quite another kind: this is not an exercise in variation, nor a series of works based on one given painting. Here he blends a number of pictures: one version of 'The Massacre of the Holy Innocents'[52] and two of 'The Rape of the Sabines' (figs. 58, 59).[53] The result is a *mélange* of Poussin and David. This was his last

history painting, prompted no doubt by the ominous events in Cuba which brought him back to warlike subjects and innocent victims. The violence of the action forces him into expressive foreshortenings and anatomical distortions. In the final version, the presence of the horse and the woman with a child – treated like the 'Young Ladies of the Banks of the Seine', after Courbet – constitutes an indirect reference to 'Guernica'.

The 'Sabines' were followed by the helmeted 'Warriors',[54] then by a number of portraits of 'Jacqueline Seated in an Armchair'.[55] Picasso now turned once more to the dialogue between painting and sculpture, making pictorial counterparts of the Chicago 'Head', the 'Woman in a Hat', 1961 (cat.74) and the painted sheet-metal cut-outs of heads (cat.75).

By 1963 painting had been his model for ten years, in which he had analysed and taken apart the paintings of other artists, and in which he had also taken sculpture a great leap forward through the development of planar sculpture. Having now done all he could with subjects of general import and multi-figure compositions, he returned to his point of departure: the scene of enactment, as it were, the fundamental battleground, the face-to-face confrontation between the painter and the model. This was the decisive turning point of the period.

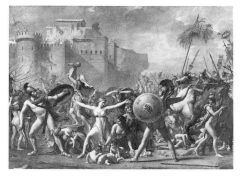

fig.58 Jacques-Louis David, 'The Rape of the Sabines', 1799. *Musée du Louvre, Paris*

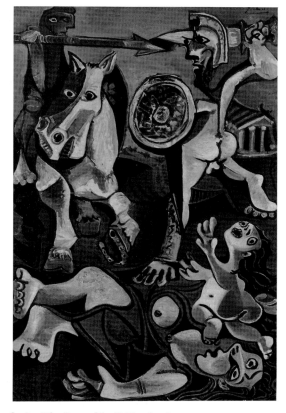

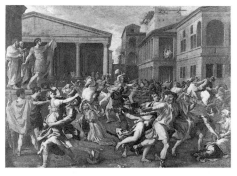

fig.59 Nicolas Poussin, 'The Rape of the Sabines', c.1635–37. *Musée du Louvre, Paris*

fig.60 'The Rape of the Sabines', 9 January– 7 February 1963, Mougins

ARTIST AND MODEL

Picasso painted, drew and etched this subject so many times in his life that, as Michel Leiris has remarked,[56] it almost became a genre in itself, like landscape or still-life. In 1963 and 1964 he painted almost nothing else: the painter, armed with his attributes, palette and brushes, the canvas on an easel, mostly seen from the side, like a screen, and the nude model, seated or reclining, in a space which presents all the characteristics of an artist's studio: the big window, the sculpture on a stool, the folding screen, the lamp, the divan, etc. All these stage props have nothing to do with Picasso's real situation; he always painted without a palette and without an easel, directly on to a canvas laid flat. This is therefore not so much a record of his own work as an 'epitome of a profession'.[57]

'In February 1963,' Hélène Parmelin tells us, 'Picasso went wild. He painted 'The Artist and his Model'. And from that moment on he painted like a mad thing, in a frenzy, as perhaps never before.'[58] From February to May 1963, in January, October, November and December 1964, and again in March 1965, paintings poured out one after another. There are a number of variants: sometimes the model is absent and the painter is alone with his canvas; sometimes the scene shifts from the studio to the open air, in a landscape reminiscent of 'Le Déjeuner sur l'Herbe'. Then the painter appears alone, in profile, in close-up, with his troubled, piercing gaze.[59] At times the format, generally firmly horizontal in order to place the protagonists on either side of the median line, changes and become vertical. The figures become elongated and move closer to each other; the woman becomes confounded with the easel.

'From the look that scrutinizes to the look that desires is only one step.'[60] This step was taken on 13 March 1962 with a canvas recalling the painting of 'Rembrandt and Saskia', in which the painter takes the model on his knee (fig.61). This sudden transition from model to lover is an anticipation of the series of etchings on the theme of 'Raphael and the Fornarina', after Ingres, which formed part of the '347' series of 1968. In October 1964 the painter is seen painting the woman's body 'directly', or else penetrating the canvas with his brush (cat.29).

The theme of the artist and his model,[61] or of art in practice, is a corollary of the studio theme; it was not a new subject to Picasso. It runs like a thread through his whole career, mostly concealed but sometimes quite explicit. It first appeared in a painting of 1914 that foreshadows the subsequent reversion to a classical style (fig.63). In 1926, having been commissioned by Vollard to illustrate Balzac's *Le Chef-d'oeuvre inconnu*, and while he was at work on the preliminary drawings, Picasso painted a large canvas in grisaille in which the figures of the artist and his model are united in a tangle of lines (fig.62). From this cat's-cradle there emerges one enormous foot, as if Picasso had been thinking of Frenhofer's famous painting in Balzac's story. An etching of 1926 shows the painter, his model who sits knitting, and the tangle of lines that he is putting on his canvas (fig.64). The myth of the ultimate masterpiece; the suicidal obsession of the painter, Frenhofer, whose perfectionism progressively obliterates his painting; the

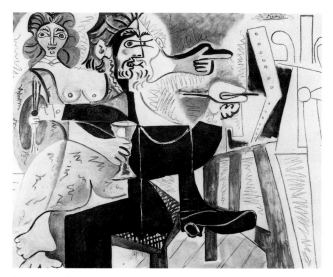

fig.61 'Rembrandt and Saskia', Mougins,
13–14 March 1963

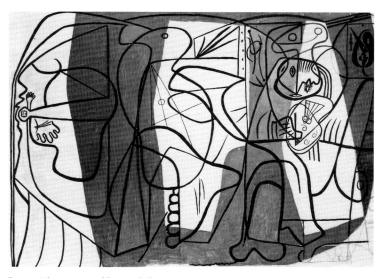

fig.62 'The Artist and his Model', Paris 1926.
Musée Picasso, Paris

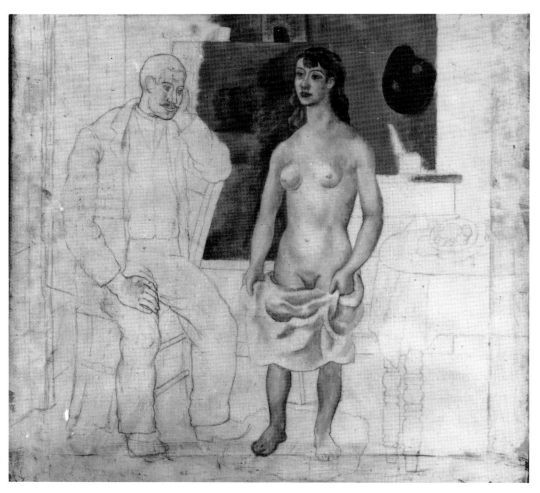

fig.63 'The Artist and his Model',
Avignon, summer 1914.
Musée Picasso, Paris

contrast between the real model, shown in a figurative style, and her abstract pictorial counterpart; the artist's need to choose between art and love, and between the creature and the creation: all the themes that are interwoven in Balzac's book henceforth haunt Picasso to the point of obsession.

All his life he continued to hark back to this basic creation myth, which defines the artist as a creator equal to God, able to give life – or rather the illusion of life – to an inanimate substance. But Picasso is no Frenhofer; his art is not doomed to destruction; his figures live because they are also paintings. In 1933 the theme shifted into an objective register with the series 'The Sculptor's Studio', which forms part of the Vollard Suite, and which shows the sculptor facing both his model and her sculptural – and thus concrete – image. The stylistic interplay between the work and the model is still present, but the discrepancy between the real woman and the painted image is replaced by the sculptor's direct, manual, physical contact with the work, and by its logical conse-quence, the (amorous) repose that he enjoys with the model.

Twenty years later, in the 'Verve' series, Picasso continued the exploration of this essential theme. But, as we have seen, here his timeless, bearded artists are replaced by painters so powerfully individualized as to be caricatures. Conscious of the vulnerability of the painter's trade, Picasso shifts from idealism to down-to-earth, caustic laughter. 'Poor painter!' he used to say. 'The Artist and his Model' gave rise to a series of portraits of men illustrating the prototype of 'The Artist',[62] decked out in assorted headgear – the artist's traditional black slouch hat, or Van Gogh's battered straw – sometimes bearded, sometimes dressed in a striped jersey (like Picasso) and sometimes with a cigarette in his mouth. Picasso sets out here to create a real flesh-and-blood character. 'The painter fellow,' he used to call him: 'I've even done his boot and his trousers'[63] (fig.65). He spoke with gentle mockery of this *Doppelgänger* of his, the impecunious, obsessive *artiste-peintre*, 'the easel's everlasting minion, with his implements of torture'.[64] 'Ah, if only I were an *artiste-peintre*!' he said to Brassaï,[65] regretting that he no longer had the naïveté of the Impressionists, who were content to describe themselves thus – or even that of the Sunday painters. 'He thinks he'll manage somehow, poor creature!'[66]

Michel Leiris, analysing the deeper significance of the artist-and-model theme, finds in it two underlying elements. One is that of voyeurism, the acting-out of looking, the starting-point of creation, 'eye and hand'; and the other is that of mockery of his own profession, the acting-out of painting. Through all these manifold scenes Picasso is asking himself the question, 'What is a painter? A man who works with brushes, a dauber, an unrecognized genius, or a demiurge, a creator who mistakes himself for God?' Through the constant recapitulation of this scenario he is also trying to capture the impossible, the secret alchemy that takes place between the real model, the artist's vision and feeling, and the reality of paint. Which of these three elements will prevail, and how is each to maintain its true character? 'No model, no painter,' he said, confirming yet again his 'indestructible attachment to the external world'.[67]

'The subject has never scared me,' he said. 'It's a joke, the idea of getting rid of the

subject, it's impossible. It's like saying "Just carry on as if I weren't here." Even if the canvas is green, okay, the subject is the colour green.'[68]

The more Picasso painted this theme, the more he pushed the artist–model relationship towards its ultimate conclusion: the artist embraces his model, cancelling out the barrier of the canvas and transforming the artist–model relationship into a man–woman relationship. Painting is an act of love, according to Gert Schiff,[69] and John Richardson speaks of 'sex as a metaphor for art, and art as a metaphor for sex'.[70]

Just one more series of works, growing progressively more allusive in style, in March 1965,[71] and then that is the end of this particular theme. In this series, the motif seems no more than a pretext – hence its literal, and even anecdotal, rather than painterly character. Picasso is telling the story of painting; he is *narrating* rather than *painting*; the act of painting is something he cannot paint, and so he opts for a shorthand style, a hybrid between painting and writing, all signs and ideograms.

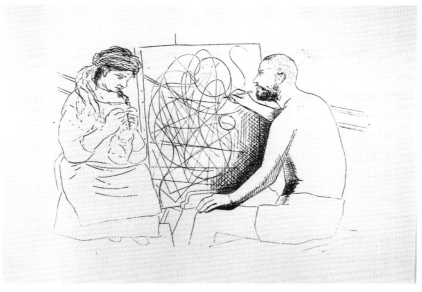

fig.64 'Artist and Model Knitting', illustration for Balzac's *Le Chef d'Oeuvre Inconnu*, 1926

fig.65 'The Artist', 18 May 1963 v

From 1964 onwards, painting is 'stronger than he is'. He lets it flow, overflow, act, move off the canvas. After his bout of strenuous body-contact with painting, he passes on to the painting of the body, and then to the body of painting, 'thus promoting the material process of painting to be the matter of painting itself'.[72]

1963–1973: The Archetypes

WOMAN AND THE NUDE: THE PAINTING OF THE BODY

After 1963, the rich and varied iconography of the period since 1953, which drew with such relish on the imagery of the past, took second place, in painting, to the issue of pictorial form. The story continued, but only in the etchings. In painting there were no more direct allusions to the art of the past, and no more compositions involving multiple figures. Picasso now chose to work with isolated figures, archetypes, and concentrated on the essential: the nude, the couple, man in disguise or stripped bare: it was his way of dealing with the subject of women, love, and the human comedy.

After isolating the painter in a series of portraits, it was logical that Picasso should now paint the model alone: that is to say a nude woman lying on a divan, offered up to the painter's eyes and to the man's desire. It is characteristic of Picasso, in contrast to Matisse and many other twentieth-century painters, that he takes as his model – or as his Muse – the woman he loves and who lives with him, not a professional model. So what his paintings show is never a 'model' of a woman, but woman as model. This has its consequences for his emotional as well as his artistic life: for the beloved woman stands for 'painting', and the painted woman is the beloved: detachment is an impossibility. Picasso never paints from life: Jacqueline never poses for him; but she is there always, everywhere. All the women of these years are Jacqueline, and yet they are rarely portraits. The image of the woman he loves is a model imprinted deep within him, and it emerges every time he paints a woman, just as whenever he paints a man he thinks of his father, Don José.[73]

In the series of large 'Reclining Nudes' of 1964 (cats.26, 27), the artistic references are indirect: 'Venus, Maja, Olympia', writes Christian Geelhaar, quite correctly.[74] The posture of the woman with arms raised, showing her armpits, recalls Goya's 'Maja Nude'; and the presence of the little black cat recalls Manet's 'Olympia'. The black cat is not just an erotic adjunct, however; this was a real cat that Picasso and Jacqueline had taken in at Mougins. The first nudes, massive and voluminous, are lying on a bed, and are seen in profile while offering all their parts to view: both legs, both big feet, both buttocks, both breasts. This forces the bodies to twist and bend in order to occupy the whole surface of the canvas. Picasso remains faithful to the principle of simultaneity which was pioneered by Cubism, the desire to grasp reality from all directions at once.

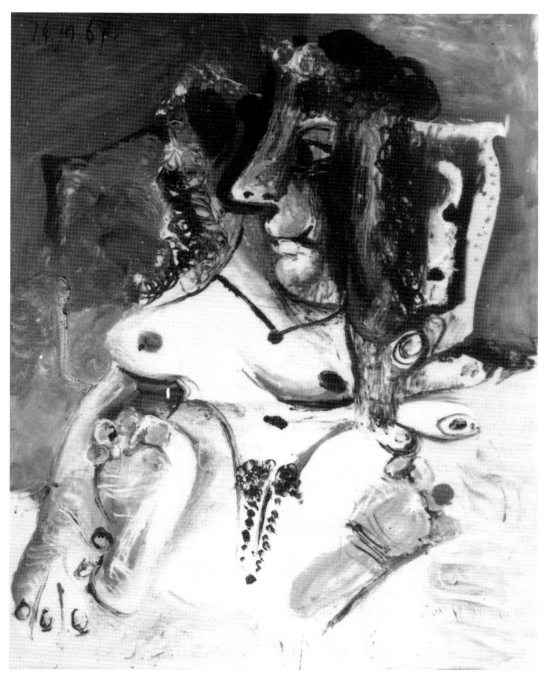

fig.66 'Nude Leaning on Cushions',
24 October 1967, 146 × 114 cm,
Marina Picasso Collection,
Galerie Jan Krugier, Geneva

Then, in 1967, he swings the body round to give a frontal view, while keeping the face in profile. This perspectival view, and the foreshortening that places the soles of the feet in the foreground of the picture, makes it necessary for him to arrange the parts of the body around a central focus, which is the vulva (cat. 35 and fig.66).

These nominally reclining nudes, who look rather more as if they were sitting up or standing – such as the 'Reclining Nude' in the Musée Picasso (fig.4) – present a body that is dislocated, abused, with all its parts topsy-turvy, but which nevertheless remains

intact. This work on the female body recalls, in a way, the manipulations and distortions of the Dinard 'Woman Bathing'. But then the bodies were in profile, and their simplified limbs fitted together like pieces of a jigsaw; or else they were blown up like balloons: in any case they were viewed more as sexual machines than as nudes. Now Picasso seeks to conserve the unity and cohesion of the body; and, indeed, despite all the simplifications that have taken place, 'It's all there'. Picasso said: 'I try to do a nude as it is. If I do a nude, people ought to think: It's a nude, not Madame Whatsit.'[75]

In this obsession with the nude there are a number of factors. One is the desire to convey the physical and carnal reality of the body, to make the picture so true and 'natural' that you can't tell the difference, as he said: 'With Braque, when you looked at his pictures you said to yourself "Is it a woman or a painting – do its armpits smell?"'[76] Another is the fascination with the 'feminine myth' which became an obsession at the end of his life. In the paintings of these last years the women remain young and attractive; they are conceited and sometimes comical; they have massive, well-rounded forms and colossal proportions – although in the late drawings and etchings they are sometimes cruelly and tragically overtaken by old age and decrepitude. This vision of a body that is fragmented, blown apart, and nevertheless still in one piece despite its state of dispersal, corresponds to a certain state of sexual arousal in women, close to implosion; it also marks the impulse that Picasso feels, as a man and as a painter, to dominate a woman's body, the object of desire and the eternal subject of painting.

Picasso is *the* painter of woman: goddess of antiquity, mother, praying mantis, blown-up balloon, weeper, hysteric, body curled in a ball or sprawled in sleep, pile of available flesh, cheerful pisser, fruitful mother or courtesan: no painter has ever gone so far in unveiling the feminine universe in all the complexity of its real and fantasy life. This intimate, passionate awareness is a constant source of renewal for his painting, which revels in the variety of the repertoire of forms that it affords, mineral and carnal by turns. He thus works with an infinite range of possibilities that make all metamorphoses possible.

A woman's body is the obstacle on to which he projects his male desire and his creative energy. The gap between art and reality, and the irremediable distance between man and woman, enable him to keep up the tension. Picasso's obsessive theme of the artist and his model now undergoes a metamorphosis into an erotic relationship, and this stimulates an extraordinarily prolific period of work which marks the rise of a new painting.

THE KISS, THE EMBRACE, THE COUPLE

The violence of the eroticism, both male and female, to which Picasso gives material expression in his painting, expresses itself in concrete form in the theme of the kiss.

Man and woman, the infernal couple, are seen in every conceivable position – 'ultimately, love is all there is,' he said[77] – and all their frantic embraces: the raw realism

of his 'Kisses' sums up the place that physical passion occupies in his life. In cinematic close-up (cat.49), the two profiles merge into a single line, the noses collide and bend into a figure-of-eight, the eyes protrude and rise to the top of the tossed-back head, the mouths devour each other. Picasso makes two beings into one, expressing the physical blending that takes place at the moment of the kiss. Never has erotic force been suggested with such realism.

In his 'Embraces' (cat.53), he unveils sexuality in a totally explicit way. 'Art is never chaste,'[78] said the painter, wielding his brush to depict, in graffiti-like detail, the phallus and the act of copulation. Then other couples reappear – the serenade (cat.57), the flute-player, the watermelon-eaters – and objects turn into sexual surrogates. In 1969 Picasso painted a series of anything-but-still lifes, bunches of flowers and voracious plants (cats.50, 52), that represent, as it were, his organic vision of sexuality.

This series forms the old man's last salute to the pleasures of the flesh. 'The Embrace' of 26 September 1970 (cat.55) presents the woman all alone, with the ghostly head of a man; the 'Nude Man and Woman' of 18 August 1971 (cat.63) shows a helpless old man supported by a woman. It seems that love is no longer a possibility. And yet, in June 1972, there is one last 'Embrace' (cat.72): a couple in a strange position in which their limbs are so enmeshed that it is impossible to tell the man from the woman, nor what belongs to whom, in spite of the precise indication of the two sexual organs, the breasts, the presence of four feet and a number of hands. This beast with two heads, its faces barely distinguishable, is sinking beneath the sea. The oceanic reference, and the hybrid form, are the image of a primal bisexuality, a state of fusion, rather than that of desire in action. Picasso has pursued the mysteries of life to the ultimate.

MAN AND THE HUMAN COMEDY

Woman is shown in every state, right down to the most terrifying of all, that of the last 'Nude in an Armchair' (fig.163): a miserable, gaping sex, a spider with four limbs, half-skeletal, half-hairy and male, her body so shrunken that it seems to be retracted into itself. Man, on the other hand, always plays a part, or wears a disguise: as a painter at work or as a matador-musketeer, laden with his male attributes, the long pipe, the sabre or the sword. One last new figure appears in Picasso's iconography in 1966, and dominates the period to the point of becoming its emblem: this is a nobleman of the 'Siglo de Oro', half Spanish, half Dutch, gaudily dressed, sporting a ruff, a cloak, boots and a big plumed hat. 'It happened when Picasso started to study Rembrandt,'[79] said Jacqueline to André Malraux. Other sources have been mentioned,[80] but whether they come from Rembrandt, from Velázquez, from Shakespeare, from Piero Crommelynck's goatee beard, or from that of Picasso's father, all these musketeers are men in disguise, romantic lovers, soldiers who are arrogant, virile, vain and ultimately absurd, for all their panache. Costumed, armed, helmeted, man is always seen in action; and the musketeer sometimes takes up a brush and becomes the painter.

In this series Picasso is returning to his first love; but the acrobats and *saltimbanques* of his youth – marginal itinerants, frail and epicene – are succeeded at the end of his life by figures from a masquerade: Baroque heroes of the Age of Expansion, cavaliers and adventurers. Pierrot and Harlequin make one last appearance, but the slender, mercurial silhouette of Harlequin has given way to a squat, masked figure who brandishes his lath sword in a decidedly aggressive manner. Love of the past and dislike of fashion have combined to turn Picasso's attention to antiquity, then to the Middle Ages, and then to the seventeenth century: hence these painters of another age, these richly dressed *hidalgos*. Feeling his own sexual powers deserting him, Picasso finds a source of rejuvenation in the amorous exploits of his musketeers, who make their appearance, as Christian Geelhaar has pointed out, during his convalescence. Matisse too, after his illness, reread *The Three Musketeers*.[81] Backward-looking romantics and nostalgic dreamers, they are often associated with the youthful Cupid, armed with his deadly dart, the symbol of the prick of desire (fig.6). The pipe-smokers (cats.40, 45), quite apart from Picasso's fondness for this object – which dates back to Cubism – represent another palliative for frustration. 'Old age has forced us to give it [cigarette-smoking] up,' he said to Brassaï, 'but the craving is still there. It's the same with love.'[82]

The male is no longer the Jupiter-like sculptor, in the prime of life, nor the monstrous Minotaur, symbol of duality, but a fictional character, a carnival dummy whose identity, and whose truth, lie in masks and signs. Malraux quite rightly likened these figures to the flat, enigmatic images of the Tarot. Of course, Picasso does not take these characters – or their love-life, as chronicled in his etchings – entirely seriously. The very idea of painting musketeers, in 1970! These are ornamental figures whose garments serve as pretext for a blaze of blood-red and golden yellow, a resurgence of Spanishness, *hispanidad*.

Another figure with a sword rubs shoulders with the musketeers: his hat identifies him as the matador, and his tragedy is a real one. He is a last reminder of Picasso's passion for the bullfight, and he represents the true hero, the man who faces danger and who kills.

In parallel with these Baroque figures, Picasso paints a gallery of portraits of men who are seen 'in majesty', writing or smoking. With their bearded, elongated faces, their huge questioning eyes, their long hair with or without a hat, these 'Heads' (cats.58, 59) represent one last concession on the painter's part to the 'all-too-human'. By contrast with the musketeers – who all have the same face – these are true portraits, strongly characterized and individual. One looks like a hippie, another like a prophet or perhaps an evangelist; Picasso used to amuse himself, with his friends Edouard Pignon and Hélène Parmelin, by giving them names and identities, describing their individual traits, their expressions, their personalities. 'Characters who are also paintings start to take precedence over painting itself.'[83]

Picasso's confrontation with the human face, which makes him into the great portrait-painter of the twentieth century, brings him back to a confrontation with

himself, the painter, young or old. After his concession to human expressivity in the 'Heads' he pays homage to life, to childhood, to motherhood and to fatherhood. Mother and child; old man and child; father, mother and child (or Holy Family): the themes recall those of the Rose and Blue Periods. The older Picasso gets, the closer he comes to his own childhood. In the drawings and the etchings, the figure of an innocent youth reappears several times in juxtaposition to an old man (the Ages of Man); and one of the very last paintings is 'The Young Artist' (fig.67). Close to death, Picasso projects himself here into a soft-focus vision, in a few brushstrokes on a white canvas, of a startled young painter grasping his brush and wearing the eternal hat.

This work has a slightly earlier pendant, 'The Seated Old Man'. A fate-laden portrait of the painter as an old man, this vividly coloured painting condenses into a single image a number of formal, painterly and symbolic references. The most moving and the most tragic of Picasso's self-portraits, it is a portrait of the old artist at the end of his life,[84] but it is also a portrait of Matisse ('The Romanian Blouse'), of Van Gogh (the hat), of Renoir (the missing hand) and of Cézanne ('The Gardener Vallier'). These references unite to mark the starkness of the artist's confrontation with death, the crushing burden of

fig.67 'The Young Artist', Mougins, 14 April 1972.
Musée Picasso, Paris

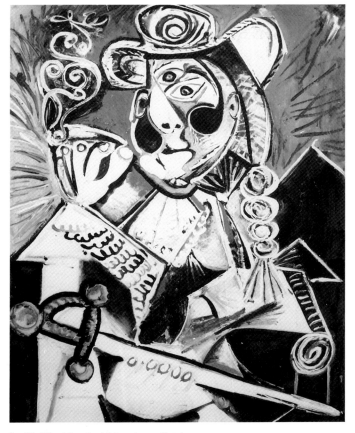

fig.68 'The Matador', Mougins, 4 October 1970.
Musée Picasso, Paris

knowledge and the weight of existence, the loneliness and the yearning in a pair of eyes that have seen everything and now recall the vital images for one last time; there, too, is the violent passion for painting to which one man sacrificed his ear and another both his hands. But Picasso remains Picasso to the end, and the life-force within him transmutes old age into an apotheosis, expressed by the vehemence of the brushwork, the swirls of Fauve colour, the pentimenti and the runs of paint.

Only one face remained to be confronted: that of Death itself; and to do this Picasso gave Death his own features and the multiplicity of his own styles.

Four drawings done in 1972, in each of which Picasso associates his features, or figures from his previous work, with a death's-head, encapsulate a range of styles taken from his past. One drawing evokes Cubism, and the skull in 'Les Demoiselles d'Avignon'; another inserts a profile resembling those of Marie-Thérèse into a mineral head that recalls the Dinard 'Women Bathing'; a third (cat. 101) shows the head of a woman (Dora Maar), or of a man with Dora's long hair, marked by the twist that he imparted to the two halves of the human face in works of the 1940s.

The last and most realistic of the four (cat. 102) recalls the strong features, the nose, the wide eyes, of the 1907 self-portrait. Blue arrows mark the face, the speechless mouth is articulated by three bars, and the green and mauve colour scheme, as Pierre Daix points out, is the same as that of the still-life painted after the death of Júlio González.[85] Picasso looks death straight in the eye; he has had his say, and he has nothing to hide. The mask is the truth. When the two faces, that of reality and that of art, coincide exactly, it means that the end is near. 'I did a drawing yesterday, I think I touched something . . . it's not like anything that has been done before.' Picasso then, according to Pierre Daix, 'held up the drawing alongside his face to show that the fear in the drawing was an invention'.[86]

The drawing 'Self-Portrait in front of Death' and the painting of a musketeer whose face disappears to make room for a bird:[87] these are the last Picassos.[88]

THE LATE STYLE: A TONE OF URGENCY

The most striking feature of the late period is undoubtedly its vitality. It is conveyed by the prodigious volume of the output and by the speed and vehemence of the execution, the one being the corollary of the other. As for quantity, here are a few figures, which for a man of eighty-eight are unique in the history of painting: 347 etchings between March and October 1968; 167 paintings between January 1969 and January 1970; 194 drawings between December 1969 and January 1971; 156 etchings between January 1970 and March 1972; 201 paintings between September 1970 and June 1972. Again: of the twenty-three volumes of the Zervos catalogue, thirteen are devoted to the last twenty years.

As for speed, which is one of the reasons for the volume of his output (the other being the repetitive principle), this is the sign of the sense of urgency that impelled Picasso at

this time of his life. Accumulation and speed were the only defences he had left in his fight to the death with time. Every work he created was a part of himself, a particle of life, a point scored against death. 'I have less and less time,' he said, 'and I have more and more to say.'[89] What allowed him to gain time, to go faster, was his recourse to conventional signs, formal abbreviations, the archetypal figure that concentrates the essence of what he has to say.

The late style, which first emerged in the course of 1964, is characterized by the juxtaposition of two ways of painting: one elliptical and stenographic, made up of ideograms, codified signs which can be inventoried; and the other thick and flowing, a hastily applied *matière* of runny, impastoed, roughly brushed paint. Picasso thus combines a painterly form of writing with a painterly form of painting, a material literalism that lays bare and sets free the substance of paint. The ideographic style can be seen evolving through the 'Studios' and 'Las Meniñas', and reaches its ultimate form in 'The Artist and his Model', of 1964 (cat.29). The artist's face is suggested by a sort of X which links the eyes, the nose and the mouth, and the model is reduced to her basic contours: 'A dot for the breast, a line for the artist, five spots of paint for the foot, a few pink and green lines – that's enough, isn't it? What more need I do? What can I add to that? It's all been said.'[90]

This schematic approach, these foreshortenings, correspond to the desire to paint and draw at the same time: 'What has to happen, when you finally look at it, is that drawing and colour are the same thing.'[91] There is also an impulse to simplify: 'At the moment, in my paintings, I'm doing less and less.'[92] Less and less paint, too: hence the thin, light application of colour and the importance attached to the white of the canvas. For Picasso, to paint is to say. 'Things have got to be *named* . . . I want to *say* the nude; I don't just want to make a nude like a nude; I just want to *say* breast, to *say* foot, to *say* hand, belly – find a way to *say* it and that's enough.'[93]

This is why, as his exploration proceeds, he adopts codified signs that summarize and signify each part of the body, and whose total image expresses the nude: 'One word will do when you talk about it.'[94] The recourse to ideographic writing is a way of abolishing the distance between the thing that is to be said and the way in which it is shown, so that the image is the object. Just as Matisse, at the end of his life, learned to draw directly by cutting into colour, Picasso succeeds in painting by drawing.

He does not, however, entirely rest content with this rather dry shorthand, and the gestural, supple, impastoed painting that has appeared in the 'Women of Algiers' and some of the 'Déjeuners' returns to invade the canvas of another 1964 version of 'The Artist and his Model' (cat.28). This wholly uninhibited work, subject to no rule, bounded by no contour, spreading out in swirls, arabesques, tongues of flame, erasures and spatters of paint, is the expression of the prodigious energy that still animates the aged Picasso.

From 1965 onwards the two styles blend, to the extent that there is no way to single out drawing, form, colour or composition from the whole. The thick strokes and

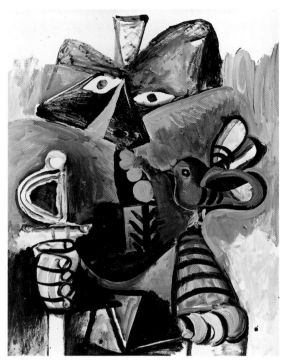

fig.69 Person with Bird', Mougins, 13 January 1972.
Courtesy Thomas Ammann Fine Arts, Zurich

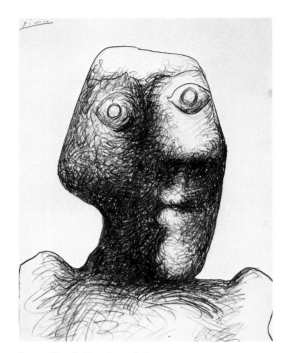

fig.71 'Head', Mougins, 3 July 1972

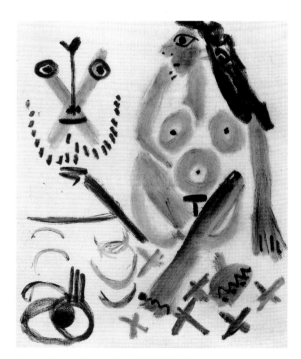

fig.70 'The Artist and Seated Nude', Mougins,
3 December 1964 I *Picasso 1970–1972, 201 peintures*,
exhibition at the Palais des Papes, Avignon, 1973

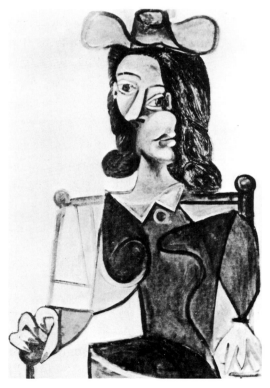

fig.72 'Bust of Woman Wearing Hat', 9 June 1941.
Musée Picasso, Paris

dynamic lines that imply the tensions and the forms within the work are absorbed into a stratified texture, and this, through the use of transparency, creates subtle ranges of tones. The figure seems to erupt from this molten mass, in which painting and drawing unite within a single surface to form the body of the picture, its flesh and its armature. Picasso is deforming rather than forming. If these paintings are compared with the closely related works of 1939–42, which share the same decorative patchwork of striations, stars, grids and thick lines, and also the same postures, a difference becomes apparent. Before the final period, Picasso had always given his forms an outline which he invented and traced in order to impose his own vision on the paint; now, on the other hand, it is the *matière*, the paint itself, that gives 'form'.[95] It seems as if the figuration results less from a deliberate formal choice than from the will of the figure itself.

Among the conventional signs of the Avignon period are the hairpin eyes, the fishbone vulva, the huge fanlike hands and feet with circles for digits, horizontal figures of eight (∞) for noses, spirals for ears, swirls for hair, double-ellipse hats with pompoms, and a number of recurrent decorative motifs such as stripes, checks, stars, arrows, fishbones and vague but vigorous scrawls. The use of these prime signs, which evoke the drawings of children ('It took me a lifetime to learn to draw like them,'[96] he said), and which he combines with repetitive ornamental motifs, creates what can only be called 'pattern painting'.

Certain elements, like the arrow, the fishbone, the dot and the dash, have an obvious sexual resonance. Painting is the result of a penetration, a fusion of male and female elements. As Paul Klee put it in his journal: 'In the beginning, the motif, insertion of energy, sperm. The work as creatrix of material form: fundamentally female. The work as sperm determining the form: fundamentally male.'[97]

This new manner of painting, in which some contemporary observers saw nothing but 'incoherent scrawls done by a frantic old man in death's antechamber'[98] – a verdict belied by the virtuosity and sureness of execution that characterize the drawings and etchings – is thus entirely deliberate. It is the result of the artist's long-standing and single-minded endeavour to let painting 'speak' for itself and to submit himself to its inherent laws. Art is something to eliminate, according to Picasso: 'The less art, the more painting.'[99]

The desire to lose control, to take fewer and fewer decisions ('I don't choose any more'), is characteristic of Picasso's late style – as it is of that of Matisse, who said at the end of his life that he wanted to 'surrender to instinct', and that he regretted having been 'held back by his own will', having lived with his 'belt buckled up tight'.[100] Old age, for some, marks the possibility of a resurrection, a second wind. Liberated from the past – and Picasso, for one, had settled his accounts in the grand manner – the old painter is free to break the rules and be as unprofessional as he likes; he can permit himself anything, because he is permited nothing.

One of the proofs of the originality of this style is the mental block that prevented the public from seeing it. The distortions were not a problem (though the subjects may have

been): much more extreme distortions appear in Picasso's works of 1939–43. What really bothered people was the technique, the apparent *non finito*, the sketchiness, the 'bad painting' that is the sole privilege of painters who really can paint. 'You have to know how to be vulgar. Paint with four-letter words,'[101] said Picasso; 'every day I do worse.'[102] In concrete terms this means a dirty, muddy sort of painting, with smudged flat areas of colour, violent contrasts of pure hues, and the creation of hybrid monsters in which humanity blends with the crudest animality. Paradoxically, this 'botched' style sometimes gives rise to a form of painting that is rich, smooth, flowing, subtle, worthy of the great Spanish masters, with subtle nuances of pink, blue, grey: the pale, tender colours of childhood.

The slangy art of which David Sylvester speaks, the refusal to conform or to accept the bounds of elegance or style, is the final manifestation of Picasso's ineradicable anarchism. Having learned everything, one must forget everything. 'Painting has still to be made,' he used to say, as if the art were still in a primordial phase, and as if the 'Late Style' were the means of imparting form to chaos, conveying the essential images of things hitherto unformulated.

The other characteristic element of the last period is the artist's tendency to use repetition as a mode of creation. Picasso always preferred the idea of the series, and the set of variations, to that of the unique, finished masterpiece. In the variations on the old masters he systematized this technique; the work is the totality of the paintings on the same theme, each of which is no more than one mesh in the weave, a creative moment held in suspense. What matters to him is 'the movement of painting, the dramatic effort from one vision to the next, even if the effort is not carried right through . . . I have reached the stage where the movement of my thought interests me more than the thought itself.'[103]

Picasso expresses this mental wanderlust, this refusal to stay put or to regard anything as definitive, in a maxim: 'To finish an object means to finish it, to destroy it, to rob it of its soul, to give it the *puntilla* as to a bull in the ring.'[104] This encapsulates his whole attitude to time and to duration. 'The role of painting,' he said, 'is to arrest motion.'[105] 'Speed,' said Octavio Paz, 'allows him to be in two places at once, to belong to every century without losing touch with here and now. He is not the painter of movement within painting; he is movement that has become painting. He paints out of urgent necessity, and what he paints is urgency itself. He is the Painter of Time.'[106]

Repetition is the sign of a conceptual art that concerns itself more with the mechanism of creation, the process, than with the product. To Picasso repetition represents a quest for perfection, a way of attaining truth through the exploration of the whole range of available styles: 'If I look for truth on my canvas, I can do a hundred canvases with that truth.'[107] He said to Roland Penrose: 'I make a hundred studies in a few days while another painter may spend a hundred days on one picture. As I continue I shall open windows. I shall get behind the canvas and perhaps something will happen.'[108]

Ultimately, repetition is an extrapolation of Cubism in space and in time, since the simultaneous vision of an object from every direction on one canvas is replaced by a multiplicity of canvases on one subject.

THE LEGACY OF PICASSO

Picasso's last period raises two issues at once: the old age of the painter and the youth of the works. They are an end, but they are also a beginning: and it is necessary to consider their contemporaneity, their possible relevance to the art of today. Can it be said of Picasso, as Baudelaire said of Manet in a double-edged comment, that he is 'only the foremost amid the *decrepitude* of his art'?

We have seen that late Picasso presents all the characteristics of the late style of all great painters, as it is to be found for example in Titian, Rembrandt, Goya or Cézanne: a tendency towards simplification, and concentration on the essential; total freedom in respect of manner and style; a preponderance of references to the past; and a late return to the early work. In Picasso's case these characteristics are exemplified by a reversion, in another form, to Expressionist sentiment and Blue Period themes; by crude, sharply contrasting colours; by a primal, forceful graphic form; and above all by the identi-fication of the painter with his painting, the subject with the object. Old age is often a kind of return to the immediacy of childhood, to the eloquence of naïveté, and to a certain freshness of vision: a regression to youth, in short, which psychoanalysts tend to explain as the 'liquidation' of what has been repressed ('murdering the Father' is one description that has been given of Picasso's relationship with the old masters) and the affirmation of the pleasure principle through the liberation of the vital instinct, which at last coincides with the object of desire.

While prudently resisting the temptation to fence the work about with reductionist psychoanalytical explanations, one cannot help observing, in the light of this last period, how closely the course of his life, and the peregrinations of his art, adhere to the scenario of Freudian analysis. It is as if, in the successive stages of his career, Picasso had given form to the rhythms of the unconscious; as if he had embodied and materialized the 'bodily unconscious'.[109] Closely attuned as he was to the external forces of the cosmos – hence his magician aspect – and to the initiatory myths that underlie all creation, Picasso consistently pursued the logic of the dream, and of those multiple associations, Chinese boxes with false bottoms, which extract the image from the most tangled pathways.

In addition, at the end of his life, the impending threat – and then the reality – of impotence led him to exploit to the full the resources of bisexuality.[110] Subliminal in his earlier work, this now becomes explicit; it appears in his intimate knowledge of the female body, in the constant switching of sexes in the drawings, and in the desire for fusion, both with woman and with painting itself: bisexuality permits him, by exploring the female realm, to replace sexual potency with creative power.

José Bergamin divides Picasso's career into three phases, which correspond to the

three ages of life: withdrawal (Cubism), fury ('Guernica') and ecstasy (the last period).[111] And ecstasy is the right word to describe these works, in which, more than ever before, Picasso affirms the erotic dimension of life, in love as in art, and in which he paints with a quite unprecedented wildness. Ecstasy means a physical and carnal transmutation and sublimation, as opposed to the state of grace which Matisse achieved at the end of his life, and which is the true mark of the spirituality immanent within his work. (Which would one choose, Matisse's paradise or Picasso's hell? The Golden Age or the Age of Man?) Picasso remains, to the very end, the painter of man, of flesh, of physical love: hence his attachment to the figure and to the material density of his canvases; hence, also, his obsession with death as the sole obstacle to life.

Eros and Thanatos: is Picasso, as some have written, the last Renaissance painter, 'the last representative of the Greek inheritance'?[112] This remark, made in 1966, was typical of the progressivist, modernist view of art history which tended to imprison Picasso within the classical humanistic culture in which he did indeed have his origins, and which set up Duchamp as his diametrical opposite: 'They plunder Duchamp's shop,' commented Picasso, 'and they change all the packaging.'[113]

What Picasso does seem to have rediscovered at the end of his life is his own roots, his Spanishness, his closeness to those great Spanish painters and poets of the seventeenth century who combine their realistic concerns with a capacity for imaginative fiction and fantasy, and who extract their spirituality from the material world. Cervantes, Góngora, Quevedo, Calderón and Velázquez are his true ancestors, and he is the last representative of the 'Siglo de Oro', with its Baroque blend of outrageousness, down-to-earth realism, mockery and magnificence. This is a vision of the world in which *la vida es sueño*, life is a dream, a comedy, a play (and this, as Brigitte Baer says, is just what emerges from Picasso's last etchings). Here man wears a mask, and his picture is a mirror. Harlequin, Minotaur and musketeer by turns, the artist disguises himself in order to reveal himself.

'Art,' said Nietzsche, 'is a lie that helps us to understand truth.' All his life, according to Malraux, Picasso pursued the mask, that is to say the sign, the symbol, the schema, the talisman: from the African ritual mask to the Tarot images that he painted for Avignon, the pursuit is the same. But whereas the African or Romanesque mask refers to another, invisible reality – that of the sacred or the divine – Picasso's masks refer only to painting, to himself, and to his own creative power. Trapped in this hall of mirrors, beneath these layers of masks, choked and sated with paint, does Picasso's work merit the severe criticisms levelled at it by Claude Lévi-Strauss?

This is work that does not so much convey an original message as refine and overrefine the rules of painting. A second-degree interpretation, an admirable discourse about paint, rather than a discourse about the world . . . Picasso has played his part in tightening the grip of that locked universe in which man, left alone with his own works, imagines that he is self-sufficient. A sort of ideal prison, and a gloomy one at that.[114]

However, structuralist analysis ultimately falls just as short of the mark as modernist criticism; for both seem to underrate both the exemplary courage of the man and the irreducible originality of the work: 'an art that is intrinsically ill-adapted to becoming the conformism of any age or of any society', as Maurice Jardot called it in 1955.[115]

An analysis of this last period, from the initial variations to the last archetypes, shows that Picasso is not only Cronos, devouring his own children in order to halt the march of time, or Prometheus, enchained as a punishment for stealing fire from the gods, but rather the Phoenix, eternally reborn from his own ashes, drawing his energies from a constant process of deconstruction and construction, death and resurrection. 'One is one's own Prometheus, simultaneously the one who devours and the one who is devoured.'[116]

He lives out his own antagonisms and his own duality as a dynamic tension which serves as the mainspring of his vitality, and he lucidly concludes that, when all is said and done, 'there is nothing behind the mirror' but emptiness and non-being: Picasso is the painter of the void (of non-being, and therefore of being, according to Heidegger).[117] The void is sensed and conveyed in many different ways: it is expressed, paradoxically, by his accumulative obsession, confirmed by his cosmic vision of the universe, and suggested, finally, by the mental and formal confrontation in his last drawings and etchings between the female organ of generation, the matrix of life, the gaping hole that shows itself, and the mask/face that conceals death.

Hence the misinterpretations, and the sheer incomprehension, that greeted his work at the 1973 exhibition in Avignon, when the public was simultaneously shocked by the form of his work and impervious to its content. 'The inheritors of his spirit did not accept his forms,' wrote Malraux, 'and the inheritors of his forms did not accept his spirit.'[118] 'Picasso has confused the pleasure of painting with creation,' said Martial Raysse in 1966 (he who was the first to return to the pleasure of painting).

AVIGNON: THE LAST JUDGEMENT

The two exhibitions in Avignon (a magic name for Picasso, from the brothel to the Palais des Papes, by way of his summer in Avignon in 1914) mark a turning-point in the history of late twentieth-century painting. Ignored by a generation whose allegiances were strictly formalist and post-Matissian, violently criticized by many and praised only by a few unconditional admirers,[119] they can now be seen, in relation to the contemporary artistic climate, in all their richness, their novelty, their audacity. Picasso in Avignon was 'the Pope of modern art in exile' (figs.8, 9).[120]

Hung unframed, in tiers, and arranged in series, an exuberant and colourful procession of cavaliers, couples, nude women and solemn portraits filled the bare walls of the chapel like sacrilegious votive plaques: this was Picasso's 'Last Judgement'. An art 'full of sound and fury', in which everything moves and resonates, hurrying the eye from one canvas to the next amid the clatter of sabres, the sweep of plumes, the twist of

bodies, the wild, visionary eyes, the strident colours, the frenzy of the brushwork: Picasso is presenting us with his artistic last will and testament.

This last stage of all is also a source of new potential for painting, an opening towards a renewal of figurative language, a plea for the newly recovered lyric power of the painted image. Late Picasso seems to have played, in relation to the developments of the 1980s, the role of a beacon, a frame of reference, just as Matisse's *papiers découpés* had done for the 1960s and 1970s. Picasso has done his time in Purgatory. His rediscovery has been made possible by two things: sheer distance – 'he must be forgotten before he can be rediscovered'[121] – and the context of contemporary art. The revival of interest in painting, in the figure, in Neo-expressionism and in subjectivity has now made it possible for these works to be looked at and their point taken at last.

It seems, indeed, that the contemporary avant-garde has taken up the issue just where Picasso left it in 1973: the invention of a new idiom, based on total liberty and spontaneity; the expression of a fantasmagorical, obsessional universe; a private or collective mythology; a brutal, primal aesthetic of 'bad painting' and *non finito*; quotations from other pictures; and a stress on the naked material reality of paint.

All this is an inheritance that belies the severe verdict handed down by Roger Caillois, who wrote in 1975: 'I can't see him as the origin of anything.'[122] It is a lesson in pure painting given by a painter who, by separating the essence of painting from the painter's art, succeeded in sidestepping the eternal issue of 'the death of painting' – a demise which is constantly announced but which never seems to become an accomplished fact. 'What will painting do when I'm dead? It'll have to walk over my body! There's no way round, is there?'[123]

It has become apparent that present-day artists who think of themselves as painters, whether they are 'makers' of painting or 'discoursers', are haunted by the same fundamental problems that are raised by Picasso's actions and by the nature of his painting itself: the infinite plastic possibilities of the figure and its placing in the pictorial space, the symbolic functioning of the image (the mask, the mirror, the wall), the identity of the artist, the history of painting, and all the rest.

He has set an example, too, of total commitment by the creator to his work: 'Each picture is a phial filled with my blood,' he once said. As Michel Leiris has stressed, this is no romantic posture: it is accompanied by a lucid irony, an awareness that art is about play. Like every Spaniard, Picasso has a sense of humour that can be cruel, grotesque or sombre. 'What does it mean, going further, going through the sound barrier with a painting? Does it mean leaving it blank? Doing just anything? Or does it mean being Van Gogh?'[124]

In other words, what does 'transcending the real' really mean? Is it abstraction, nihilism, or is it the artist's inner drama, the *Angst* at the core of his being? The further an artist goes into himself, the further he goes in painting. By expanding his personal universe into universal myths, his own story into history, Picasso has made his art into 'a discourse on the world'.

The last message he leaves for us, in this concluding apotheosis of his, is simply that of enthusiasm, a commodity that has become rare in these days of flagging aesthetic morale. To the very end, Picasso went on living, he went on loving, and he went on creating; he set a perfect example of the artist's return to the 'childhood' of art, the moment when everything is ready to start all over again. 'That is called the Dawn,'[125] said Jean-Luc Godard.

translated by David Britt

Notes

1 Words written on the inside back cover of sketchbook MP.1886, dated 10–12 February 1963, and devoted to the theme of the artist and his model.

2 *Picasso. Das Spätwerk*, Kunstmuseum, Basle, 1981, exhibition organized by Christian Geelhaar.

3 *Picasso: The Last Years (1963–1973)*, Solomon R. Guggenheim Museum, New York, 1984, exhibition organized by Gert Schiff.

4 *Picasso. Oeuvres reçues en paiement des droits de succession*, Grand Palais, Paris, 1979.

5 *Pablo Picasso: A Retrospective*, The Museum of Modern Art, New York, 1980.

6 M. Leiris, 'Picasso et la comédie humaine ou les avatars de Gros Pied', *Verve*, vol.8, 1954, no.29–30, n.p.

7 *Ibid.*

8 David Douglas Duncan, *Picasso's Picassos*, 'The Treasures of La Californie', London, Macmillan & Co. Ltd, 1961, p.183.

9 Musée Picasso, Paris, MP.1879.

10 Musée Picasso, Paris, MP.1882.

11 Musée Picasso, Paris, MP.1883.

12 Roland Penrose, *Picasso*, Harmondsworth, Penguin, 1971, p.406.

13 D.-H. Kahnweiler, 'Entretiens avec Picasso au sujet des Femmes d'Alger', *Aujourd'hui*, no.4, 1955.

14 *Ibid.*

15 Studios and workrooms were not an entirely new subject in his work. In 1926 he depicted the *atelier* of a dressmaker (Musée National d'Art Moderne, Paris); in 1927–28 he painted some very geometrical studio interiors including, schematically, the artist, the model, and the easel. The sharp-edged outlines and the spatial tension in these works correspond to the iron wire 'Figures' of 1928. A number of isolated works, such as a view from his Rue des Grands-Augustins window in 1943 (Zervos XIII.68) and 'The Kitchen', of 1948 (Musée Picasso, Paris) brought him back indirectly to the theme of interior space.

16 H. Parmelin, *Picasso dit*, Paris, Gonthier, 1966, p.80.

17 Musée Picasso, Paris.

18 Musée National d'Art Moderne, Paris.

19 *Les Baigneuses* (1920), Musée Picasso, Paris.

20 P. Daix, *La Vie de peintre de Pablo Picasso*, Paris, Editions du Seuil, 1971, p.362.

21 A. Vallentin, *Picasso*, Paris, Albin Michel, 1957, p.441.

22 Quoted by William Rubin, *Picasso in the Collection of The Museum of Modern Art*, New York, 1972, p.179.

23 The Museum of Modern Art, New York.

24 Quoted by Dore Ashton, *Picasso on Art*, London, Thames and Hudson, 1972, p.105.

25 Zervos, XVII.391.

26 Musée Picasso, Paris, MP.1884 and MP.1885.

27 See the drawings in the Musée Picasso, Paris: 'The Studio', 18 April 1937, MP.1178–MP.1191.

28 G. Picon, '*La Chute d'Icare' au Palais de l'Unesco*, Geneva, Albert Skira, 1971 (in the series 'Les Sentiers de la création').

29 Zervos XVIII.26, 27.

30 MP.1885, p.22, drawing dated 23 December 1957 (II).

31 Parmelin (as note 16), p.112.

32 MP.1885 or Zervos XVII.419–36.

33 Zervos VII.348.

34 Spies 509, 538, 541, 542, 543, 544.

35 Picon (as note 28), p.19.

36 Spies 492, 493, 495.

37 P. Daix, *Picasso créateur*, Paris, editions du Seuil, 1987, p.342

38 Picon (as note 28), p.18.

39 Daix (as note 37), p.347.

40 Musée Picasso, Paris.

41 Zervos XVIII.333, 334, 336–59.

42 Zervos XVIII.434–41.

43 See M.-L. Bernadac, 'De Manet à Picasso, l'éternel retour', in catalogue *Bonjour, Monsieur Manet*, Musée National d'Art Moderne, Centre Georges Pompidou, Paris, 1983, pp.33–46.

44 Written on the back of an envelope from the Galerie Simon, dated 1929. Archives Picasso. (The sentence may well date from 1939, the date of a Manet retrospective at the Orangerie, Paris.)

45 Musée Picasso, Paris, MP.1882.

46 Zervos XVI.478, 479.

47 The words are those of Delacroix.

48 Musée Picasso, Paris.

49 Zervos XII.291.

50 As exemplified by the concrete sculptures of the figures in the painting, installed in the garden of the Moderna Museet, Stockholm, in 1960.

51 D. Cooper, *Pablo Picasso, Les Déjeuners*, Paris, Cercle d'Art, 1962.

52 Nicolas Poussin, 'Le Massacre des Innocents', Musée Condé, Chantilly.

53 Jacques-Louis David, 'Les Sabines', and Nicolas Poussin, 'L'Enlèvement des Sabines', both Musée du Louvre, Paris.

54 Zervos XXIII.56, 57.

55 Zervos XXIII.76–93.

56 M. Leiris, 'Le Peintre et son modèle', in *Au Verso des*

[57] *images*, Montpellier, Fata Morgana, 1980, p.50.

[57] *Ibid.*, pp.54–55.

[58] H. Parmelin, *Picasso, le peintre et son modèle*, Paris, Cercle d'Art, 1965, p.114.

[59] Zervos XXIII.173–80.

[60] M. Leiris (as note 56), p.64.

[61] This was originally to have been part of the title of this exhibition.

[62] Zervos XXIV.148–66, 177–83, 190–202, 214–43, etc.

[63] *Le bonhomme-peintre*; Parmelin (as note 16), p.109.

[64] H. Parmelin, *Les Dames de Mougins*, Paris, Editions Cercle d'Art, 1964, pp.18–19.

[65] Brassaï, *Conversations avec Picasso*, Paris, Gallimard, 1986, p.150. [English edn exists]

[66] Parmelin (as note 16), p.113.

[67] A. Breton, 'Pablo Picasso', in *Le Surréalisme et la peinture*, Paris, Gallimard, 1965, p.117.

[68] Parmelin (as note 16), pp.56–57.

[69] G. Schiff, 'Suite 347 or Painting as an Act of Love', in *Picasso in Perspective*, Englewood Cliffs, Prentice-Hall, 1976, pp.163–67.

[70] J. Richardson, 'Les Dernières Années de Picasso: Notre-Dame-de-Vie', in catalogue *Pablo Picasso, Rencontre à Montréal*, Montreal, Musée des Beaux-Arts, 1985, p.91.

[71] Zervos XXV.53–87.

[72] K. Gallwitz, *Picasso Laureatus*, Lausanne and Paris, La Bibliothèque des Arts, 1971, p.70.

[73] 'Every time I draw a man, I find myself thinking of my father. . . . To me, a man means "Don José", and it will always be so, all my life. . . . He wore a beard. . . . All the men I draw I see more or less with his features.' Picasso, in Brassaï (as note 65), p.71.

[74] Ch. Geelhaar, 'Themen 1964–1972', in catalogue *Picasso. Das Spätwerk* (as note 2).

[75] A. Malraux, *La Tête d'obsidienne*, Paris, Gallimard, 1976, p.110.

[76] H. Parmelin, *Voyage en Picasso*, Paris, Robert Laffont, 1980, pp.82–83.

[77] Picasso to Tériade, *L'Intransigeant*, 15 June 1932; published in *Verve*, vol.5, no.19–20, 1948.

[78] Vallentin (as note 21), p.268.

[79] Malraux (as note 75), p.11.

[80] See Geelhaar (as note 74), pp.30–32.

[81] See P. Schneider, *Matisse*, Paris, Flammarion, and London, Thames and Hudson, 1984, p.740.

[82] Brassaï, 'The Master at 90 – Picasso's Great Age Seems Only to Stir Up the Demons Within', *The New York Times Magazine*, 24 October 1971.

[83] Parmelin (as note 76), p.81.

[84] It is by way of being an equivalent to Matisse's 'The Sadness of the King', another last self-portrait.

[85] 'Still-life with Bull's Skull', 1942, Kunstsammlung Nordrhein-Westfalen, Düsseldorf.

[86] Daix (as note 37), p.378.

[87] Zervos XXXIII.274.

[88] It seems difficult to be sure which were Picasso's last works. Jacqueline told Malraux (as note 75, p.82) that the last painting was 'Musketeer with Bird', but the 'Reclining Nude and Head' (Zervos XXXIII.398), of 25 May 1972, is considered by John Richardson to be the last Picasso. As for drawings, there are a 'Nude' and a 'Head of a Man with Bird' dated 5 and 11 November 1972 (Zervos XXIII.531, 532). Hélène Parmelin (as note 76) publishes a drawing dated 23 December 1972, 'The Clown and the Bareback Rider'.

[89] Quoted by Gallwitz (as note 72), p.166.

[90] Parmelin (as note 16), p.19.

[91] Parmelin (as note 58), p.40.

[92] *Ibid.*, p.30.

[93] Parmelin (as note 16), p.111.

[94] *Ibid.*

[95] 'There is a time in life, after one has worked a great deal, when forms come of their own accord, pictures come of their own accord. Everything comes of its own accord, death too.' P. Cabanne, *Le Siècle de Picasso*, Paris, Denoël, 1975, vol.2, p.412.

[96] Penrose (as note 12), pp.315–16.

[97] Quoted by Geelhaar (as note 74), p.60.

[98] The words are those of Douglas Cooper, in *Connaissance des Arts*, no.257, July 1973, p.23; they can be turned inside-out like a glove. The 'incoherent scrawls' represent a deliberately chosen style. The 'old man' was old indeed, but how often does one see an old man full of such vitality? And as for 'death's antechamber', of course: Picasso was painting in the presence of death.

[99] Parmelin (as note 64), p.30.

[100] Schneider (as note 81), pp.663–64.

[101] Cabanne (as note 95), p.347.

[102] *Ibid.*, pp.308, 449.

[103] Quoted by Gallwitz (as note 72), p.166.

[104] Penrose (as note 12), p.486.

[105] Parmelin (as note 16), p.41.

[106] O. Paz, *Marcel Duchamp or the Castle of Purity*, London, Cape Goliard Press, 1970.

[107] Parmelin (as note 16), p.83.

[108] Penrose (as note 12), p.407.

[109] See M. Gagnebin, 'Erotique de Picasso', *Esprit*, January 1982.

[110] See M. Gagnebin, 'Picasso iconoclaste', *L'Arc*, no.82, 1981. She says that there exists 'a link between the process of creation and the achievement of psychic bisexuality [androgyny] . . . bisexuality, haunted by a lack, seems to govern the space of creativity.' It is hard to imagine Picasso resting content with a single sex.

[111] J. Bergamin, in catalogue *Picasso. Das Spätwerk* (as note 2).

[112] H. Télémaque, *Arts*, no.61, 1966, p.37.

[113] Parmelin (as note 76), p.71.

[114] C. Lévi-Strauss, *Arts*, no.60, 1966, pp.40–41.

[115] M. Jardot, introduction to catalogue *Picasso. Peintures 1950–1955*. Musée des arts décoratifs, Paris, 1955.

[116] Parmelin (as note 16), p.120.

[117] Heidegger: 'the manner of asking questions about non-being has the function of a measuring instrument and an index for the manner of asking questions about Being.' Quoted by Gagnebin (as note 110).

[118] Malraux (as note 75), p.78.

[119] See Guy Scarpetta, 'Picasso après-coup', in catalogue *le Dernier Picasso*, Centre Georges Pompidou, Paris, 1988, pp.109–128.

[120] K. Levin, 'Die Avignon-Bilder', in catalogue *Picasso. Das Spätwerk* (as note 2), p.68.

[121] J. Hélion, 'Le Courage illimité de Picasso', *L'Arc*, no.82, 1981, pp.44–48.

[122] R. Caillois, 'Picasso le liquidateur', *Le Monde*, 28 November 1975.

[123] Cabanne (as note 95), p.411.

[124] Parmelin (as note 16), p.24.

[125] Quoting Giraudoux (*Electre*), at the end of *Prénom Carmen*, a film that in itself is turned towards the memory of the cinema, the old age (or sickness) of the artist, and the film within a film.

Seven Years of Printmaking: The Theatre and its Limits

Towards an 'explication de texte'

BRIGITTE BAER

'Il faut que tout
soit rangé
à un poil près
dans un ordre
fulminant.'

Everything must
Be arranged
To a hair's breadth
In thunderclap
Order.

Antonin Artaud, *Oeuvres complètes*, vol.XIII, p.66

For Picasso, printmaking is an art in itself; it is never used simply as a way of reproducing another work. Moreover it is an art, as we shall see, that enabled him to put himself in order at the end of his life.

The organizing committee of this exhibition has decided to show only works dating from after the major surgery that Picasso underwent at the end of 1965. We must nevertheless begin by going back a little further, if only to say that from the autumn of 1963 onwards he had had new printers, the Crommelynck brothers.[1] They were old acquaintances who had previously worked for Lacourière. But with printers, as with women, Picasso took his time; he liked to test them, to try them out. He had done this with Lacourière, and he did it again with the Crommelyncks. Even so, 'The Artist and his Model' series of 1963–65 includes some superb prints; it dwells on a theme that he might seem to have exhausted in the 'Vollard Suite', but which now appears totally transformed – and with good reason: the model is no longer Marie-Thérèse but Jacqueline, and his relationship with her is an entirely different one.

Both Marie-Thérèse and Jacqueline have their place, in symbolic guise, in Picasso's private mythology. Fernande, Olga, Dora Maar and Françoise inspired some superb portraits; but they are hardly if at all to be found in the scenes which he fantasizes. Marie-Thérèse and Jacqueline, by contrast, are omnipresent, confronting the Minotaur, for instance, or mingling with the stock figures of the stories he tells: refashioned but recognizable, these women are muses and symbols as well as lovers.

During the period from 1963 to 1965, Picasso went back to his experiments with techniques such as the use of a varnish stick (a sort of lithographic crayon) for stopping out portions of the copper plate; he also carried to an ultimate pitch of refinement his system of creating a whole range of whites, greys, and blacks by biting his aquatints directly by hand.

In 1966, his convalescence over, Picasso returned to printmaking. The resulting

prints are often strange works in which he seems to be trying himself out, as if to make sure that the shock of the operation has not deprived him of any of his creative potency. This concern finds literal expression in compositions in which immense phalluses come to life and turn into tumbler toys on a theatrical stage (Bloch II.1418, fig.76). He sets himself to perform abstruse technical feats in which the gongorism of the style seems to prevail over the inspiration. See for example the splendid plate (Bloch II.1416, fig.77) in which the highly contemporary graffiti effect is rendered simply (but not without some risk) through dissolving away the varnish on the stopped-out areas with turpentine. Hence the soapy textures and the rich gamut of tones from white to black which generate the spectral evocation of the bottom of the woman who pulls up her petticoat: an allusion, perhaps, to the fine monotype by Degas in the Louvre (Cachin 158).

This gestation period, paralleling that of 1932, came to an abrupt end in 1968. In the series known as the '347', the technique is dazzling – almost literally so. It is so much under control that, as he himself said, he has only to leave it to do its work; which is as much as to say that the details can take care of themselves. And they do. The economy of means is almost magical. It is only now that the experimentation, and the baroque of technique, come to an end. Sure of himself, Picasso leaves the biting of the plate to the Crommelyncks and thinks only of what he sees, of what he makes the beholder see, and of the stories he is telling.

He proclaims the revival – and the growth – of his joy in creation, freedom and vital energy, in an interesting composition (Bloch II.1681, fig.74) which is at one and the same time a tribute to the aged Goya and a self-portrait. On the left is a child, with a woman who seems to have stepped straight out of the beautiful painting in the Musée Picasso, 'Women at their Toilet' of 1956 (Zervos XVII, 54). On the right is an odalisque who recalls both the Delacroix of the 'Women of Algiers' and Matisse. In the background is someone who looks rather like Velázquez, or at any rate a Spanish painter. In the centre is a man on a swing; he has a frizzy head of hair, is solidly built, and endowed with a gigantic emblem of potency. This man alludes to the famous Goya print, done in Bordeaux (G.W.1825, fig.78), in which a little old man, wreathed in smiles, is happily swinging like a child; and no doubt it also alludes to the old man in the no less celebrated drawing 'Aún aprendo' (G.W.1758), whose walking-sticks Picasso turns upward to form the two fat ropes of his swing. *Joie de vivre* and freedom: that's what Goya found in France. It is also what Picasso had recovered in 1968. Our print is a clear hint at the parallelism between the destinies of the two artists in old age who had just recuperated from serious illnesses. Picasso has given his man the full face and unruly hair of the young Goya (G.W.666, fig.79). It is the free, vigorous handling, with its scraped half-tones surrounding the man – a further reference to Goya – that constitutes the beauty of this joyous composition which seems to be a confrontation between the severity of the Spanish painter in the background and the discovery of France and of Paris, of Ingres and of Delacroix, which both Goya and Picasso had made in different centuries and at very different times in their lives.

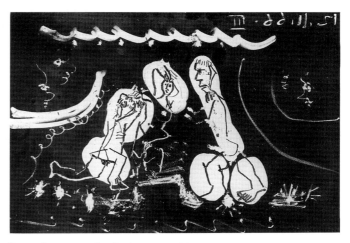

fig.75 Aquatint and etching, 12 November 1966 (III),
22.4 × 32.5 cm, *Galerie Louise Leiris, Paris.* (cat.109)

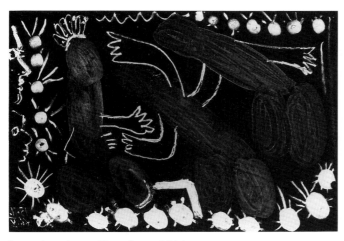

fig.73 Aquatint, 15 November 1966 (V),
22.5 × 32.5 cm. *Galerie Louise Leiris, Paris.* (cat.111)

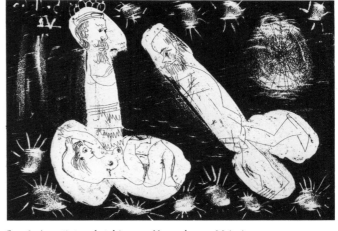

fig.76 Aquatint and etching, 15 November 1966 (VI).
Galerie Louise Leiris, Paris. (cat.112)

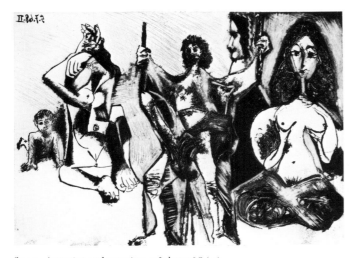

fig.74 Aquatint and scraping, 5 July 1968 (II).
Galerie Louise Leiris, Paris. (cat.117)

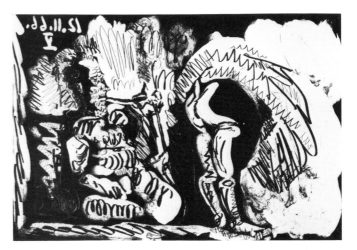

fig.77 Aquatint and etching, 12 November 1966 (V).
Galerie Louise Leiris, Paris. (cat.110)

fig.78 Goya, 'Old Man in Swing', 1825–27.
Etching and aquatint

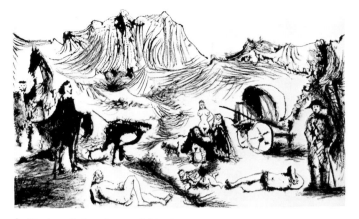

fig.80 Aquatint, 15 June 1968 (III).
Galerie Louise Leiris, Paris

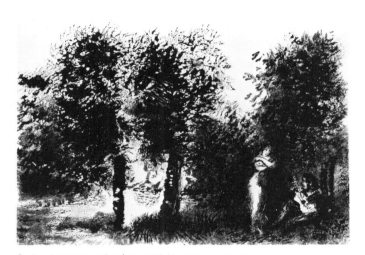

fig.81 Aquatint, 5 October 1968 (I), 22.5 × 32.5 cm.
Galerie Louise Leiris, Paris

fig.79 Goya, 'Self-portrait', 1795–7.
Metropolitan Museum of Art, New York

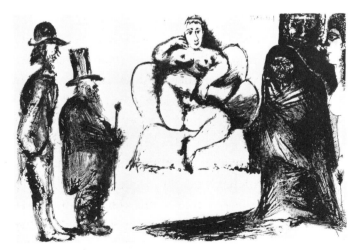

fig.82 Aquatint, 1 October 1968 (I).
Galerie Louise Leiris, Paris

One may wonder at what point, after the operation he underwent in 1965, with the years of uncertainty that followed – a kind of slow-ripening Indian summer – Picasso finally came to the process by which he accepted 'castration'. However unpleasant this may have been at the time, it bore ample fruit in the years that followed, most of all in the growth of his expressive freedom. In any case, 'the Father' henceforth appears constantly, and in the most varied disguises; he has become an element of Picasso's syntax, someone who can be invoked and argued with. No longer is he locked in the prison of unconscious repression.

The series '347', which dates in its entirety from 1968, is filled with the creative joy of making. The economy with which Picasso manipulates his sugar-lift aquatint, ridding it of its heavy, flat and – one might say – rather lifeless quality by greasing the copper and producing a droplet-like texture in some parts enables the artist to play with light and shade without varying the strength of the black. See, for instance, the beautiful tree in Bloch II.1761 (perhaps one of Picasso's very few allusions to Van Gogh), or the strolling players of Bloch II.1618 and II.1641 (fig.80), among whom he inserts, disguised as an Infanta, Rembrandt's 'Girl Pissing'. There is not a single alteration or afterthought in the whole print. And then there is the positively devilish rendering of Impressionist painting in Bloch II.1807, II.1808 and II.1827 (fig.81), obtained almost entirely by crushing the end of a brush (probably a Chinese calligraphic brush) on the greased copper plate.

Finally, there is one superb plate (fig.82) in which Jacqueline appears surrounded by empty space, seated in an armchair – the armchair from the painting 'Woman in a Shift' of 1913 – with, on one side, the aged bawd Celestina, and on the other the caricatures of Manet by Fantin-Latour and of Marcellin Desboutin by Manet. Apart from the space around the central figure, which might be a reminiscence of all the white that surrounds Manet's 'Olympia', it is worth noticing the way in which the lady's two visitors are rendered, with lights and shadows in pure black and white which contrive to suggest greys: an extreme of virtuosity which looks so simple that the beauty of the composition is not impaired. The technique seems a matter of course; one is simply seduced and intrigued by the balance, the rhythm and the meaning.

Elsewhere (Bloch II.1565, fig.83), there is an inversion of conventional etching technique that is remarkable not so much for the skill it demands as for the effect it creates: the nuances of white and grey (bare and stopped-out copper plate) shape, and give a glossy gleam to, the young woman's body, orchestrate the blacks and whites, and recall certain of Goya's 'The Destruction of War'. Picasso begins by stopping out his subject in varnish, as if the whole background were to be grained in the aquatint technique and bitten to leave the subject white against black on the paper. Then he scratches the stopped-out areas (the figures, with the exception of the girl's naked body; the stage set; the clouds; the veiled moon), leaving the background areas bare. The result has a weird rhythm: it evokes a haloed moon and its black light, a visual oxymoron.

In some works, such as Bloch II.1686 (fig.85), Picasso contrives to give his own rendering of some Goya drawings – 'Time Will Tell' (fig.84, G.W.1343), or 'Inside Prison'

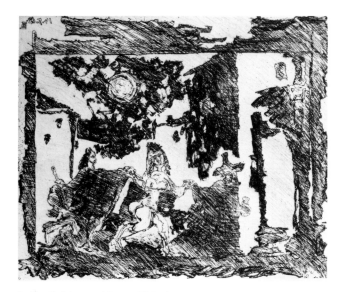

fig.83 Etching, 14 May 1968 (III), 29.5 × 34.5 cm.
Galerie Louise Leiris, Paris

fig.85 Aquatint, 16 July 1968 (I), 31.5 × 39.5 cm.
Galerie Louise Leiris, Paris

fig.84 Goya, 'Time Will Tell', between 1814 and
1820. India ink and sepia wash. *Prado, Madrid*

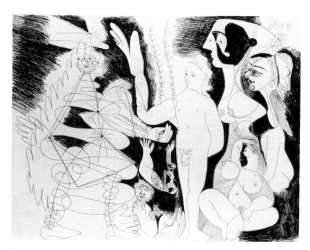

fig.86 First state, 16 February 1970. See fig.87

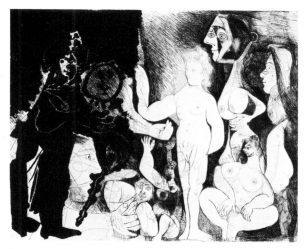

fig.87 Fourth (definitive) state. Etching, aquatint,
dry-point and scraping, 16 February, 2, 4 March
1970. *Galerie Louise Leiris, Paris.* (cat.143)

(G.W. 1530) – using a few touches of aquatint to bring out the white skin of the two well-fleshed women plunged in the gloom of their prison cell; the light from the barred window reveals only their nakedness and the anguish of the girl (who is taken from 'Time Will Tell'), expressed by the whiteness of her lost profile and of her breast; her tense, pathetic body is simply outlined in grey, with the scraper, on the aquatint.

Another daring technical feat is the comical (and, with its graffiti effect, highly contemporary) little etching Bloch 11.1704, in which the artist has scratched the varnish with his metal brush to create, in a couple of rough strokes, a duel in the style of *The Three Musketeers*; only the onlooker, a rising sun which has Rembrandt's eyes, is carefully traced with the needle.

The '156' series (1970–72) is very different. Aside from a few dazzling strokes of audacity, these engravings are entirely classical, as if the tale had to be told swiftly – or at any rate as if the subject were more important than the effect. The effect, when there is one, is there for a specific reason; in the best prints in the series it carries with it the certainty that it is the only possible solution.

'It is remarkable that the work of the dream is so little concerned with representation through words; it is always ready to substitute one word for another until it finds the expression that can be most easily manipulated in dramatic visualization.' Yes, Freud, once more. To trace the development of Picasso's idea through the successive states of the finest print of the '156' series is to find that the process follows this very pattern.

In front of a tiny Picasso, seated centrally in the background of the composition, a play is being acted out through the four successive states of Bloch IV.1870 (figs.86, 87). The artist is simultaneously the spectator and the stage manager, the dreamer and the dreamed ('I cry out in a dream / but I know that I am dreaming / and on both sides of the dream / I impose my will': Antonin Artaud, *Le Théâtre et son double*). He is also simultaneously the stagehand and the actor. An androgynous figure, first a young man, then a twin-sexed woman, points out to the women on the right – who are either 'Demoiselles d'Avignon' or inmates of Degas' brothel, the 'Maison Tellier' – a performance that seems to revolve around the following question: What is man to us (or to you) women? Then there is a play within a play, as in *Hamlet*.

The diminutive spectator, his female companion, and the women on the right change little in the successive states of the plate. On the other hand, the show itself is transformed, as the tiny Picasso fantasizes or dreams the desire of Woman, the desire of the Other. First we see a puppet on a string, offering a jewel in his outstretched hand; then the puppet splits into a rapt young boy, a grown man who is clapping or stretching out his hands, and an old man who holds out the same jewel. Finally, in the fourth state, or the fourth act, there is a *coup de théâtre* which gives the print both its meaning and its beauty: in wide flat tints of thick sugar-lift aquatint, Picasso obliterates the boy and the old man (the man with the outstretched hands stays put) and brings in, stage right, none other than Captain Frans Banning Cocq from Rembrandt's 'Night Watch' (fig.89). Black and somewhat disjointed, the Captain is *le mot juste*. What women *really* want is the

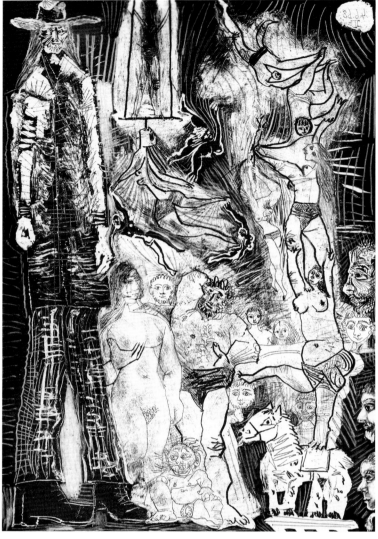

fig.88 Aquatint and etching. 4 June 1968 (II),
50 × 33.5 cm (cat.116)

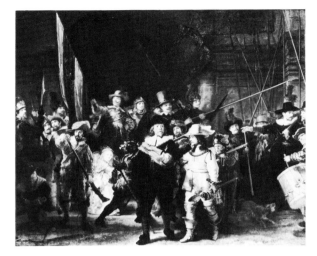

fig.89 Rembrandt, 'The Night Watch', 1642,
Rijksmuseum, Amsterdam

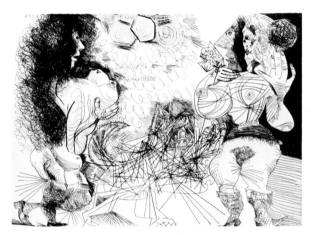

fig.90 First state, 1 March 1972. See fig.91

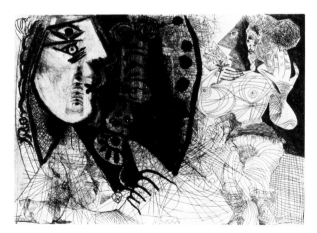

fig.91 Seventh (definitive) state. Etching, dry-point,
aquatint and scraping, 1, 5 March 1972.
Galerie Louise Leiris, Paris. (cat.155)

soldier, the man who has power and is sure of himself, the man who is well known; or, it may be, the painter who is famous by virtue of what he creates. The hermaphrodite perhaps now takes on another value, that of childhood, and alludes to the little girl with the cock in 'The Night Watch'; be that as it may, the print becomes something weighty, full, finished, indeed powerful, with its strange rhythm and its two unbalanced halves held together by the epicene Athena-figure and the tiny Picasso with his female companion.

The same theatrical surprise takes place in one of Picasso's last prints, a spectacular and mysterious work (Bloch IV.2010, figs.90, 91, cat.155). The traditional techniques – etching, drypoint, scraper – are once more carried through six successive states; and then, as before, the sugar-lift technique abruptly intervenes to set right and sum up the subject. It sums up Picasso's mood, too: the anecdote becomes an icon. The new meaning, more precise and more general, is what gives the image its evocative power, while the balance of the whole composition teeters.

The initial composition, indeed, is almost anecdotal. On the right is a rather terrifying woman, a booted circus rider, who seems to be made of cut-out metal; she does not change at any point in the sequence. On the left, like her mirror image, is a tart in black stockings, chubby, with curly hair down to the small of her back. She is a flesh-and-blood woman, but a terrified one: for there in the centre, beneath the three light-globes of the 'Maison Tellier', is a Great Mastiff, fangs bared, bristling with rage. Startled by the iron lady, it is about to bite her. Picasso's Afghan hound, Kaboul, was notorious for nipping his master's guests in the behind; but he only bit men, which goes some way towards explaining the weirdness of the woman whom he threatens here and the terror of the other woman, the young and tender whore.

In the next state the dog's rage infects the artist, who deletes and destroys not only the mastiff but most of the pretty woman as well. One scrap of dog, however, stays there for two states longer; he has closed his mouth, turned his head, and looks benignly upon what is left of the ravaged little whore. In the fourth state, the chips are down: no more light-globes, no more dog; the woman on the left takes on an enormous, nightmarish face. She is mutating, but there is no knowing what she is turning into.

It is only in the fifth and sixth states that her face emerges from the shadow, from the print and from Picasso's hand. In profile, her face takes on the aspect of an idol: a majestic beauty with, on her cheek, strange quasi-ritual scars which later become seven eyes. The train of thought seems to crystallize here – and, unexpectedly, it does so around the vanished dog. First sketched with the scraper, then emphasized with etched lines, a large, crepuscular man-head appears in the centre. The light-globes return, but in the form of the man's eyes. He has a third, Cyclopean eye in the middle of his forehead: 'one eye too many', like King Oedipus. The dog's place between the two women is taken up by the artist, the seer, the visionary.

The last state: the woman's face becomes more precise, and, through the same process of dousing the plate with opaque aquatint, the face of the man undergoes a dramatic

transformation. Sombrely mysterious, it now has a long, highly sexed nose, a sensual mouth, two gimlet eyes (the eyes that Picasso always gives to Rembrandt, here associated, through the metamorphosis of the light-globes, with Degas), and a weird Egyptian headdress which recalls the sculpture for the Chicago Civic Center; one of its flaps enfolds the woman's head, the other is adorned with four balls. The *mot juste* and the last word, once more. Is the headdress an allusion to the epithet 'Egyptian painter' that Douanier Rousseau applied to Picasso? Maybe. But the two flaps are also Kaboul's ears, and this brings us back – by way of the dog's rage, and that of the etcher, Picasso, as it works itself out through the first five states – to a hybrid man-beast, ultimately a new version of his Minotaur.

Here it is the successive states of the print that tell the story; and a mysterious tale it is. Who is the plump and dimpled woman who becomes so hieratic a consort for Picasso/Kaboul? What is the meaning of the seven eyes on her cheek? Are they the eyes of all the women Picasso has had? This woman, who is simultaneously a whore and an idol – is she simply a twofold image of woman, a counterpoint to the man/mad-dog? And the iron lady, unalterable, who so frightens the dog and the other woman? Is she yet another image of the woman, who thinks she is delicate and fragile, but is, in fact a fearsome, armoured being? Does the interwoven image of the Kaboul/woman indicate that woman too is a Minotaur, a monster?

James Joyce said that he would keep the 'professors' busy for a long time. Picasso was another who tortured images, styles, works and languages; he, too, will give them plenty to work on. What matters is to ask the question.

It is impossible to leave the subject of technique as syntax without first mentioning the small print Bloch IV.1879 (fig.92). Here Picasso has used an architect's draughting pen to stop out spiralling lines on a grained copper plate. These lines enable him to render the effect of those layers of white and yellow pigment that give lustre to the gold chains on the garments of the figures in Rembrandt's 'turbaned' period: see for example the chains and the underside of the hat in 'Aristotle Contemplating the Bust of Homer'. Picasso additionally crowns his old man with the same extraordinary headgear, shaped like a wedding cake, that Rembrandt himself borrowed from Pisanello to adorn the head of the centurion in the final state of 'The Three Crosses'.[2] The woman crouching over the neck of the little horse on the right was boldly stopped out, probably using india ink, in the first state. The horse has been redrawn with the scraper, bigger and prouder, but its old outline still stirs mysteriously in the background as if to suggest that something is afoot in the darkness. The head of the woman who leans over to speak to the old man can still just be discerned. The resulting Rembrandtesque chiaroscuro suggests that the subject might be quite simply 'The Departure of the Shunammite Woman' (fig.93).

Finally, another deliberate piece of risk-taking on the artist's part, Bloch IV.1871 (fig.94). To appreciate it fully one needs to know that no successive states of this work exist; he worked on the large plate day after day without ever checking the effect, and without scraping or effacing. A virtuoso performance, it also embodies a first allusion to

Degas' 'Maison Tellier', with, as early as February 1970, the light-globes in position, and the figures at top right who must be already caricatures of Degas.

This is a strange scene, in which Picasso blends the 'Maison Tellier' with the Côte d'Azur. The decor recalls the lobbies of the grand hotels in Cannes, the madame has the air of a veteran baccarat player, and there is a man in uniform who looks like Goya's Ferdinand VII: the monarch of repression. Then there is a homosexual smothered in jewels, a Cocteau-like figure, who looks impassively at the sexual display afforded him by a 'society lady', blonde and elaborately coiffured, who may well be a reminiscence, ten years after, of Francine Weiswéiller. A pretty odd world, you might say, as seen by the aged Picasso who can remember a time when at least you could tell the difference between a respectable woman and a tart, and when different sexes and different manners could at least still be told apart. On the left a painter squats on his haunches to draw a pretty Jacqueline who is not there; he has Piero Crommelynck's face (and therefore, by virtue of the goatee and the old-fashioned cravat, the face of Don José, and of Picasso's youth). A young lady is leaving the scene ('There are no young ladies any more!'), and the painter's female companion, the only feminine woman present, wears the bracelet of Ingres's 'Grande Odalisque': she too, although she is present, belongs to the past, long, long ago. Perhaps this mingling of the past (Ingres, Degas, Don José, Picasso's own youth) with the present is the reason why Picasso worked for so long on this one plate, without ever pulling a trial proof and without deleting anything: for that is the way life itself works, the way dream works, too.

Text, Quotations, Staging, Comedy

As will have become apparent, Picasso in his last prints is quoting all the time. What he sees is himself, disguised, duplicated, multiplied; and these reflections are not mediated by the real people around him but by 'the painters', by their paintings, or by a single figure extracted from a composition to take on a life of its own. He brings Degas and Raphael on stage, taking as his point of departure an initial 'text' which may be a Degas monotype or a painting by Ingres. He never stops quoting: Ingres's 'Turkish Baths' (as in Bloch IV.1974, fig.95, note, too, that Ingres plays the part of a voyeur in this all-female composition, Turkish baths always having been single-sex establishments), and within the 'Turkish Baths', in particular, the standing bather at the back on the left; Delacroix's 'Women of Algiers', especially the woman on the right (Bloch IV.2004); Manet's 'Déjeuner sur l'herbe', especially the woman who leans forward, her feet in the water. These women seem to take on the quality of symbols, and also that of allusions.

Picasso quotes Goya; he quotes Rembrandt; he quotes El Greco and Velázquez. He quotes Ingres, and the 'Grande Odalisque', once more in Bloch IV.1858–59 (figs.96, 97), in which he gives us a backstage view of what we see in Ingres's painting: Picasso's

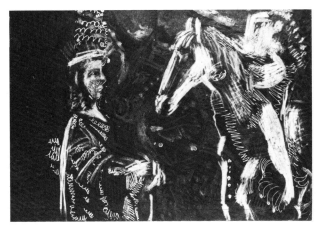

fig.92 Aquatint and scraping [15 March 1970 (III)]
[16 March 1970], 15 × 21 cm. *Galerie Louise Leiris, Paris*

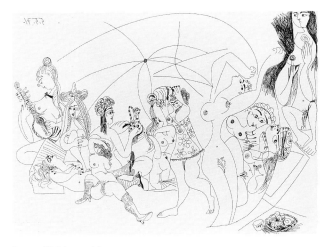

fig.95 Etching, 5 May 1971.
Galerie Louise Leiris, Paris. (cat.150)

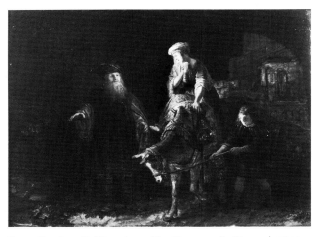

fig.93 Rembrandt, 'Departure of the Shunammite Woman', 1640.
*By permission of the Trustees of the Victoria and Albert
Museum, London*

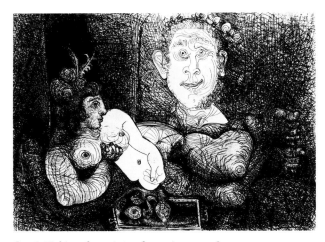

fig.96 Etching, dry-point and scraping, 15, 16, 17,
18, 19 [20–31] January 1970 [I], 6 February 1970,
32 × 42 cm. *Galerie Louise Leiris, Paris*

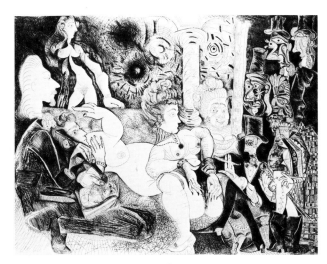

fig.94 Etching [19 February 1970].
Galerie Louise Leiris, Paris. (cat.144)

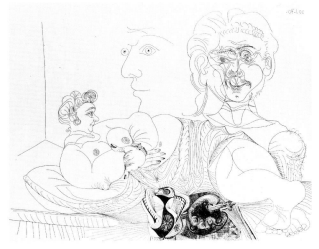

fig.97 Etching, 20 January 1970, 48 × 60 cm.
Galerie Louise Leiris, Paris

vantage point is that of the painting's background so that he shows not only the front side of the model but also Ingres looking at her backside, thus stressing the artifice, the contrivance of the creative process. Here he stages two women who certainly do not have the Odalisque's supernumerary vertebrae. One of them, old, ugly and vulgar, caricatures the other; she wears on her wrist, not the Odalisque's twisted strands of gold, but a hideous watch with an expanding wristband.

He no longer seeks inspiration; he no longer dissects: he engages the painter from the past – the Father – in a sort of painter-to-painter dialogue whose subject is 'Painting' and its secret.

It seems, for example, that the 'text' on which Bloch II.1604 (fig.98) is based is Velázquez's 'Las Meniñas', along with his own 'Demoiselles d'Avignon', the 'Women of Algiers', etc. The peculiar covered dais that shelters the figures, in this patio in a poor

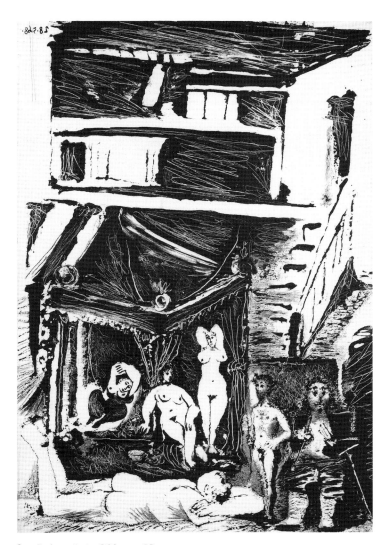

fig.98 Aquatint, 28 May 1968.
Galerie Louise Leiris, Paris. (cat.115)

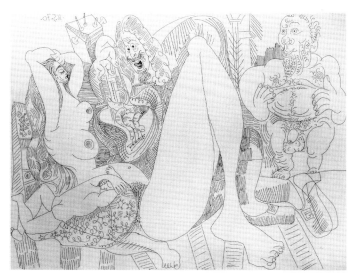

fig.99 Etching, 16 May 1970, 27.5 × 35 cm.
Galerie Louise Leiris, Paris

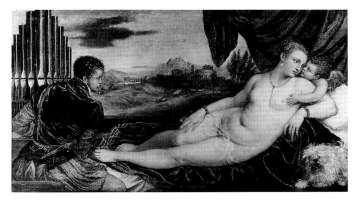

fig.100 Titian, 'Venus with an Organist, Cupid and a Small Dog', 1550. *Staatliche Museen, Berlin*

suburb, probably stands for Fame. He himself, the painter, is there in the guise of an old baby who lies dreaming in the very pose of the babies on cushions who are the staple of all family photo albums. But he is also there in the guise of a Velázquez – open-shirted like Picasso but looking a little like Rembrandt – who, just as in 'Las Meniñas', is not looking at the subject of the painting. Picasso is there, yet again, in the guise of a young Greek god, who, wreathed with leaves, may signify 'Tel qu'en lui-même enfin l'éternité le change' or may, because his wreath is of vine leaves, embody the artist's desire for the women he paints, a transposed Dionysian longing.

Only a little stairway – the ladder of Velázquez's 'Las Hilanderas', of Picasso's own 'Minotauromachie', but also that of a *Descent from the Cross* – leads to the outside world. In just the same way, in 'Las Meniñas', the single little door in the background opens on the world of freedom outside the prison of the royal palace; the *Descent from the Cross*, too, marks the end of Jesus's misfortunes; and the sculptor and the Minotaur, in the famous Picasso print, 'choose freedom' by leaving the stage.

Another 'text' that Picasso chooses to treat in comic terms is Titian's 'Venus with an Organist, a Cupid and a Small Dog' (fig.100; see Bloch IV.1906, fig.99). The print is funny in itself: the hilarious scene on the left has the spectator on the right holding his sides with laughter. A frantic guitarist is strumming away for dear life, serenading at the top of his voice a lovely lady who is not only unmoved but – despite the din – half-asleep. The Cupid has dozed off altogether, his hands over his ears, his head turned towards the lady's pudenda, which the guitarist has his eye on too. The joke is extended when one realizes that Picasso is parodying Titian's famous painting, and specifically the Berlin version rather than the one in Madrid which he knew better. Picasso's Cupid is more modern, and therefore more daring: instead of nestling on Venus's shoulder with his lips close to hers he has chosen to sleep on the veil that does not veil very many of the charms of Titian's Venus, close to the sex of his mother and patroness. But what seems to have struck Picasso even more forcibly – and understandably so – is the rapt desire in the face of the organist, who is looking neither at his keyboard nor at his music but only at Venus's charms. She, on the other hand, seems to respond neither to the music nor to the young man's desire, handsome though he is. She knows the tune.

Picasso also quotes from his own sculptures, in the numerous self-portraits in '156'; he quotes the Spain of his youth, with its street festivals; he quotes his own early themes, including that of Salome; it is as if, working alone through the night, he were surrounding himself with friends that would remain closer, more familiar, more available than his own family and friends: his work, 'the painters', their painting. For want of old chums, with whom he could talk without being addressed as 'Master', he chooses to talk shop with the painters of the past. And this largely takes place in his prints.

True, he was strong and cheerful, as he told Malraux, but 'there is this Spanish sadness . . . a funny sort of sadness. Like the Escorial.'[4] A sadness that speaks of death: death as we live with it every day of our lives, from the day we are born.

It seems as if he were using the melancholy kind of enumeration exemplified by Jorge Luis Borges in 'The Aleph' and 'The Zahir', as if to circle round and round the lost Object, to transform it through invocation into a 'magical object', while endlessly repeating, in a series of synecdoches and metaphors, that it truly is lost and gone. Picasso's litany is not that of the Blessed Virgin, but that of painting. It is as if he were exorcizing Doubt, the fear of that black hole into which he knew Van Gogh had looked, and into which he never looks himself, although he knows it is there: the void, the death of his father, his own death, that of his painting, that of all Painting, the night, 'the dark'.

No longer is Picasso devouring or swallowing other painters: he is magically invoking them. The old masters are always there, and the proof is that Picasso can bring them and their painting back to life. The theatre he creates is there for just this purpose. Once brought on stage, they revive; once their compositions are re-presented, there is no more repetition, and therefore no more death, but the evolution of life; and anything can still happen.

The Role of Printmaking in Picasso's Work

In Picasso's last prints, as in the works of 1933–36, he tells stories; and of course he tells about himself. Printmaking – more so than drawing, and much more so than painting – is a narrative, tell-tale medium that seems to reveal 'the man himself'. It is as if he were giving expression through image and technique alike, if not to his unconscious, then at least to something, disguised as it is by dream, that springs from the depths of his being. In a sense he transforms printmaking into a form of writing, a form of literature. It takes the place of the quasi-Surrealist texts that he wrote between 1935 and 1942, and which must have had their *raison d'être* in the structure of his own psyche. Printmaking serves him as an outlet, but his 'creative power' transforms that outlet into art. This is no mere automatic writing; it is a kind of poetry.

Why printmaking? The answer is hard to pin down. It is true that printmaking had always served him as a confidant; but to say so only shifts the question further back. The technique itself has an affinity to the inversions that we meet in dreams: the subject is drawn inversely, and it will reverse in the printing. Even though Picasso is so used to it that his hand performs the inversion automatically, he still cannot directly see what he has just said. It is not until the next day (he works at night) that, through the medium of a biting and printing done for him by the Crommelyncks, the true meaning of his work will be apparent to him.

Another explanation: the copper plate demands concentration: the conscious attention and the hand are absorbed by a difficult piece of work which is largely craftsmanlike and physical. The copper resists, it has to be attacked, bent to the artist's will; it will not give up its virginity without a struggle; it has to be seduced, like a woman. Perhaps all this tense application is what allows the imagination to operate more freely:

all the more so because Picasso is so utterly in command of his technique that his anxiety cannot be diverted into the process of making, which requires only attention. Another part of him, detached from concentration, is set free.

It is well known that the tone, the style, and even to a large extent the insight, of Henry James's writing underwent a change when, no longer able to hold his pen, the author of *What Maisie Knew* began to dictate to a stenographer: by the nature of the act of dictation, he was forced to address his words to the person in front of him. Similarly, in the late prints, Picasso hardly ever does the biting or printing of his plates himself. He thus has a sort of immediate audience, to whom he speaks directly: the printer who will see the 'story' unveiled the next morning, when he applies the acid and pulls the first proof.

In any case, printmaking seems to represent for Picasso a way of writing, telling stories. This constitutes an immense saving, from his point of view: it means that none of this need be done in his painting, which is not anecdotal at all. Printmaking lies somewhere between writing and painting, between the word and the thing: 'It's just that when you're doing it, it soothes you. And that's what matters.'[5]

The stories he tells embody a coded language, of course. This is no longer the world of meanings, founded largely on the Holy Writ, of the old masters. The code is highly twentieth-century, highly contemporary. Its mythology, like our own, bears the stamp of referentialism and 'Freudianism'. Picasso himself, in spite of all he has said about the impossibility of anyone else entering into his dreams, his fantasies, his thoughts, has no qualms about making interpretative forays into the work of other painters: El Greco, for instance. Of course he doesn't explain: he shows, he interprets, he stages; sometimes as 'savagely' as a Mesguish.

Take for instance his restaging of the 'Burial of the Count of Orgaz' (fig.101; Bloch 11.1676, fig.102). On the previous day he had extracted from the painting the figure who stands in the centre over the bishop's mitre, the one who stares so intently upwards that his eyes start from his head. Then he had carefully taken out the figure that is known as a self-portrait of El Greco; he had enveloped it in what looks like a barbed-wire circle, once more studying the eyes, which this time look straight at 'us' and at the painter. On 30 June he went through the whole painting with a fine-toothed comb.

He picked the row of heads that form a frieze between heaven and earth, and bunched them together on the left, using the man who looks upward as the prototype of all the others; in place of the self-portrait of El Greco he put himself, striped jersey and all (to the left of the woman's head). El Greco's presence among the spectators is maintained and blown up out of all proportion: the portrait of El Greco (fig.103), with his visionary eyes, occupies almost half the composition; it is on the right-hand side, as in the painting.

In the centre there is the action, and it is a sacred action at that: the 'Burial' clearly resembles a *Descent from the Cross*. Picasso therefore changes the corpse into a roasted chicken ('This is my body') presented by El Greco's son, who points at the body in the 'Burial'. Jorge Manuel thus becomes the Son, the Christ. If he is the Son, then it is the

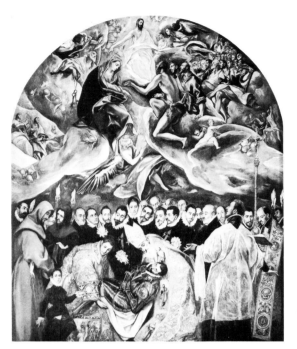

fig.101 El Greco, 'Burial of the Count of Orgaz',
1586. *San Tomé church, Toledo*

fig.103 El Greco, 'Burial of the Count of Orgaz'
(detail). Presumed to be self-portrait of El Greco

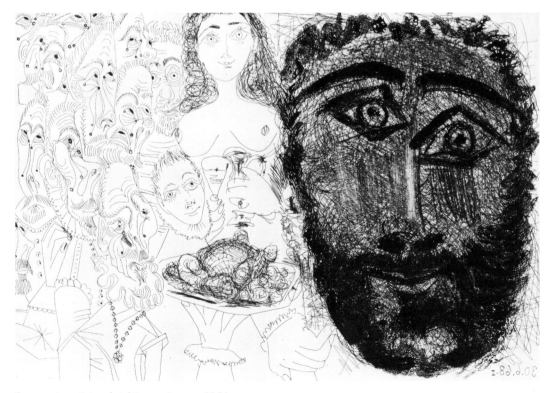

fig.102 Aquatint and etching, 30 June 1968 (1),
28 × 39 cm. *Galerie Louise Leiris, Paris*

Zeus-like head of El Greco that stands for God the Father. The Virgin Mary, the only woman in the painting, becomes the naked woman whom (as in the painting) all the men are eyeing. She is helping herself to a glass of wine (i.e. the chalice and the cruet of the Mass). As for the potatoes that garnish the chicken, they cannot be anything else than the priests in the painting! A somewhat sacrilegious joke, perhaps; and yet, chastely concealed beneath the irony, the composition displays his reflection, homage, admiration and, let us say it, envy.

The process of interpretation, therefore, is begun by Picasso himself. And because he is never a hermetic artist, because he cares about his public and tries to give universal validity to his dreams and fantasies, he is speaking to us – even if sometimes we have no idea what he is talking about. He is speaking the alternative language of art. In the same way, in the theatre, if the performance is a real one, and if we are receptive, the meaning of the play shuttles between us and the events on the stage like a ping-pong ball crossing the net: the net being the footlights.

Picasso said to Pierre Daix, when speaking of his Degas series,[6] that it is the printmaking which is the real voyeur. This is not to be taken literally, only in connection with the Degas series or with that on 'Raphael and the Fornarina'. What the copper plate does for Picasso is to enable him to see himself: in these two series he is a voyeur twice over, watching himself watching the voyeur. What he is telling us about is his own curiosity, the sexual curiosity that he ascribes to Degas or to the Pope, as well as that which consists of wanting to guess the secret of creation, not only *artistic* but of how babies are made. Raphael, the painter *par excellence*; Degas, who looked like Picasso's father; that father, José Ruiz, who was a painter himself, and who had made him, Picasso. All of his prints, from the simplest to the most complex, are at the same time a question and an attempted answer, a keyhole through which nothing can be seen but blackness, and which forces the looker to guess at the secret of what goes on in the parents' bedroom.

The copper plate, to Picasso, is like the telescope of Coppola/Coppelius, in E. T. A. Hoffman's tale *The Sandman*: he sees right through people and things, and he suspects what Hoffmann shows in that frightening story: that there are things that must not be seen. Picasso, nevertheless, never got close to that 'sound barrier' that Hoffmann and Van Gogh broke through. He never saw 'beyond'; he never looked into the bottomless hole; and so he never hurled himself from the town hall tower, as Hoffmann's hero did, sent mad by what he 'saw'. Even so, he came close at times to a vision of the world, and of Woman in particular, which is pretty terrifying. But then this is only a play, and he does bring in an Athena figure who comforts, or a Father figure who protects (see below, Bloch IV.1868) or imposes order. This is the case even more often in the '156' than elsewhere.

In Bloch IV.1876 (fig.104), it is Nathan the prophet, towering and thunderous as Yahveh himself, who is the Father. Cowering beneath his reproaches, and racked with guilt, King David has shrunk to a tiny size, but he still holds out his hand to a beautiful

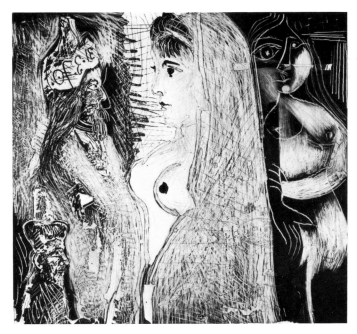

fig.104 Aquatint, dry-point and scraping [12 March 1970 (II)], 31 March 1970, 2 April 1970, 51 × 54 cm. *Galerie Louise Leiris, Paris*

fig.106 Seventh (definitive) state. Etching, aquatint and scraping, 3 February 1970 (IV) [5, 6 March 1970]. *Galerie Louise Leiris, Paris.* (cat.141)

fig.105 First state, 3 February 1970 (IV). See fig.106

fig.107 Rembrandt, 'Ecce Homo', first state. See fig.108

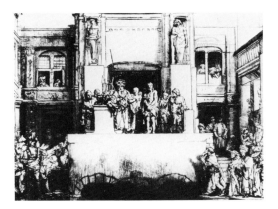

fig.108 'Ecce Homo', 1655. Eighth (definitive) state. Dry-point and scraping

Bathsheba who looks rather like Raphael's 'Donna Velata', but who splits into a nude woman, esculent and enticing.

Elsewhere, as in Bloch IV.1865 (figs.105, 106, and cat.141), it is none other than Rembrandt who is the Father, as represented by the given 'text', which Picasso turns inside out like a rabbit skin, but which remains the text. This print has been the subject of voluminous comment, but it is still worth analysing briefly. Here Picasso is spying on Rembrandt at work. He appropriates for himself the composition and the title of the celebrated etching 'Ecce homo', the meaning of which he diverts to his own ends. This, then, is a self-portrait; included in the package, however, is all his envy of the greatest printmaker of all time, whose steps he retraces in reverse, whose work he chews, swallows, digests and expels – because 'it soothes you' – in the form of a creation which has become his own, and which represents himself.

Borrowings. Rembrandt borrows – from Lucas van Leyden and from Marcantonio, after Bandinelli – the architecture and the composition of 'Ecce Homo': see the first and seventh states (figs.107, 108).

Picasso borrows from Rembrandt the architecture and the staging of his composition. (Breaking with his otherwise invariable custom, Picasso asked Crommelynck to set the central scene for him by drawing a rectangle on the plate in varnish, 'a bit off-centre': this intrusion of another's hand counts as a sign in itself, another borrowing.) He also borrows, with a slight displacement, the meaning of the title, 'Behold the Man'. He borrows a number of figures. One is the old fellow in a turban, on the left, half on stage and half off, who stands in for Rembrandt (Rembrandt who not only watches the show but schemes and stages it), and who is as well the only figure that Rembrandt leaves at the foot of the podium after the fifth state of 'Ecce Homo'. Another is the caryatid on the right, under the entablature of the door to Pilate's palace, whom Picasso transforms into an immense female in a turban to the right of the central scene: she, of course, is an Amazon, a symbol of Prudence, and a guardian of Liberty. The onlookers who lean out of the windows in Rembrandt's etching, and whom Picasso replaces by the figures at the very top of the composition – spectators in the gods who are also stagehands in the flies – are all self-portraits. On the stage itself, other figures borrowed from Rembrandt are the Man, who is Picasso himself; Pilate (himself again, washing his hands of the whole business); Pilate's wife, whom he has brought down from the window where Rembrandt placed her; the halberdier; and the old man at the bottom right-hand corner of Rembrandt's etching, whom he has moved to the right-hand side of the stage along with his own troupe of stock figures (the bareback rider, the bather, the pierrot).

Picasso borrows from other painters the little boy who is pointing at the Man, and who recalls El Greco's son in the 'Burial'; the young woman who kneels behind the Rembrandt figure, and who seems to be Ingres' Thetis, the virgin mother who pleads for her son. She has replaced the lone female suppliant, very 'Guernica', who was below the podium in the first state of the plate.

Theft and inversion. Picasso said to Zervos in 1935: 'A painting used to be the sum of a

process of addition. With me, a painting is the sum of a process of destruction.'[7] Here it is Rembrandt who has stolen a march on Picasso: he too has operated through a process of destruction. Picasso, in consequence, sets out to make 'the sum of a process of addition'.

In the fourth state, Rembrandt slices off the top of his plate: Picasso, by filling this area with the light-toned heads of the spectator-stagehands, uses an optical illusion to make it seem higher.

Rembrandt, through five successive states of his plate, shows, below the podium on which Jesus stands, the surging mass of the mob shouting for Barabbas. Then he deletes the mob and replaces it with two dark arches which set off the bareness of the wall and the loneliness of Christ, but which may also – if it is really a Neptune which was between the arches – symbolize the sewers[8] beneath, and hence the crowd's unconscious, filled with anger and hate. He retains only the head and hand of the boy on the left and the bearded man with his hand raised, on the right, at the corner of the wall.

Picasso, for his part, leaves the lower part of his composition almost blank in the first state, and then peoples it with the dense crowd that embodies his life. The two figures in Rembrandt's last state, the child and the old man who seems to take pity – and who is perhaps the artist himself – are transformed in Picasso's first state into a desperate woman and a man whose pleasure at the sight of what is happening on stage is so great that he is ejaculating (the pleasure of creation, if this is Rembrandt; the pleasure of seeing a spectacle which is not clear because it lies half-way between the narcissistic Picassian display and the more complex display of the suffering and humiliated god who is about to die). The mob that appears in Rembrandt's first states is replaced in Picasso's last states by Picasso himself (but then this is logical: in a sense Rembrandt, too, is *within* the crowd). He is accompanied here by his women: a profile of Dora Maar on the left, and then, from left to right, a profile of Françoise Gilot, an almost Cubist head that refers perhaps to Fernande and Eva, Marie-Thérèse's blonde hair and Grecian nose, and then a big nude Jacqueline. As for the kiss, which is supposed to be a sign of love and not of hate, it has been one of the themes of Picasso's paintings, and in 1931 it appeared in a decidedly fierce guise; here it links together all those women who meet behind the man's closed eyelids.

Envy and theatre. Admiration, dialogue with the Father (Rembrandt), destruction and reconstruction of his work: all these are present. But there is envy, too: there is the destructive envy of the mob; there is Pilate's envy of Christ; there is Rembrandt's envy, as shown in the form of the man in Picasso's first state who climaxes as he looks on at the downfall of the god-man. Picasso takes all this envy upon himself and adds to it his own envy of Rembrandt's creation (Rembrandt, too, is everywhere in his composition, in the mob, on stage, as Christ, as Pilate, and so on). Picasso is as it were exposing himself, almost like a child showing off; he has women and success, and at the same time he is the creator of all this: or at any rate the all-powerful stage manager and stagehand.

What he shows, in addition, is that all this is theatre. Printmaking is theatre; what Rembrandt is doing is theatre (there he is, half on stage and half off); what Pilate is

saying is theatre; ultimately what Jesus is doing is theatre, too, because after the show is over he will be going back to 'his Kingdom'. By showing himself in the guise of Jesus, perhaps Picasso is even implying an essentially theatrical pleasure on Jesus's part in showing himself naked: the same pleasure that he, Picasso, seeks for himself. Fortunately, all this envy is itself theatre; and the performance, the print, the dream, will soon be over. Rembrandt, Jesus and Picasso will still be there, unscathed.

Disguises

What are all the disguises in aid of? One may well ask. Musketeers, swathed in their cloaks, Spanish-style; men in sixteenth-century ruffs, or in seventeenth-century lace collars, buckled shoes and plumed hats; harlequins, punchinellos, pierrots; resplendent nineteenth-century soldiers; turbaned figures straight out of Rembrandt, or the *Arabian Nights*, or *Sergeants Three*; Degases and Manets, in period costume; painters in little round black-framed glasses *à la* Goya or Cardinal Guevara; beplumed Greeks and Romans straight out of Central Casting . . . Obviously, all this is prettier and more romantic than a three-piece suit or the shorts and T-shirt of the Côte d'Azur; and Picasso lives more in the company of Velázquez, El Greco, Degas, Goya, Rembrandt and Ingres than with those present in Notre-Dame-de-Vie: they are more powerfully present, for him, than are the people he sees every day.

There is indeed truth in all this, but as an explanation it is too logical and too pat. It may be noticed, incidentally, that apart from old Celestina and the madame of the Maison Tellier the women are seldom in costume: they are naked, or almost so; and the madame and Celestina are no longer really women, only characters.

Dream disguises things; when a character is burdened with too much meaning Dream simply multiplies him; Dream plays games with time, which no longer really exists in its world; Dream mingles 'everyday' people with Theseus, the Minotaur or Superman, in response to the dreamer's personal mythology, or what one happens to be reading, or the play one saw last night. Dream splits and multiplies self-identities and self-representations, making the bad wholly bad, the nice really nice, the old ancient, the child tiny. The image of the Mother, or of Woman, which is another form of self-projection, bifurcates in the same way: the fairy and the witch, the tender and the devouring, the seducer and the mummy.

Voyeurism reappears: the copper plate is the voyeur, because on it Picasso puts himself on stage – always in disguise, as a musketeer, as a gladiator, as Christ, as Degas, as Rembrandt, as Leo X and Raphael simultaneously, as a baby, as an old man, as a sailor, as a dog, and even sometimes as himself. Only femininity – that of women, but also his own, which surges hungrily from the primal depths in the minotaur cycle – remains in the nude: it has become more accepted, and less primal, but it is still a raw wound.

Theatre

The disguises they wear, these images of himself, are those of the dream; but they are also those of the theatre. Theatre, as we have seen, is omnipresent. Picasso had returned to it with his illustrations for Fernand Crommelynck's *Le Cocu magnifique*. And, indeed, many of the prints of 1966 show theatrical scenes, often separated from the spectator by a starry row of footlights, and often horrific: executioners, beheadings, homicidal thoughts – such as those that pass through the mind of David as he looks at Bathsheba and ponders Uriah's death.

Most of the '347' prints are pure theatre. There are the illustrations for *La Celestina*, the action of which is written as a play, let's not forget it; and there are other prints in which the artist carefully marks out the acting area by drawing a rectangle a few centimetres from the edge of his plate, often sliding spectators or actors half into the wings, in a position intermediate between the spectacle on stage and that of the composition itself (see, e.g., Bloch II.1565 and II.1567).

Picasso announces from the very first plate in the series (Bloch II.1481, fig.109) that this is going to be a theatrical display. He places himself, and us, as if looking through a 'transparent' scrim, backstage, where a narcissistic, androgynous figure, lying full-length in the foreground of the image, is dreaming or fantasizing the whole thing. Beyond the stage, we see the countless eyes of the audience, a bullfight crowd that is watching, not the real death of the *corrida*, but a Jacqueline riding bareback. And she in turn is also a 'painting', if only through the reference to the portrait of Elizabeth de Bourbon by Velázquez, mediated by a 1959 drawing (Zervos XVIII.367).

One foot on stage, one foot off, there stands a splendid fairground strongman who looks rather like the sculptor in 'Minotauromachie', but with the Minotaur's pouch: both figures amalgamated in a single ball of clay. This is Picasso's 'theatre of the 1930s'. The strongman, too, is on his way out; or at least he is leaving the stage.

Picasso himself stands at stage left in a jester's costume. Behind him is a figure who looks like a magician, and who wears the soft hat from Rembrandt's self-portrait; one hand emerges from his cloak in an allusion, recurrent in Picasso's work, to Rembrandt's portraits of men. But the magician himself looks like Jean Cocteau, the prince of hokum, the great illusionist, the deceiver, the 'impostor'. These two are stage-managing the spectacle we see, which by its very nature is both real and unreal. It's all a performance: the women, Cocteau, Picasso, painting itself perhaps, printmaking too, are all simply putting on a show. This is no *corrida*: nobody is going to die. And, what is more, the show is a success: the house is full.

One etching, Bloch II.1589 (fig.110), embodies the ultimate in Picassian theatre. The first thing to notice about it is its sheer beauty, with the rhythm of black and white that singles out from the whole the woman's nakedness and the only real spectator, the ugly little boy: this is a quotation in itself, from the chiaroscuro passages in Rembrandt. All this is theatre; or perhaps it is television, transformed into theatre by Picasso. He places

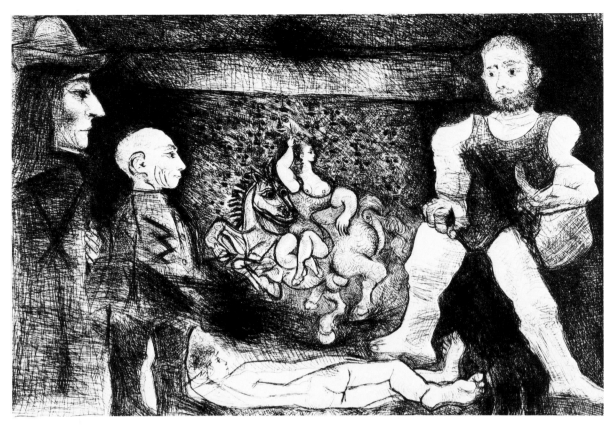

fig. 109 Etching, 16, 17, 18, 19, 20, 21, 22 March 1968.
Galerie Louise Leiris, Paris. (cat. 113)

fig. 110 Aquatint, 25 May 1968 (I). *Galerie Louise Leiris, Paris.* (cat. 114)

fig. 111 Rembrandt, 'Hendrickje in Bed'.
National Gallery of Scotland, Edinburgh

his frail, mocking urchin outside the field of action and off the stage, and he inserts, half-way into the wings, a bearded figure who is himself, shown simultaneously as a spectator who is stepping on stage, as the stage manager, and perhaps as an actor.

On stage are two protagonists. In a four-poster bed lies a naked woman who combines the poses of Rembrandt's 'Bathsheba' and 'Hendrickje in Bed' (fig. 111), and whose face and black stockings, like those worn by Degas's 'Maison Tellier' women, identify her as a harlot. She has a male visitor whose stick and gait are those of the Captain in 'The Night Watch', although he has politely doffed his hat. The scene takes place after the Night Watch has stood down; the Captain is out for a night on the town.

The aged bawd, Celestina again, recalls Rembrandt's etchings of his own mother; and the man in a hat, to the right, is Rembrandt himself, potato nose and all. His cane is the same as his Captain's. The pretty, small boy looks like El Greco's son. He is a painter's son who has been brought into his father's work and made to take part in a story, just as El Greco made young Jorge Manuel play his part in the 'Burial': another creation/creature, like Rembrandt's Captain. No doubt this, as well as the fact that Jorge Manuel was good-looking and became a painter himself, explains why Picasso introduces him in place of Titus, the son of Rembrandt and Saskia, whom one might have expected to find here instead. The absurd poodle, between the men and the women, is of course a symbol of the sexual relationship: the Minotaur is done with. All this is only theatre.

In his *Poetics*, Aristotle tells us that the aim of tragedy is never better achieved than when it illustrates the ties of blood; and he instances the nuclear family itself. The blood relationships in this particular drama are evidently highly complex; seen perhaps by the urchin, they are experienced by the boy on stage, especially if he stands for Titus. On the female side, there are the harlot who is simultaneously the Father's new 'wife', and the Mother who is at the same time a procuress. On the male side there are the Father, Rembrandt, and his creature, the Captain, who has stepped out of a painting to live a life of his own, and with whom – according to Picasso – Rembrandt identifies himself: for it is he who is about to join Hendrickje in bed, and it is he who lusts after Bathsheba. And then there is the boy who is trapped for all time inside this composition, and who is wondering what is happening in his father's painting and in his father's life.

The two old people, Rembrandt and the Mother, are seen at half-length, either half-sunk beneath the stage floor or framed in a head-and-shoulders shot. The show is going on in their heads, too, but it is the man on the right (Picasso) who is directing them, seeing the scene through the eyes of the little boy on the stage and for the sole benefit of the one and only spectator, the irreverent urchin.

Aristotle writes in the *Poetics* that it is the poet's task to tell, not of things that have really happened, but of things that might happen. What could be better theatre than to behold characters from a number of different paintings escaping and finding themselves caught in a web of complicated family relationships? Picasso is making real theatre: his etching is a theatre stage and shows, on this stage, a theatre performance which conforms moreover to the rules of Aristotle![9]

Another theatrical creation is the series 'Raphael and la Fornarina', which is rather like a strip cartoon, but which is also inherently theatrical because Picasso here introduces Ingres (his 'text') as a voyeur who spies on a voyeur (Leo X, Michelangelo, or whoever) who is endeavouring in his turn to discover the secret of the parents' bedroom – which is that of sexual relations, of course, but is much more importantly that of creation, whether of babies or of painting. In any case, the subject is Ingres' curiosity about Raphael, Michelangelo's curiosity about Raphael, and Picasso's curiosity about Ingres, Michelangelo *and* Raphael. It is a curiosity mingled with admiration, but also with murderous envy. Picasso borrows the figure who draws aside the curtain to spy, not from Ingres's 'Raphael and la Fornarina' (fig. 112), but from another work by the same artist, 'Paolo and Francesca' (fig. 113), which also furnishes the new version of Raphael with Paolo's looks and hat. Now, as is well known, it is Gianciotto who thus comes upon his wife and his younger brother, and Gianciotto who unhesitatingly dispatches them to the Second Circle of Dante's *Inferno*.

This is all theatrical, also, because Picasso is telling us what 'might happen' given a very simple situation which implies nothing more than the twofold relationship

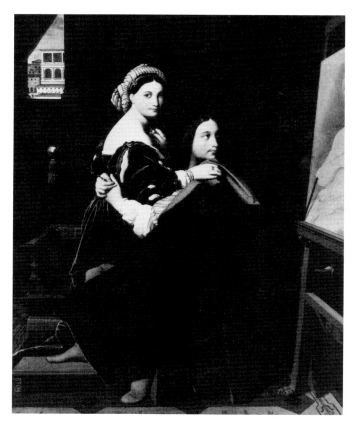

fig. 112 Ingres, 'Raphael and la Fornarina', 1814. *Fogg Art Museum, Cambridge, Mass.*

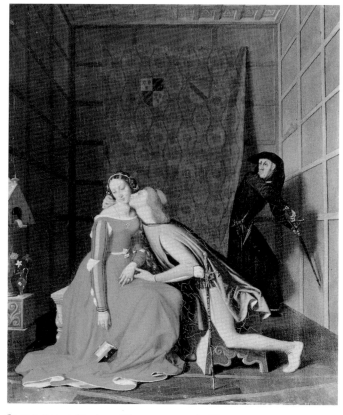

fig. 113 Ingres, 'Paola and Francesca surprised by Gianciotto', 1819. *Musée des Beaux-Arts, Angers*

fig.114 Etching, 29 August 1968 (I), 28 × 39 cm
Galerie Louise Leiris, Paris

fig.117 Etching, 31 August 1968 (II). *Galerie Louise Leiris, Paris.* (cat.126)

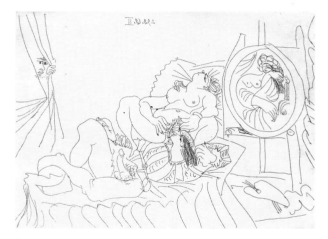

fig.115 Etching, 29 August 1968 (II),
Galerie Louise Leiris, Paris. (cat.124)

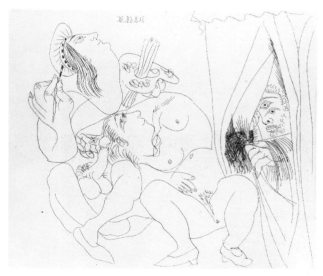

fig.118 Etching, 31 August 1968 (III). *Galerie Louise Leiris, Paris.* (cat.127)

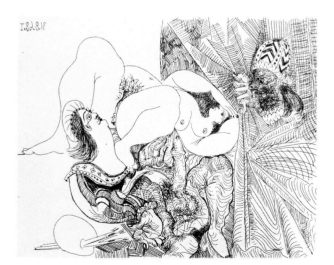

fig.116 Etching, 31 August 1968 (I),
Galerie Louise Leiris, Paris. (cat.125)

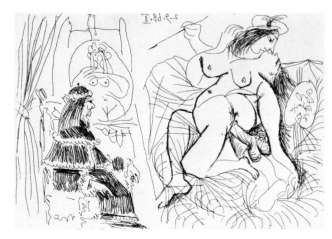

fig.119 Etching, 2 September 1968 (II), 15 × 20.5 cm.
Galerie Louise Leiris, Paris

between the artist and his model: the sexual relationship and the interchange on the level of creativity. Here, too, there are blood relationships: in 'Paolo and Francesca' the elder brother stands for the Father. In the Picasso series, Raphael is present, in a sense, as the 'Father' of painting; and as for the voyeur, he is both Father and Son: the Holy Father, who is also a baby sitting on a pot; Piero Crommelynck, youthful but wearing Don José's goatee beard; Michelangelo, hiding under the bed like a child, but also old, because, even though he outlived Raphael (whom he loathed) by forty-four years, he was born eight years before him.

The series unfolds like a story (figs. 114–134). Initially the lovers are alone; then the voyeur, who soon turns into the Pope, spies on them from behind the curtain. He eventually walks into the room, sends for the armchair we see in his portrait, withdraws for a moment, but has no intention of missing anything, settles in again, this time seated on his chamber pot. Raphael is making love and painting at the same time. The voyeur goes back behind his curtain, turns into an old fool in a jester's cap, and the lovers turn back into a man and a woman loving each other. *E finita la commedia!* It has indeed been a theatre piece. In one print (Bloch II.1797, fig.131), Michelangelo looks like a big curly-haired dog. What fascinates these Peeping Toms is not Raphael's antics with his famous model but Raphael's painting: or, as one might put it, how he was able to 'create' just by carrying on with that woman. There is magic in all this: the magic of art.

The '156' are theatre, too in their own way. In many of them Picasso shows himself as a spectator of a play (as in Bloch IV.1870 and IV.1868). In others he goes back to the more complex processes involved in staging a 'text', in which he shows the voyeur/spectator while identifying with him only as the audience in a theatre identifies with the characters: conscious, that is, that it is only a play, and that the actor himself can act only as long as the performance lasts.

The 'text' he uses is, for example, the set of Degas monotypes that he took out of a drawer, ten years after he had bought them, and (as the madame's lapdog goes to prove) combined with other monotypes on related themes by the same artist. Legend will have it that he asked himself the question: 'But what on earth was he doing *there* [i.e. in the brothels]?' This was the question he set out to answer. The true answer lies in what his given 'text' leaves unsaid, forcing him to fill the gaps in the discourse by inventing and fantasizing, and ultimately to acknowledge that the truth remains hidden. The voyeur, his eye glued to the keyhole, ultimately sees nothing but blackness; for in the end, of course, they put out the light.

Picasso defines his subject, and also the real answer to his question, in one of the first compositions in the series (Bloch IV.1936, fig.139), in which he places Degas in the midst of the women but then duplicates him and shows him again, drawing them. The gap in the discourse, the secret that cannot be discovered by looking through the keyhole, is once more the secret of creation: the creation of the monotypes by Degas that Picasso owned, but also that of the others, the beautiful images of 'Women at their Toilet', to which he alludes from time to time (as he does, for example, in Bloch II.1939,

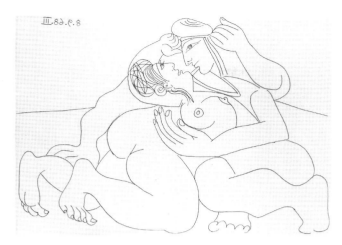

fig.120 Etching, 8 September 1968 (I), 15 × 20.5 cm,
Galerie Louise Leiris, Paris. (cat.138)

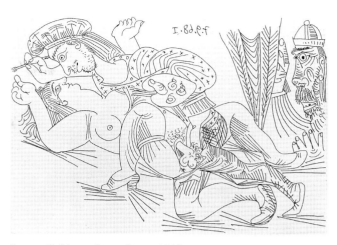

fig.123 Etching, 7 September 1968 (I), 15 × 20.5 cm,
Galerie Louise Leiris, Paris. (cat.135)

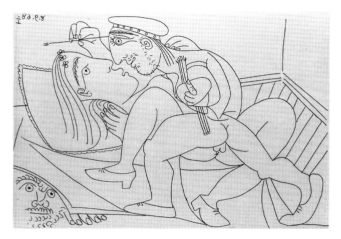

fig.121 Etching, 8 September 1968 (I), 15 × 20.5 cm,
Galerie Louise Leiris, Paris. (cat.136)

fig.124 Etching, 4 August 1968 (IV), 20 × 32.5 cm,
Galerie Louise Leiris, Paris. (cat.119)

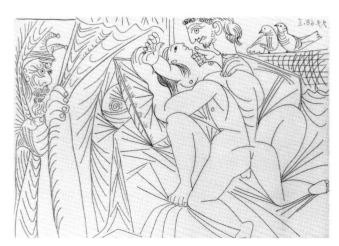

fig.122 Etching, 9 September 1968 (I), 15 × 20.5 cm,
Galerie Louise Leiris, Paris. (cat.139)

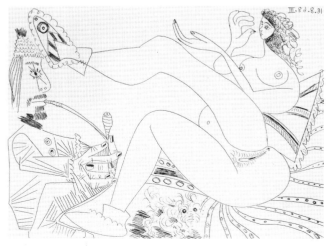

fig.125 Etching, 18 August 1968 (III), 15.5 × 20.5 cm,
Galerie Louise Leiris, Paris. (cat.120)

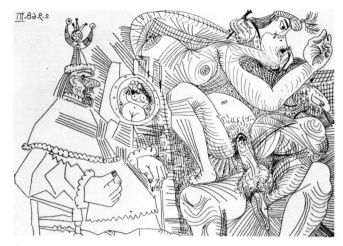

fig. 126 Etching, 2 September 1968 (III).
Galerie Louise Leiris, Paris. (cat. 128)

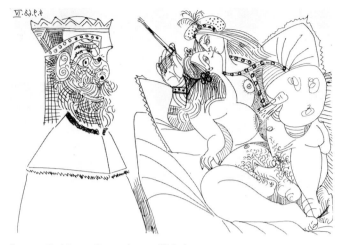

fig. 129 Etching, 4 September 1968 (IV).
Galerie Louise Leiris, Paris. (cat. 133)

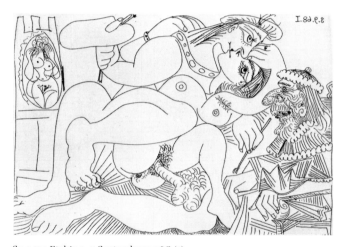

fig. 127 Etching, 3 September 1968 (I).
Galerie Louise Leiris, Paris. (cat. 129)

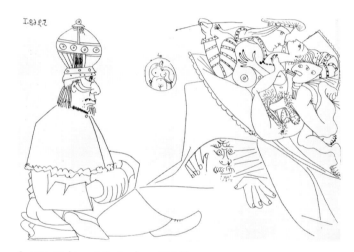

fig. 130 Etching, 5 September 1968 (I).
Galerie Louise Leiris, Paris. (cat. 134)

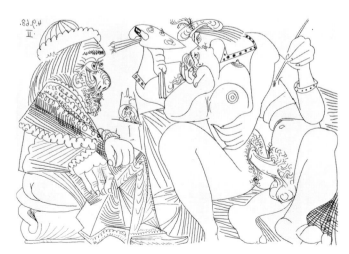

fig. 128 Etching, 4 September 1968 (II).
Galerie Louise Leiris, Paris. (cat. 131)

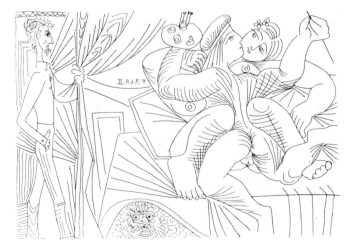

fig. 131 Etching, 8 September 1968 (II).
Galerie Louise Leiris, Paris. (cat. 137)

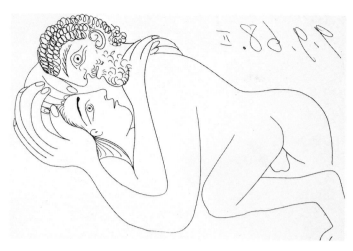

fig.132 Etching, 9 September 1968 (II).
Galerie Louise Leiris, Paris. (cat.140)

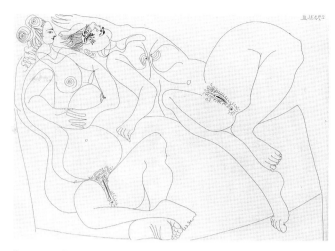

fig.135 Etching, 29 March 1971 (III), 37 × 50 cm,
Galerie Louise Leiris, Paris. (cat.146)

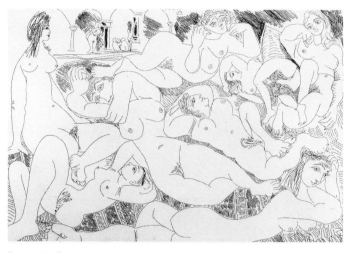

fig.133 Etching, 21, 22 August 1968.
Galerie Louise Leiris, Paris. (cat.123)

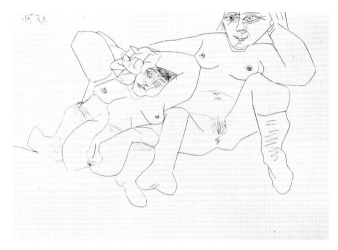

fig.136 Dry-point, 3 May 1971, 37 × 50 cm, *Galerie Louise
Leiris, Paris.* (cat.149)

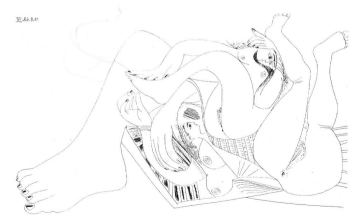

fig.134 Etching, 18 August 1968 (IV).
Galerie Louise Leiris, Paris. (cat.121)

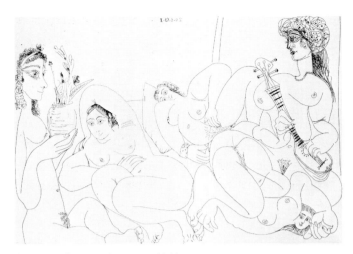

fig. 137 Etching, 20 August 1968 (I).
Galerie Louise Leiris, Paris. (cat. 122)

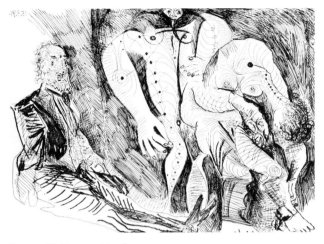

fig. 140 Etching, 15 March 1971.
Galerie Louise Leiris, Paris.

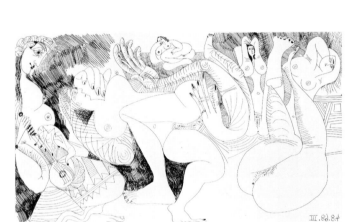

fig. 138 Etching, 4 August 1968 (III).
Galerie Louise Leiris, Paris. (cat. 118)

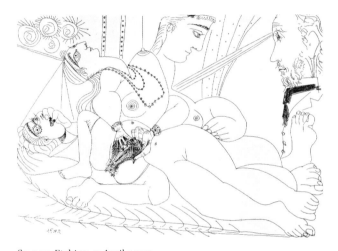

fig. 141 Etching, 9 April 1971.
Galerie Louise Leiris, Paris. (cat. 147)

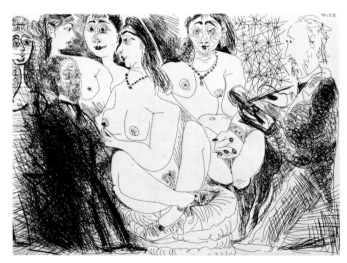

fig. 139 Etching, 13 March 1971.
Galerie Louise Leiris, Paris.

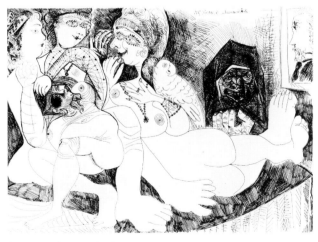

fig. 142 Etching, 4 April 1971.
Galerie Louise Leiris, Paris.

fig. 140; see Cachin 158). This is the secret that Picasso is looking for, and the rest is theatre. Not that this does not interest him: he clearly finds no difficulty in identifying with Degas the voyeur.

The world of 'Raphael and la Fornarina' was a man's world: la Fornarina was simply an object. The world of the licensed bawdy-houses, the *maisons closes*, whose very name in French implies secrecy, is a woman's world, and there it is the client who is an object. Picasso asks himself a number of questions that can never be answered: What do they get up to when there are no men around? (His work shows that he had always been intrigued by this.) They get up to homosexual games, that's what (Bloch IV.1966, fig. 141); they chatter like parrots and laugh about men's little secrets (Bloch IV.1964, fig. 142). And the madame, what part does she play? She is the Mother. The mother of the *filles*, who celebrates her name-day with childlike glee: one of them perches herself on her lap (Bloch IV.1983, fig. 145), and others present her with bunches of flowers that look, in Degas's original, like the one held by the black maid in 'Olympia', but which Picasso has, oddly, removed from their paper cones (see fig.143 and Bloch IV.1982, IV.1984–86, figs.146–148). She is the client's mother, too; for he goes to 'those places' to be someone's spoilt only child, to be coddled and admired (Bloch IV.1960) by all those women. She is the destroying mother, too, the *faiseuse d'anges* (abortionist), with that bland, sly face, those witch's hands, and that chihuahua which springs out of her lap, and which is no more and no less than a foetus (Bloch IV.1972, fig.149).

As it is Picasso who is outside looking in through the keyhole, Degas is always visible; but he is shown as he shows himself in his monotypes, as an anonymous client, half in and half out of the composition (fig.144), cut in half, reduced to a sliver of himself and sometimes even to a photograph hanging on a nail, or else pressed against the wall to take up less room. He looks on, hands behind his back, and no one takes any more notice of him than if he were a vase.

One day Picasso became bored, and Degas is leaving (Bloch IV.1988, fig.150). This time the girls look at him. One is slipping into her stocking the money he has just given her, and making it clear (this is a pious understatement) that she is not amused. What good is a client who doesn't *do* anything? None, says the obscene hand-gesture on the left. The girl in the centre fixes Degas, whose figure is reduced to a third of itself, with an icy stare. The client's payoff is contempt, on the girls' part, although in a sense this is offset by Picasso's technique itself, which here comes close to that of the monotypes. Degas did, after all, 'do something there': the monotypes are the proof of it. What could have been better? Even so, Picasso is spiting Degas, and betraying his own envy, by exposing him to the contempt of these whores.

Destructive envy is part of everyone's primal feminine nature. Picasso showed this, in the raw, in the metamorphosis of his Minotaur into a female ghoul about to devour the Athenian children delivered under treaty (Bloch I.229). The same force is the cause of the minotaur's departure in 'Minotauromachie': it was better to leave Marie-Thérèse than to tear her child to pieces. But since then Envy has changed its face. It has made the

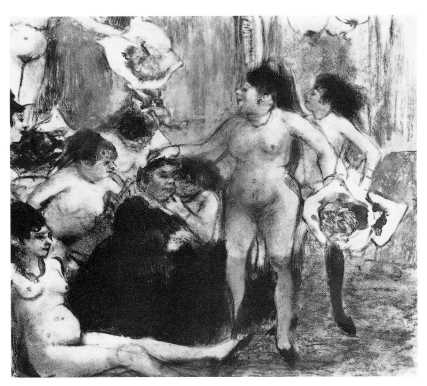

fig. 143 Degas, 'The Madam's Birthday', 1878–79,
26.6 × 29.6 cm. Monotype in ink touched up with
pastel. *Musée Picasso, Paris*

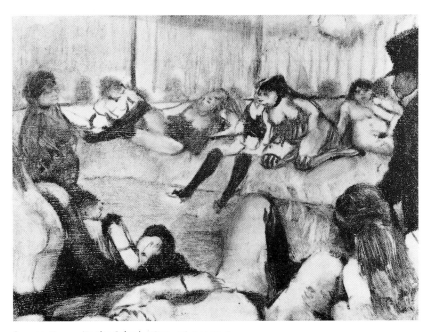

fig. 144 Degas, 'In the Salon', 1879, 16.4 × 21.5 cm.
Monotype in ink. *Musée Picasso, Paris*

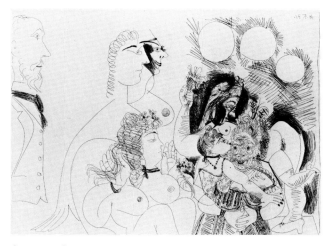

fig.145 Etching, 16 May 1971.
Galerie Louise Leiris, Paris. (cat.151)

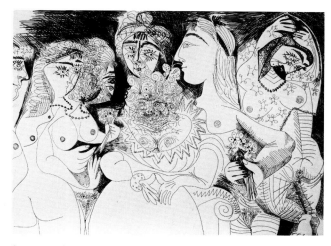

fig.148 Etching, 20 May 1971, 37 × 50 cm.
Galerie Louise Leiris, Paris

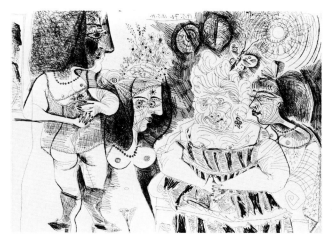

fig.146 Etching, 17, 18 May 1971.
Galerie Louise Leiris, Paris. (cat.152)

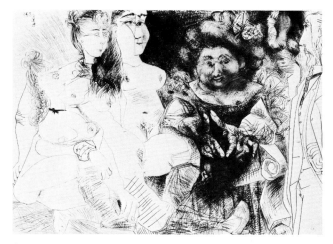

fig.149 Dry-point and scraping, 1, 4 May 1971.
Galerie Louise Leiris, Paris. (cat.148)

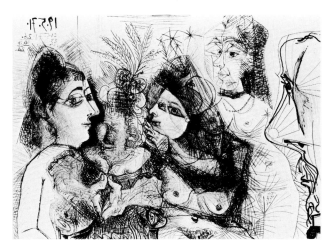

fig.147 Aquatint, dry-point and scraping, 19, 21,
23, 24, 26, 30, 31 May, 2 June 1971.
Galerie Louise Leiris, Paris. (cat.153)

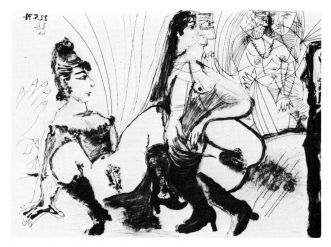

fig.150 Aquatint, dry-point and scraping, 22,
26 May, 2 June 1971. *Galerie Louise Leiris, Paris.* (cat.154)

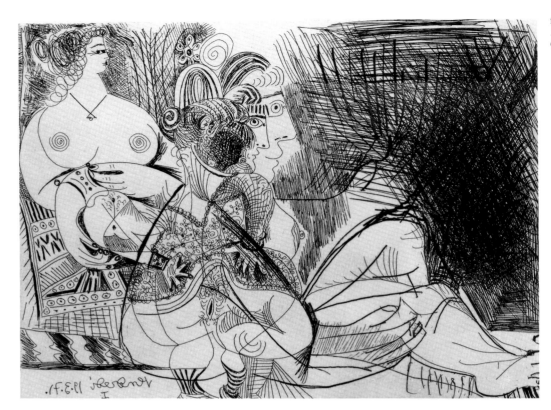

fig.151 Etching, 19 March 1971,
23 × 31 cm,
Galerie Louise Leiris, Paris. (cat.145)

transition from raw to cooked, by courtesy of Athena, and also by virtue of a recovered ability to engage in dialogue with the Father. The vision of womanhood that is represented is still a fairly bewildering one, but it can now be shown in terms of theatre, which is truth and falsehood at the same time.

Look for example at the superb print Bloch IV.1868 (fig.153). Here, once more, it is the successive states that tell the story and make it possible to grasp the meaning of the final outcome. On the left is the spectator, a self-portrait as a baby/ancient, to whom a girl circus rider, an Athena, is presenting a play. He holds up on the end of a stick (which in the first state, fig.152, is an olive-branch) a shield like that of Perseus, but adorned with the head of Rembrandt instead of Medusa; and this curious object sprouts two arms which reach out to support and comfort him. In transit from the auditorium towards the stage we see a Cupid, weary, disconsolate and fearful, clutching his unstrung bow. In the first state he is alone, but subsequently the man in the background lays a protecting hand on his head. This Cupid is Picasso, of course; but he is also Paris, as is apparent from the first state, where, in the presence of an assembly of women, he is confronted with an odd, fat Athena, here as the goddess of war, hiding a whip behind her back, an Aphrodite garlanded with flowers, and an ageing Hera.

Then the show on the right begins to unfold and takes the shape that we see in the final state. The tribunal of women gives way to a couple, reminiscent of the portraits of the king and queen in 'Las Meniñas', and the King/Father places his hand on Cupid's

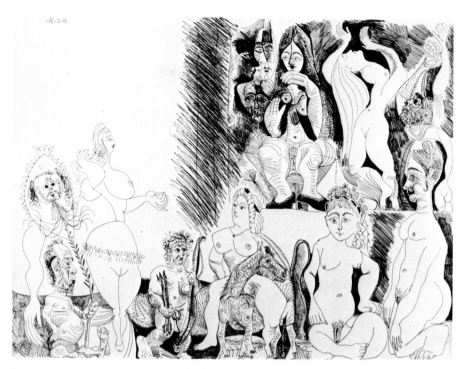

fig. 152 First state, 11 February 1970. See fig. 153

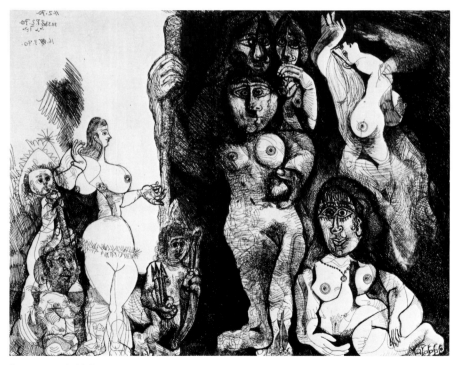

fig. 153 Ninth (definitive) state. Etching and
scraping, 11, 28 February 1970, 3, 16, 30 March
1970. *Galerie Louise Leiris, Paris.* (cat. 142)

head. Aphrodite has absorbed Athena (who subsists only as the goddess of reason, front of house), and, proud of her victory, holds in her hand the golden apple – which looks rather more like a stone held in readiness to throw at the head of some potential suitor. Like the frog in the fable, she has expanded to monstrous dimensions: her powers of seduction have transformed Athena's whip into Hercules' club. It is not surprising that her own son, Eros, goes in fear of her: this goddess of love is not an inviting sight. Another vision of femininity: the aged whore (formerly Hera), her face thick with paint, represents the Lie. A third and last vision is the Maenad on the right, whose dance spells unbridled love but also – as it did for Pentheus – death.

But Love is now under the protection of the Father, and the spectator, Picasso, has received the shield which is Athena's gift, and which is painting. All this can now be shown on the stage. It is pure theatre. It can be watched with pleasure because, seen from the safety of the stalls, it is nothing but myth: tales of long, long ago. Through the process of identification, Envy has become livable-with, accepted, mediated by affection for the Father.

The Theatre and its Limits

The question remains why, in the prints of his last years, Picasso has chosen to tell his stories through the medium of the theatre.

Is it simply that he manufactures images, and images are spectacle? This is true, as far as it goes; but he did not choose to present the story of the Minotaur in a theatrical form. And then he lays such stress on the fact that this is, specifically, theatre: the separation between the audience and the stage, and the separation between onstage and offstage, are barriers that can be crossed, but they are clearly defined.

Was it the work on illustrating *Le Cocu magnifique* and *La Celestina* that started him thinking about the theatre? What is more, there was a television set at Notre-Dame-de-Vie; and there is nothing better than an absurd television programme to make you dream up your own personal scenario within the four corners of the screen: it is the classic instance of suspended attention.

There must have been another reason, even so. However much may have been done of late to eliminate the footlights, they do set up a reciprocal ballgame between the play and the spectator. The latter may identify with what he sees, but he remains aware of the barrier of otherness that divides the outside world from the world inside the theatre (or in this case from the world on the copper plate), the stage from the auditorium, and the play in his head from the play on the stage. All he can do is try to knit the separated worlds together. That is the meaning of the figures that Picasso has placed half on stage and half off.

For the spectator, there is also the world where the deception is concocted: the wings

and the backstage area, which form an impassable barrier because without them there would be no play at all. Again, Picasso often places his characters half in, half out of the wings, and in the wings he rules as the stage manager. He, the painter, may seek to affirm his own omnipotence by invading the auditorium, the stage and the wings, all at once; but, as we have seen, he never loses sight of the existence of a text, a law, a Father.

The space of the dream, of the stage, or of the copper plate, confronts us with the concept of the closure of the performance ('cloture de la représentation').

The onstage action – in which one must try to fill up the gaps in the web of language, if only to follow what is going on – is staged by Picasso: it represents his self-identification with other characters, who are often defined in advance by his 'text', but whom he puts on stage for his own benefit, as if in order to divine what is left unsaid within the text that he manipulates, explores and extends.

And then, finally, there are the wings. They show/conceal that the truth/falsehood is not so simple or so complicated as all that: there is no more to the play than someone is willing to show. Without the wings, there would be no theatre. Picasso takes possession of them, but he is only pushing the frontier back a little. Beyond the wings, as in certain plays where the action goes backstage – *Hamlet* is the prime example – there are still other wings, for ever more wings, the secret, the unconscious.

Perhaps this is what explains the choice of the theatre as a theme. Picasso sees, and shows, 'all that'; but even if he seems to be providing all the 'keys' (as shows in his insistent emphasis on the man who keeps the keys of Queen's quarter in the Royal Palace from 'Las Meniñas', who undergoes a sex-change in Bloch IV.2000 and IV.2002), there will always be an infinite recession of wings. He tells us and he tells himself, for he is also the actor; but he laughs longest who laughs last and it is 'the man himself', his secret self, his unconscious, and this will always elude both Picasso and us. All we can ever see is a succession of molehills: we can try to guess which way the mole is going, but his burrowings remain secret, and some of them even the mole forgets. Perhaps they have caved in, leaving isolated, pitch-dark chambers.

He mocks himself, and his own pretensions to communicate something momentous; he mocks the audience which thinks it understands and in fact understands only what the representation reveals and conceals. He only tosses us a bone to pick over, but it is a fine one, a bone incised with hieroglyphs. All this is pure theatre. Picasso shows himself off and conceals himself; he sees himself without seeing himself. As an actor, he wears one mask more than all those he gave himself as a stage manager. As in life: he is 'a cheerful man', and yet there is this 'Spanish sadness'.[10]

With the Minotaur, there was the distancing mechanism of 'Once upon a time'; but there was also the 'cruelty' of the bullfight, where death is real. Now, on the other hand, the play's the thing. In the theatre, no one dies, and the characters, the dead as well as the living, are there to take their curtain call at the end. There has been only one exception: Molière, once. And perhaps he is tantamount to that 'Spanish sadness' which has a taste of death and that Picasso used to speak of, parodying Lorca.

And so, through 'writing and difference' Picasso in his old age succeeded in imposing an order of a kind: not exactly 'thunderclap order', perhaps, but an order nonetheless: very many things had now been accepted, integrated, made representable. In the solitude of the near-prison that he had made for himself at Notre-Dame-de-Vie, he seems to have lived more intensely in those seven last years than in all the rest of his life.

All the painters of the past, whom he loved and whom he brings on stage, whom he engages in dialogue, at and with whom he laughs, were images of his father. Nonetheless, there was one painter whose life and whose letters he knew intimately, one whom he had set on a pedestal, like a saint, and from whom he hardly ever quoted: Van Gogh. There are, it is true, those bouquets of 1969 – such as the one dated 7 November – that allude, timidly, to the 'Sunflowers'. There is the 'Portrait of a Man in a Straw Hat', of the same date, which is an obvious allusion to the 1887 self-portrait in which Van Gogh wears a grey trilby-like hat, and which so fascinated Artaud (Picasso has even cropped the left ear). There is the tree, in an etching, that reminds one of the 'Mulberry Tree'. Then there is Picasso's pinpoint interest in Raphael, who died at about the same age as Van Gogh, and Picasso who identifies himself with Michelangelo, his fascination and his envy. It's not much.

So what? Of course, Van Gogh provided him with no anecdotes to manipulate in his etchings. But there is something else: Van Gogh had 'gone through the sound barrier' (we have Picasso's own word for that),[11] and that was the exorbitant price he paid to paint as he did. Picasso, at his age, had nothing either to hope for or to fear from that direction. In any case, he had never come close to the blackness and the flashing lightning of madness; he lacked the desire, the courage and the power to do so. He would never be a visionary painter; he would never paint like Van Gogh; he would never understand music or be able to put it into painting. It would never be possible for Artaud, or anyone else of the same stamp, to write these 'thunderous' words about his painting:

> . . . the painter of all painters, who, without going beyond what goes by the name of – and is – painting, without going beyond the tube, the brush, the setting of the motif and the canvas . . . succeeded in instilling passion into nature and objects to such a degree that no fabulous tale [and here Artaud cites the great visionary storytellers] has told more on the psychological and dramatic plane than have his paintings. (*Oeuvres complètes*, vol.XIII, p.28.)

Picasso, for his part, would have to make do with Eluard.

His admiration/envy of Van Gogh was no doubt too much alive in him, right to the end, for him to put into 'presentation' and, all the more reason, to stage. The 'texts' Picasso would have needed, those of Van Gogh as well as those of his own feelings, remained inaccessible to him. In such a case there can be no dialogue: there is nothing to be done but set up a pedestal. However, Picasso – possibly through his etching – did go far enough in self-analysis to acknowledge the fact that, whereas he had the gift of

seeing through things, there were others who could see beyond them, and that the gulf between the two is unbridgeable. This recognition of 'something else' is perhaps what gives some of the best of the 'Avignon' paintings that 'something more' that is undeniably there. Just as it is there in Beethoven's very last quartets.

translated by David Britt

Notes

1 It would be wrong to jump to the conclusion that Picasso neglected printmaking between 1953 and 1963. In 1953 he produced the large 'Woman's Torso', and a superb portrait of Françoise Gilot; in 1955, among other things, there were the two series, 'Women of Algiers' and 'Brothels' (Baer 908–18, 921–26), and the beautiful portrait of Jacqueline, which was bitten directly with acid on a grained plate. Then, as the years passed, there were some sharp works to illustrate books by Iliazd, there was the virtuoso performance of *Tauromaquía*, and much more beside. In 1959 and 1962 he turned to linocut and stood the medium on its head by working on all the colours consecutively on a single piece of linoleum.

2 On the hat, see Janie Cohen, 'Picasso's Exploration of Rembrandt's Art', *Arts Magazine* (New York), October 1983.

3 *Ibid.*, p.101.

4 André Malraux, *La Tête d'obsidienne*, Paris, Gallimard, 1974, p.117.

5 Hélène Parmelin, *Picasso dit . . .*, Paris, Gonthier, 1966, pp.98, 99.

6 Pierre Daix, *Picasso créateur. La Vie intime et l'oeuvre*, Paris, Le Seuil, 1987, p.375.

7 Christian Zervos, 'Conversations avec Picasso', *Cahiers d'art* (Paris), vol.x, no.7/10.

8 See Kenneth Clark, *Rembrandt and the Italian Renaissance*, London, John Murray, 1966, p.92.

9 On an anecdotal level, but nevertheless interesting in relation to this particular composition, there is the role played by inventories in the two painters' lives: the one which followed the death of Saskia, and which prevented Rembrandt from marrying Hendrickje, and the one that took place in 1935 and prevented Picasso from making the break with Olga official and marrying – well, marrying the others. In both cases the painter was more attached to his works than to a woman, more attached to his creation than to his life as a man.

10 André Malraux, *La Tête d'obsidienne*, Paris, Gallimard, 1974, p.117.

11 Hélène Parmelin, *Picasso dit . . .*, Paris, Gonthier, 1966, p.82.

Reference works cited in abbreviated form in the text:

Bloch: Georges Bloch, *Pablo Picasso. Catalogue raisonné de l'oeuvre gravé et lithographié*, vols.I, II, IV, Berne, Kornfeld & Klipstein, 1968, 1971, 1979.

Baer: Brigitte Baer: *Picasso, peintre-graveur*, vol.IV, Berne, Kornfeld & Klipstein, 1988.

Cachin: Jean Adhémar and Françoise Cachin, *Degas, gravures et monotypes*, Paris, Arts et Métiers graphiques, 1973. English edition: *Degas: The Complete Etchings, Lithographs and Monotypes*, London, Thames and Hudson, 1974.

G.W.: Pierre Gassier and Juliet Wilson, *Vie et oeuvre de Francisco Goya*, Fribourg, Office du Livre, 1970. English edition:

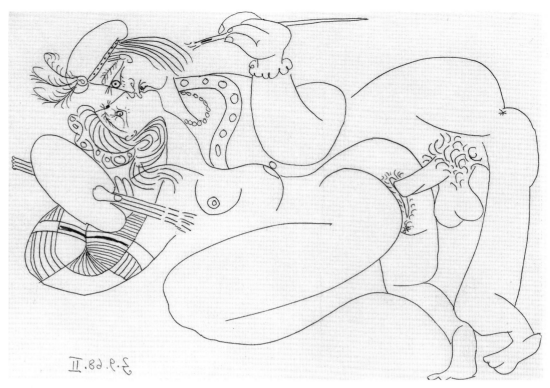

fig.154 Etching, 3 September 1968 II,
15 × 20.5cm, *Galerie Louise Leiris, Paris.* (cat.130)

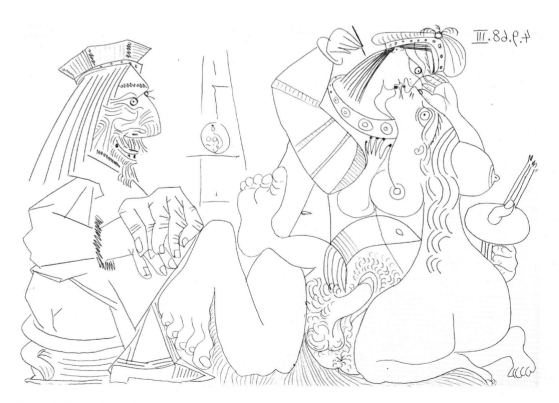

fig.155 Etching, 4 September 1968 III,
15 × 20.5cm, *Galerie Louise Leiris, Paris.* (cat.132)

End Game

DAVID SYLVESTER

I

The dignity of an old man's acceptance of approaching death is touched by absurdity in so far as he is already dead as a man. For a woman, the horror of ageing resides in no longer attracting; for a man, in no longer acting. In Oshima's *Ai no corrida*, when the heroine decides to offer herself to an old tramp his opportunity turns out to be useless and an occasion for shame; when the hero decides to pleasure an ageing geisha her opportunity is clearly and poignantly the first for years but is still an occasion for delight. An old woman is the ruin of a woman; an old man is a non-man.

That conclusion and the long shadow it casts before it has always been a favourite theme of stand-up comics. It is a great theme, and Picasso's late work is the first known body of work in the visual arts to realize its potential, through a remarkable conjunction of events. From the start Picasso had produced a diary of an artist's erotic life, a record of obsessions with particular satisfactions and frustrations and fantasies and partners; he happened to survive into his nineties and he went on producing that diary almost to the end. At the same time, during his last years it became admissible to exhibit and publish images of a degree of erotic frankness previously forbidden: indeed, it is worth remembering that, as late as 1968–69, when the '347' series was first shown, at Louise Leiris's, the most extreme images were on view in a private room and illustrated in a supplement to the catalogue; today they can be openly shown and reproduced by national museums (and no doubt the time will return when images much less extreme are not permitted to be shown or reproduced anywhere).

So a splendid conspiracy of the fates brought about an extraordinary mass of work on the subject of loss of manhood, loss of face, loss of everything but the ambivalent pleasures of voyeurism and the will and force to go on making art. One of the great themes of this tragi-comedy is that, while the young painter, even in the course of enjoying the model, is able to portray her, to transform her, to manage her likeness as well as her person, the old painter's incapacity to enjoy her makes him appear ridiculous even in trying to portray her, but he goes on all the same. He has the consolation that the young painter, when he assumes as he often does the form of Raphael (e.g., figs. 154, 155), is due to die before he reaches forty; and the deeper consolation – the theme of one of the very last drawings (cat. 108), in which a woman lies there complacently displaying herself for the devouring gaze of an old man – that he still has eyes with which to exercise his inexhaustible obsession with the marvels of a paradise which his body can no longer enter.

There was an Ur-version of the tragi-comedy in the series of 180 drawings which Picasso made in the winter of 1953–54 after Françoise Gilot left him (figs.13, 15, cats.76, 77). The iconography is an impressive demonstration of putting a brave face on despair. But as drawings they have nothing of the toughness of the prints of the last years. Picasso portrays himself as a ridiculous old man, but he renders doing so bearable by using a style that puts the tragi-comic subject-matter into soft focus. But then the whole Françoise period was near enough the least vigorous artistically of Picasso's career – one of those periods of repose that happen in the work of any long-lived artist. It doesn't do to make easy correlations between an artist's life and his work, but that period was surely the time when Picasso got his life together as never before: he was living with a young woman who was very beautiful and very intelligent and who quickly presented him with an enchanting son and daughter (the birth of his son Paolo in 1921 had been followed by a rather weak two or three years in the middle of an intensely creative time); he had as many loving and admiring friends as even an artist could need; he was as rich, as famous and as photographed as a film star; he was a moral hero of the Resistance, a lighthouse of the Left and a popular cultural hero (as an inquiry in *Réalités* in 1960 revealed) who might in passing make incomprehensible art but was all right because he had fathered a photogenic family when nearing seventy. Our exhibition begins with the ending of that earthly paradise, centred on an archetypal example of the theme of the model in the studio, perhaps the most obsessive of the various obsessive themes of the remaining almost twenty years.

A major factor in Picasso's persistent artistic renewal in those years seems to have been the intensely competitive game he played, more than ever and more systematically than hitherto, of making series of paraphrases – of Delacroix, Velázquez and Manet, and of Poussin combined with David. Doing those series must have been like performing in a very heady jam session, where a player is inspired to improvise variation upon variation both by the lift the others' playing gives him and by the wish to outplay them. In the series on Velázquez's 'Las Meniñas', 1957 (figs.2, 3, 33–36), he was not only taking on his motherland's greatest master but also, I suggest, his old ally and enemy, Braque – 'ma femme', as he is supposed to have called him. Now, Braque had been in tremendous form during the previous ten years, surely in better form than at any time since the heyday of Cubism, the days when he and Picasso had been, as he said, like 'two mountaineers roped together'. And during those recent years his major works had been a series of paintings on a theme which Picasso had long been making his own: the theme of the studio. Compare Braque's 'The Studio V', say, or the grisaille 'The Studio II' (fig.156) with the large grisaille which initiated the 'Meniñas' series (fig.157), and it looks extremely likely that Picasso's composition of a set of variations on the most famous of all pictures on the theme of the studio was set off by a desire to answer Braque in kind.

The prototypes for paraphrases are not confined to great machines. Images of Jacqueline singly can be based, or seem to be based, on famous Old Masters: for example,

[138]

fig.156 Georges Braque, 'Studio, II',
1949. *Kunstsammlung
Nordrhein-Westfalen, Dusseldorf*

fig.157 'Las Meniñas, after Velázquez',
Cannes, 17 August 1957.
Museu Picasso, Barcelona

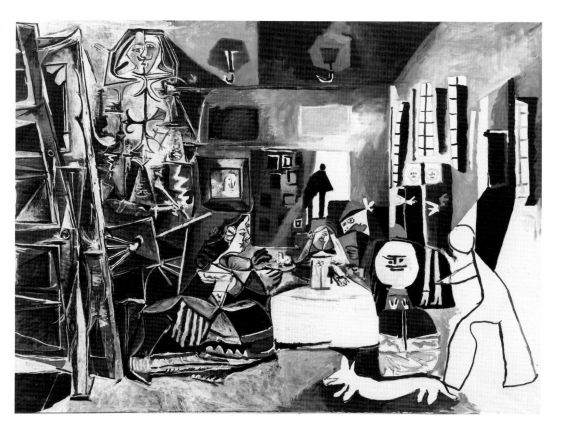

fig.158 Rembrandt, 'A Woman Bathing in a Stream',
1655, 61.8 × 47cm, *National Gallery, London*

fig.159 'Woman Pissing' 16 April 1965, 195 × 97cm,
*Musée National d'Art Moderne, Centre Georges Pompidou,
Paris. Donated by Louise and Michel Leiris 1984.* (cat.33)

as has long been suggested, the large reclining nudes with or without a cat painted in the spring of 1964 (fig.1, cats.26, 27) seem to be versions both of Goya's 'Maja' and of Manet's 'Olympia', while the 'Woman Pissing' of April 1965 (fig.159) seems a version of Rembrandt's 'Woman Bathing' (fig.158) in the National Gallery, London. She is also, of course, as the head's stylistic allusion to Greek vase-paintings tends to confirm, a version of the birth of Venus, she who rose from the froth of the sea after the severed genitals of Uranus had been thrown there by his son Saturn.

This monstrous leering goddess, adorably shameless, thrilled by her prodigality, belongs to a different world from the reclining nudes done only a year before. The earlier pieces are classic works, fluently drawn and succulently painted. The interval between them and the 'Woman Pissing' is scarcely represented in this exhibition: it was a period of transition which produced few pictures of great worth. Picasso emerged from it early in 1965 as an artist who had found his late style – if by 'late style' we mean a style that is all pithiness and abandon.

'Now it seems to me', wrote Adrian Stokes, 'that modern art, the art typical of our day, is the slang, so to speak, of art as a whole, standing in relation to the Old Masters as does slang to ordinary language.' Slang is elliptical, punning, subversive, abusive, casual, witty, unexpected, insolent, abrupt, throwaway and rich in teasing allusions to mandarin matters. If modern art is the slang of art, it has never been as extremely and gloriously so as in Picasso's last works.

They are works which lay utterly naked the horror of growing old. But Picasso was never an expressionist, never one to wear his bleeding heart upon his sleeve. He was a Spaniard, like Don Juan, who joked in the teeth of death and shouted defiance when they dragged him to hell. Picasso's art affirmed until the end that, even when it is a diary, art is not meant to be a confession but a game.

October 1987

II

Seen across the spaces of Beaubourg, the paintings radiated an explosive vitality that outshone their every other quality. The poignancy and the irony and the ribald or terrible truthfulness which they share with the drawings and prints were made rather marginal by the sheer energy with which the paint summarizes form. These paintings' most telling answer to the closing-in of death was their simple demonstration of a gargantuan aliveness. I have rarely, if ever, seen an exhibition in which the presence of the paintings so overwhelmed that of the visitors. Paintings generally, when hemmed in by visitors, seem to retire into their shells; these reach out and consume their public.

The exhibition ran concurrently with one at the Musée Picasso of and around 'Les Demoiselles d'Avignon' (fig.160). That concurrence was due to chance, not to someone's having come up with the bright idea that the 'Demoiselles' had some sort of

special affinity with the late works. But once they were shown virtually together, students of Picasso were struck by the notion that there was in fact a remarkable affinity – that this was a classic instance of the way Picasso had of picking things up, consciously or unconsciously, where he had left them long before. It would also be an instance of our habit in old age of looking at our early days: 'Les Demoiselles d'Avignon' was the giant step of Picasso's early days – he knew it at the time and so did his friends, and his enemies – and in retrospect it went on being the most crucial single work in his entire development. So, given Picasso's perennial habit of self-quotation and given that this became more addictive as he got older, it is not inconceivable that his late works sometimes quote the 'Demoiselles' – that, for example, the head of the 'Woman with a Pillow', 1969 (cat.42), is a conscious allusion to the head of the seated figure in the bottom right corner and not simply a typical Picasso head. However, the real interest does not lie in possible quotations but in the general attributes the 'Demoiselles' and the late works seem to have in common.

Sometimes it is the glance. Often the glance of the late figures resembles one or another of the ways in which caged animals look at us, but quite often it resembles the bold and brazen look of the inmates of the brothel in Avignon Street, a look to be expected there, of course. Above all, there is the over-life-size scale of the figures and the insistence placed on this by their confronting us so directly and challengingly – a scale made significant by the fact that the figures are not gods or demi-gods – pantocrators or madonnas, for instance – but people – some importunate, some indifferent – people we might find ourselves confronted by in a street market, a bar, a station, a brothel, a studio or a fancy-dress party, but who loom up over us here so that they bring us to a sudden and apprehensive stop. The confrontation calls to mind a moment at a Notting Hill carnival when, in a side street where there was space to move, I suddenly heard, above the sounds of the steel bands and the heavy metal, a booming voice call out my name. I perceived that the summons emanated from the figure, standing across the street, of a masked tribal dancer eight or nine feet tall. I found myself walking up to it and standing before it, wondering and afraid. 'You used to come to the Copacabana Club when I was a barman there', it said. 'My name's Cyril. Don't you remember me?'

The resemblance of figures in the 'Demoiselles' and in late Picasso to masked tribal dancers is as crucial as their scale in giving them a threatening force. It is irrelevant whether or not particular faces or bodies are based on particular tribal models: what matters is the air these personages have of coming from a world more primitive, possibly more cannibalistic and certainly more elemental than ours. At the same time the pictorial space also belongs to a less developed culture. Despite the rich assortment of allusions to paintings in the Renaissance tradition, the treatment of space rejects that tradition in favour of an earlier one, the flat unperspectival space of, say, mediaeval Catalan frescoes. All this involves the assimilation of an unprecedented variety of sources, but not so that the work becomes ponderous with erudition. At twenty-five, Picasso's raw vitality was already being enriched by the beginnings of an encyclopaedic

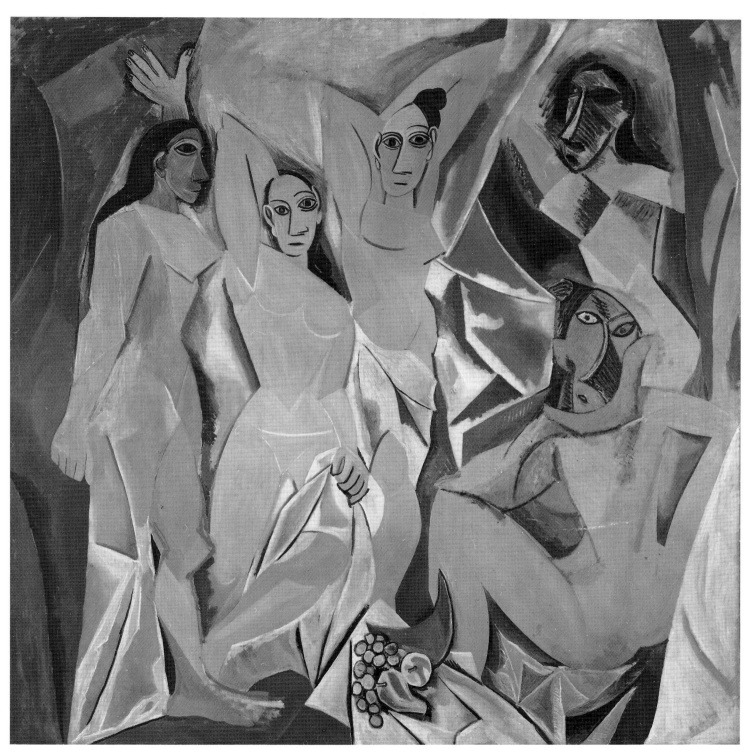

fig.160 'Les Demoiselles d'Avignon', 1907.
244 × 234cm, *Museum of Modern Art, New York*

awareness of art; at ninety, his encyclopaedic awareness of art was still being enlivened by a raw vitality.

It has to be admitted, all the same, that even at its best the late work does not possess the awesome intensity of the 'Demoiselles', that the period 1965–72 is not quite the equal of Picasso's supreme periods, which I take to be, certainly 1907–14, probably 1919–21, and certainly 1925–33: for one thing, there is not the same impression that the artist is continually surprising himself. But it is one of his great periods, and it produced a number (most of which reproduce badly) of his masterpieces, such as the 'Woman Pissing', 1965 (cat.33), the 'Woman with a Pillow', 1969 (cat.42), the 'Seated Musketeer with Sword', 1969 (cat.43), the 'Kiss' dated 24 October 1969 (cat.49), 'The Embrace' dated 19 November 1969 (cat.53), and the one dated 26 September 1970 (cat.55), the 'Reclining Nude' dated 7 September 1971 (cat.63), and the one dated 14–15 November 1971 (cat.67), the 'Landscape' dated 31 March 1972 (cat.69), the 'Reclining Nude and Head', 1972 (fig.161).

That persistence of a raw vitality may be what makes for a crucial difference between Picasso's late style and the late styles which have tended to form our idea of 'late style' – those of Titian and Rembrandt and Michelangelo and also Beethoven and Shakespeare. Late Picasso does not conjoin as they do the trance-like, the blurred, the abruptly abrupt. 'Ripeness is all', said Lear, and perhaps quintessential 'late style' has to be reached through a ripeness precluded by eternal youth.

Yet it seems to me that there are a very few very late pieces which come much closer to the familiar ideal of late style. For one, there is the 'Landscape' dated 31 March 1972 (cat.69). I am sure it is the greatest painting Picasso ever did in the genre – a genre he scarcely touched in his last years – and unsure of everything else about it. I suspect that it is a landscape seen in rainy, windy weather, that it is painted from indoors, that it is a metaphor for a reclining female figure, and also that, despite its wholly modern technique, the way it is painted has something in common with late Titian.

And then there are three paintings all measuring 130 × 195 cm, the standard format called 120F, with its unusual proportions of two to three: the 'Reclining Figure' dated 7 September 1971 (cat.63), the 'Reclining Nude and Head' dated 25 May 1972 (fig.161) and 'The Embrace' dated 1 June 1972 (cat.72). The last is clearly an *alla prima* painting and perhaps one that Picasso would have liked to go on with; the second was undoubtedly, as John Richardson points out, worked on over a period of time. These two are among Picasso's three or four last known paintings; the other was painted nearly nine months earlier but is very close to them in feeling and in idiom. It is an idiom which looks back, not to that of the 'Demoiselles', but – despite the difference in scale – to that of certain synthetic Cubist collages, constructions and paintings of 1913–14, especially some of those in which Picasso became a Surrealist *avant la lettre*: for example, the 'Reclining Nude and Head' (fig.161) is strongly reminiscent of one of the relief constructions made in 1913, the one with a guitar and a bottle of Bass, in its first state (fig.162) – and the painting also has the quasi-pointillist dots highly characteristic of

fig.161 'Reclining Nude and Head',
25 May 1972, 130 × 195cm,
Private Collection. (cat.70)

fig.162 'Guitar and Bottle of Bass', 1913
1st state of work in Musée Picasso
photo: *Galerie Louise Leiris, Paris*

this phase. It is interesting that Picasso's very last paintings relate to the phase in his past which surely has a more plausible claim than any other to being the embodiment of the essential Picasso.

In these late late paintings the synthetic cubist structures exist in that uncanny, swimmy sort of atmosphere which is typical of late style and seems to have to do with loss and departure and floating away (as well as with fading sight and the insouciance of old age). The structures too are mysterious, indecipherable, full of uncertainties. They suggest images of barges bearing dead heroes to their resting places; suddenly Picasso's element seems to be water, after always being fire or air. Such speculation apart, there are intimations of both serenity and menace which together seem to speak of a will to embrace death. It is a will which, under the torture of extreme longevity, is seen to break down in certain drawings done after the final paintings, drawings possessed by horror. Here it can no longer be said that Picasso was never an expressionist. Here he lets go, in those staring heads done at the end of June (cats. 100, 101) and the drawing dated 3 October of a naked woman lying back in an armchair (fig. 163). She is masturbating, using both her hands, and all around there are hands, hands without explanation. They might be instruments of forces which are mauling her and threatening to tear her apart; they might be holding her together. They certainly serve in their multiplicity to emphasize her aloneness. They might, in spite of all that and along with all that, be about the fact that, when an artist is past almost everything, he can still watch his beloved, or think of her, using her hand to pleasure herself and can still, perhaps, use his hand to draw. The image seems a statement that that much consolation is not enough.

April 1988

fig.163 'Nude in an Armchair',
3 October 1972, 59 × 75.5cm,
Musée Picasso, Paris

Catalogue

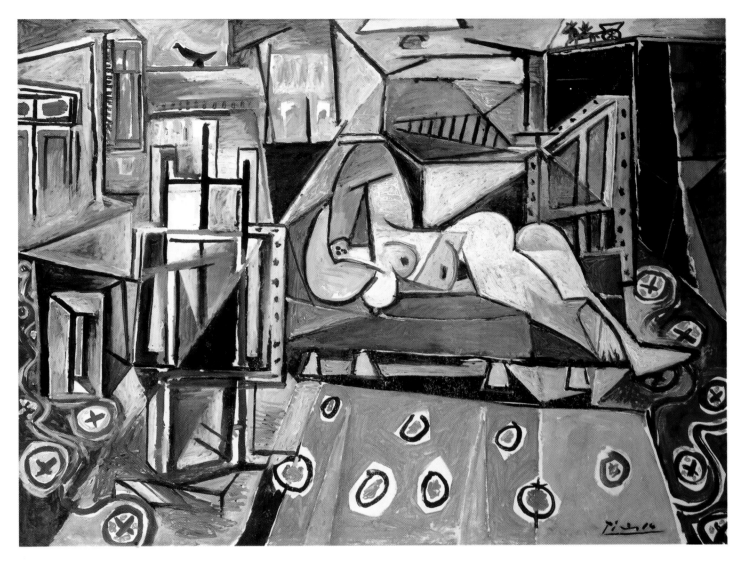

2 Nude in the Studio
30 December 1953
$35 \times 45\frac{3}{4}$ (89 × 116.2)

1 The Shadow
29 December 1953
$49\frac{1}{2} \times 38$ (125.5 × 96.5)

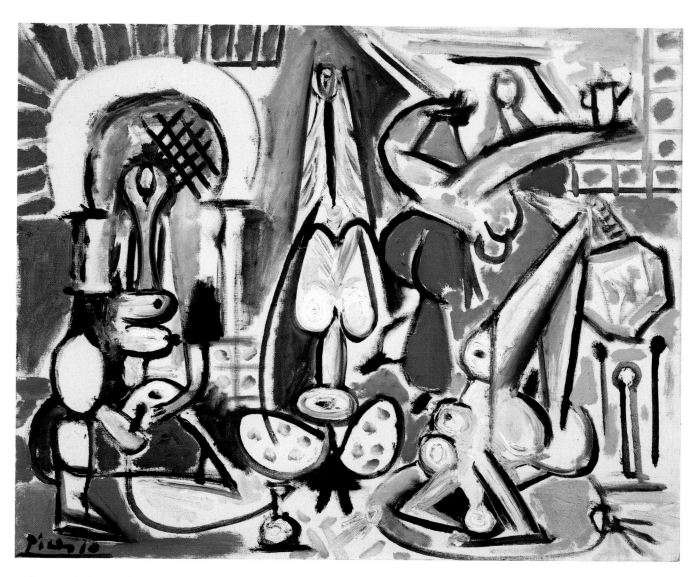

3 Women of Algiers, after Delacroix
28 December 1954
$21\frac{1}{4} \times 25\frac{1}{2}$ (54 × 65)

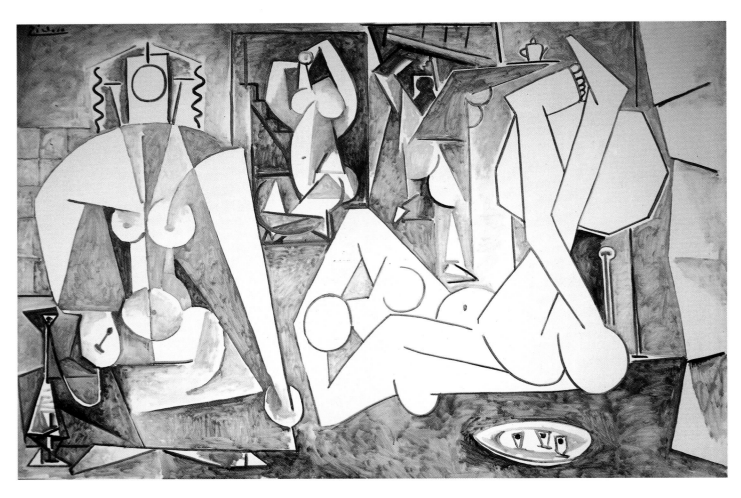

4 Women of Algiers, after Delacroix
11 February 1955
$51\frac{1}{4} \times 76\frac{3}{4}$ (130 × 195)

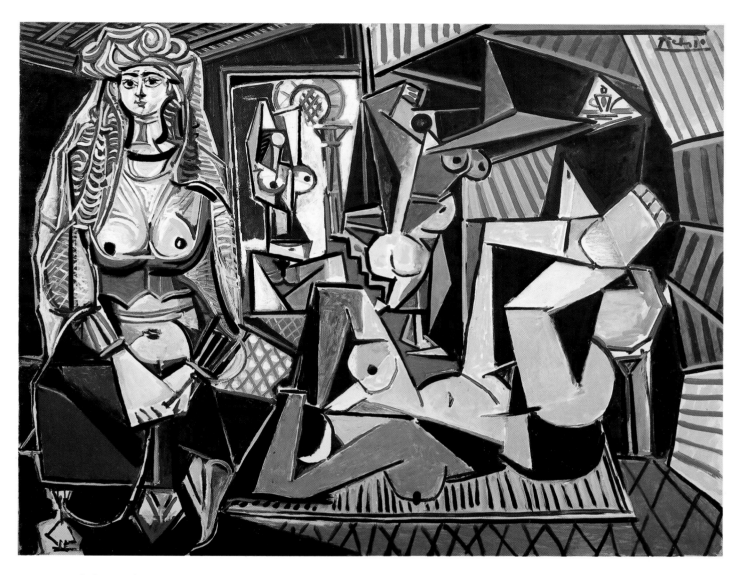

5 Women of Algiers, after Delacroix
14 February 1955
$45 \times 57\frac{1}{2} (114.2 \times 146)$

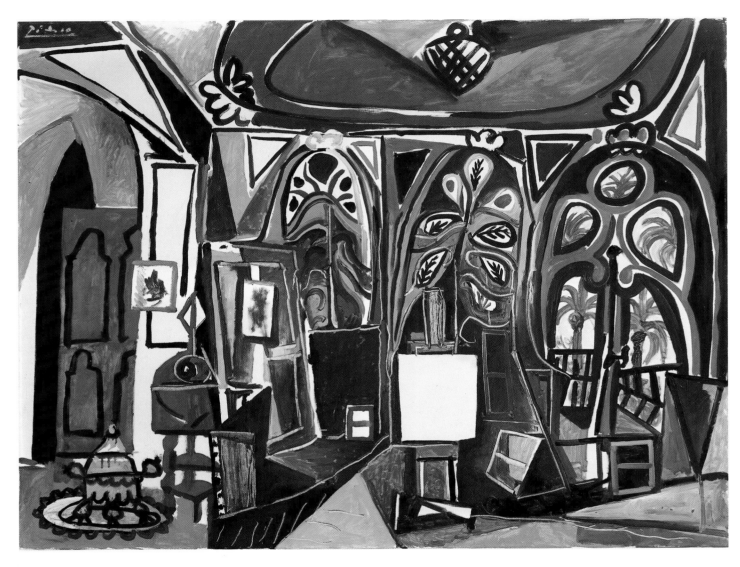

7 The Studio
1 April 1956
$35 \times 45\frac{3}{4}$ (89 × 116)

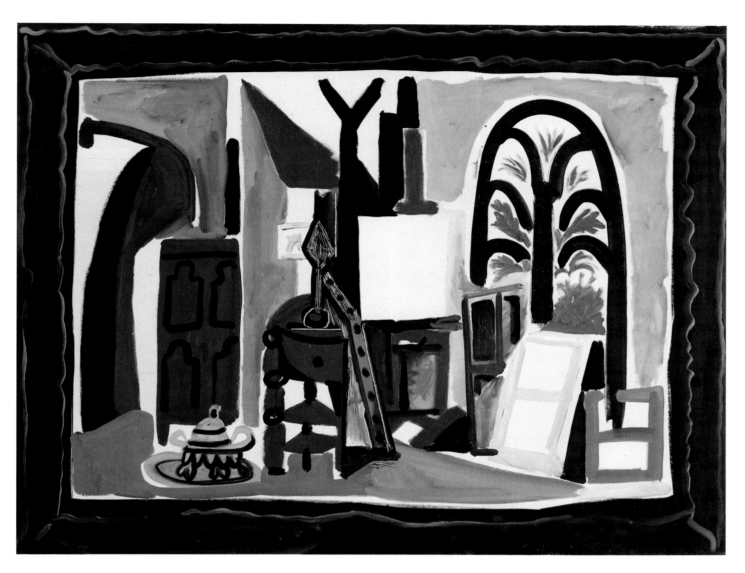

8 The Studio in a Painted Frame
2 April 1956
$35 \times 45\frac{1}{2}$ (88.8 × 115.5)

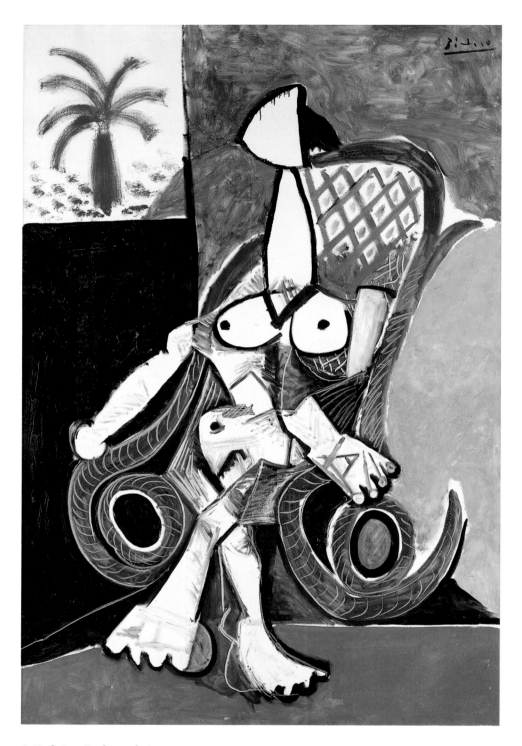

6 Nude in a Rocking-chair
26 March 1956
$76\frac{3}{4} \times 51\frac{1}{4}$ (195 × 130)

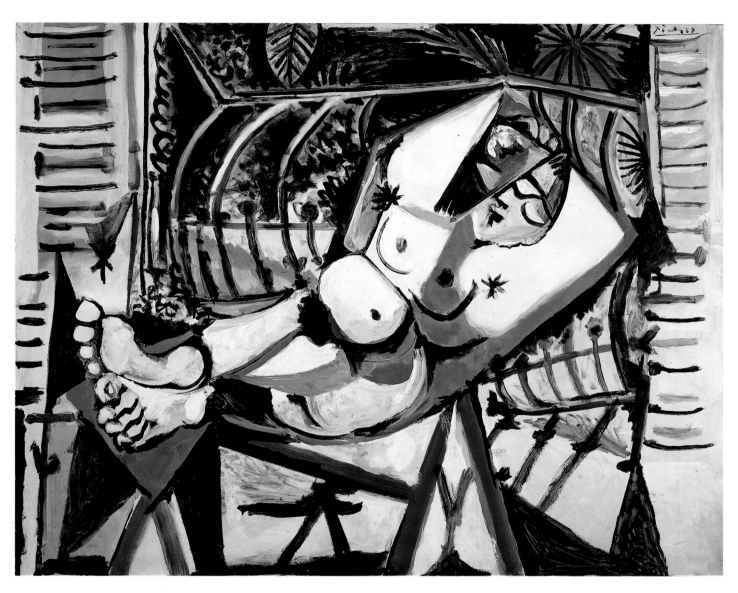

9 Nude in front of a Garden
29–31 April 1956
$51\frac{1}{4} \times 64$ (130 × 162.5)

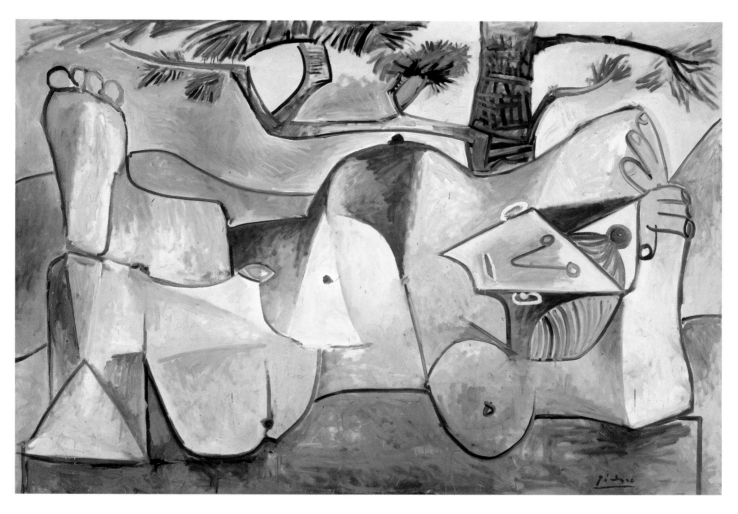

10 Nude under a Pine Tree
20 January 1959
$76\frac{1}{2} \times 110$ (194.3 × 279.5)

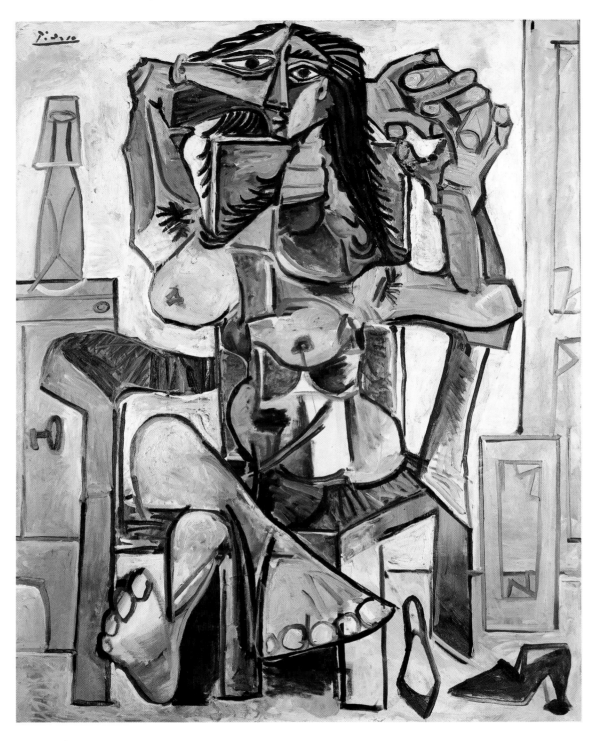

11 **Seated Nude**
1959
$57\frac{1}{2} \times 45$ (146 × 114.2)

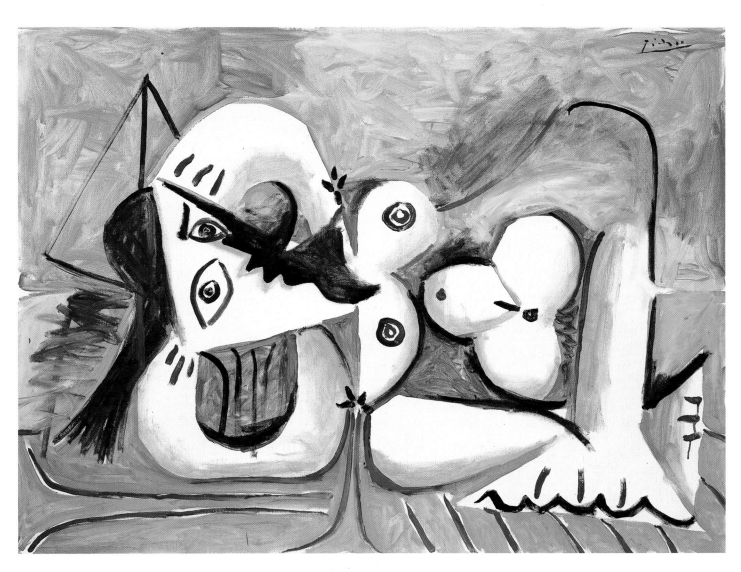

12 Reclining Nude on a Blue Divan
20 April 1960
35 × 45½ (89 × 115.5)

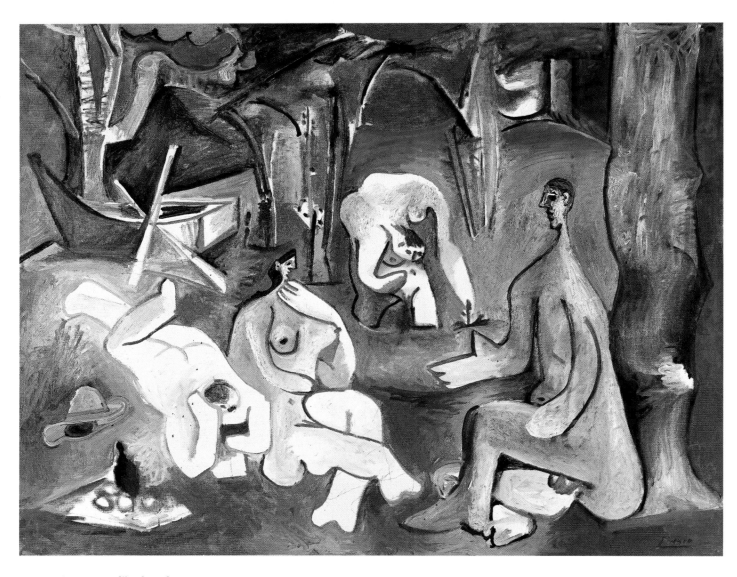

13 Le Déjeuner sur l'herbe, after Manet
10 July 1961
$45 \times 57\frac{1}{2}$ (114 × 146)

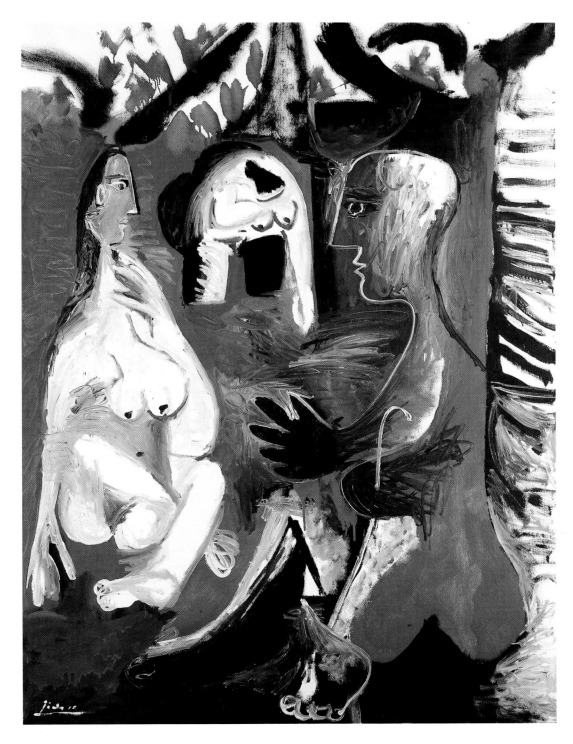

14 Le Déjeuner sur l'herbe, after Manet
30 July 1961
$51\frac{1}{4} \times 38\frac{1}{4}$ (130 × 97)

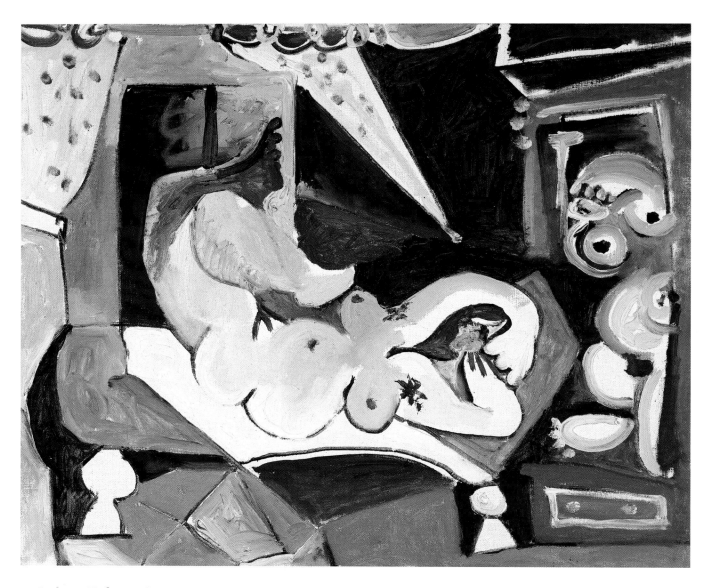

15 **Reclining Nude in an Interior**
27 November 1961 (I)
18 × 21¾ (46 × 55)

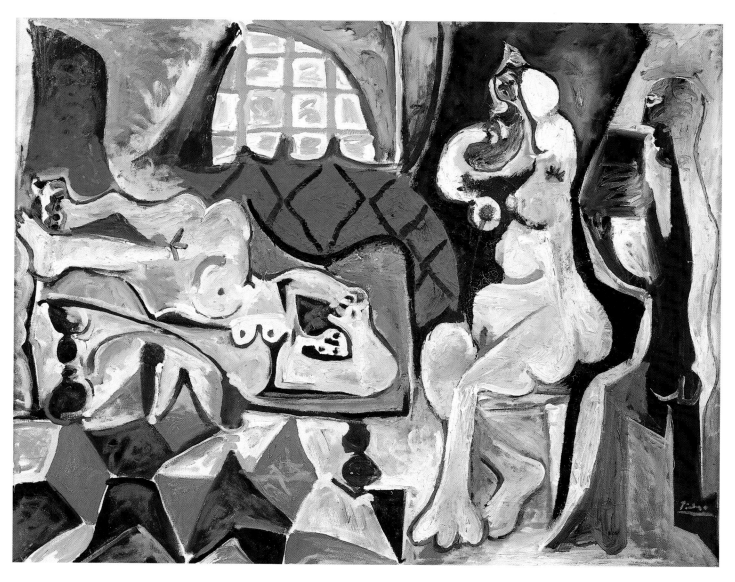

16 Nudes in an Interior
27 November 1961–31 January 1962
29 × 36 (73.6 × 91.4)

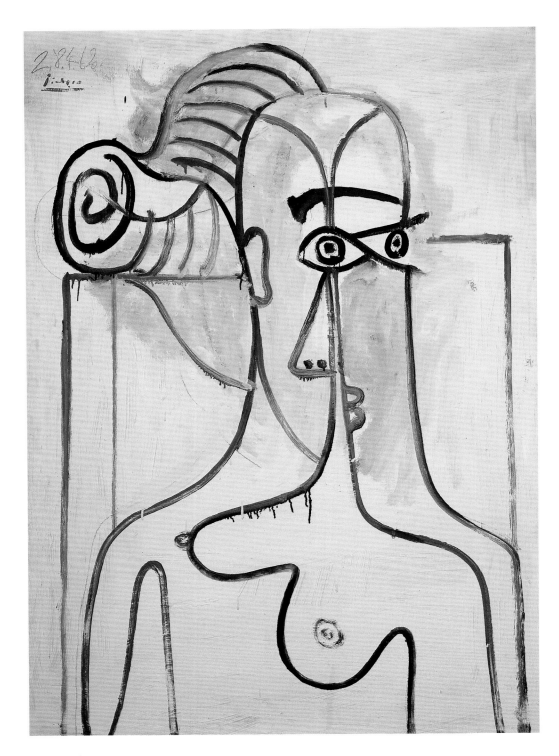

17 Bust of a Woman
28 April 1962
$41\frac{3}{4} \times 29\frac{1}{2}$ (106 × 75)

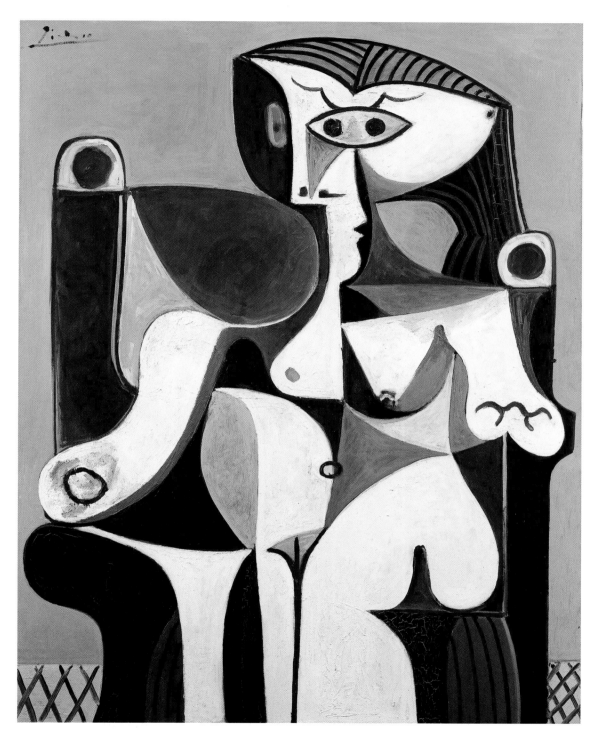

18 Seated Nude
13 May – 16 June 1962
$57\frac{1}{2} \times 45$ (146 × 114)

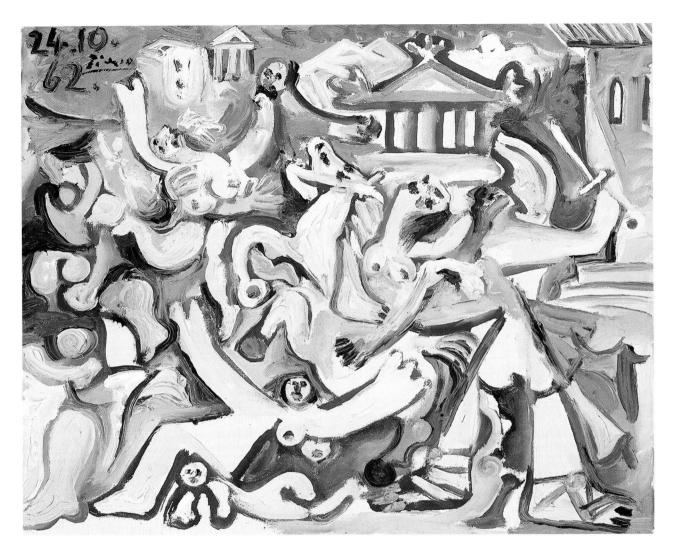

19 The Rape of the Sabines
24 October 1962
18 × 21¾ (46 × 55)

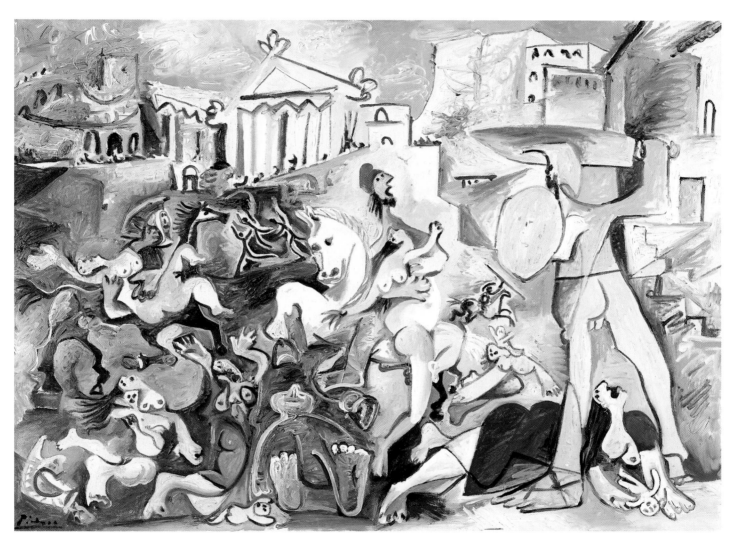

22 The Rape of the Sabines
4, 8 November 1962
$38\frac{1}{4} \times 51\frac{1}{4}$ (97 × 130)

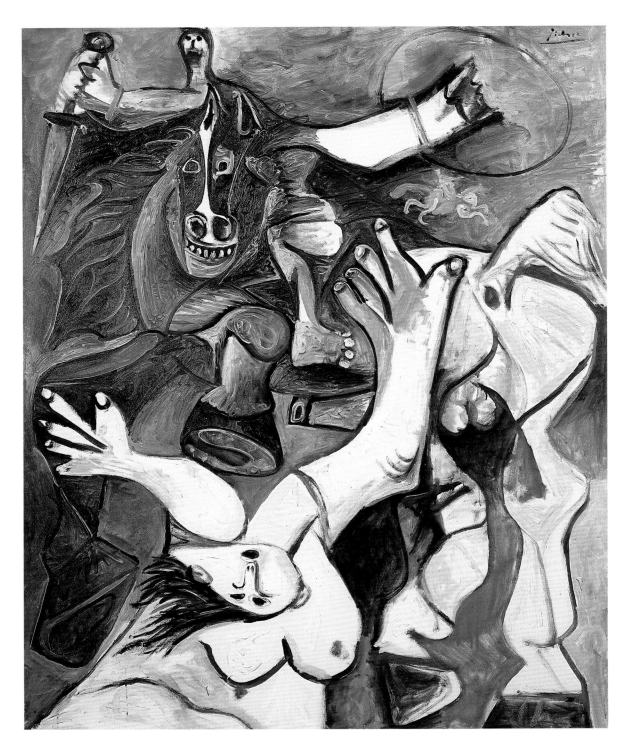

21 The Rape of the Sabines
2 November 1962
$63\frac{3}{4} \times 51\frac{1}{4}$ (162 × 130)

20 Still-Life with Cat and Lobster
23 October, 1 November 1962
$51\frac{1}{4} \times 63\frac{3}{4}$ (130 × 162)

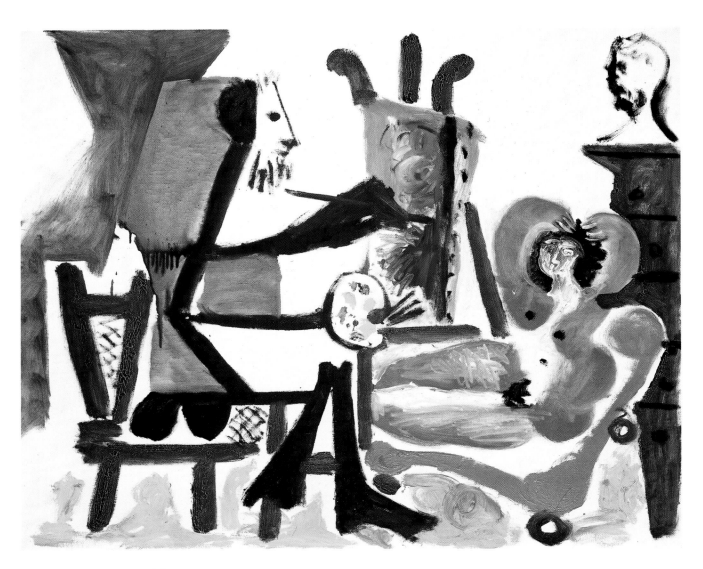

23 The Artist and his Model
4, 5 March 1963
$32 \times 39\frac{1}{2}$ (81×100)

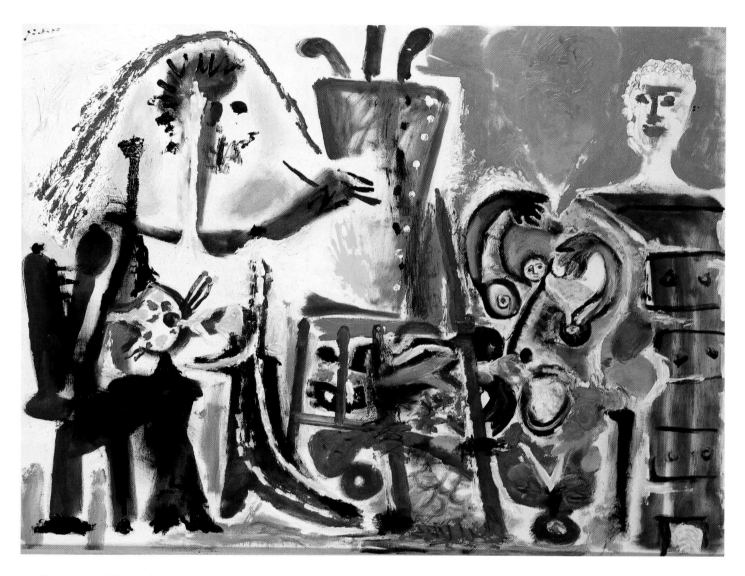

24 The Artist and his Model
5 March, 20 September 1963
$35 \times 45\frac{3}{4}$ (89 × 116.5)

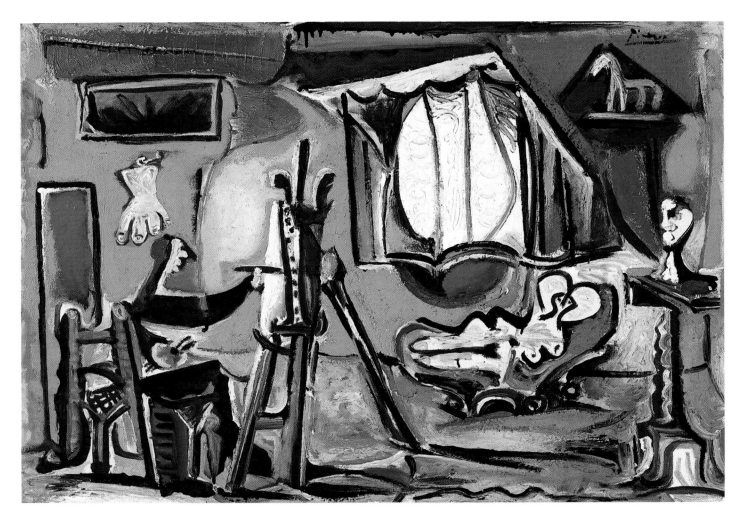

25 The Artist and his Model in the Studio
9 April 1963
$25\frac{1}{2} \times 36\,(65 \times 92)$

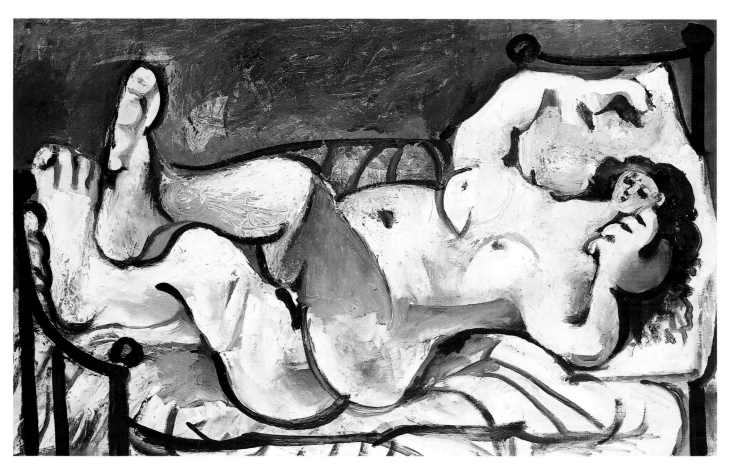

26 Reclining Nude
9, 18 January 1964
$25\frac{1}{2} \times 39 \ (65 \times 100)$

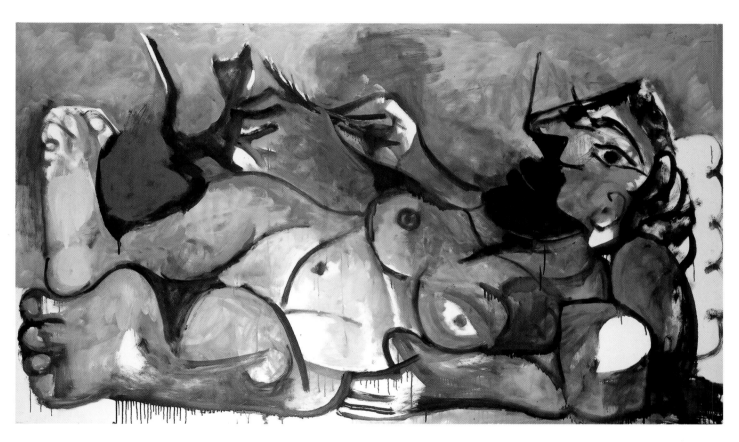

27 Reclining Nude Playing with a Cat
10, 11 May 1964
45 × 76¾ (114.2 × 195)

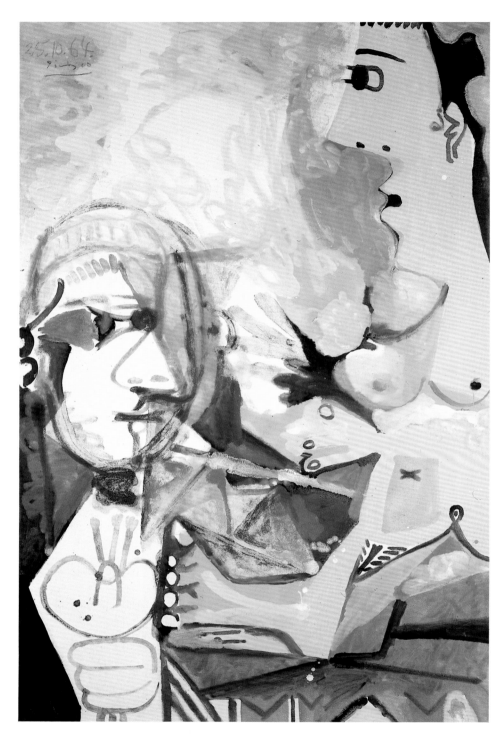

28 The Artist and his Model
25 October 1964
$76\frac{3}{4} \times 51\frac{1}{4}$ (195 × 130)

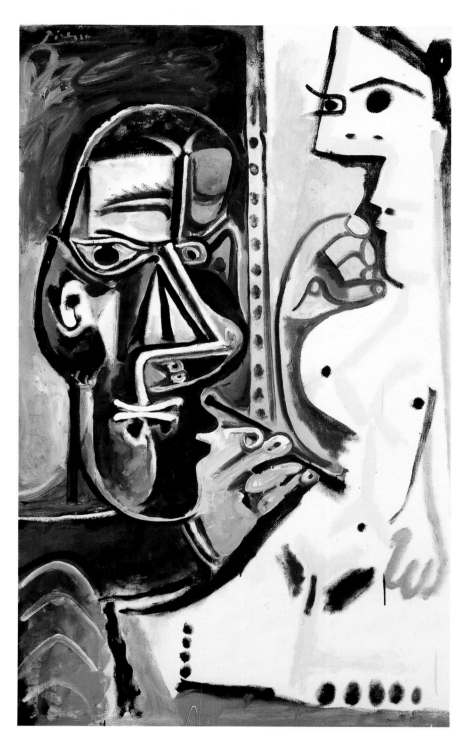

29 The Artist and his Model
26 October (II), 3 November 1964
$57\frac{1}{2} \times 35$ (146 × 89)

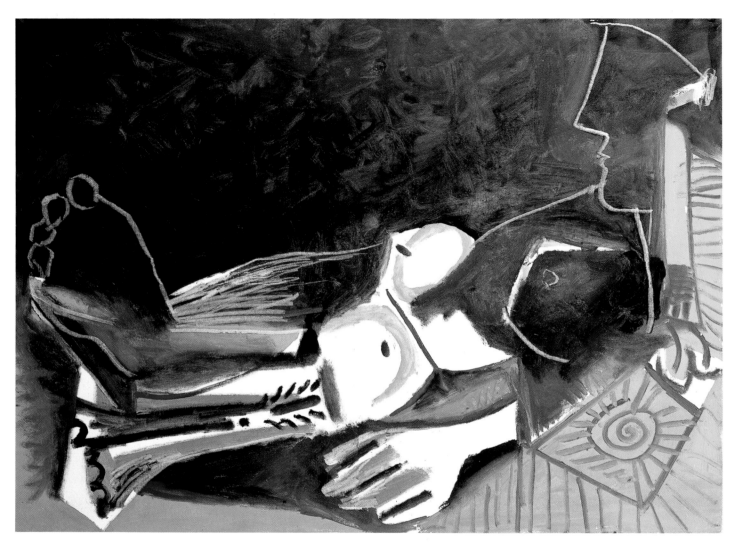

31 **Reclining Nude with a Green Background**
24 January 1965
$35 \times 45\frac{3}{4}$ (89 × 116)

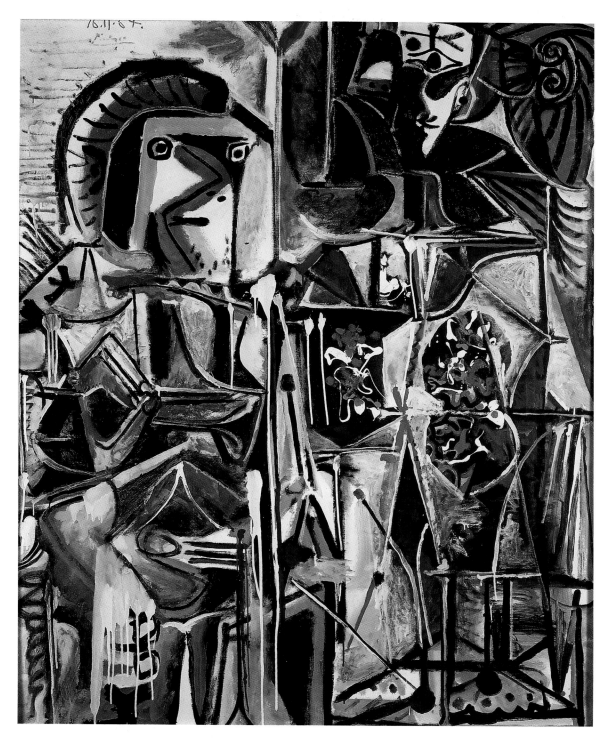

30 The Artist and his Model
16 November – 9 December 1964
$63\frac{3}{4} \times 51\frac{1}{4}$ (162 × 130)

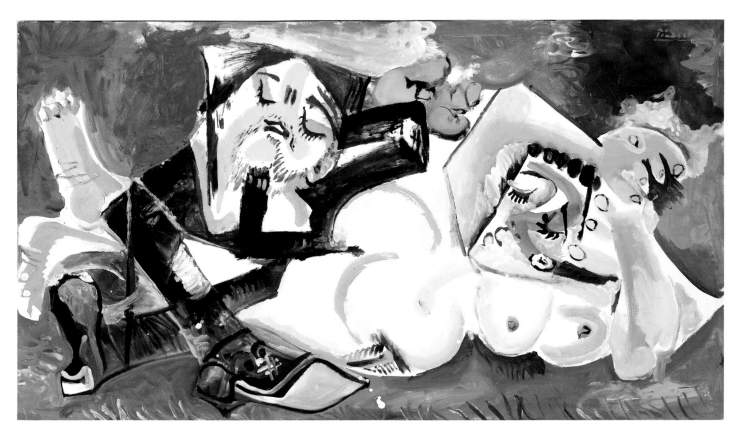

32 The Sleepers
13 April 1965
45 × 76¾ (114.2 × 195)

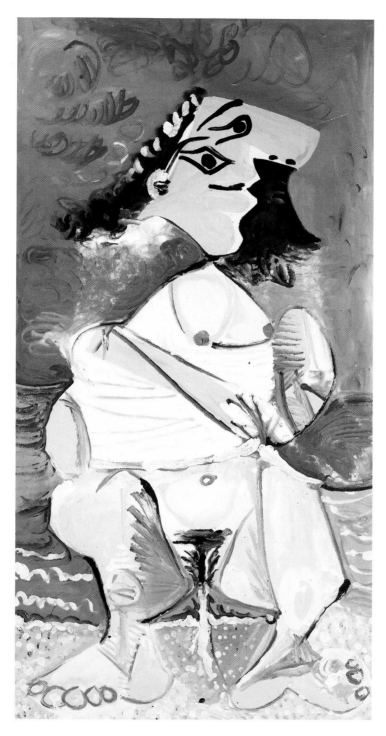

33 Woman Pissing
16 April 1965 (I)
76¾ × 38¼ (195 × 97)

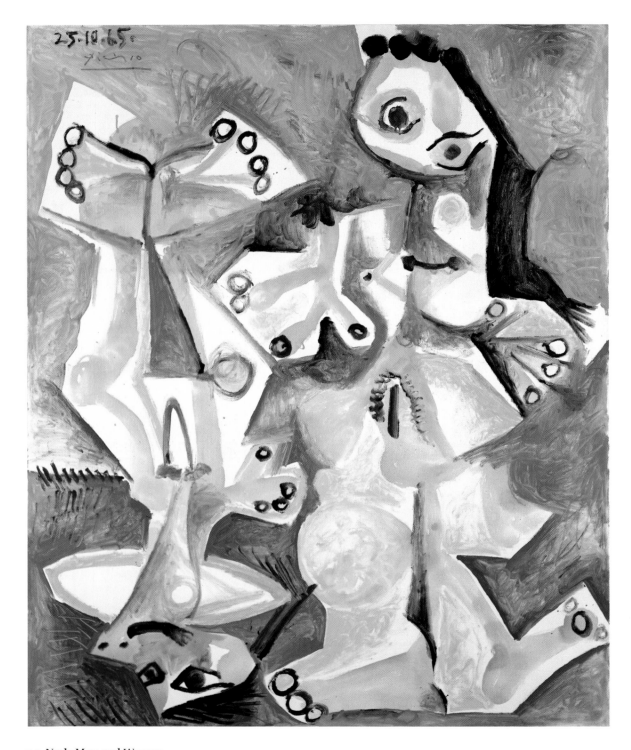

34 Nude Man and Woman
25 October 1965
$63\frac{3}{4} \times 51\frac{1}{4}$ (162 × 130)

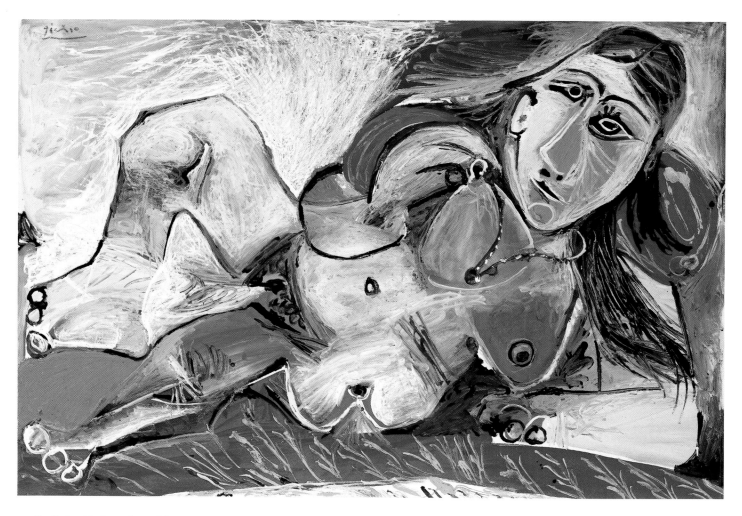

37 Reclining Nude with Necklace
8 October 1968 (I)
$44\frac{3}{4} \times 63\frac{3}{4}$ (113.5 × 161.7)

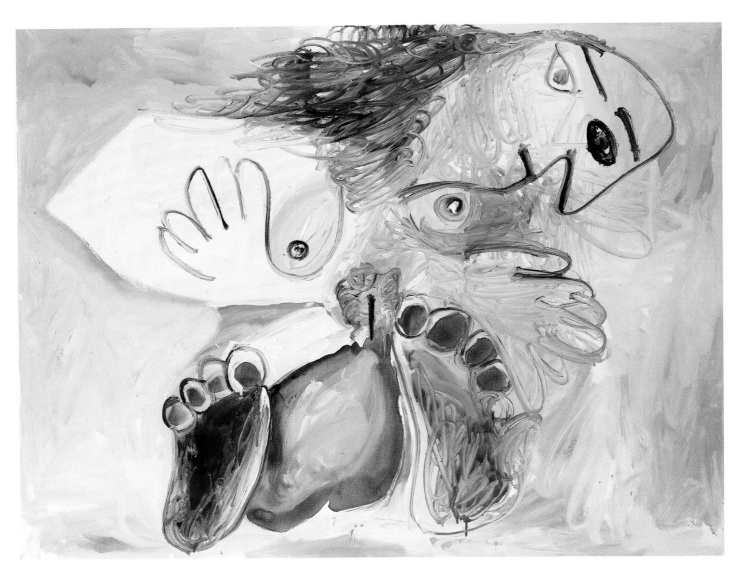

35 Reclining Nude
9 October 1967
45 × 57½ (114.2 × 146)

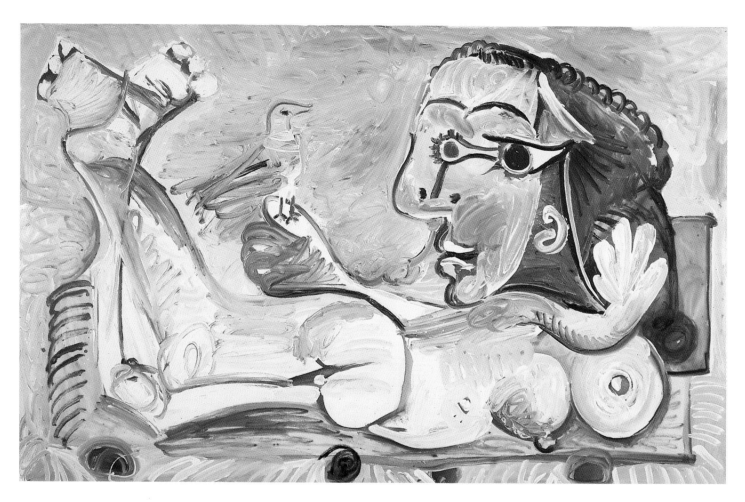

36 Reclining Nude with Bird
17 January 1968
$51\frac{1}{4} \times 76\frac{3}{4}$ (130 × 195)

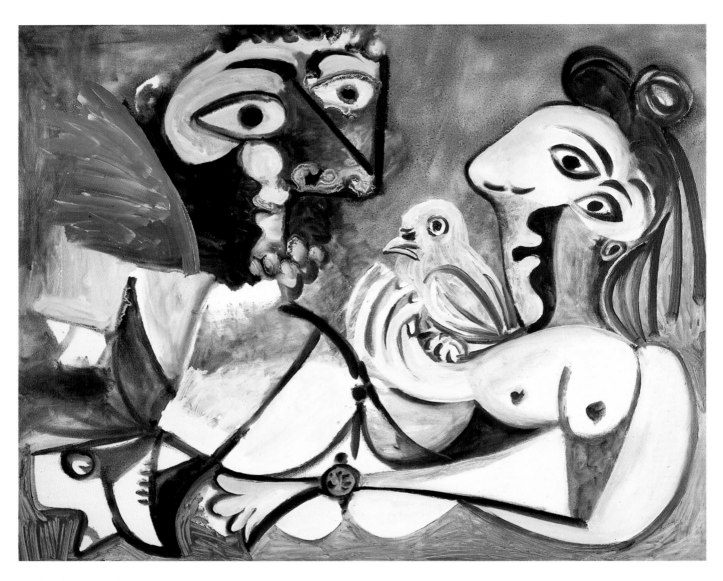

39 Couple with Bird
17 January 1969
51¼ × 63¾ (130 × 162)

42 Woman with a Pillow
10 July 1969
$76\frac{3}{4} \times 51\frac{1}{4}$ (195 × 130)

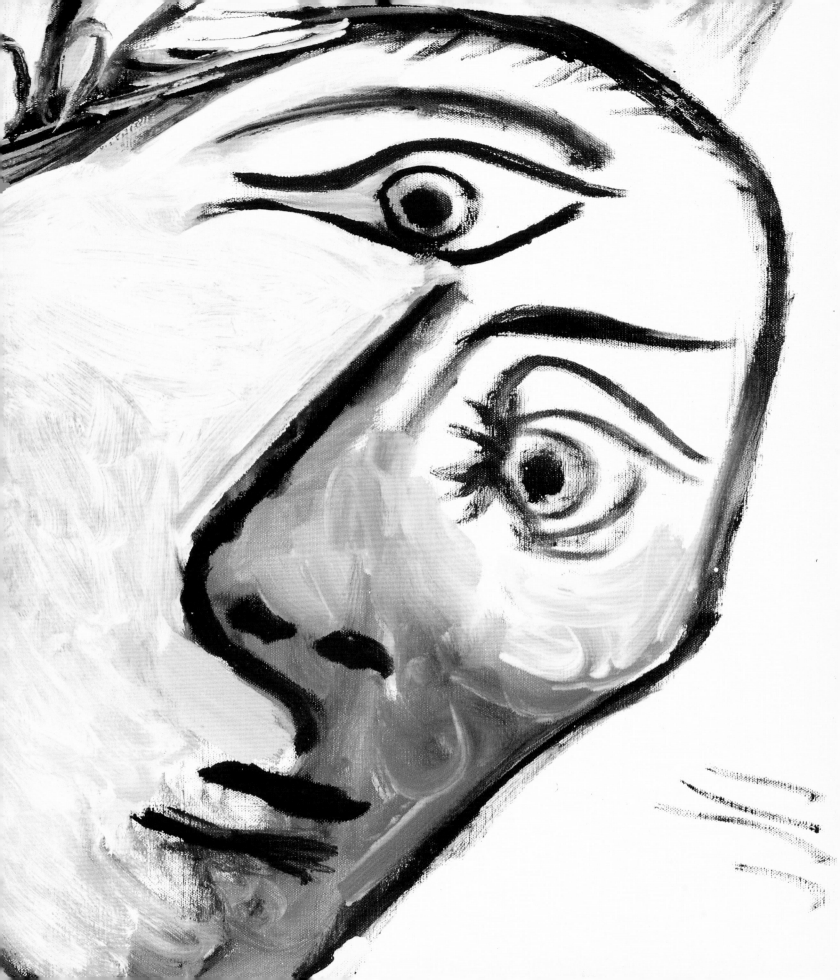

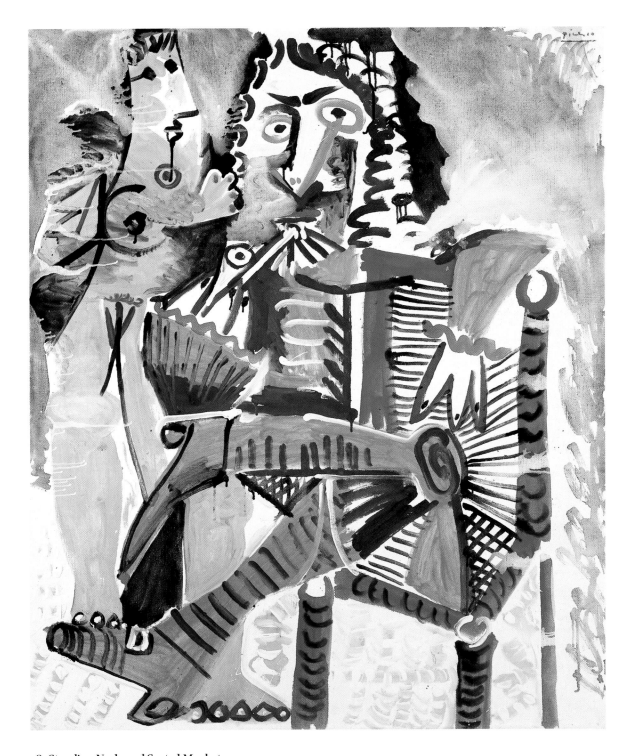

38 Standing Nude and Seated Musketeer
30 November 1968
$63\frac{3}{4} \times 51\frac{1}{4}$ (162 × 130)

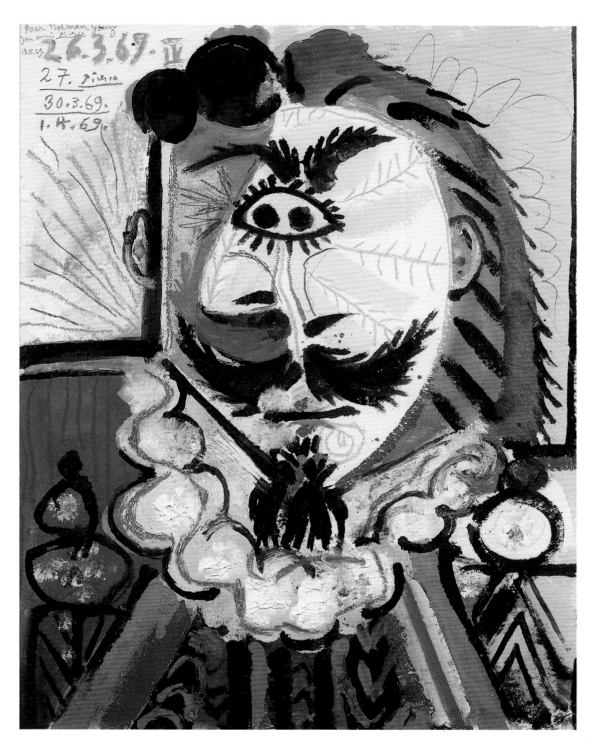

41 Musketeer
1 April 1969
$25\frac{1}{4} \times 19\frac{3}{4}$ (64 × 50)

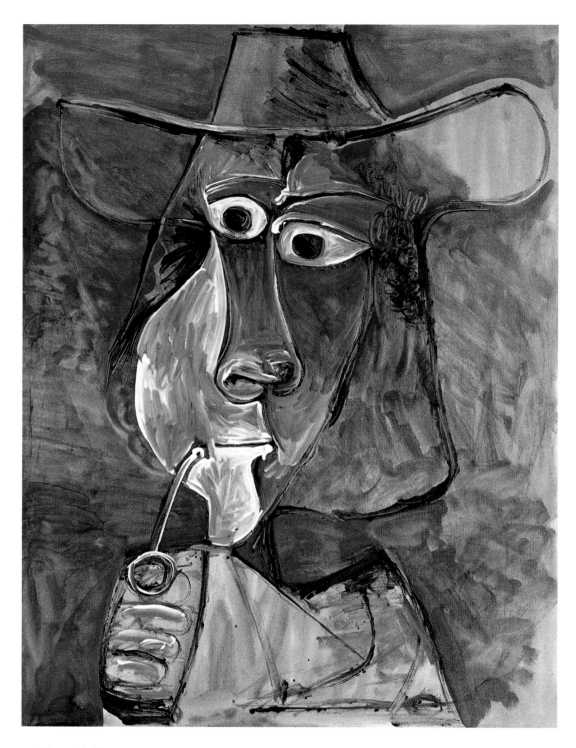

45 Man with Pipe
10 September 1969 (I)
$51\frac{1}{4} \times 38\frac{1}{4}$ (130 × 97)

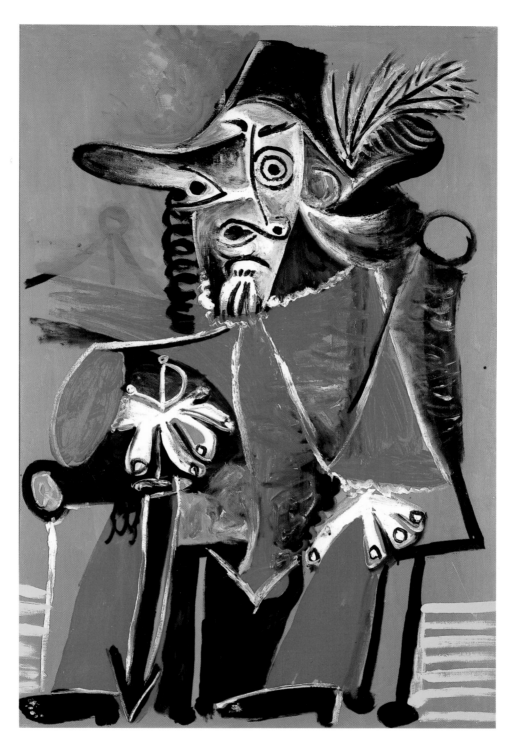

43 Seated Musketeer with Sword
19 July 1969
$76\frac{3}{4} \times 51\frac{1}{4}$ (195 × 130)

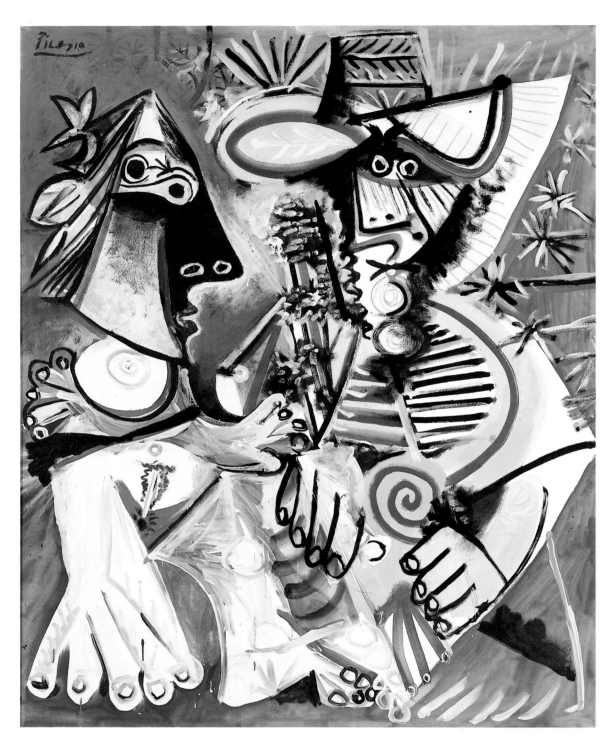

44 Man and Woman
7 September 1969
$64 \times 51\frac{5}{16}$ (163 × 130.2)

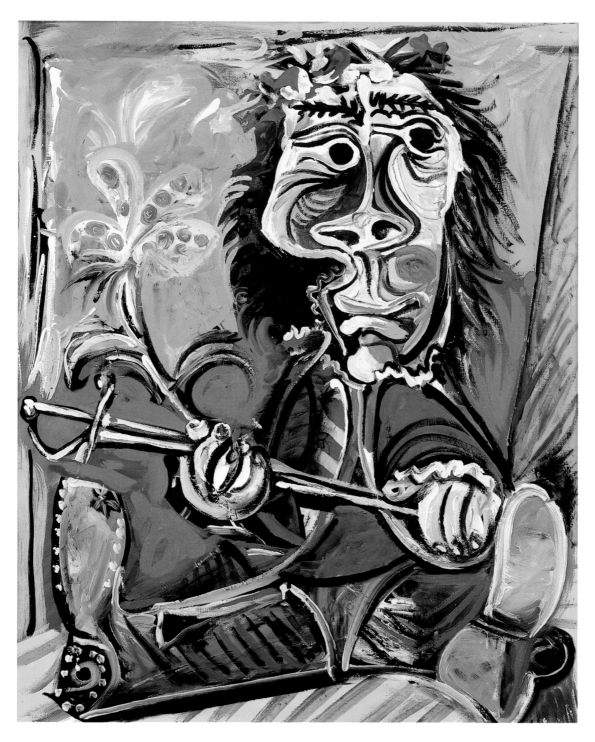

46 Seated Man with Sword and Flower
2 August (II), 27 September 1969
$57\frac{1}{2} \times 45$ (146 × 114.2)

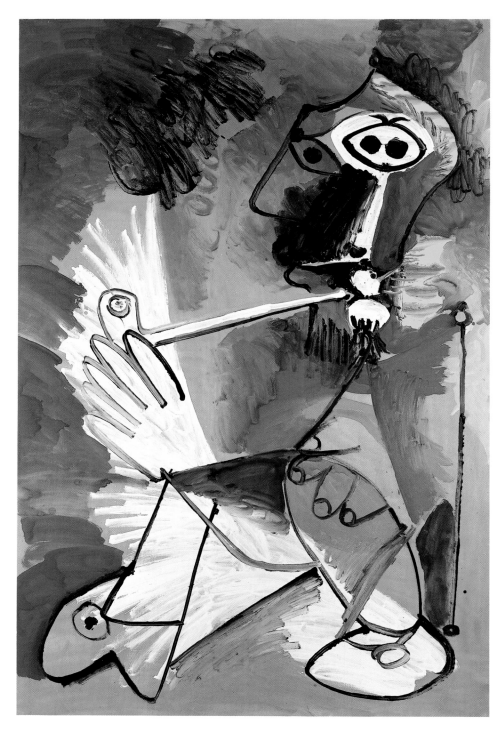

40 The Smoker
14 March 1969 (IV)
$76\frac{3}{4} \times 51\frac{1}{4}$ (195 × 130)

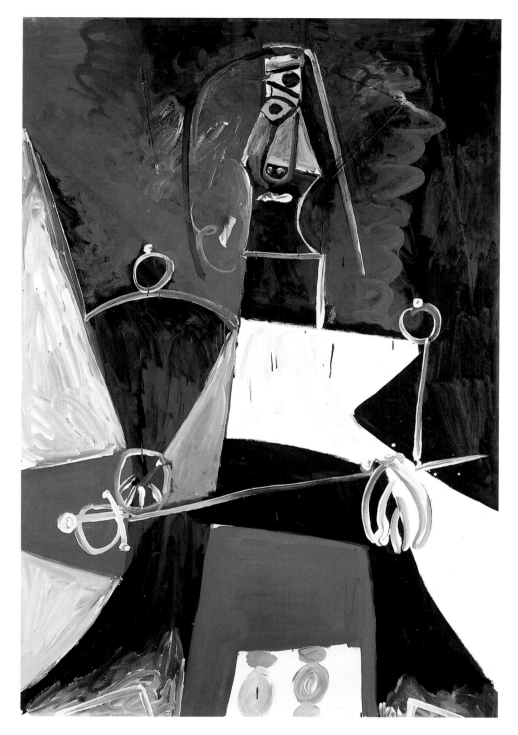

47 Seated Man with Sword
30 September 1969
$76\frac{3}{4} \times 51\frac{1}{4}$ (195 × 130)

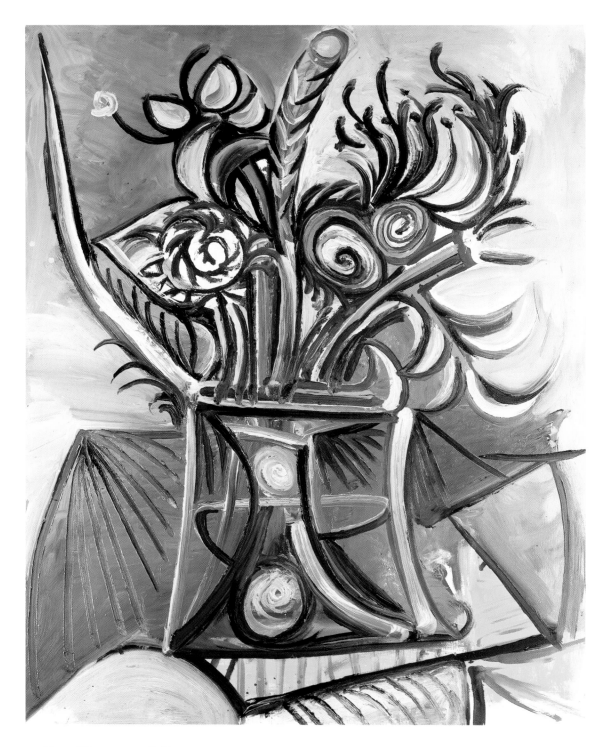

50 Vase of Flowers on a Table
28 October 1969
$45\frac{3}{4} \times 35$ (116 × 89)

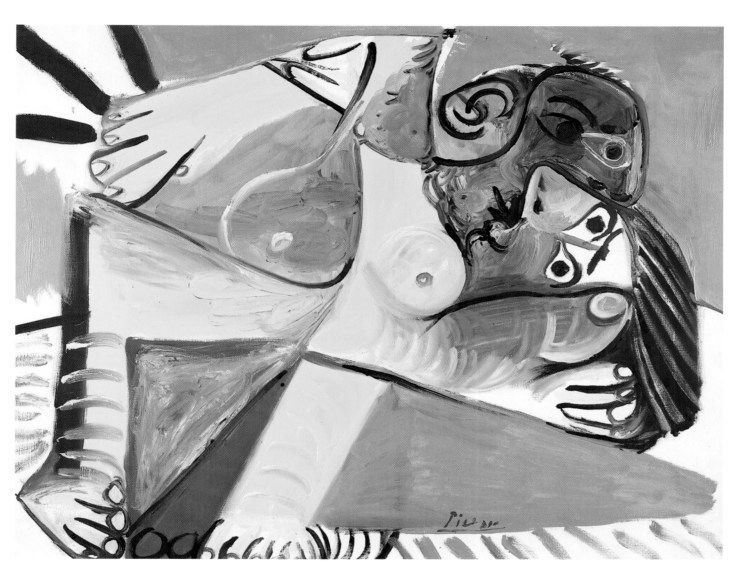

48 Couple
23 October 1969
45 × 57½ (114.2 × 146)

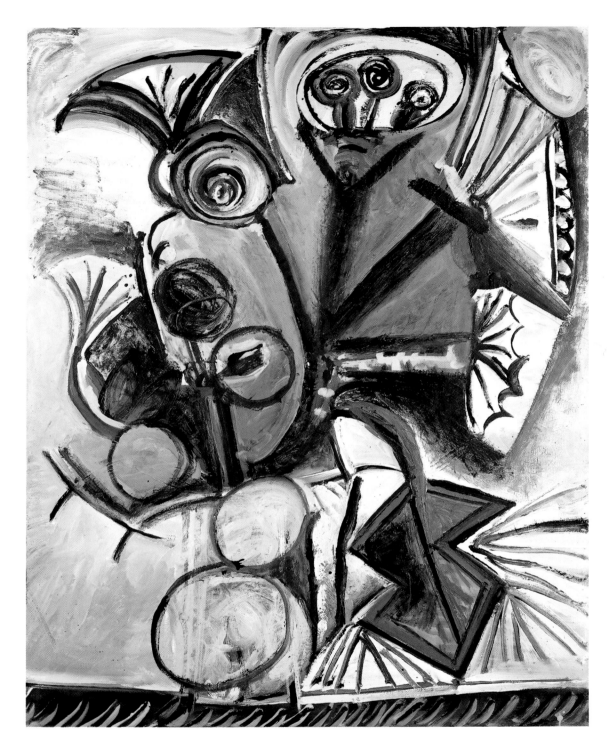

52 Bunch of Flowers
7 November 1969 (II)
$57\frac{1}{2} \times 45$ (146 × 114.2)

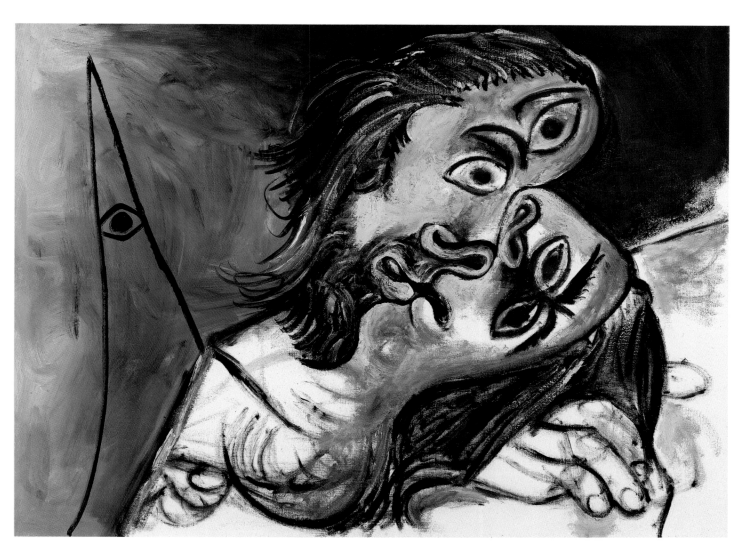

49 The Kiss
24 October 1969 (I)
$38\frac{1}{4} \times 51\frac{1}{4}$ (97 × 130)

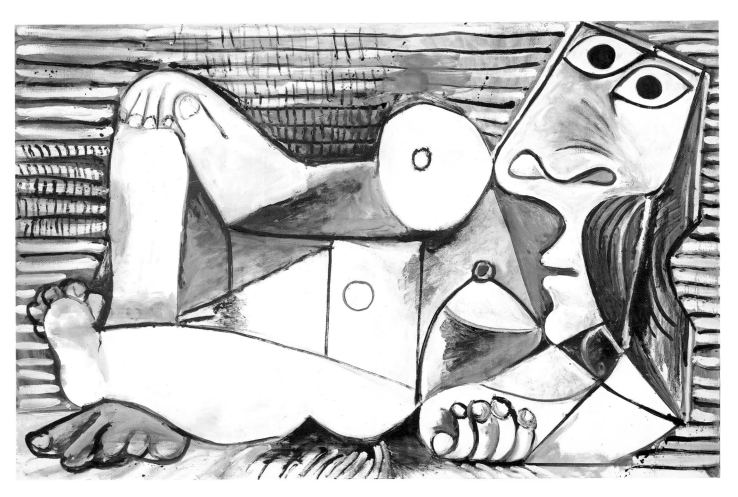

51 Reclining Nude
2 November 1969
$51\frac{1}{4} \times 76\frac{3}{4}$ (130×195)

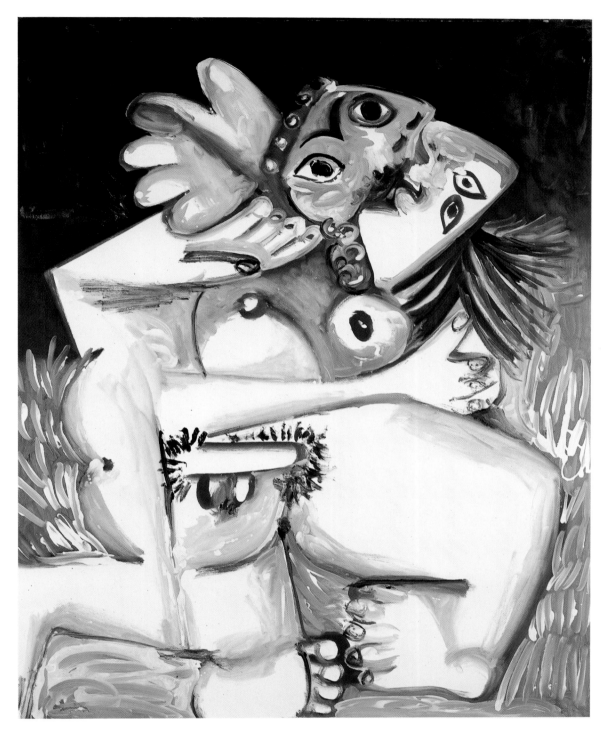

53 The Embrace
19 November 1969 (II)
63¾ × 51¼ (162 × 130)

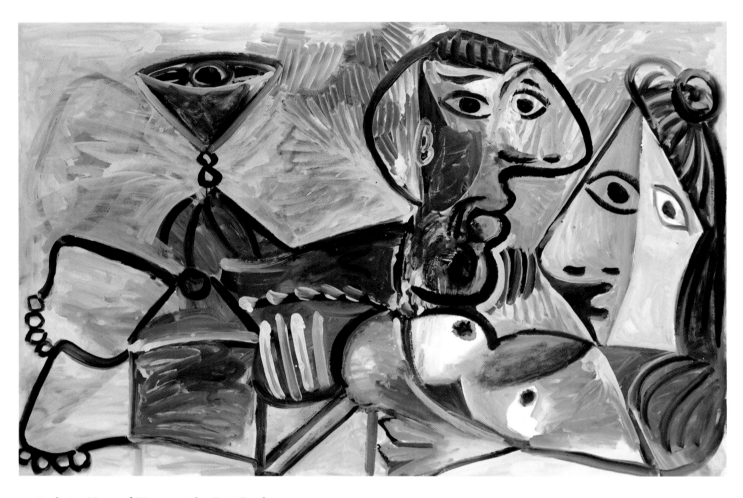

54 Reclining Man and Woman with a Fruit Bowl
29 December 1969
$51\frac{1}{4} \times 76\frac{3}{4}$ (130 × 195)

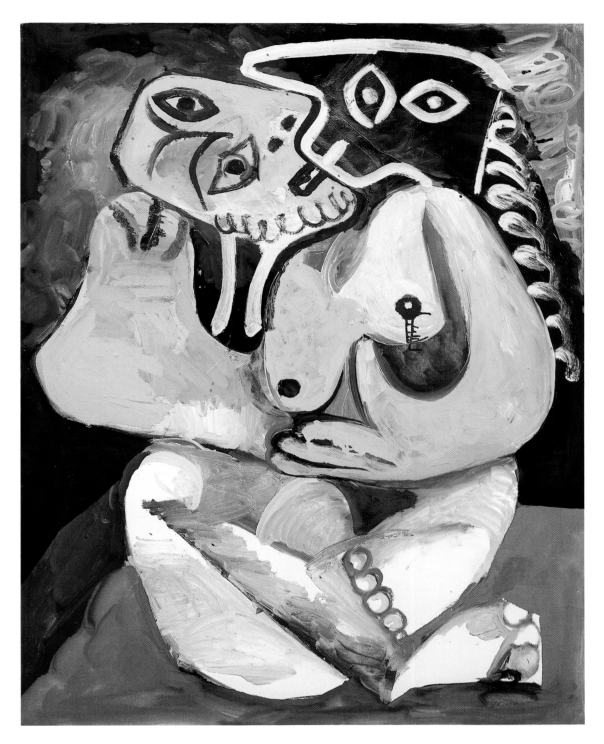

55 The Embrace
26 September 1970 (II)
$57\frac{1}{2} \times 45$ (146 × 114.2)

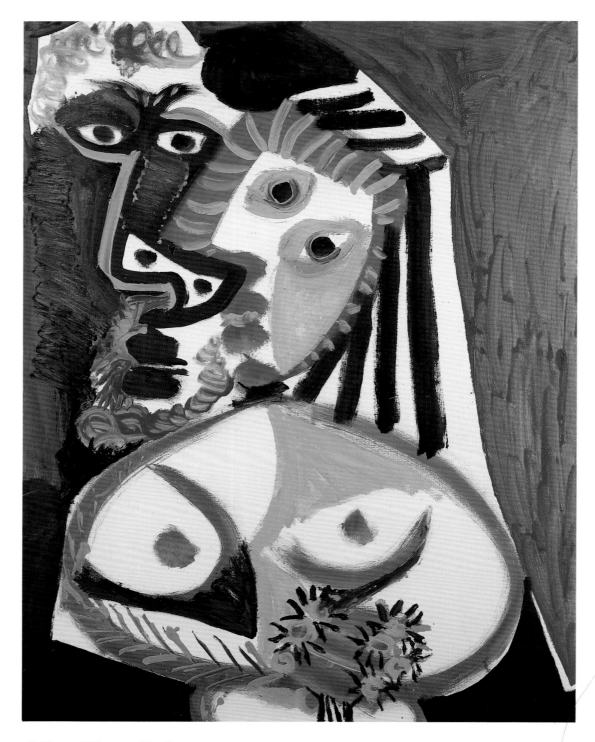

56 Man and Woman with a Bouquet
26 October 1970
$45\frac{3}{4} \times 35$ (116 × 89)

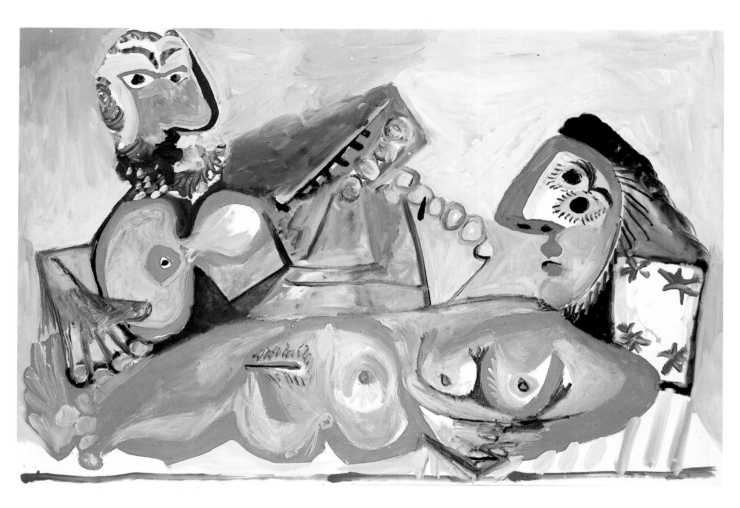

57 Reclining Nude with a Man Playing the Guitar
27 October 1970
$51\frac{1}{4} \times 76\frac{3}{4}$ (130 × 195)

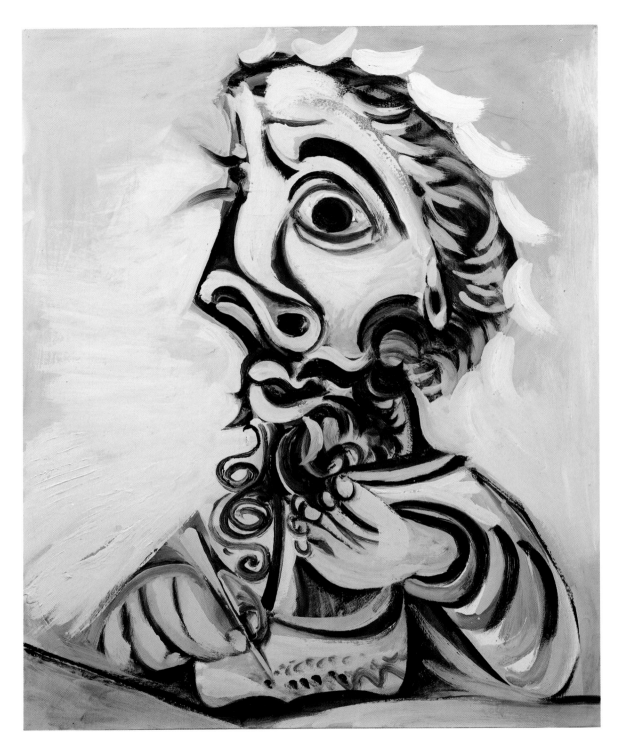

58 Man Writing
7 July 1971 (II)
$43\frac{1}{4} \times 32 \ (110 \times 81)$

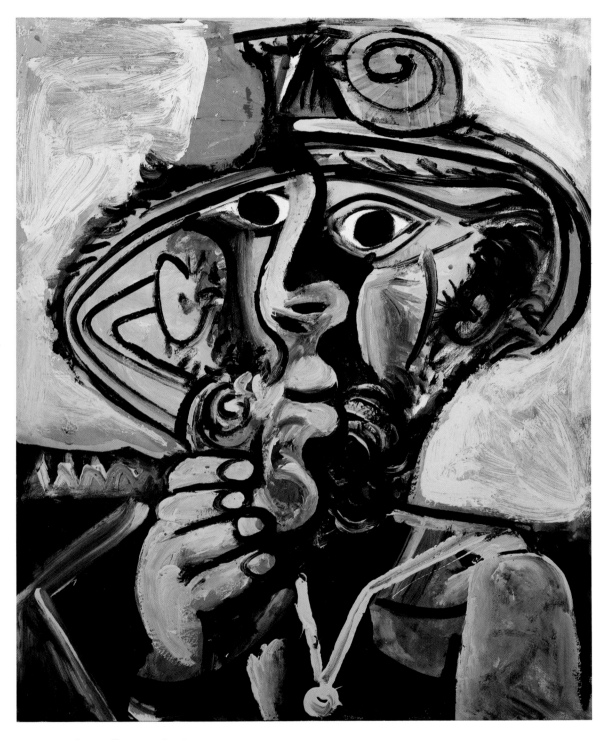

59 Man with Pipe (for Jacqueline)
18 July 1971
$39\frac{1}{4} \times 32$ (100 × 81)

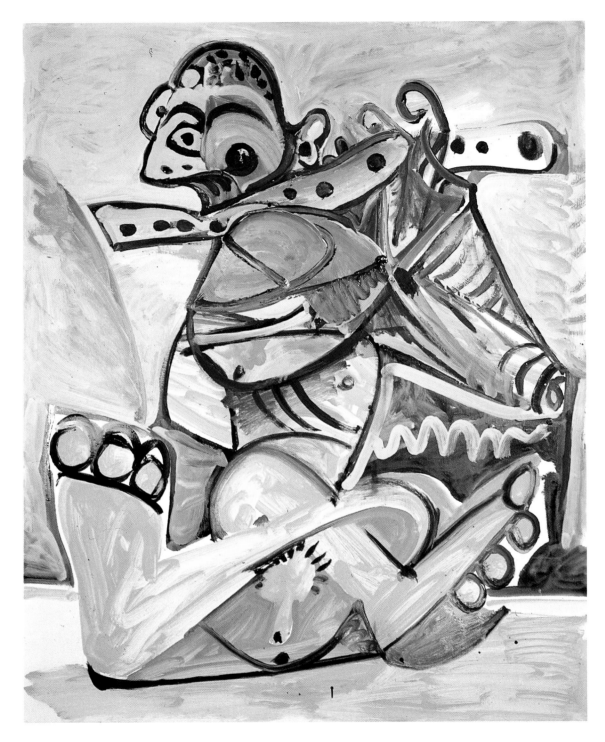

60 Flautist
30 July 1971 (II)
57½ × 45 (146 × 114.2)

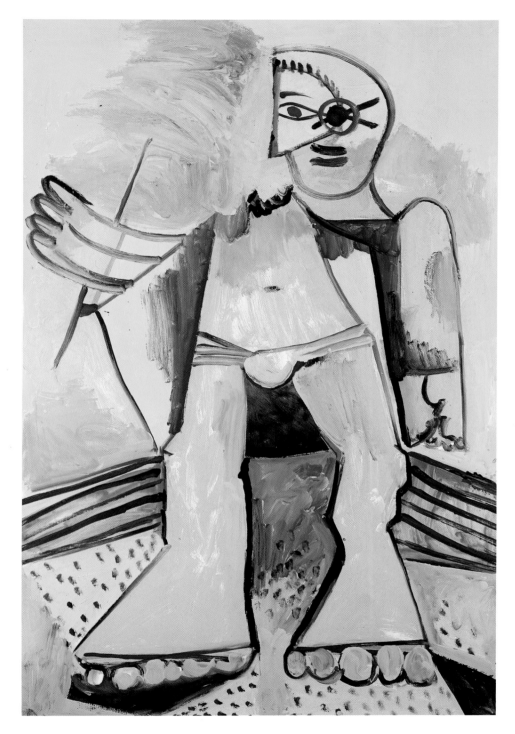

61 Standing Bather
17 August 1971
$76\frac{3}{4} \times 51\frac{1}{4}$ (195 × 130)

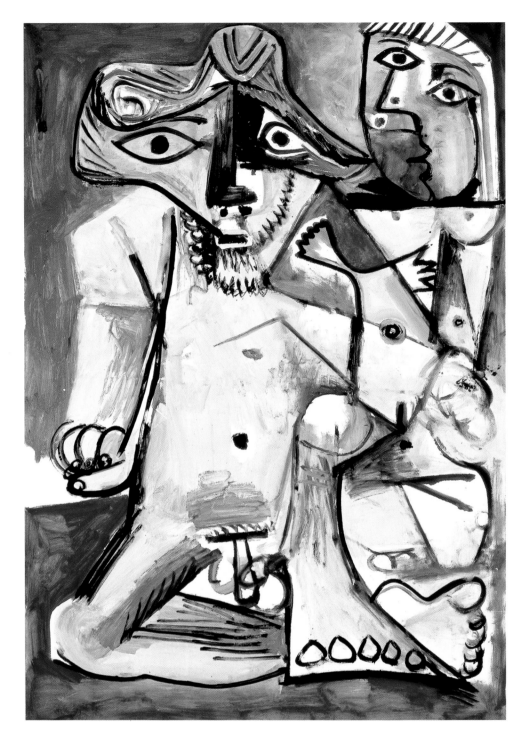

62 Nude Man and Woman
18 August 1971
$76\frac{3}{4} \times 51\frac{1}{4}$ (195 × 130)

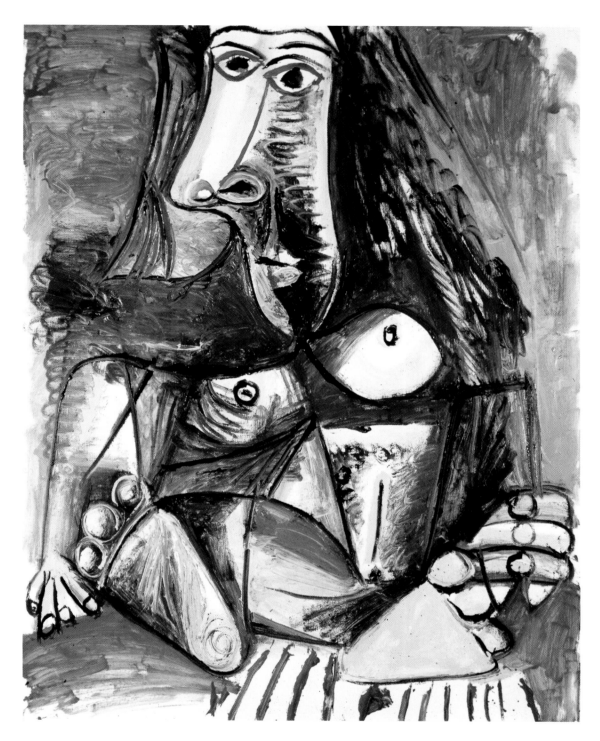

65 Seated Nude
15 September 1971 (II)
45¾ × 35 (116 × 89)

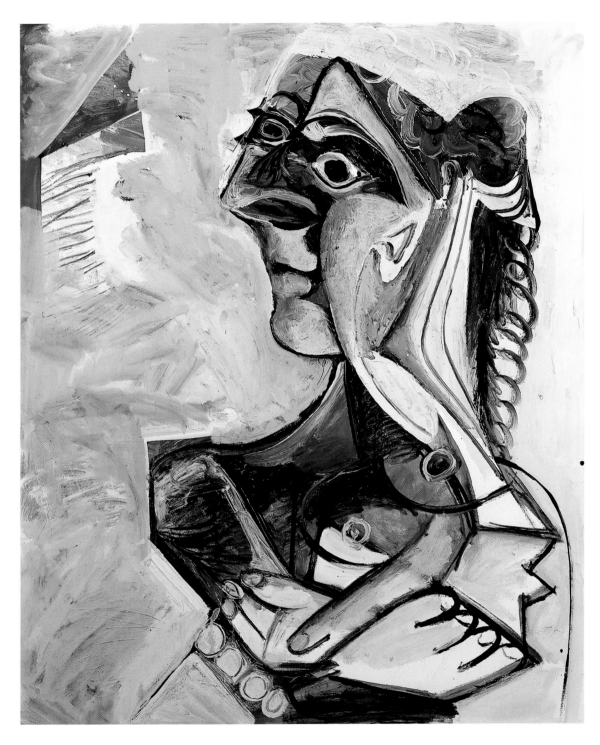

64 Woman at Rest
14 September 1971
$57\frac{1}{2} \times 45$ (146 × 114.2)

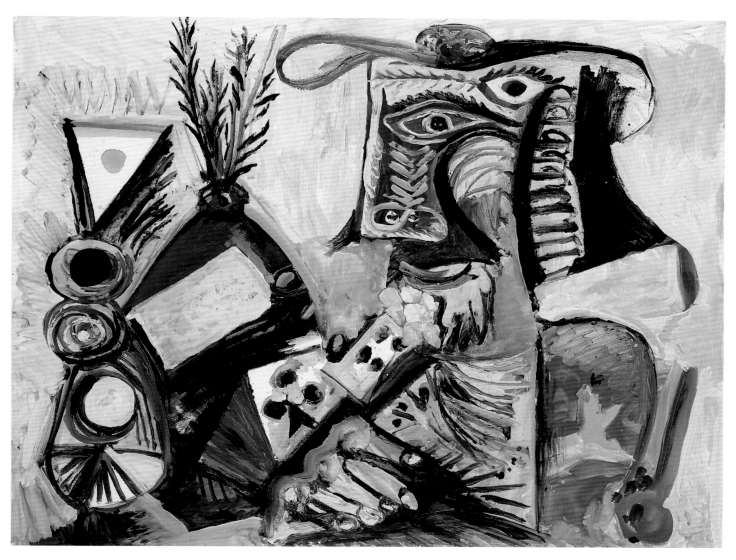

68 Card Player
30 December 1971 (II)
45 × 57½ (114.2 × 146)

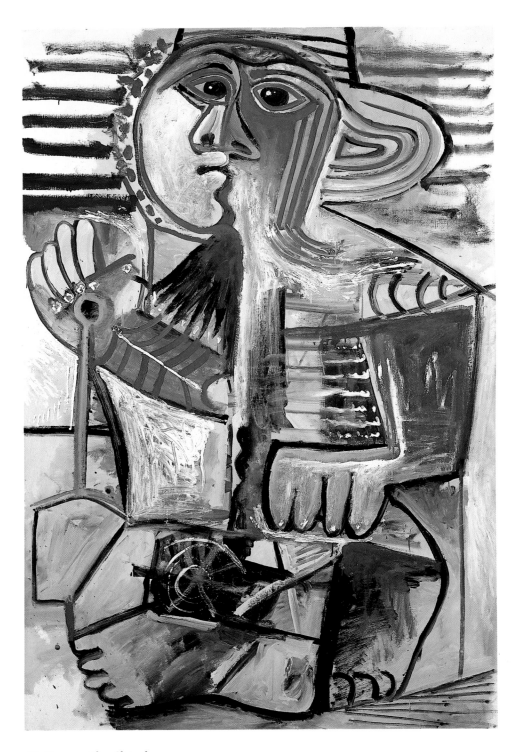

66 Figure with a Shovel
17 July, 14 November 1971
$76\frac{3}{4} \times 51\frac{1}{4}$ (195 × 130)

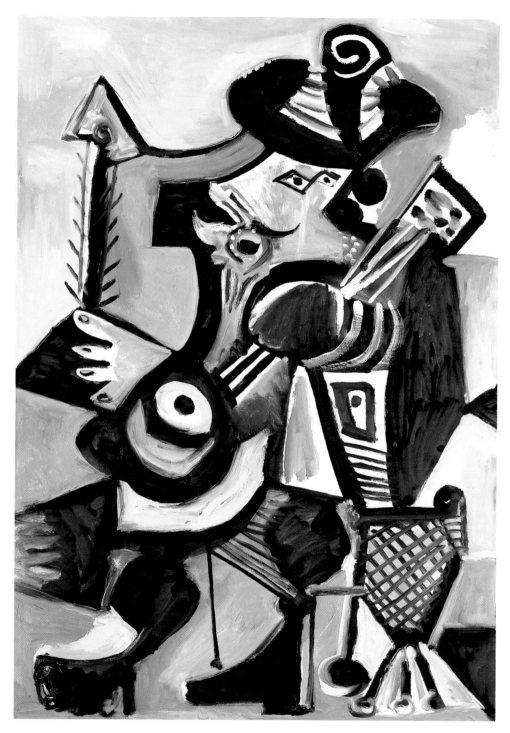

71 Musician
26 May 1972
$76\frac{1}{2} \times 51$ (194.5 × 129.5)

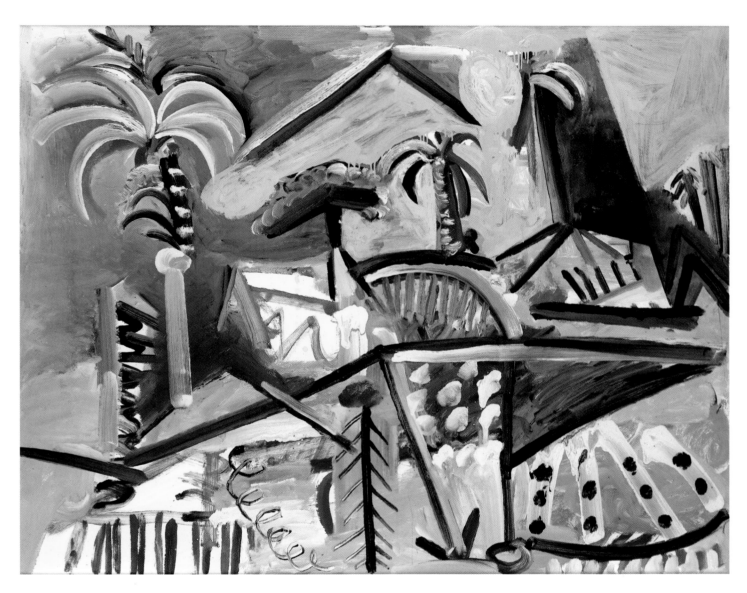

69 Landscape
31 March 1972
$51\frac{1}{4} \times 63\frac{3}{4}$ (130 × 162)

67 Reclining Nude
14 (I)–15 November 1971
$51\frac{1}{4} \times 76\frac{3}{4}$ (130 × 195)

63 Reclining Nude
7 September 1971
51¼ × 76¾ (130 × 195)

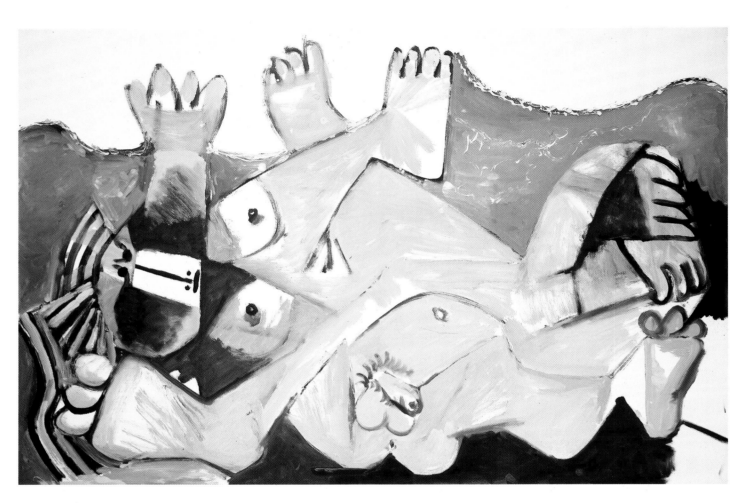

72 The Embrace
1 June 1972
$51\frac{1}{4} \times 76\frac{3}{4}$ (130 × 195)

70 Reclining Nude and Head
25 May 1972 (I)
$51\frac{1}{4} \times 76\frac{3}{4}$ (130 × 195)

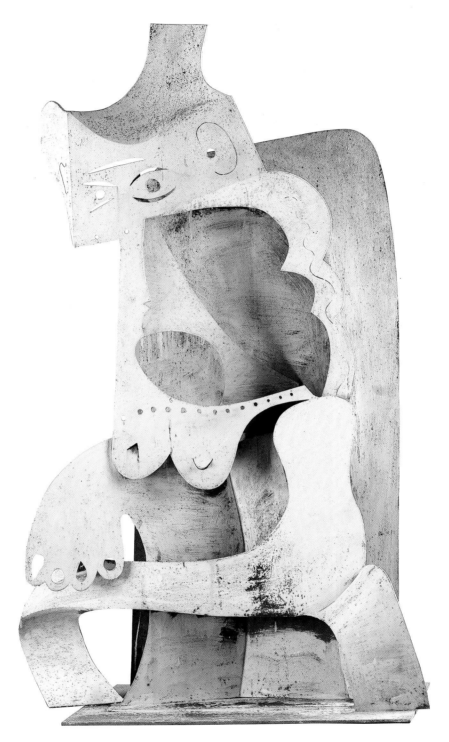

74 Woman with Hat
1961
$50 \times 29\frac{1}{4} \times 15\frac{3}{4}$ ($127 \times 74 \times 40$)

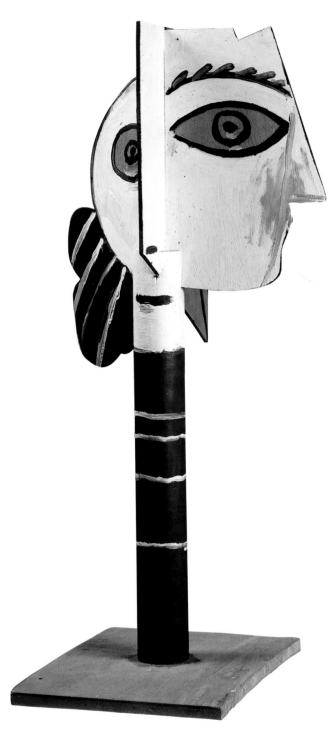

73 Head of Woman
(Project for a monument)
1957
$31 \times 13\frac{1}{2} \times 14\frac{1}{4}$ (78.5 × 34 × 36)

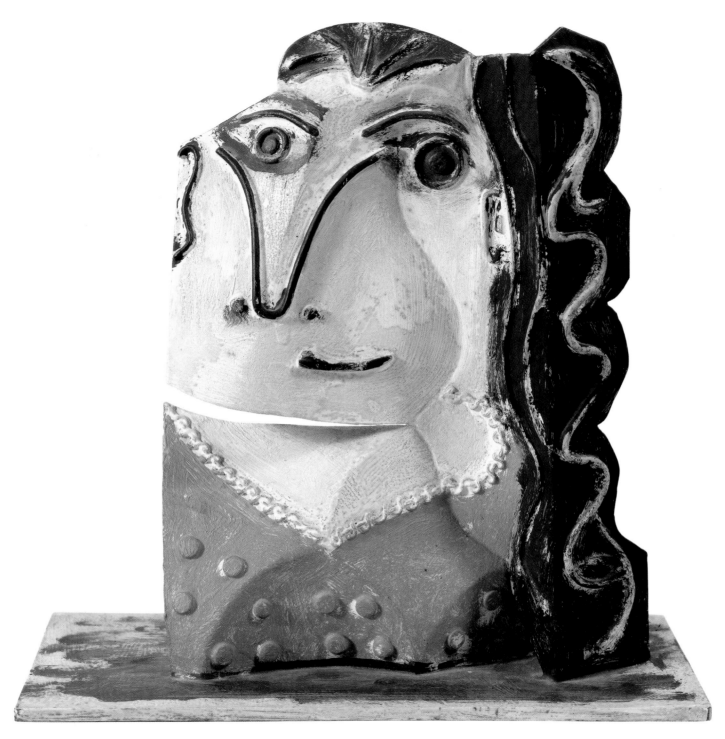

75 Head of Woman
1962
$9\frac{3}{4} \times 9\frac{1}{2} \times 4\frac{3}{4}$ (24.5 × 24.2 × 12)

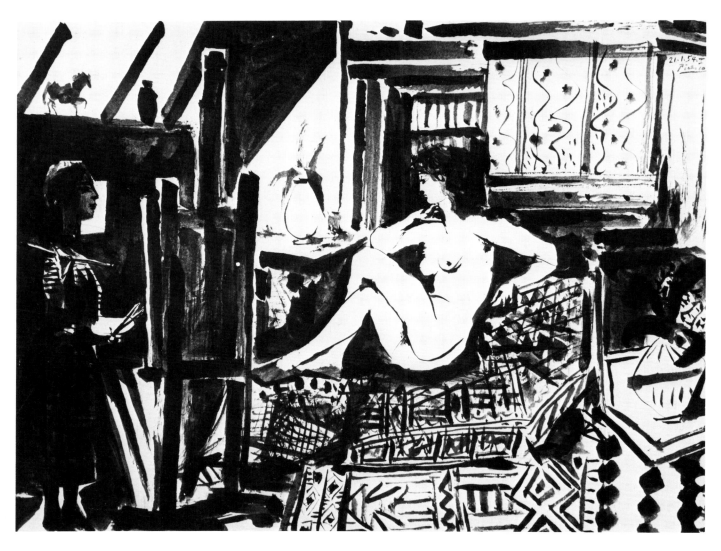

**76 Interior (Woman Artist
and Nude in a Studio)**
21 January 1954
$9\frac{1}{4} \times 12\frac{1}{4}$ (23.5 × 31)

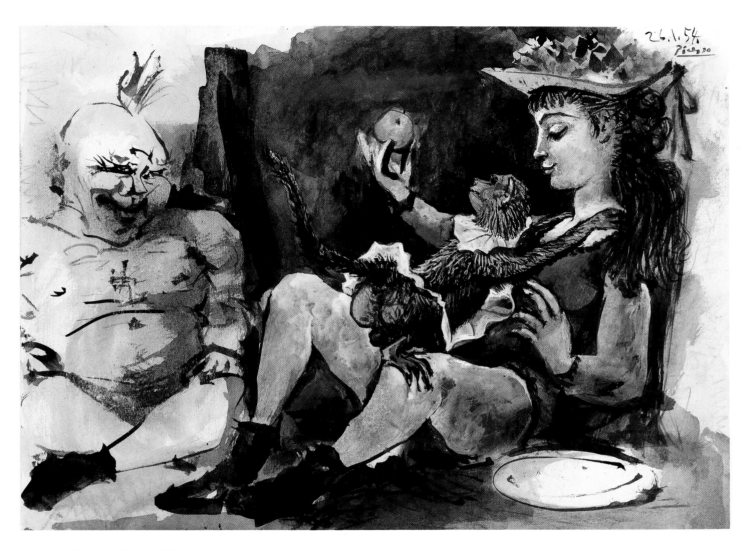

**77 Seated Man and Young Girl
with Monkey and Apple**
26 January 1954
$9\frac{1}{2} \times 12\frac{1}{2}$ (24 × 32)

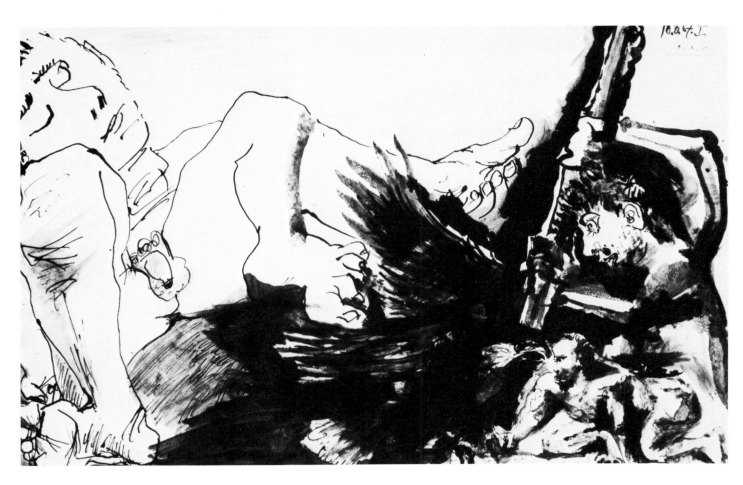

79 Eagle and Figures
10 March 1967 (I)
$19\frac{1}{2} \times 29\frac{3}{4}$ (49.5 × 75.5)

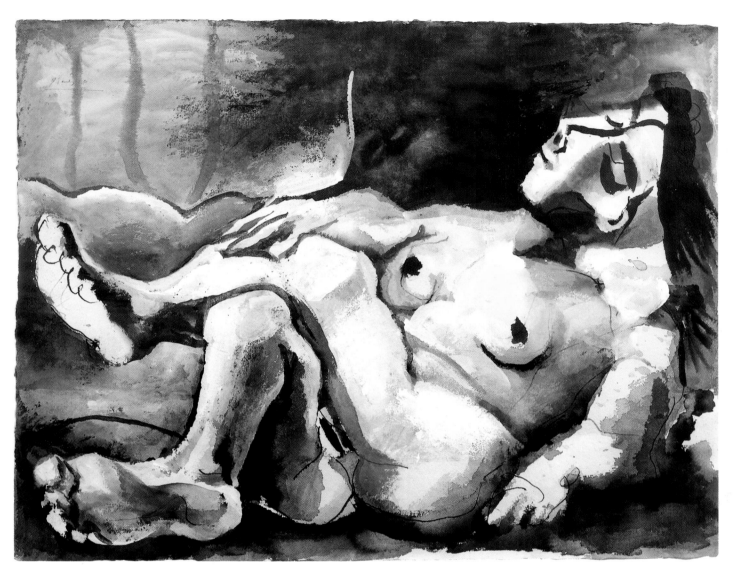

78 Reclining Nude with Legs Crossed
21–23 January 1965
19¾ × 25¼ (50 × 64)

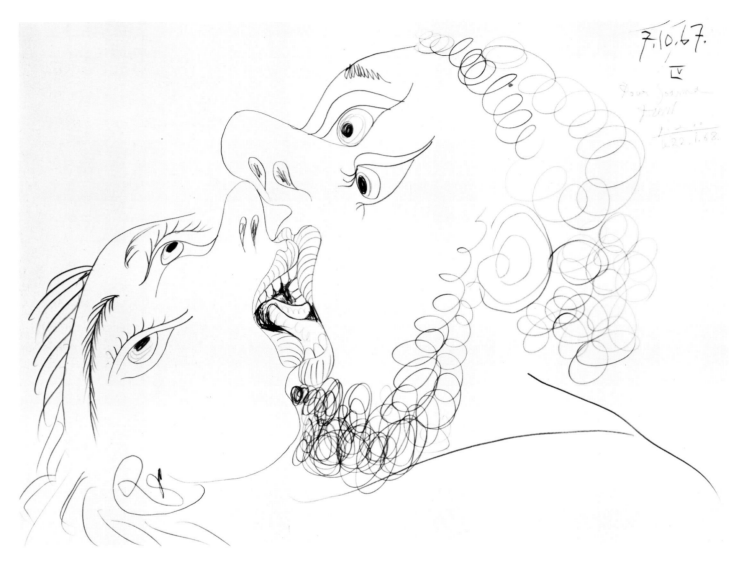

80 The Kiss
7 October 1967 (IV)
20 × 25½ (50.5 × 64.5)

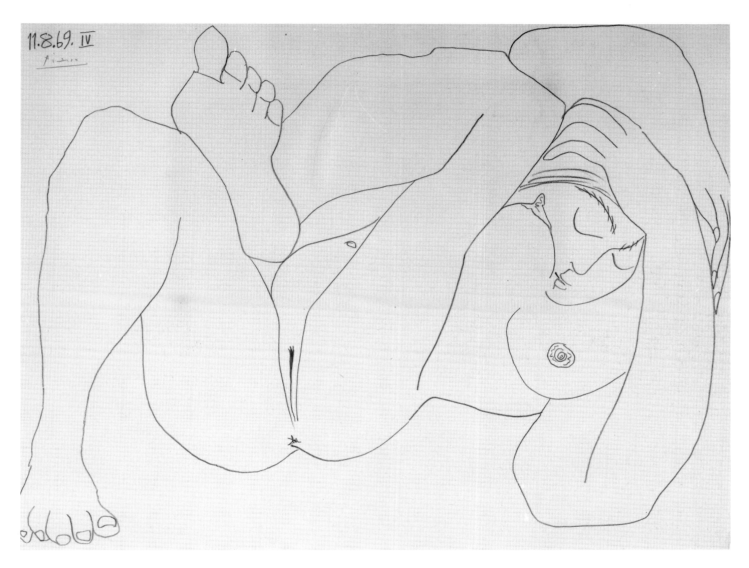

81 Reclining Nude
11 August 1969 (IV)
20 × 25¾ (50.5 × 65.3)

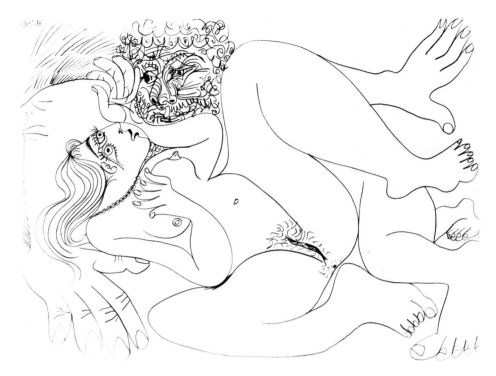

82 Man and Reclining Nude
4 September 1969 (IV)
$20 \times 25\frac{5}{8}$ (50.5 × 65)

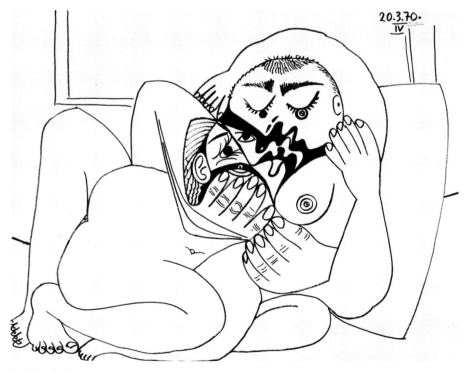

85 The Embrace
20 March 1970 (III, IV) recto
$20\frac{1}{2} \times 29\frac{1}{2}$ (52.4 × 74.7)

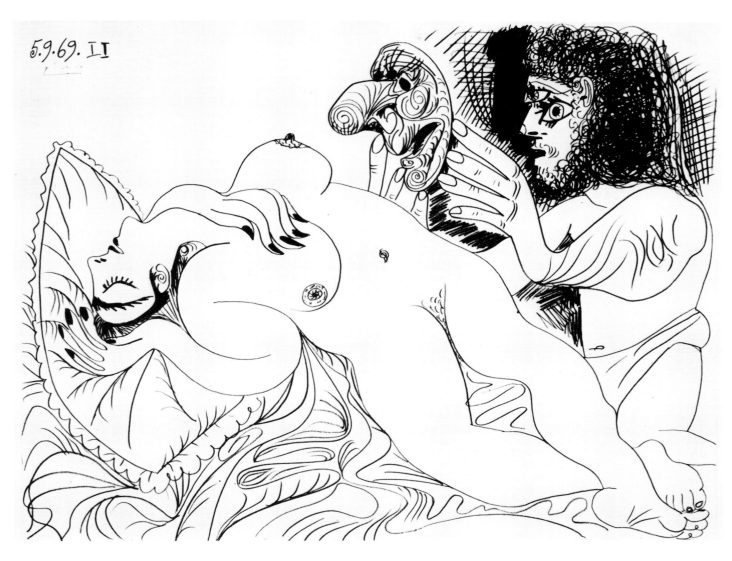

83 Nude and Man with Mask
5 September 1969 (II)
20 × 25⅝ (50.5 × 65)

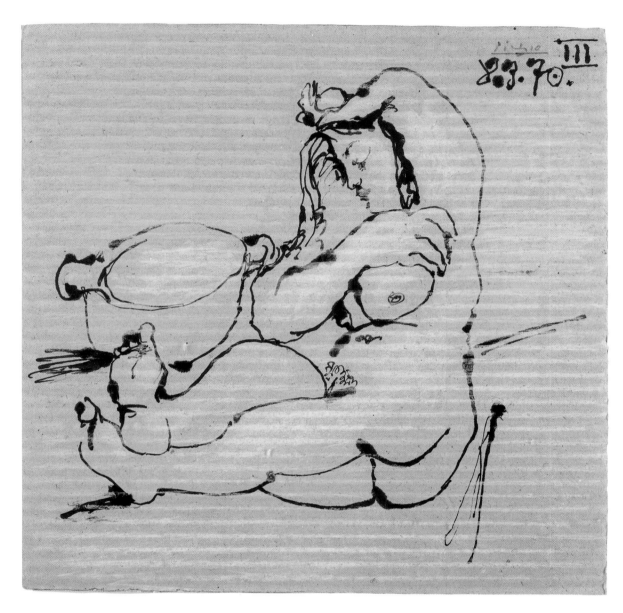

84 Nude at her Toilet
8 March 1970 (III)
$12\frac{1}{2} \times 12\frac{1}{2}$ (31.5 × 31.5)

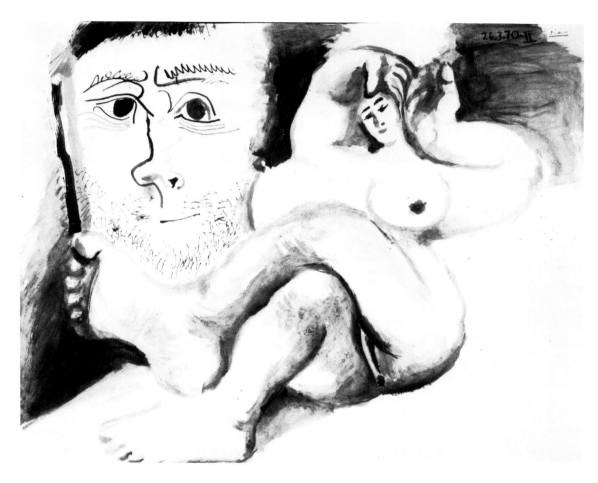

86 Reclining Nude and Head of Man
26 March 1970 (II)
$20\frac{3}{4} \times 25\frac{3}{8}$ (52.5 × 64.5)

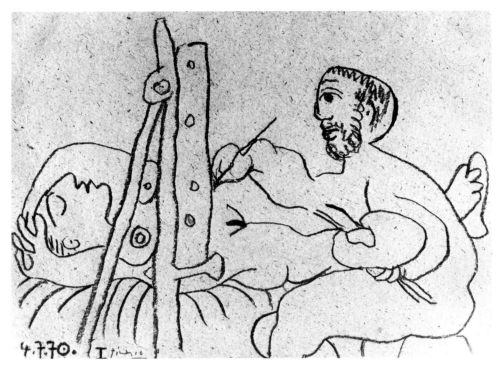

87 The Artist and his Model (I)
4 July 1970
10 × 13½ (25.5 × 34.3)

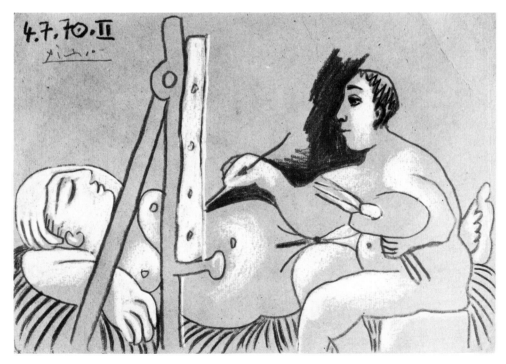

88 The Artist and his Model (II)
4 July 1970
8½ × 12¼ (21.7 × 31)

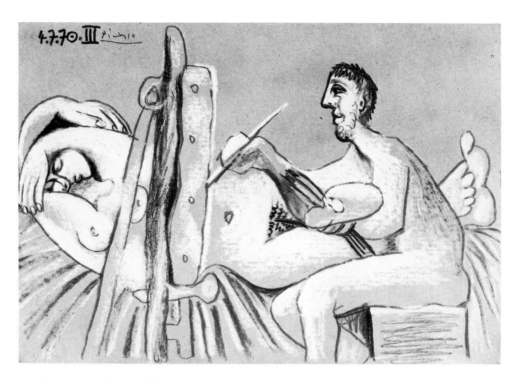

89 The Artist and his Model (III)
4 July 1970
$8\frac{7}{8} \times 12\frac{3}{8}$ (22.5 × 31.4)

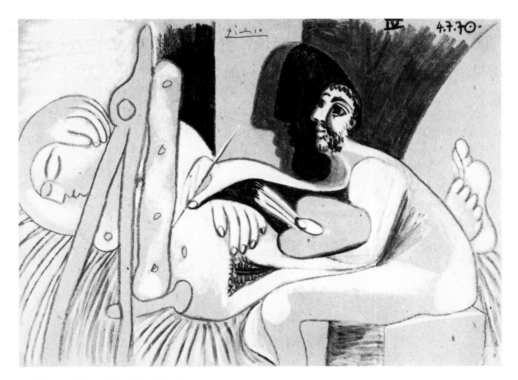

90 The Artist and his Model (IV)
4 July 1970
$8\frac{3}{4} \times 12\frac{1}{4}$ (22.1 × 31)

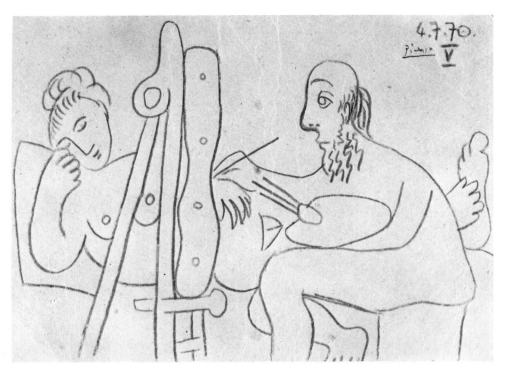

91 The Artist and his Model (V)
4 July 1970
$8\frac{3}{4} \times 12\frac{1}{4}$ (22.1 × 31.1)

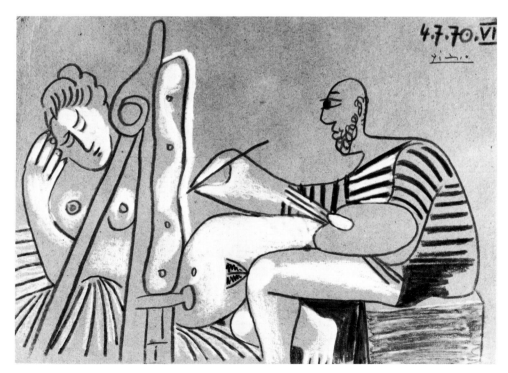

92 The Artist and his Model (VI)
4 July 1970
$8\frac{7}{8} \times 12\frac{3}{8}$ (22.5 × 31.4)

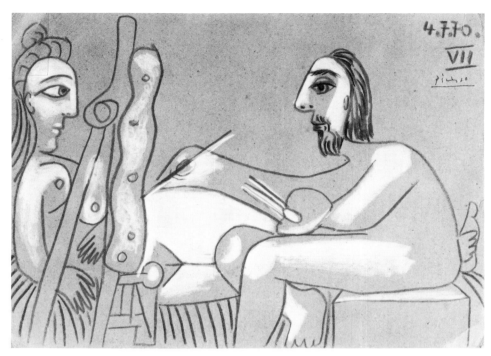

93 The Artist and his Model (VII)
4 July 1970
$8\frac{11}{16} \times 12\frac{3}{8}$ (22 × 31.3)

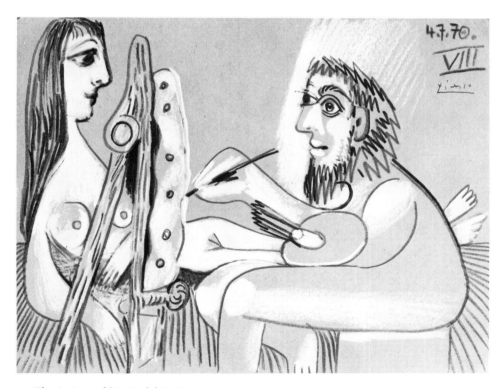

94 The Artist and his Model (VIII)
4 July 1970
$9\frac{1}{2} \times 12\frac{1}{2}$ (23.8 × 31.5)

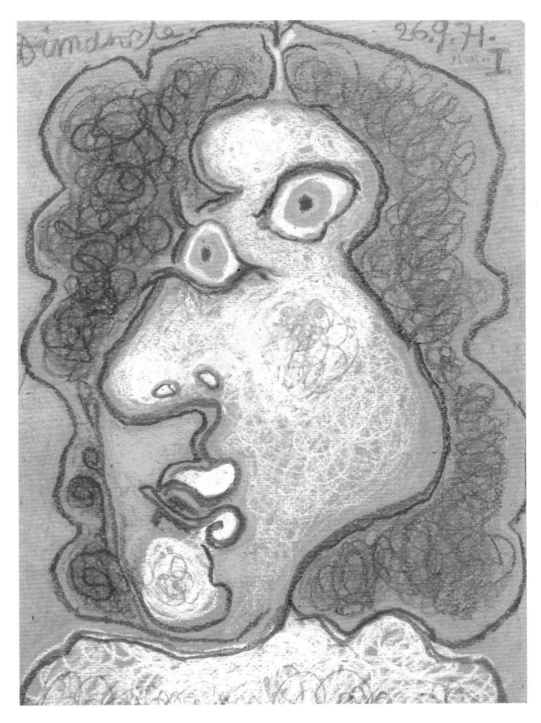

95 Head
26 September 1971
$13\frac{1}{2} \times 9\frac{1}{2}$ (34×23.8)

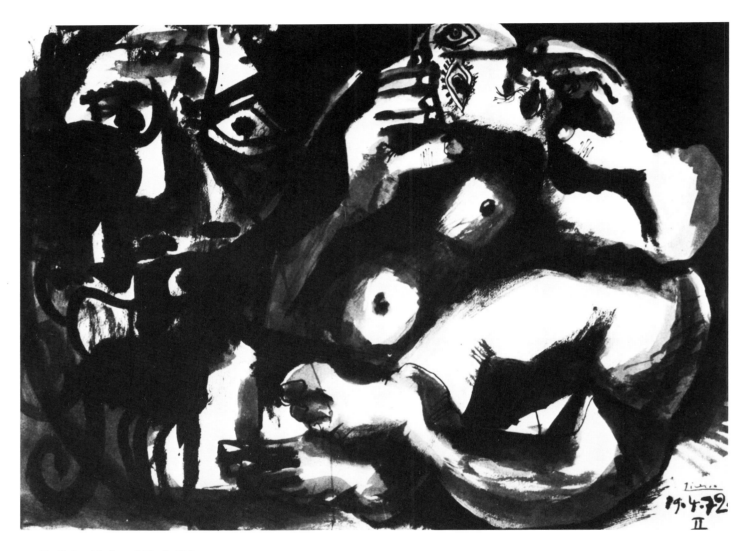

97 Reclining Nude and Head of Man
19 April 1972 (II)
$19\frac{1}{2} \times 25\frac{1}{2}$ (49.3 × 64.5)

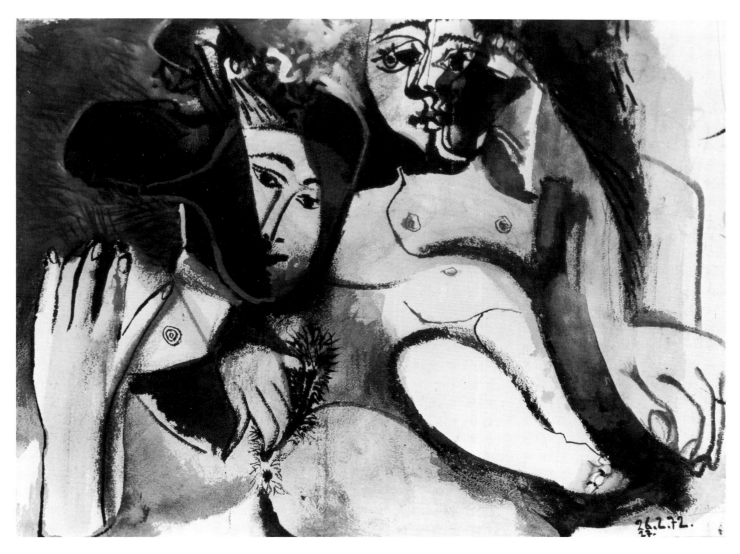

96 Two Women
26–27 February 1972
$21\frac{3}{4} \times 29\frac{1}{2}$ (55.5 × 74.8)

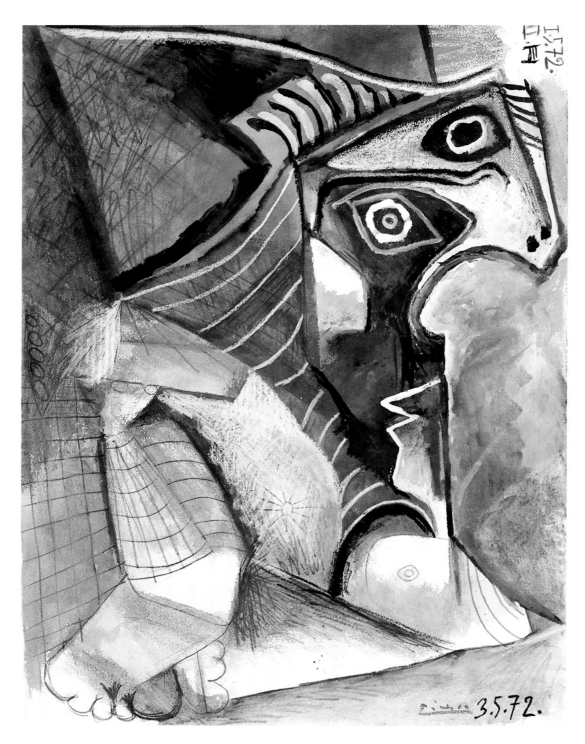

99 Nude
1 May (II–III), 3 May 1972
29¼ × 22 (74.3 × 55.9)

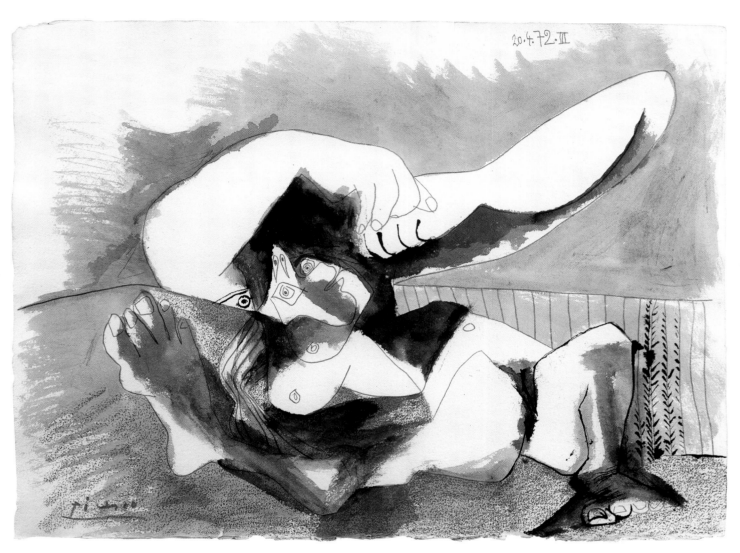

98 Reclining Nude
20 April 1972 (III)
$22\frac{1}{4} \times 29\frac{1}{2}$ (56.5 × 75)

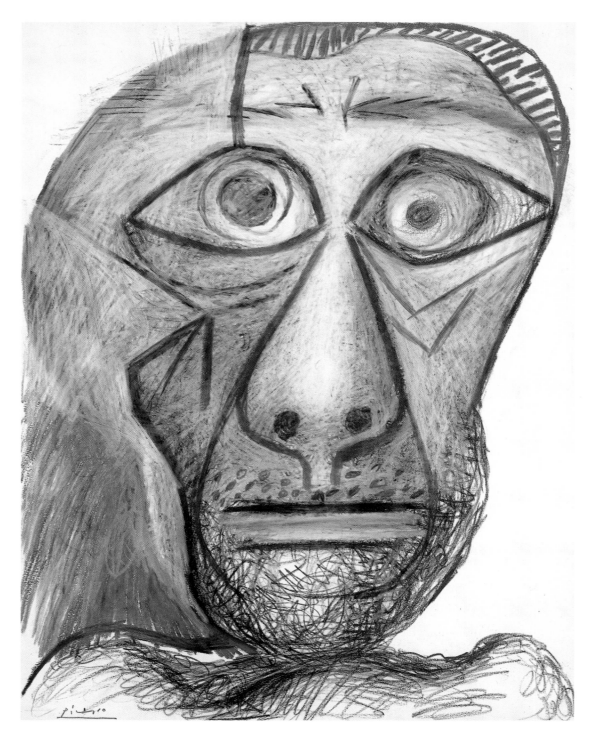

101 Self-Portrait
30 June 1972
25¾ × 20 (65.7 × 50.5)

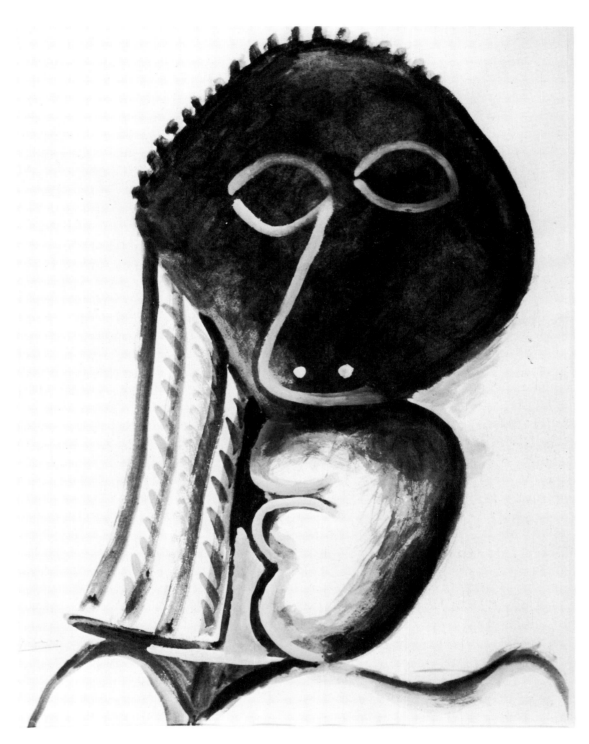

100 Head
29 June 1972
26 × 20 (65.7 × 50.5)

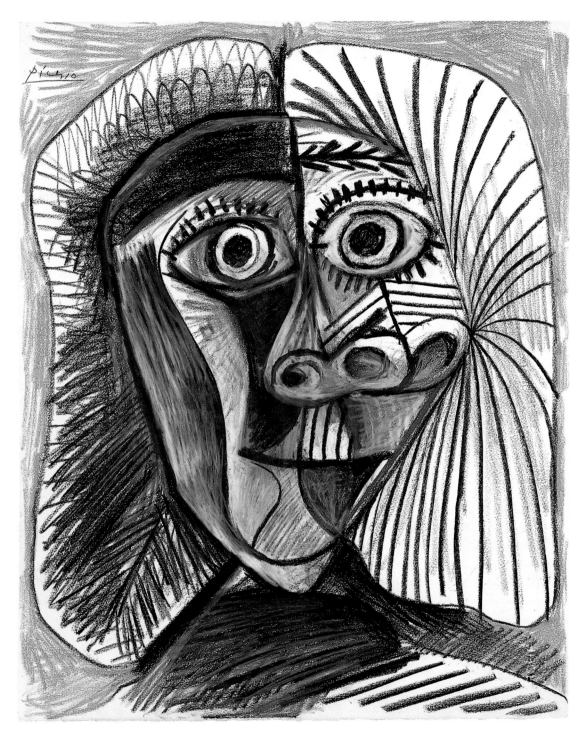

102 Head
3 July 1972
26 × 20 (65.7 × 50.5)

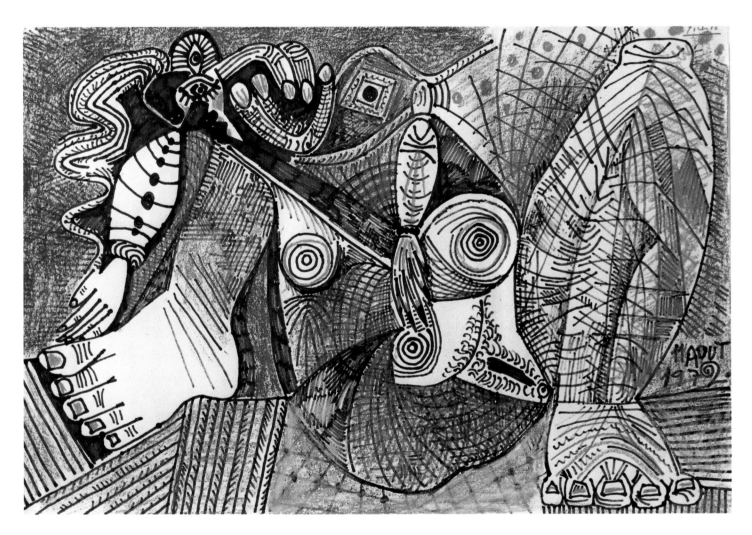

105 Reclining Nude
11 August 1972
$7\frac{1}{2} \times 5\frac{1}{4}$ (19×13.5)

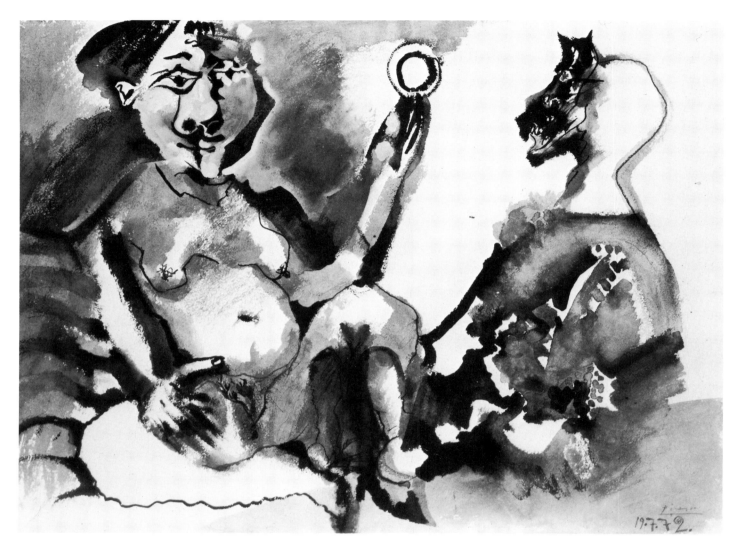

103 Nude with Mirror and Seated Figure
19 July 1972
22 × 29½ (56 × 74.7)

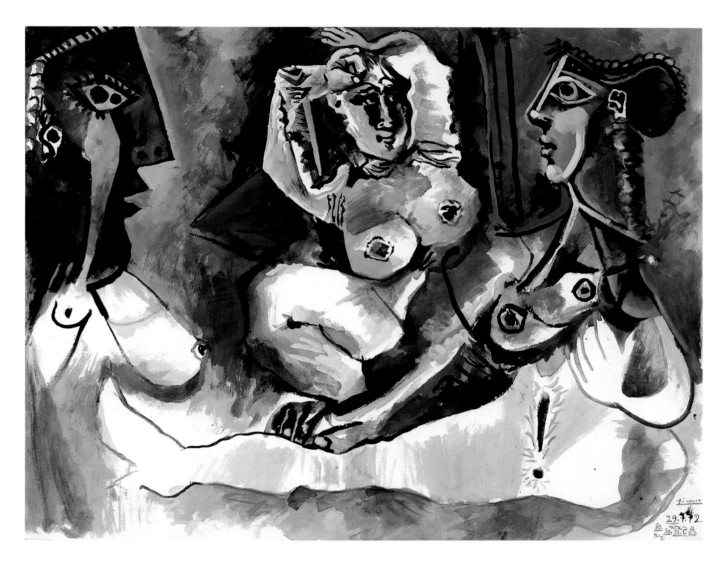

104 Three Women
29 July–5 August 1972
23¼ × 30 (59 × 75.7)

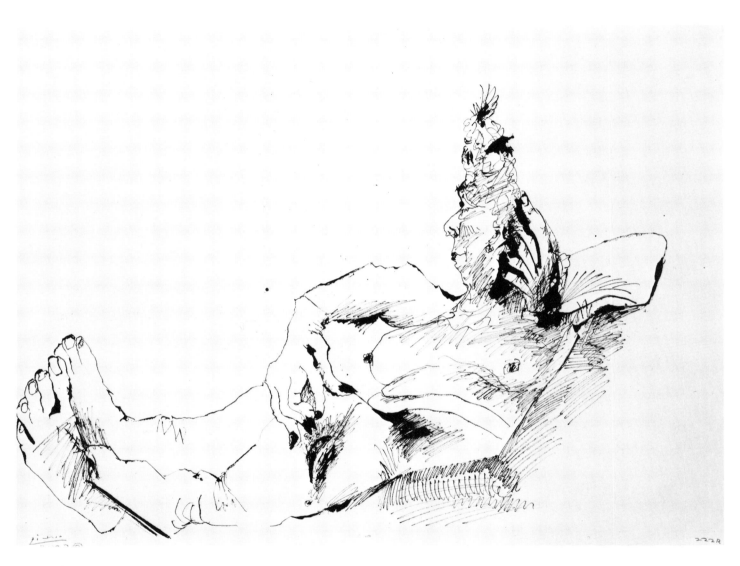

106 Reclining Nude
18 August 1972
$23\frac{1}{2} \times 30$ (59.4 × 75.7)

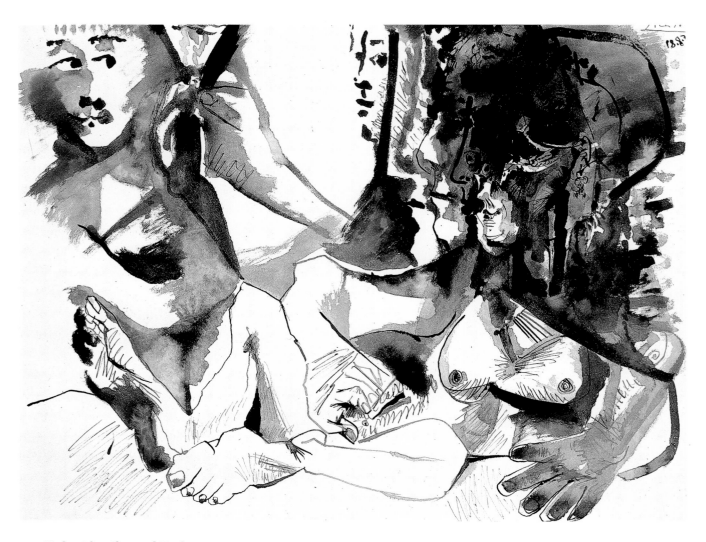

107 Nude with a Glass and Heads
18 August 1972
$23\frac{1}{4} \times 30$ (59 × 75.7)

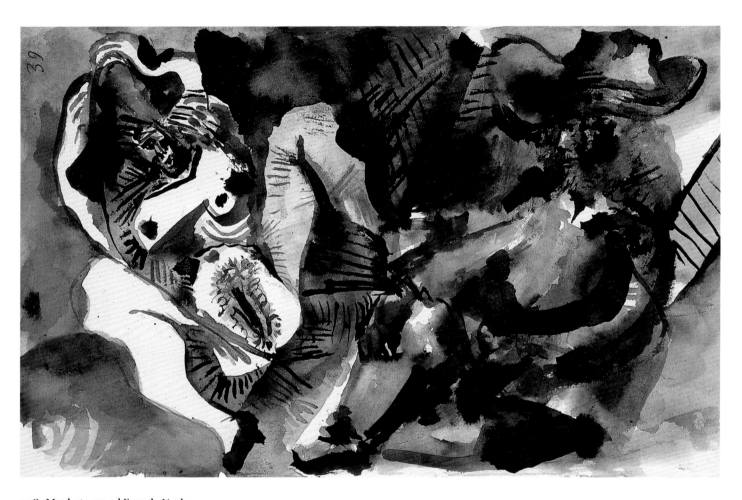

108 Musketeer and Female Nude
1972
$8\frac{7}{8} \times 14$ (22.5 × 35.2)

List of Exhibits

While the exhibition represents Picasso's output from December 1953 until he stopped working in the autumn of 1972, its emphasis is on the years from 1964 on. Thus two-thirds of the paintings, all of the drawings bar two and all of the prints date from that period.

The choice of paintings begins with two works which exemplify Picasso's most recurrent theme in his later years: the artist and his model in the studio. It concludes with three paintings which were among his very last.

Of the three sculptures included, two exemplify the technique used in Picasso's final large body of three-dimensional work, produced in 1961–62: to cut out and fold sheet metal and polychrome it.

The choice of drawings excludes pages from sketchbooks, as a major exhibition of such material has lately been shown in London. The choice lays a particularly strong emphasis on very late works: all but eight date from 1970–72; several were done after Picasso had stopped working in any other medium.

The selection of prints focuses on two groups. First, the '347' series of 1968, and here there is a concentration on the works after two paintings by Ingres, the 'Turkish Bath' and 'Raphael and la Fornarina'. Second, etchings of 1970–72, with an emphasis on those inspired by Degas' monotypes of the brothel.

In all four sections the selection shown in London lacks some works that were shown in Paris, the most important of which are reproduced on pages 16, 21, 22, 27, 33, 35, 43. At the same time it includes a few works which were not shown in Paris: four paintings (cats.17, 21, 41, 56) and three drawings (cats.81, 95, 108).

Picasso did not provide his works with titles. The titles by which they are known are purely descriptive. This catalogue therefore gives titles primarily in English, supplemented in this list by the French title used in the catalogue of the Paris showing of the exhibition together with that catalogue number. Measurements are given in inches followed by centimetres in brackets; height precedes width.

KEY TO ABBREVIATIONS

Books

Rafael Alberti, *Picasso en Avignon*, Paris, Editions Cercle d'Art, 1971 (1): Alberti.

Georges Bloch, *Catalogue raisonné de l'oeuvre gravé et lithographié*, Berne, Editions Kornfeld et Klipstein (volume II, 1971, volume IV, 1979): Bloch.

Douglas Cooper, *Pablo Picasso: Les Déjeuners*, Paris, Editions Cercle d'Art, 1962: Cooper.

Jaime Sabartés, *Pablo Picasso, Les Ménines et la vie*, Paris Editions Cercle d'Art, 1958: Sabartés.

Werner Spies, *Das Plastische Werk*, Stuttgart, Verlag Gerd Hatje, 1983: Spies.

Christian Zervos, *Pablo Picasso*, Paris, Editions Cahiers d'Art (volumes XVI to XXXIII): Zervos.

Exhibitions

Avignon, 1970: *Pablo Picasso 1969–1970*, Palais des Papes, Avignon, 1970: Avignon 1970.

Avignon, 1973: *Pablo Picasso 1970–1972, 201 peintures*, Palais des Papes, Avignon, 1973: Avignon 1973.

Basle, 1981: *Picasso. Das Spätwerk: Themen 1964–1972*, Kunstmuseum, Basle, 1981: Basle 1981.

New York, 1980: *Pablo Picasso a Retrospective*, The Museum of Modern Art, New York, 1980: New York 1980.

New York, 1984: *Picasso. The Last Years 1963–1973*, The Solomon R. Guggenheim Museum, New York, 1984: New York 1984.

Paris, 1966: *Hommage à Pablo Picasso*, Grand Palais, Paris, 1966–1967: Paris 1966.

Paris, 1971: *Picasso. Dessins en noir et en couleur*, Galerie Louise Leiris, Paris, 1971: Paris 1971.

Paris, 1973: *Picasso, 172 dessins en noir et en couleur*, Galerie Louise Leiris, Paris, 1973: Paris 1973.

PAINTINGS

1 **The Shadow**
(L'Ombre, cat.1)
29 December 1953, Vallauris
Oil and charcoal on canvas
$49\frac{1}{2} \times 38$ (125.5 × 96.5)
Musée Picasso, Paris
Illustrated page 152

Bibliography:
Zervos, XVI, 100

2 **Nude in the Studio**
(Nu dans l'atelier, cat.2)
30 December 1953, Vallauris
Oil on canvas
$35 \times 45\frac{3}{4}$ (89 × 116.2)
Private Collection
Illustrated page 151

Bibliography:
Zervos, XVI, 96

Exhibitions:
Paris, 1966, 230

3 **Women of Algiers, after Delacroix**
(Les Femmes d'Alger, d'après
Delacroix, cat.3)
28 December 1954, Paris
Oil on canvas
$21\frac{1}{4} \times 25\frac{1}{2}$ (54 × 65)
Mrs Victor W. Ganz, New York
Illustrated page 153

Bibliography:
Zervos, XVI, 345

4 **Women of Algiers, after Delacroix**
(Les Femmes d'Alger, d'après Delacroix
cat.4)
11 February 1955, Paris
Oil on canvas
$51\frac{1}{4} \times 76\frac{3}{4}$ (130 × 195)
Mrs Victor W. Ganz, New York
Illustrated page 154

Bibliography:
Zervos, XVI, 357

Exhibitions:
New York, 1980, repr.p.424

5 **Women of Algiers, after Delacroix**
(Les Femmes d'Alger, d'après
Delacroix, cat.5)
14 February 1955, Paris
Oil on canvas
$45 \times 57\frac{1}{2}$ (114.2 × 146)
Mrs Victor W. Ganz, New York
Illustrated page 155

Bibliography:
Zervos, XVI, 360

Exhibitions:
Paris, 1966, 237
New York, 1980, repr.p.425

6 **Nude in a Rocking-chair**
(Femme nue dans un rocking-chair,
cat.8)
26 March 1956, Cannes
Oil on canvas
$76\frac{3}{4} \times 51\frac{1}{4}$ (195 × 130)
Art Gallery of New South Wales, Sydney
Illustrated page 158

Bibliography:
Zervos, XVII, 55

7 **The Studio**
(L'Atelier, cat.10)
1 April 1956, Cannes
Oil on canvas
$35 \times 45\frac{3}{4}$ (89 × 116)
Mrs Victor W. Ganz, New York
Illustrated page 156

Bibliography:
Zervos, XVII, 57

Exhibitions:
New York, 1980, repr.p.428

8 **The Studio in a Painted Frame**
(L'Atelier dans un cadre peint, cat.11)
2 April 1956, Cannes
Oil on canvas
$35 \times 45\frac{1}{2}$ (88.8 × 115.5)
*Museum of Modern Art, New York, Gift
of Mr and Mrs Werner E. Josten, 1957*
Illustrated page 157

Bibliography:
Zervos, XVII, 58

9 **Nude in front of a Garden**
(Femme nue devant le jardin, cat.12)
29–31 April 1956, Cannes
Oil on canvas
$51\frac{1}{4} \times 64$ (130 × 162.5)
*Stedelijk Museum, Amsterdam. Acquired
with support from the Vereniging
Rembrandt and the Theo Van Gogh
Stichting*
Illustrated page 159

Bibliography:
Zervos, XVII, 158

Exhibitions:
Paris, 1966, 284

10 **Nude under a Pine Tree**
(Femme nue sous un pin, cat.15)
20 January 1959, Cannes-
Vauvenargues
Oil on canvas
$76\frac{1}{2} \times 110$ (194.3 × 279.5)
*Art Institute of Chicago, Grant J. Pick
Purchase Fund*
Illustrated page 161

Bibliography:
Zervos, XVIII, 323

11 **Seated Nude**
(Femme nue assise, cat.17)
1959, Cannes or Vauenargues
Oil on canvas
$57\frac{1}{2} \times 45$ (146 × 114.2)
Mrs Victor W. Ganz, New York
Illustrated page 164

Bibliography:
Zervos, XVIIA, 308

Exhibitions:
New York, 1980, repr.p.435

12 **Reclining Nude on a Blue Divan**
(Femme couchée sur un divan bleu,
cat.18)
20 April 1960, Vauvenargues
Oil on canvas
$35 \times 45\frac{1}{2}$ (89 × 115.5)
*Musée National d'Art Moderne, Centre
Georges Pompidou, Paris. Donated by
Louise et Michel Leiris, 1984*
Illustrated page 165

Bibliography:
Zervos, XIX, 279

13 **Le Déjeuner sur l'herbe, after Manet**
 (cat.19)
 10 July 1961, Mougins
 Oil on canvas
 45 × 57½ (114.2 × 146)
 Staatsgalerie, Stuttgart
 Illustrated page 166

 Bibliography:
 Zervos, XX, 88
 Cooper, 109

14 **Le Déjeuner sur l'herbe, after Manet**
 (cat.21)
 30 July 1961, Mougins
 Oil on canvas
 51¼ × 38¼ (130 × 97)
 *Louisiana Museum of Modern Art,
 Humblebaek*
 Illustrated page 167

 Bibliography:
 Zervos, XX, 113
 Cooper, 151

15 **Reclining Nude in an Interior**
 (Femme couchée dans un intérieur,
 cat.23)
 27 November 1961 (I), Mougins
 Oil on canvas
 18 × 21¼ (46 × 55)
 Private Collection, Paris
 Illustrated page 168

 Bibliography:
 Zervos, XX, 148

16 **Nudes in an Interior**
 (Femmes nues dans un intérieur,
 cat.24)
 27 November 1961 – 31 January
 1962, Mougins
 Oil on canvas
 29 × 36 (73.6 × 91.4)
 Mr and Mrs Raymond D. Nasher
 Illustrated page 169

 Bibliography:
 Not illustrated in Zervos

17 **Bust of a Woman**
 28 April 1962, Mougins
 Oil on canvas
 41¾ × 29½ (106 × 75)
 Galerie Louise Leiris, Paris
 Illustrated page 170

 Bibliography:
 Zervos XX, 223

18 **Seated Nude**
 (Femme assise, cat.26)
 13 May – 16 June 1962, Mougins
 Oil on canvas
 57½ × 45 (146 × 114.2)
 Private Collection
 Illustrated page 171

 Bibliography:
 Zervos, XX, 227

 Exhibitions:
 New York, 1980, repr.p.443

19 **The Rape of the Sabines**
 (L'Enlèvement des Sabines, cat.28)
 24 October 1962, Mougins
 Oil on canvas
 18 × 21¾ (46 × 55)
 Národní Galerie, Prague
 Illustrated page 172

 Bibliography:
 Zervos, XXIII, 6

20 **Still-Life with Cat and Lobster**
 (Nature morte, chat et homard, cat.27)
 23 October, 1 November 1962,
 Mougins
 Oil on canvas
 51¼ × 63¾ (130 × 162)
 Hakone Open-Air Museum, Japan
 Illustrated page 177

 Bibliography:
 Zervos, XX, 356

 Exhibitions:
 New York, 1980, repr.p.445

21 **The Rape of the Sabines**
 2 November 1962, Mougins
 Oil on canvas
 63¾ × 51¼ (162 × 130)
 Private Collection
 Illustrated page 176

 Bibliography:
 Zervos, XXIII, 1

22 **The Rape of the Sabines**
 (L'Enlèvement des Sabines, cat.29)
 4, 8 November 1962, Mougins
 Oil on canvas
 38¾ × 51¼ (97 × 130)
 *Musée National d'Art Moderne, Centre
 Georges Pompidou, Paris. Donated by
 D. H. Kahnweiler, 1964*
 Illustrated page 173

 Bibliography:
 Zervos, XXIII, 69

23 **The Artist and his Model**
 (Le Peintre et son modèle, cat.31)
 4, 5 March 1963, Mougins
 Oil on canvas
 32 × 39½ (81 × 100)
 *Marina Picasso Collection, Galerie Jan
 Krugier, Geneva*
 Illustrated page 178

 Bibliography:
 Zervos, XXIII, 151

 Exhibitions:
 New York, 1984, 5

24 **The Artist and his Model**
 (Le Peintre et son modèle, cat.32)
 5 March, 20 September 1963,
 Mougins
 Oil on canvas
 35 × 45¾ (89 × 116.5)
 Hakone Open-Air Museum, Japan
 Illustrated page 179

 Bibliography:
 Zervos, XXIII, 164

25 **The Artist and his Model in the Studio**
 (Le Peintre et son modèle dans l'atelier,
 cat.33)
 9 Avril 1963, Mougins
 Oil on canvas
 25½ × 36 (65 × 92)
 *Musée National d'Art Moderne, Centre
 Georges Pompidou, Paris. Donated by
 Louise and Michel Leiris, Paris*
 Illustrated page 180

 Bibliography:
 Zervos, XXIII, 205

26 **Reclining Nude**
 (Nu couché, cat.35)
 9, 18 January 1964, Mougins
 Oil on canvas
 25½ × 39 (65 × 100)
 Galerie Rosengart, Lucerne
 Illustrated page 181

 Bibliography:
 Zervos, XXIV

 Exhibitions:
 Basle, 1981, 1, repr.p.93
 New York, 1984, 7

27 **Reclining Nude Playing with a Cat**
 (Nu couché jouant avec un chat,
 cat.39)
 10, 11 May 1964, Mougins
 Oil on canvas
 45 × 76¾ (114.2 × 195)
 Ernst Beyeler, Basle
 Illustrated page 183

Bibliography:
Zervos, XXIV, 145

Exhibitions:
Basle, 1981, 6, repr.p.97

28 The Artist and his Model
(Le Peintre et son modèle, cat.40)
25 October 1964, Mougins
Oil on canvas
76¾ × 51¼ (195 × 130)
Gilbert de Botton, Switzerland
Illustrated page 184

Bibliography:
Zervos, XXIV, 245

29 The Artist and his Model
(Le Peintre et son modèle, cat.41)
26 October (11), 3 November 1964,
Mougins
Oil on canvas
57½ × 35 (146 × 89)
*Mr and Mrs Morton L. Janklow,
New York*
Illustrated page 185

Bibliography:
Zervos, XXIV, 246

Exhibitions:
Basle, 1981, 7, repr.p.17
New York, 1984, 13

30 The Artist and his Model
(Le Peintre et son modèle, cat.42)
16 November – 9 December 1964,
Mougins
Oil on canvas
63¾ × 51¼ (162 × 130)
*Ludwig Collection, Aix-la-Chapelle, on
loan to the Nationalgalerie, Berlin (DDR)*
Illustrated page 187

Bibliography:
Zervos, XXIV, 312

Exhibitions:
New York 1980, repr.p.447

**31 Reclining Nude with a Green
Background**
Nu couché sur fond vert, cat.44)
24 January 1965, Mougins
Oil on canvas
35 × 45¾ (89 × 116)
Paloma Picasso-Lopez
Illustrated page 186

Bibliography:
Zervos, XXV, 20

32 The Sleepers
(Les Dormeurs, cat.45)
13 April 1965, Mougins
Oil on canvas
45 × 76¾ (114.2 × 195)
Galerie Louise Leiris, Paris
Illustrated page 188

Bibliography:
Zervos, XXV, 106

Exhibitions:
Paris, 1966, 273
Basle, 1981, 14
New York, 1984, 20

33 Woman Pissing
(La Pisseuse, cat.46)
16 April 1965 (1), Mougins
Oil on canvas
76¾ × 38¼ (195 × 97)
*Musée National d'Art Moderne, Centre
Georges Pompidou, Paris. Donated by
Louise and Michel Leiris, 1984*
Illustrated page 189

Bibliography:
Zervos, XXV, 108

Exhibitions:
Paris, 1966, 275
New York, 1984, 21

34 Nude Man and Woman
(Homme et femme nus, cat.47)
25 October 1965, Mougins
Oil on canvas
63¾ × 51¼ (162 × 130)
Private Collection, St. Moritz
Illustrated page 190

Bibliography:
Zervos, XXV, 183

Exhibitions:
Basle, 1981, 18
New York, 1984, 23

35 Reclining Nude
(Nu couché, cat.49)
9 October 1967, Mougins
Oil on canvas
45 × 57½ (114.2 × 146)
Bernard Ruiz-Picasso
Illustrated page 192

Bibliography:
Zervos, XXVII, 139

36 Reclining Nude with Bird
(Nu couché à l'oiseau, cat.51)
17 January 1968, Mougins
Oil on canvas
51¼ × 76¾ (130 × 195)
Museum Ludwig, Cologne
Illustrated page 193

Bibliography:
Zervos, XXVII, 195

37 Reclining Nude with Necklace
(Nu couché au collier, cat.52)
8 October 1968 (1), Mougins
Oil on canvas
44¾ × 63¾ (113.5 × 161.7)
Tate Gallery
Illustrated page 191

Bibliography:
Zervos, XXVII, 331

Exhibitions:
Basle 1981, 28, repr. p.111

38 Standing Nude and Seated Musketeer
(Nu debout et mousquetaire assis,
cat.54)
30 November 1968, Mougins
Oil on canvas
63¾ × 51¼ (162 × 130)
*Jointly owned by the Metropolitan
Museum of Art, New York and A. L. and
Blanch Levine, 1981*
Illustrated page 198

Bibliography:
Zervos, XXVII, 384

Exhibitions:
New York, 1984, 52

39 Couple with Bird
(Couple à l'oiseau, cat.55)
17 January 1969, Mougins
Oil on canvas
51¼ × 63¾ (130 × 162)
*Courtesy Thomas Ammann Fine Art,
Zurich*
Illustrated page 194

Bibliography:
Zervos, XXXII, 31
Alberti, I, 106

40 The Smoker
(Le Fumeur, cat.62, ill. as cat.57)
14 March 1969 (IV), Mougins
Oil on canvas
76¾ × 51¼ (195 × 130)
Private Collection
Illustrated page 206

Bibliography:
Zervos, XXXI, 101
Alberti, I, 73

41 Musketeer
1 April 1969, Mougins
Oil on canvas
$25\frac{1}{4} \times 19\frac{3}{4}$ (64 × 50)
Private Collection
Illustrated page 199

Bibliography:
Zervos, XXPI, 315

Exhibitions:
Avignon, 1970, 11

42 Woman with a Pillow
(Femme à l'oreiller, cat.58)
10 July 1969, Mougins
Oil on canvas
$76\frac{3}{4} \times 51\frac{1}{4}$ (195 × 130)
Private Collection
Illustrated page 195

Bibliography:
Zervos, XXXI, 315
Alberti, I, 14

Exhibitions:
Avignon, 1970, 56
New York, 1980, repr.p.449

43 Seated Musketeer with Sword
(Mousquetaire à l'épée assis, cat.59)
19 July 1969, Mougins
Oil on canvas
$76\frac{3}{4} \times 51\frac{1}{4}$ (195 × 130)
Maya Ruiz-Picasso
Illustrated page 201

Bibliography:
Zervos, XXXI, 328
Alberti, I, 199 (Homme à l'épée)

Exhibitions:
Avignon, 1970, 62 (Homme à l'épée)
New York, 1984, 58

44 Man and Woman
(Homme et femme, cat.61)
7 September 1969, Mougins
Oil on canvas
$64 \times 51\frac{5}{16}$ (163 × 130.2)
Museo de Arte Contemporáneo, Caracas
Illustrated page 204

Bibliography:
Zervos, XXXI, 417
Alberti, I, 92

Exhibitions:
Avignon, 1970, 75

45 Man with Pipe
(Homme à la pipe, cat.57, ill. as cat.62)
10 September 1969 (I), Mougins
Oil on canvas
$51\frac{1}{4} \times 38\frac{1}{4}$ (130 × 97)
Private Collection
Illustrated page 200

Bibliography:
Zervos, XXXI, 419
Alberti, I, 79

Exhibitions:
Avignon, 1970, 77

46 Seated Man with Sword and Flower
(Homme assis à l'épée et à la fleur, cat.60)
2 August (II), 27 September 1969, Mougins
Oil on canvas
$57\frac{1}{2} \times 45$ (146 × 114.2)
Bernard Ruiz-Picasso
Illustrated page 205

Bibliography:
Zervos, XXXI, 449
Alberti, I, 211 (Homme à l'épée et fleur)

Exhibitions:
Avignon, 1970, 85 (Homee à l'épée et fleur)
Basle, 1981, 40

47 Seated Man with Sword
(Homme à l'épée assis, cat.63)
30 September 1969, Mougins
Oil on canvas
$76\frac{3}{4} \times 51\frac{1}{4}$ (195 × 130)
Private Collection
Illustrated page 207

Bibliography:
Zervos, XXXI, 450
Alberti, I, 212

Exhibitions:
Avignon, 1970, 88 (Homme assis à l'épée)

48 Couple
(Couple, cat.64)
23 October 1969, Mougins
Oil on canvas
$45 \times 57\frac{1}{2}$ (114.2 × 146)
Private Collection on loan to Museum Boymans-van Beuningen, Rotterdam
Illustrated page 209

Bibliography:
Zervos, XXXI, 474
Alberti, I, 95

Exhibitions:
Avignon, 1970, 101

49 The Kiss
(Le Baiser, cat.65)
24 October 1969 (I), Mougins
Oil on canvas
$38\frac{1}{4} \times 51\frac{1}{4}$ (97 × 130)
Gilbert de Botton, Switzerland
Illustrated page 211

Bibliography:
Zervos, XXXI, 475
Alberti, I, 56

Exhibitions:
Avignon, 1970, 102
Basle, 1981, 42, repr.p.47

50 Vase of Flowers on a Table
(Vase de fleurs sur une table, cat.67)
28 October 1969, Mougins
Oil on canvas
$45\frac{3}{4} \times 35$ (116 × 89)
Ernst Beyeler, Basle
Illustrated page 208

Bibliography:
Zervos, XXXI, 486
Alberti, I, 28 (Bouquet)

Exhibitions:
Avignon, 1970, 107 (Bouquet)
Basle, 1981, 44, repr.p.131
New York, 1984, 66

51 Reclining Nude
(Nu couché, cat.68)
2 November 1969, Mougins
Oil on canvas
$51\frac{1}{4} \times 76\frac{3}{4}$ (130 × 195)
Private Collection
Illustrated page 212

Bibliography:
Zervos, XXXI, 488
Alberti, I, 30 (Femme nue couchée)

Exhibitions:
Avignon, 1970, 108 (Femme nue couchée)
Basle, 1981, 45, repr.p.133

52 Bunch of Flowers
(Bouquet de fleurs, cat.69)
7 November 1969 (II), Mougins
Oil on canvas
$57\frac{1}{2} \times 45$ (146 × 114.2)
Marina Picasso Collection, Galerie Jan Krugier, Geneva
Illustrated page 210

Bibliography:
Zervos, XXXI, 492
Alberti, 1970, 113 (Bouquet)

Exhibitions:
Avignon, 1970, 113 (Nature morte)

53 The Embrace
(L'Étreinte, cat.70)
19 November 1969 (II), Mougins
Oil on canvas
$63\frac{3}{4} \times 51\frac{1}{4}$ (162 × 130)
Private Collection
Illustrated page 213

Bibliography:
Zervos, XXXI, 507
Alberti, I, 97 (Couple)

Exhibitions:
Avignon, 1970, 116 (Couple)
Basle, 1981, 46
New York, 1984, 68

54 Reclining Man and Woman with a Fruit Bowl
(Nu couché et homme à la coupe, cat.72)
29 December 1969, Mougins
Oil on canvas
$51\frac{1}{4} \times 76\frac{3}{4}$ (130 × 195)
Bernard Ruiz-Picasso
Illustrated page 214

Bibliography:
Zervos, XXXI, 564
Alberti, I, 39 (Couple)

Exhibitions:
Avignon, 1970, 140 (Couple)

55 The Embrace
(L'Étreinte, cat.74)
26 September 1970, (II), Mougins
Oil on canvas
$57\frac{1}{2} \times 45$ (146 × 114.2)
Private Collection
Illustrated page 215

Bibliography:
Zervos, XXXII, 266
Alberti, II, 5 (Le Baiser)

Exhibitions:
Avignon, 1973, 3, repr.p.13
(Le Baiser)

56 Man and Woman with a Bouquet
26 October 1970, Mougins
Oil on canvas
$45\frac{3}{4} \times 35$ (116 × 89)
Douglas S. Cramer
Illustrated page 216

Bibliography:
Zervos, XXXII, 292

57 Reclining Nude with a Man Playing the Guitar
(Nu couché et homme jouant de la guitare, cat.75)
27 October 1970, Mougins
Oil on canvas
$51\frac{1}{4} \times 76\frac{3}{4}$ (130 × 195)
Musée Picasso, Paris
Illustrated page 217

Bibliography:
Zervos, XXXII, 293
Alberti, II, 19 (Nu couché et homme à la guitare)

Exhibitions:
Avignon, 1973, 25, repr.p.35 (Nu couché jouant de la guitare)
Basle, 1981, 51, repr.p.139

58 Man Writing
(Homme écrivant, cat.76)
7 July 1971 (II), Mougins
Oil on canvas
$43\frac{1}{4} \times 32$ (110 × 81)
Private Collection
Illustrated page 218

Bibliography:
Zervos, XXXIII, 92
Alberti, II, 110

Exhibitions:
Avignon, 1973, 80, repr.p.96

59 Man with Pipe (for Jacqueline)
(Homme à la pipe pour Jacqueline, cat.78)
18 July 1971, Mougins
Oil on canvas
$39\frac{1}{4} \times 32$ (100 × 81)
Private Collection
Illustrated page 219

Bibliography:
Zervos, XXXIII, 104
Alberti, II, 120

Exhibitions:
Avignon, 1973, 93, repr.p.112

60 Flautist
(Joueur de flûte, cat.79)
30 July 1971 (II), Mougins
Oil on canvas
$57\frac{1}{2} \times 45$ (146 × 114.2)
Private Collection
Illustrated page 220

Bibliography:
Zervos, XXXIII, 127
Alberti, II, 143

Exhibitions:
Avignon, 1973, 105, repr.p.123
Basle, 1981, 64

61 Standing Bather
(Baigneur debout, cat.80)
17 August 1971, Mougins
Oil on canvas
$76\frac{3}{4} \times 51\frac{1}{4}$ (195 × 130)
Bernard Ruiz-Picasso
Illustrated page 221

Bibliography:
Zervos, XXXIII, 144
Alberti, II, 71 (Personnage debout)

Exhibitions:
Avignon, 1973, 115, repr.p.134
(Personnage debout)
Basle, 1981, 66, repr.p.149

62 Nude Man and Woman
(Homme et femme nus, cat.81)
18 August 1971, Mougins
Oil on canvas
$76\frac{3}{4} \times 51\frac{1}{4}$ (195 × 130)
Mr and Mrs Raymond D. Nasher
Illustrated page 222

Bibliography:
Zervos, XXXIII, 148
Alberti, II, 136 (Homme et femme)

Exhibitions:
Avignon, 1973, 119, repr.p.138
(Homme et femme)
Basle, 1981, 67
New York, 1984, 93

63 Reclining Nude
(Nu allongé, cat.85)
7 September 1971, Mougins
Oil on canvas
$51\frac{1}{4} \times 76\frac{3}{4}$ (130 × 195)
Gilbert de Botton, Switzerland
Illustrated page 233

Bibliography:
Zervos, XXXIII, 170
Alberti, II, 159 (Femme nue couchée)

Exhibitions:
Avignon, 1973, 127, repr.p.147
(Femme nue couchée)
New York, 1985, 97

64 Woman at Rest
(Femme au repos, cat.86)
14 September 1971, Mougins
Oil on canvas
$57\frac{1}{2} \times 45$ (146 × 114.2)
Private Collection
Illustrated page 224

Bibliography:
Zervos, XXXIII, 181
Alberti, II, 86

Exhibitions:
Avignon, 1973, 131, repr.p.152

65 Seated Nude
(Femme assise, cat.87)
15 September 1971 (II), Mougins
Oil on canvas
$45\frac{3}{4} \times 35$ (116 × 89)
Mr and Mrs Morton L. Janklow,
New York
Illustrated page 223

Bibliography:
Zervos, XXXIII, 331
Alberti, II, 63

Exhibitions:
Avignon, 1973, 179, repr.p.207
New York, 1984, 105

66 Figure with a Shovel
(Personnage à la pelle, cat.77)
17 July, 14 November 1971, Mougins
Oil on canvas
$76\frac{3}{4} \times 51\frac{1}{4}$ (195 × 130)
Bernard Ruiz-Picasso
Illustrated page 226

Bibliography:
Zervos, XXXIII, 229
Alberti, II, 67 (Enfant à la pelle)

Exhibitions:
Avignon, 1973, 92, repr.p.111 (Enfant
à la pelle)
New York, 1980, repr.p.456
Basle, 1981, 70, repr.p.155

67 Reclining Nude
(Nu couché, cat.88)
14 (I)–15 November 1971, Mougins
Oil on canvas
$51\frac{1}{4} \times 76\frac{3}{4}$ (130 × 195)
Private Collection
Illustrated page 232

Bibliography:
Zervos, XXXIII, 228
Alberti, II, 141 (Femme couchée)

Exhibitions:
Avignon, 1973, 143, repr.p.165
(Femme couchée)

68 Card Player
(Le Joueur de cartes, cat.89)
30 December 1971 (II), Mougins
Oil on canvas
$45 \times 57\frac{1}{2}$ (114.2 × 146)
Galerie Louise Leiris, Paris
Illustrated page 225

Bibliography:
Zervos, XXXIII, 265
Alberti, II, 69 (Personnages au jeu de
cartes)

Expositions:
Avignon, 1973, 148, repr.p.171
(Personnage au jeu de cartes)

69 Landscape
(Paysage, cat.90)
31 March 1972, Mougins
Oil on canvas
$51\frac{1}{4} \times 63\frac{3}{4}$ (130 × 162)
Musée Picasso, Paris
Illustrated page 229

Bibliography:
Zervos, XXXIII, 331
Alberti, II, 63

Exhibitions:
Avignon, 1973, 179, repr.p.207
New York, 1984, 105

70 Reclining Nude and Head
(Nu couché et tête, cat.91)
25 May 1972 (I), Mougins
Oil on canvas
$51\frac{1}{4} \times 76\frac{3}{4}$ (130 × 195)
Private Collection
Illustrated page 235

Bibliography:
Zervos, XXXIII, 398
Alberti, II, 85 (Figures)

Exhibitions:
Avignon, 1973, 199 (Figures)

71 Musician
(Musicien, cat.92)
26 May 1972, Mougins
Oil on canvas
$76\frac{1}{2} \times 51$ (194.5 × 129.5)
Musée Picasso, Paris
Illustrated page 227

Bibliography:
Zervos, XXXIII, 397
Alberti, II, 190

Exhibitions:
Avignon, 1973, 200, repr.p.228
New York, 1984, 112

72 The Embrace
(L'Étreinte, cat.93)
1 June 1972, Mougins
Oil on canvas
$51\frac{1}{4} \times 76\frac{3}{4}$ (130 × 195)
Private Collection
Illustrated page 234

Bibliography:
Zervos, XXXIII, 399
Alberti, II, 199 (Couple)

Exhibitions:
Avignon, 1973, 201, repr.p.229
(Couple)

SCULPTURES

73 Head of Woman (project for a
monument)
(Tête de femme, cat.95)
1957, Cannes
Painted wood
$31 \times 13\frac{1}{2} \times 14\frac{1}{4}$ (78.5 × 34 × 36)
Musée Picasso, Paris
Illustrated page 238

Bibliography:
Spies, 493

74 Woman with Hat
(Femme au chapeau, cat.96)
1961, Cannes
Painted sheet metal
$50 \times 29\frac{1}{4} \times 15\frac{3}{4}$ (127 × 74 × 40)
Musée Picasso, Paris
Illustrated page 237

Bibliography:
Spies, 626 2b

Exhibitions:
New York, 1989, repr.p.438

75 Head of Woman
(Buste de femme, cat.99)
1962, Mougins
Painted and folded sheet metal
$9\frac{3}{4} \times 9\frac{1}{2} \times 4\frac{3}{4}$ (24.5 × 24.2 × 12)
Private Collection, Switzerland
Illustrated page 239

Bibliography:
Spies, 635

DRAWINGS

76 **Interior (Woman Artist and Nude in a Studio)**
(Interieur, cat.100)
21 January 1954, Vallauris
Indian ink wash on paper
$9\frac{1}{4} \times 12\frac{1}{4}$ (23.5 × 31)
Mr and Mrs Daniel Saidenberg
Illustrated page 240

Bibliography:
Zervos, XVI, 200

Exhibitions:
New York, 1980, repr.p.422

77 **Seated Man and Young Girl with Monkey and Apple**
(Homme assis, jeune fille avec singe et pomme, cat.101)
26 January 1954, Vallauris
Watercolour on paper
$9\frac{1}{2} \times 12\frac{1}{2}$ (24 × 32)
Private Collection
Illustrated page 241

Bibliography:
Zervos, XVI, 229

Exhibitions:
New York, 1980, repr.p.429

78 **Reclining Nude with Legs Crossed**
(Nu couché les jambes croisées, 102)
21–23 January 1965, Mougins
Gouache and Indian ink on paper
$19\frac{3}{4} \times 25\frac{1}{4}$ (50 × 64)
Private Collection, Paris
Illustrated page 243

Bibliography:
Zervos, XXV, 21

79 **Eagle and Figures**
(Aigle et figures, 103)
10 March 1967 (I), Mougins
Indian ink wash on paper
$19\frac{1}{2} \times 29\frac{3}{4}$ (49.5 × 75.5)
Courtesy of Hirschl and Adler Galleries, New York
Illustrated page 242

Bibliography:
Zervos, XXV, 289

Exhibitions:
New York, 1984, 31

80 **The Kiss**
(Le Baiser, cat.104)
7 October 1967 (IV), Mougins
Pencil on paper
$20 \times 25\frac{1}{2}$ (50.5 × 64.5)
Private Collection
Illustrated page 244

Bibliography:
Zervos, XXVII, 522

81 **Reclining Nude**
11 August 1969 (IV), Mougins
Pencil on paper
$20 \times 25\frac{3}{4}$ (50.5 × 65.3)
Private Collection, USA
Illustrated page 245

Bibliography:
Zervos, XXXI, 369

82 **Man and Reclining Nude**
(Homme et nu couché, cat.106)
4 September 1969 (IV), Mougins
Pencil on paper
$20 \times 25\frac{5}{8}$ (50.5 × 65)
Private Collection, Paris
Illustrated page 246

Bibliography:
Zervos, XXXI, 407

83 **Nude and Man with Mask**
(Nu et homme au masque, cat.107)
5 September 1969 (II), Mougins
Pencil on paper
$20 \times 25\frac{5}{8}$ (50.5 × 65)
Ernst Beyeler, Basle
Illustrated page 247

Bibliography:
Zervos, XXXI, 414

Exhibitions:
New York, 1984, 62

84 **Nude at her Toilet**
(Femme nue a sa toilette, 108)
8 March 1970 (III), Mougins
Ink and coloured pencil on corrugated cardboard

$12\frac{1}{2} \times 12\frac{1}{2}$ (31.5 × 31.5)
Galerie Beyeler, Basle
Illustrated page 248

Bibliography:
Zervos, XXXII, 39

Exhibitions:
Paris, 1971, 15, repr.p.16

85 **The Embrace**
(L'Étreinte, cat.109)
20 March 1970 (III, IV), Mougins
recto-verso
Ink on paper
$20\frac{1}{2} \times 29\frac{1}{2}$ (52.4 × 74.7)
Galerie Louise Leiris, Paris
Illustrated page 246

Bibliography:
Zervos, XXXII, 46, 47

Exhibitions:
Paris, 1971, 17 and 17 twice, repr. pp.19–20
New York, 1984, 76 and 76a

86 **Reclining Nude and Head of Man**
(Nu couché et tête d'homme, cat.110)
26 March 1970 (II), Mougins
Indian ink wash on paper
$20\frac{3}{4} \times 25\frac{3}{8}$ (52.5 × 64.5)
Private Collection, Paris
Illustrated page 249

Bibliography:
Zervos, XXXII, 54

Exhibitions:
Paris, 1971, 23, repr.p.25

87 **The Artist and his Model** (I)
(Le Peintre et son modèle (I), cat.111)
4 July 1970, Mougins
Pencil on cardboard
$10 \times 13\frac{1}{2}$ (25.5 × 34.3)
Musée National d'Art Moderne, Centre Georges Pompidou, Paris. Donated by Louise and Michel Leiris, 1984
Illustrated page 250

Bibliography:
Zervos, XXXII, 187

Exhibitions:
Paris, 1970, 102, repr.p.60

88 **The Artist and his Model** (II)
(Le Peintre et son modèle (II), cat.112)
4 July 1970, Mougins
Coloured pencil on cardboard
$8\frac{1}{2} \times 12\frac{1}{4}$ (21.7 × 31)
*Musée National d'Art Moderne, Centre
Georges Pompidou, Paris. Donated by
Louise and Michel Leiris, 1984*
Illustrated page 251

Bibliography:
Zervos, XXXII, 188

Exhibitions:
Paris, 1971, 103, repr.p.60

89 **The Artist and his Model** (III)
(Le Peintre et son modèle (III),
cat.113)
4 July 1970, Mougins
Coloured pencil on cardboard
$8\frac{7}{8} \times 12\frac{3}{8}$ (22.5 × 31.4)
*Musée National d'Art Moderne, Centre
Georges Pompidou, Paris. Donated by
Louise and Michel Leiris, 1984*
Illustrated page 251

Bibliography:
Zervos, XXXII, 189

Exhibitions:
Paris, 1971, 104, repr.p.61

90 **The Artist and his Model** (IV)
(Le Peintre et son modèle (IV), cat.114)
4 July 1970, Mougins
Coloured pencil on cardboard
$8\frac{3}{4} \times 12\frac{1}{4}$ (22.1 × 31)
*Musée National d'Art Moderne, Centre
Georges Pompidou, Paris. Donated by
Louise and Michel Leiris, 1984*
Illustrated page 251

Bibliography:
Zervos, XXXII, 190

Exhibitions:
Paris, 1971, 105, repr.p.61

91 **The Artist and his Model** (V)
(Le Peintre et son modèle (V), cat.115)
4 July 1970, Mougins
Coloured pencil on cardboard
$8\frac{3}{4} \times 12\frac{1}{4}$ (22.1 × 31.1)
*Musée National d'Art Moderne, Centre
Georges Pompidou, Paris. Donated by
Louise and Michel Leiris, 1984*
Illustrated page 252

Bibliography:
Zervos, XXXII, 191

Exhibitions:
Paris, 1971, 106, repr.p.60

92 **The Artist and his Model** (VI)
(Le Peintre et son modèle (VI), cat.116)
4 July 1970, Mougins
Coloured pencil on cardboard
$8\frac{7}{8} \times 12\frac{3}{8}$ (22.5 × 31.4)
*Musée National d'Art Moderne, Centre
Georges Pompidou, Paris. Donated by
Louise and Michel Leiris, 1984*
Illustrated page 252

Bibliography:
Zervos, XXXII, 192

Exhibitions:
Paris, 1971, 107, repr.p.60

93 **The Artist and his Model** (VII)
(Le Peintre et son modèle (VII),
cat.117)
4 July 1970, Mougins
Coloured pencil on cardboard
$8\frac{11}{16} \times 12\frac{3}{8}$ (22 × 31.3)
*Musée National d'Art Moderne, Centre
Georges Pompidou, Paris. Donated by
Louise and Michel Leiris, 1984*
Illustrated page 253

Bibliography:
Zervos, XXXII, 193

Exhibitions:
Paris, 1971, 108, repr.p.61

94 **The Artist and his Model** (VIII)
(Le Peintre et son modèle (VIII),
cat.118)
4 July 1970, Mougins
Coloured pencil on cardboard
$9\frac{1}{2} \times 12\frac{1}{2}$ (23.8 × 31.5)
*Musée National d'Art Moderne, Centre
Georges Pompidou, Paris. Donated by
Louise and Michel Leiris, 1984*
Illustrated page 253

Bibliography:
Zervos, XXXII, 194

Exhibitions:
Paris, 1971, 109, repr.p.61

95 **Head**
26 September 1971, Mougins
Coloured pencil on cardboard
$13\frac{1}{2} \times 9\frac{1}{2}$ (34 × 23.8)
*Courtesy of Hirschl and Adler Galleries,
New York*
Illustrated page 255

Bibliography:
Zervos, XXXIII, 200

96 **Two Women**
(Deux femmes, cat.119)
26–27 February 1972, Mougins
Indian ink wash on paper
$21\frac{1}{4} \times 29\frac{1}{2}$ (55.5 × 74.8)
Private Collection
Illustrated page 257

Bibliography:
Zervos, XXXIII, 327

Exhibitions:
New York, 1984, 104

97 **Reclining Nude and Head of Man**
(Nu couché et tête d'homme, cat.120)
19 April 1972 (II), Mougins
Indian ink wash on paper
$19\frac{1}{2} \times 25\frac{1}{2}$ (49.3 × 64.5)
Museo de Arte Contemporáneo, Caracas
Illustrated page 256

Bibliography:
Zervos, XXXIII, 355

Exhibitions:
New York, 1984, 108

98 **Reclining Nude**
(Nu couché, cat.121)
20 April 1972 (III), Mougins
Indian ink wash, gouache and
coloured pencil on paper
$22\frac{1}{4} \times 29\frac{1}{2}$ (56.5 × 75)
Private Collection, Paris
Illustrated page 259

Bibliography:
Zervos, XXXIII, 358

Exhibitions:
Paris, 1972, 43, repr.p.34

99 **Nude**
(Nu, cat.122)
1 May (II–III), 3 May 1972,
Mougins
Pencil and gouache on paper
$29\frac{1}{4} \times 22$ (74.3 × 55.9)
Dr and Mrs Martin L. Gecht, Chicago
Illustrated page 258

Bibliography:
Zervos, XXXIII, 375

Exhibitions:
Paris, 1972, 58

100 **Head**
(Tête, cat.123)
29 June 1972, Mougins
Indian ink wash and gouache on paper
26×20 (65.7 × 50.5)
Private Collection
Illustrated page 261

Bibliography:
Zervos, XXXIII, 434

Exhibitions:
Paris, 1972, 101, repr.p.75

101 Self-Portrait
(Autoportrait, cat.124)
30 June 1972, Mougins
Pencil and coloured pencil on paper
$25\frac{3}{4} \times 20$ (65.7 × 50.5)
Fuji Television Gallery, Tokyo
Illustrated page 260

Bibliography:
Zervos, XXXIII, 435

Exhibitions:
Paris, 1972, 102, repr.p.76
New York, 1984, 115

102 Head
(Tête, cat.125)
3 July 1972, Mougins
Coloured pencil on paper
26×20 (65.7 × 50.5)
Galerie Rosengart, Lucerne
Illustrated page 262

Bibliography:
Zervos, XXXIII, 438

Exhibitions:
Paris, 1972, 105

103 Nude with Mirror and Seated Figure
(Nu au miroir et personnage assis,
cat.126)
19 July 1972, Mougins
Indian ink wash and gouache on paper
$22 \times 29\frac{1}{2}$ (56 × 74.7)
Galerie Louise Leiris, Paris
Illustrated page 264

Bibliography:
Zervos, XXXIII, 472

Exhibitions:
Paris, 1972, 137, repr.p.92

104 Three Women
(Trois femmes, cat.127)
29 July – 5 August 1972, Mougins
Gouache and indian ink wash on paper
$23\frac{1}{4} \times 30$ (59 × 75.7)
Private Collection, Switzerland
Illustrated page 265

Bibliography:
Zervos, XXXIII, 490

Exhibitions:
Paris, 1972, 150, repr.p.101

105 Reclining Nude
(Nu couché, cat.128)
11 August 1972, Mougins
Pencil and coloured pencil on paper
$7\frac{1}{2} \times 5\frac{1}{4}$ (19 × 13.5)
Private Collection
Illustrated page 263

Bibliography:
Zervos, XXXIII, 502

Exhibitions:
Paris, 1972, 165, repr.p.11

106 Reclining Nude
(Nu couché, cat.129)
18 August 1972, Mougins
Indian ink on paper
$23\frac{1}{2} \times 30$ (59.4 × 75.7)
Lionel Prejger Collection, Paris
Illustrated page 266

Bibliography:
Zervos, XXXIII, 510

Exhibitions:
Paris, 1972, 170, repr.p.116

107 Nude with a Glass and Heads
(Nu au verre et têtes, cat.130)
18 August 1972, Mougins
Indian ink wash on paper
$23\frac{1}{4} \times 30$ (59 × 75.7)
Hakone Open-Air Museum, Japan
Illustrated page 267

Bibliography:
Zervos, XXXIII, 507

Exhibitions:
Paris, 1972, 171, repr.p.117
New York, 1984, 120

108 Musketeer and Female Nude
1972, Mougins (probably executed
around August)
Indian ink wash and gouache on paper
$8\frac{7}{8} \times 14$ (22.5 × 35.2)
Musée Picasso, Paris
Illustrated page 268

Bibliography:
Zervos, XXX, 267

PRINTS
All lent by the Galerie Louise Leiris, Paris

109 Aquatint and etching (cat.134)
12 November 1966 (III)
$8\frac{3}{4} \times 12\frac{3}{4}$ (22.4 × 32.5)
Illustrated page 97

Bibliography:
Bloch, II, 1414

110 Aquatint and etching (cat.135)
12 November 1966 (V)
$8\frac{3}{4} \times 12\frac{3}{4}$ (22.5 × 32.5)
Illustrated page 97

Bibliography:
Bloch, II, 1416

111 Aquatint (cat.136)
15 November 1966 (V)
$8\frac{3}{4} \times 12\frac{3}{4}$ (22.5 × 32.5)
Illustrated page 97

Bibliography:
Bloch, II, 1417

112 Aquatint and etching (cat.137)
15 November 1966 (VI)
$8\frac{3}{4} \times 12\frac{3}{4}$ (22.5 × 32.5)
Illustrated page 97

Bibliography:
Bloch, II, 1418

113 Etching (cat.139)
16 – 22 March 1968 (I)
$15\frac{1}{2} \times 22\frac{1}{4}$ (39.5 × 56.5)
Illustrated page 118

Bibliography:
Bloch, II, 1481

114 Aquatint (cat.140)
25 May 1968 (I)
$11\frac{3}{4} \times 13\frac{1}{2}$ (30 × 34.5)
Illustrated page 118

Bibliography:
Bloch, II, 1589

115 Aquatint (cat.141)
28 May 1968
$19\frac{1}{2} \times 13\frac{1}{4}$ (49.5 × 33.5)
Illustrated page 107

Bibliography:
Bloch, II, 1604

116 **Aquatint and etching** (cat.142)
4 June 1968 (II)
$19\frac{1}{2} \times 13$ (50 × 33.5)
Illustrated page 102

Bibliography:
Bloch, II, 1622

117 **Aquatint** (cat.144)
5 July 1968 (II)
$11 \times 15\frac{1}{2}$ (28 × 39)
Illustrated page 97

Bibliography:
Bloch, II, 1681

118 **Etching** (cat.145)
4 August 1968 (III)
$8 \times 12\frac{3}{4}$ (20 × 32.5)
Illustrated page 126

Bibliography:
Bloch, II, 1722

119 **Etching** (cat.146)
4 August 1968 (IV)
$8 \times 12\frac{3}{4}$ (20 × 32.5)
Illustrated page 123

Bibliography:
Bloch, II, 1723

120 **Etching** (cat.147)
18 August 1968 (III)
$6\frac{1}{8} \times 8\frac{1}{8}$ (15.5 × 20.5)
Illustrated page 123

Bibliography:
Bloch, II, 1764

121 **Etching** (cat.148)
18 August 1968 (IV)
$8 \times 12\frac{3}{4}$ (20 × 32.5)
Illustrated page 125

Bibliography:
Bloch, II, 1765

122 **Etching** (cat.149)
20 August 1968 (I)
$11 \times 15\frac{1}{2}$ (28 × 39)
Illustrated page 126

Bibliography:
Bloch, II, 1769

123 **Etching** (cat.150)
21–22 August 1968
$11 \times 15\frac{1}{2}$ (28 × 39)
Illustrated page 125

Bibliography:
Bloch, II, 1770

124 **Etching** (cat.151)
29 August 1968 (II)
$11 \times 15\frac{1}{2}$ (28 × 39)
Illustrated page 121

Bibliography:
Bloch, II, 1777

125 **Etching** (cat.152)
31 August 1968 (I)
$6\frac{3}{4} \times 8\frac{1}{8}$ (17 × 20.5)
Illustrated page 121

Bibliography:
Bloch, II, 1778

126 **Etching** (cat.153)
31 August 1968 (II)
$9\frac{1}{4} \times 13\frac{1}{4}$ (23.5 × 33.5)
Illustrated page 121

Bibliography:
Bloch, II, 1779

127 **Etching** (cat.154)
31 August 1968 (III)
$16\frac{3}{4} \times 19\frac{1}{2}$ (41.5 × 49.5)
Illustrated page 121

Bibliography:
Bloch, II, 1780

128 **Etching** (cat.155)
2 September 1968 (III)
$6 \times 8\frac{1}{8}$ (15 × 20.5)
Illustrated page 124

Bibliography:
Bloch, II, 1787

129 **Etching** (cat.156)
3 September 1968 (I)
$6 \times 8\frac{1}{8}$ (15 × 20.5)
Illustrated page 124

Bibliography:
Bloch, II, 1788

130 **Etching** (cat.157)
3 September 1968 (II)
$6 \times 8\frac{1}{8}$ (15 × 20.5)
Illustrated page 136

Bibliography:
Bloch, II, 1789

131 **Etching** (cat.158)
4 September 1968 (III)
$6 \times 8\frac{1}{8}$ (15 × 20.5)
Illustrated page 124

Bibliography:
Bloch, II, 1791

132 **Etching** (cat.159)
4 September 1968 (III)
$6 \times 8\frac{1}{8}$ (15 × 20.5)
Illustrated page 136

Bibliography:
Bloch, II, 1792

133 **Etching** (cat.160)
4 September 1968 (IV)
$6 \times 8\frac{1}{8}$ (15 × 20.5)
Illustrated page 124

Bibliography:
Bloch, II, 1793

134 **Etching** (cat.161)
5 September 1968 (I)
$6 \times 8\frac{1}{8}$ (15 × 20.5)
Illustrated page 124

Bibliography:
Bloch, II, 1794

135 **Etching** (cat.162)
7 September 1968 (I)
$6 \times 8\frac{1}{8}$ (15 × 20.5)
Illustrated page 123

Bibliography:
Bloch, II, 1795

136 **Etching** (cat.163)
8 September 1968 (I)
$6 \times 8\frac{1}{8}$ (15 × 20.5)
Illustrated page 123

Bibliography:
Bloch, II, 1796

137 **Etching** (cat.164)
8 September 1968 (II)
$6 \times 8\frac{1}{8}$ (15 × 20.5)
Illustrated page 124

Bibliography:
Bloch, II, 1797

138 **Etching** (cat.165)
8 September 1968 (III)
$6 \times 8\frac{1}{8}$ (15 × 20.5)
Illustrated page 123

Bibliography:
Bloch, II, 1798

139 **Etching** (cat.166)
9 September 1968 (I)
$6 \times 8\frac{1}{8}$ (15 × 20.5)
Illustrated page 123

Bibliography:
Bloch, II, 1799

140 Etching (cat.167)
9 September 1968 (II)
$6 \times 8\frac{1}{8}$ (15 × 20.5)
Illustrated page 125

Bibliography:
Bloch, II, 1800

141 Etching, aquatint with scraping
(cat.170)
3 February 1970 (IV) (5, 6 March
1970)
$19\frac{3}{4} \times 16\frac{1}{2}$ (50 × 42)
Illustrated page 113

Bibliography:
Bloch, IV, 1865

142 Etching with scraping (cat.171)
11, 28 February, 3, 16, 30 March
1970
$20 \times 25\frac{1}{4}$ (51 × 64)
Illustrated page 131

Bibliography:
Bloch, IV, 1868

143 Etching, aquatint, dry-point with
scraping (cat.172)
16 February, 2, 4, March 1970
$20 \times 25\frac{1}{4}$ (51 × 64)
Illustrated page 100

Bibliography:
Bloch, IV, 1870

144 Etching (cat.173)
19 February 1970
$20 \times 25\frac{1}{4}$ (51 × 64)
Illustrated page 106

Bibliography:
Bloch, IV, 1871

145 Etching (cat.178)
19 March 1971
$9 \times 12\frac{1}{4}$ (23 × 31)
Illustrated page 130

Bibliography:
Bloch, IV, 1945

146 Etching (cat.179)
29 March 1971 (III)
$14\frac{1}{2} \times 19\frac{3}{4}$ (37 × 50)
Illustrated page 124

Bibliography:
Bloch, IV, 1955

147 Etching (cat.184)
9 April 1971
$14\frac{1}{2} \times 19\frac{3}{4}$ (37 × 50)
Illustrated page 126

Bibliography:
Bloch, IV, 1966

148 Dry-point with scraping (cat.185)
1–4 May 1971
$14\frac{1}{2} \times 19\frac{3}{4}$ (37 × 50)
Illustrated page 129

Bibliography:
Bloch, IV, 1972

149 Dry-point (cat.186)
3 May 1971
$14\frac{1}{2} \times 19\frac{3}{4}$ (37 × 50)
Illustrated page 125

Bibliography:
Bloch, IV, 1973

150 Etching (cat.187)
5 May 1971
$14\frac{1}{2} \times 19\frac{3}{4}$ (37 × 50)
Illustrated page 106

Bibliography:
Bloch, IV, 1974

151 Etching (cat.188)
16 May 1971
$14\frac{1}{2} \times 19\frac{3}{4}$ (37 × 50)
Illustrated page 129

Bibliography:
Bloch, IV, 1983

152 Etching (cat.189)
17, 18 May 1971
$14\frac{1}{2} \times 19\frac{3}{4}$ (37 × 50)
Illustrated page 129

Bibliography:
Bloch, IV, 1984

153 Aquatint, dry-point with scraping
(cat.190)
19, 21, 23, 24, 30, 31 May, 2 June
1971
$14\frac{1}{2} \times 19\frac{3}{4}$ (37 × 50)
Illustrated page 129

Bibliography:
Bloch, II, 1985

154 Aquatint, dry-point with scraping
(cat.191)
22, 26 May, 2 June 1971
$14\frac{1}{2} \times 19\frac{3}{4}$ (37 × 50)
Illustrated page 129

Bibliography:
Bloch, IV, 1988

155 Etching, dry-point, aquatint with
scraping (cat.193)
1, 5 March 1972
$14\frac{1}{2} \times 19\frac{3}{4}$ (37 × 50)
Illustrated page 102

Bibliography:
Bloch, IV, 2010

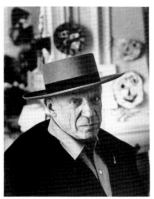
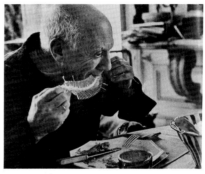

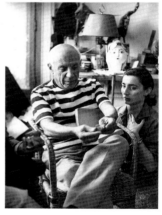
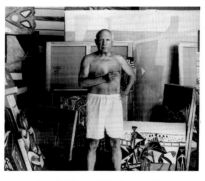

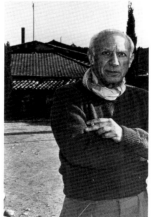

Biography

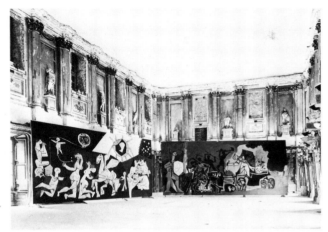

War and Peace, Picasso retrospective, Palazzo Reale, Milan, 1953.
Photo Mario Sachetti

Portrait of Stalin published in *Les Lettres Françaises*, 12–19 March 1953

1953

Mid-January: in Paris.
10 February: 'Woman with Dog' (Zervos, XV, 245).
30 January–9 April: 'Cubisme, 1907–1914' exhibition (Musée National d'Art Moderne, Paris). 'Les Demoiselles d'Avignon' exhibited here.
Mid-February: returns to Vallauris.
5 March: death of Stalin. Aragon asks Picasso to send him a portrait of Stalin for *Les Lettres Françaises*. This portrait, based on an old photograph of Stalin dated 1903, appears in the 12 March issue. The Communist Party officials are outraged by the youthful depiction of the subject; they would have preferred a portrait of Stalin in his old age. Their disapproval becomes a political issue, coming to a head in an official statement published a week later. From then on Picasso distances himself from the Party.
End March: Françoise leaves for Paris with the children.
1 May–5 July: major retrospective at the Galleria Nazionale d'Arte Moderna in Rome, with a catalogue by Lionello Venturi. The 'War and Peace' panels are exhibited here.
June: retrospective at the Lyons museum (170 works).
Summer: makes a series of heads and busts inspired by Françoise, who returns to Vallauris with the children.
Mid-August: leaves for Perpignan, accompanied by Maya, as the guest of the Lazermes, friends of Manolo.
Short stay in Paris; returns to Perpignan, accompanied by Maya, Paulo and Javier Vilato.
5 September: the Céret communists organize a festival in his honour. He attends, with Paulo, Edouard Pignon and Hélène Parmelin.
19 September: returns to Vallauris. Françoise and the children leave for Paris at the end of the month and move into rue Gay-Lussac.
23 September–31 December: the Rome retrospective, enlarged, moves to Milan. Included are: 'Guernica', 'The Charnel House', 'Massacre in Korea', 'War and Peace'. Catalogue by Franco Russoli.
October: breaks with Geneviève Laporte.

28 November: begins the drawings for 'The Artist and his Model' (cats.87–94).
13 December–20 February 1954: retrospective at the Museum of Modern Art in Sao Paulo. 'Guernica' is among the exhibits. Catalogue compiled by Maurice Jardot.
29 December: 'The Shadow' (cat.1).
30 December: 'Nude in the Studio' (cat.2).
31 December: spends New Year at Vallauris with the Lazermes and several other friends. Sabartès decides to present his personal collection to the town of Barcelona.
Luciano Emmer films Picasso working on the vault of the Temple of Peace at Vallauris.

1954

Continues the series of drawings for 'The Artist and his Model' until 3 February, enriching it with traditional themes: the circus, harlequins, mythology. The series is published in *Verve*, vol.VIII, nos.29–30.
10 February: makes a lithograph as an illustration for Claude Roy's *La Guerre et la Paix*, which gives a full account of the creation of Picasso's pictures and publishes interviews with the artist, who has been a friend of Roy's since the early 1950s (Paris, Editions Cercle l'Art).
7 March: 'Woman Doing her Hair' (Donation Rosengart, Lucerne; Zervos, XVI, 262).
April: meets Sylvette David, aged twenty, who models for him. In the course of one month makes about forty drawings and paintings of her, then some painted panels.
17 May: 'Claude Drawing, with Françoise and Paloma' (Musée Picasso, Paris).
May–June: exhibition of the complete engravings at the Kunsthaus, Zurich. Catalogue by B. Geiser and H. Bolliger.
2–3 June: three portraits of 'Madame Z' ... Jacqueline Roque, a young woman he met at Madoura's.
Sculpture assemblage: 'The Landlady' (Spies, 237).
June: book of sketches of Manet's 'Déjeuner sur l'Herbe' and Delacroix's 'Self-Portrait' (Musée Picasso, Paris).
July: exhibition '*Picasso: deux périodes, 1900–1914, 1950–1954*', at the Maison de la Pensée Française in Paris. The pictures from the Chtchoukine Collection, on loan for the first time from Soviet museums, are withdrawn and recalled to the USSR a week after the opening of the exhibition. Picasso sends some replacement works, including 'Portrait of Madame Z'. A number of works

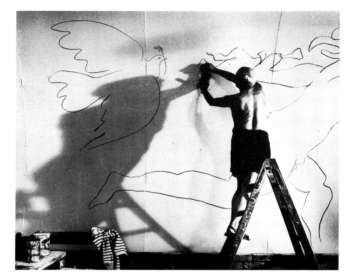

Picasso drawing on the arch of the chapel at Vallauris for Luciano Emmer's film, 1953. Photo André Villers

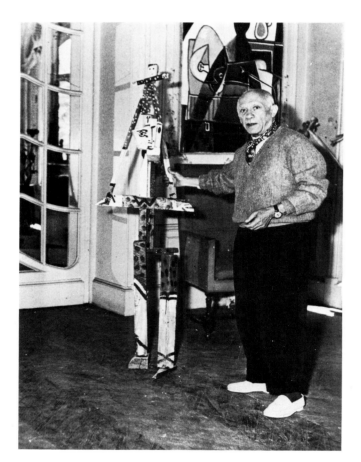

Picasso and 'Woman Carrying a Child' (1953), photographed at La Californie. Photo Edward Quinn

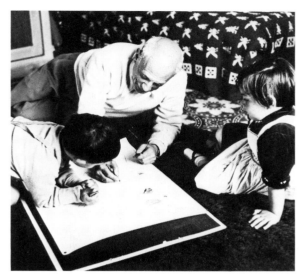

Picasso, Claude and Paloma drawing, Vallauris,
1954. Photo Edward Quinn

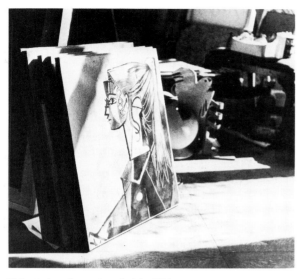

'Sylvette in a Green Armchair', 18 May 1954.
Photo André Villers

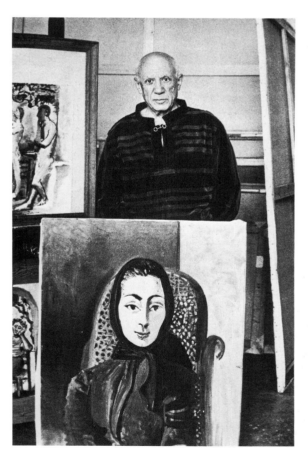

Picasso with 'Jacqueline Wearing a Black Scarf',
11 October 1954. Photo David Douglas Duncan

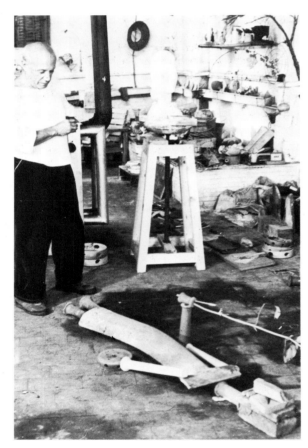

Picasso and 'The Landlady' (1954–7), Vallauris.
Photo Edward Quinn

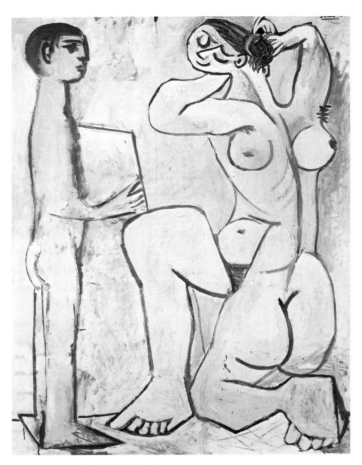

'Woman Doing her Hair', 7 March 1954

'Jacqueline Squatting' (3 June 1954), La Californie.
Photo André Villers

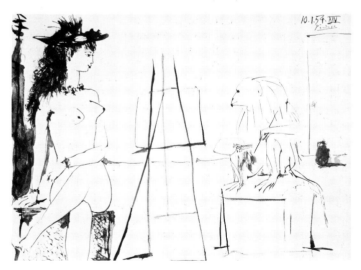

'In the Studio' (10 January 1954),
drawing published in *Verve*, 1954

Jacqueline, Picasso and Jean Cocteau with Paloma,
Maya and Claude behind them at a bullfight in
Vallauris, 1955. Photo Brian Brake, Magnum

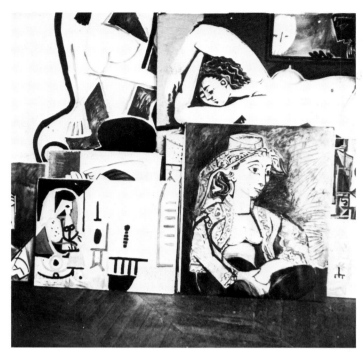

'Jacqueline in Turkish Costume' (20 November 1955).
La Californie. Photo André Gomès

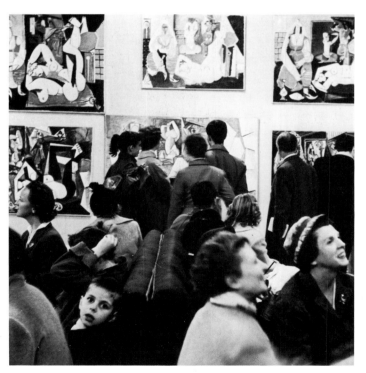

Picasso, peintures 1900–1955 exhibition.
'The Women of Algiers, after Delacroix' series, Musée des
Arts Décoratifs, Paris, 1955. Photo Edward Quinn

from the Gertrude Stein Collection are lent
by Alice B. Toklas.
5–8 July: stays in Perpignan with the
Lazermes, together with Paulo and Maya.
6 August–September: again in Perpignan,
with Paulo, Christine, Paulo's future wife,
and Maya. Drawings of Mme de Lazerme.
Françoise and the children are with him,
together with Jacqueline Roque and her
daughter Catherine. Many of Picasso's
friends visit, including Kahnweiler, the
Leiris, the Ramies, Roland Penrose, the
Vilatos, the Pignons, the Manolos, Douglas
Cooper . . .
8 September: death of André Derain.
19 September: Françoise and the children
leave for Paris.
Picasso leaves for Vallauris with Jacqueline
Roque on 25 September, them moves with
her to rue des Grands-Augustins in Paris.
11 October: paints 'Jacqueline with Black
Scarf' (Private Collection).
3 November: death of Matisse.
13 December: begins the series of variations
on Delacroix's 'Women of Algiers'
(cats. 3–5). Fifteen paintings and two
lithographs on this theme have been made
by 14 February 1955. Jacqueline bears an
uncanny likeness to the woman on the right
in Delacroix's picture.
Attends a bullfight at Vallauris with
Penrose, Cocteau, Prévert, Françoise and
the children.

1955

11 February: Olga dies in Cannes.
May: stays in Perpignan with the Lazermes,
together with Jacqueline, Paulo and Mayo.
Meets up with the Leiris and Jean Cocteau.
They attend the Whitsun bullfight at Céret.
June–October: major retrospective at the
Musée des Arts Décoratifs in Paris, *Picasso,
Peintures, 1900–1955*. 'Guernica' is among
the exhibits. Catalogue by Maurice Jardot.
After Paris the exhibition moves to Munich,
Cologne and Hamburg until April 1956.
June: buys a new home in the Midi, a large
house in the Belle Epoque style, called La
Californie, situated above Cannes with views
over the bay as far as Antibes, and with a
large garden planted with palms and
eucalyptus trees, which very soon houses a
number of sculptures.
August: makes 'Don Quixote and Sancho
Panca' for *Les Lettres Françaises*, to mark the
400th anniversary of Cervantes' birth.
Summer: shooting of Henri-Georges
Clouzot's film, *Mystère Picasso*, at the

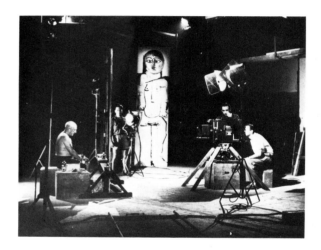

above and left column
Shooting of Henri-Georges Clouzot's film *Mystère Picasso*, 1955. Photo Edward Quinn

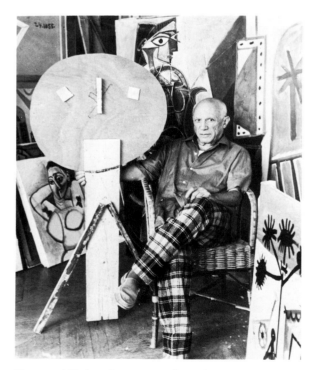

Picasso and 'Bather: the young man', 1956.
Photo Edward Quinn

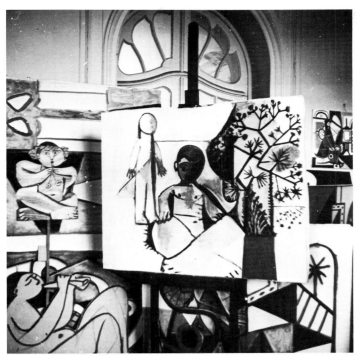

'The Children' (28 August 1956), La Californie.
Photo André Gomès

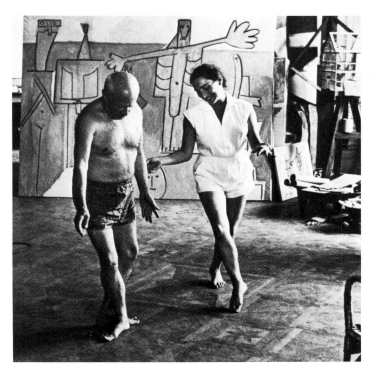

Picasso and Jacqueline dancing in front of the
painting 'The Bathers' (1957), La Californie.
Photo David Douglas Duncan

Victorine studios in Nice. The director
captures the artistic process at work by
means of a technique involving ink
spreading over paper. The film shows the
evolution of the painting 'Beach at La
Garoupe' (Marina Picasso Collection).
4 October: portrait of Jacqueline as 'Lola of
Valencia' (Zervos, XVI, 478 and 479), after
Manet. The vast rooms of La Californie,
transformed into studios, inspire a series
Picasso called 'indoor landscapes'
(23 October–12 November) (Zervos, XVI,
486–97).
10 November: a visit from Juan Vidal-
Ventosa whom Picasso has not seen for
twenty years. He brings with him Miguel
and Juan Gaspar from Barcelona.
Picasso is visited by a number of friends and
often attends the bullfights at Arles and
Nîmes. He becomes friendly with Luis-
Miguel Dominguin. Claude and Paloma pay
a visit.
20 November: paints 'Jacqueline in Turkish
Costume' (Private Collection). In the course
of the year, publication of *A haute flamme* by
Tristan Tzara (Paris, edited by the author,
with six etchings). 1 December: 'Nude with
Fez'.

1956

4 January: paints 'Women at their Toilet'
(Musée Picasso, Paris).
16 February: paints 'Two Women on the
Beach' (Musée National d'Art Moderne,
Paris), a revival of the bathers' theme.
20 March: 'Spring' (Musée National d'Art
Moderne, Paris. Leiris Bequest).
26 March: 'Nude in a Rocking-chair' (cat.6).
March-April: second series of paintings on
the theme of 'The Studio', La Californie
(Zervos, XVII, 56, 57; cats.7, 8).
11 June: 'Woman Seated by the Window'
(Museum of Modern Art, New York).
Summer: 'The Bathers', made in wood
(Staatsgalerie, Stuttgart), then cast in
bronze (Musée Picasso, Paris).
28 August: 'The Children' (Private
Collection). 6–19 October: first exhibition
by Picasso in Barcelona, Sala Gaspar.
25 October: his 75th birthday is celebrated
at Madoura's, with the Vallauris potters.
There are also birthday celebrations in
Moscow, where Ilya Ehrenburg organizes an
exhibition of works belonging to the State.
22 November: together with Edouard
Pignon, Hélène Parmelin and seven other
militants signs a letter addressed to the
Central Committee of the French

Picasso's 75th birthday, Vallauris, 1956.
Photo André Villers, *Paris-Match*

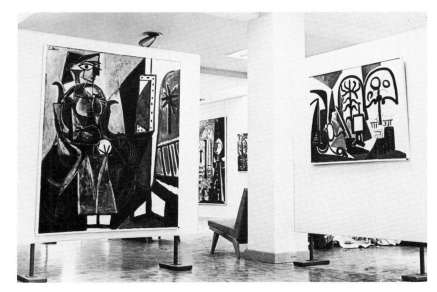

Picasso. Paintings 1955–1956 exhibition, Galerie
Louise Leiris, Paris, March–April 1957. In the
foreground, left: 'Woman Sitting by the Window',
11 June 1956. Photo André Villers

Picasso opening the present given to him by Daniel-Henry
Kahnweiler for his 75th birthday, 1956. Photo Edward Quinn

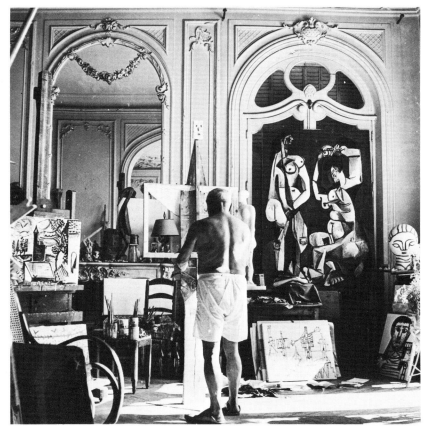

Picasso in front of a 'Bather' (1956), La Californie.
In the background: 'Woman at their Toilet', 4 January 1956.
Photo André Villers, *Paris-Match*

right and below
Picasso arranging figures around a design for a sculpture ('Head of Woman', 1957, Private Collection, photo Carl Nesjar, and 'Head of Woman', 1957, Musée Picasso, Paris). Photo David Douglas Duncan

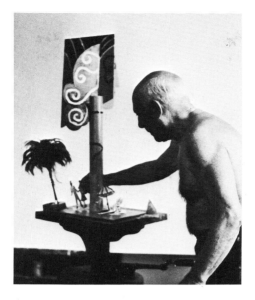

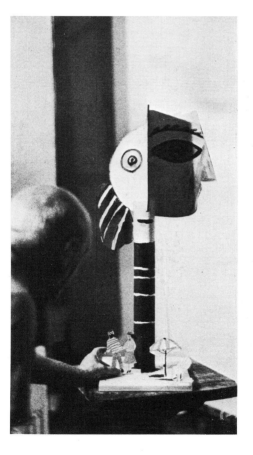

Communist Party, expressing concern over the situation in Hungary. Letter published in *Le Monde*.

In the course of the year, publication of Roch Grey's *Chevaux de Minuit* (Cannes/Paris, with a text by Iliazd, 'The 41st Degree', with thirteen engravings, one in drypoint), and René Crevel's *Nuit* (Alès, Ed. P.A.B., with one copper-plate engraving). In spring 1956 Pierre-André Benoit sends Picasso a piece of film for him to use to make an illustration for Crevel's poem. This marks the beginning of a collaboration with Pierre-André Benoit which will continue for more than ten years. Screening of *Mystère Picasso* at the Cannes Film Festival.

1957

March –April: opening exhibition at the Galerie Louise Leiris, in the new premises at 47, Rue de Monceau, Paris. The exhibition included works of 1955 and 1956.

4 May–8 September: exhibition *Picasso, 75th Anniversary Exhibition*, in New York at the Museum of Modern Art, then in Chicago (the Art Institute, 29 October –8 December), and in Philadelphia (6 January– 23 February 1958).

12 June: *Venus and Cupid* after Cranach (Zervos, XVII, 339).

6 July–2 September: exhibition of drawings, gouaches, watercolours 1898 –1957 at the Musée Réattu, Arles; catalogue by Douglas Cooper.

17 August: in a studio housed in the top floor of La Californie, the start of the variations of *Las Meniñas* after Velázquez, which ran until the 30 December.

Autumn: received a commission for a decoration of a wall for a new Unesco building, Paris.

6 December: a gouache depicting a view of the studio with a nude and a canvas, of a theme close to 'The Bathers' and forms the first idea for this work.

From 15 December: two note-books of studies for the Unesco project (Musée Picasso, Paris). During the year, realization of the first decorations of concrete engraved by Carl Nesjar after drawings by Picasso: three walls of the inside of a government building in Olso (*Beach Scene*, *Fishermen*, and *Faune and Satyr*) and the first maquettes in wood or sheet-metal cut and painted representing heads destined for larger monuments.

'Still Life with Bull's Head' (28 May–9 June 1958.
Musée Picasso, Paris), La Californie. Photo André Villers

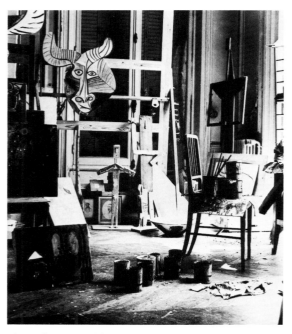

The studio at La Californie. In the background:
'The Bathers'. Left: 'Bull's Head', 29 April 1958.
Photo André Villers

'Person' (9 and 10 June 1958), La Californie.
Photo André Villers

Picasso in front of 'The Fall of Icarus', 1958.
Photo Edward Quinn

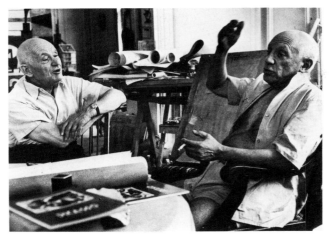

Picasso and Daniel-Henry Kahnweiler at
La Californie, 1958. Photo David Douglas Duncan

The château of Vauvenargues, 1959.
Photo Documentation by Musée Picasso, Paris

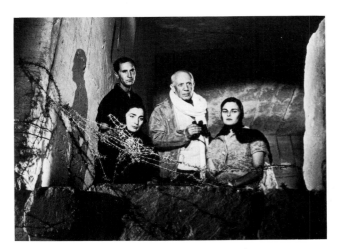

Luis Miguel Dominguin, Jacqueline and Picasso, and
Lucia Bose in Jean Cocteau's *Testament d'Orphée*,
1959. Photo Lucien Clergue

1958

18 January: the theme of the UNESCO painted panel develops: the diver watched by the bathers replaces the view of the studio. Picasso pins the various components on to a collective maquette.

The work is completed on 29 January. Series of sculptures made by assembling pieces of reconstituted wood, in the spirit of 'The Bathers' (Spies, 509, 541–4).

19 April–9 June: paints 'Cannes Bay' (Musée Picasso, Paris), as seen from the heights of La Californie.

8 March–8 June: exhibition of 150 original ceramics at the Maison de la Pensée Française, Paris.

29 March: presentation of the UNESCO painted panel at Vallauris.

The inaugural ceremony of the 'Temple of Peace' is banned because the chapel is too small.

In painting, a return to the depictions of the studio at La Californie with its baroque windows (Zervos, XVIII, 238, 240, 262–8).

September: installation of the UNESCO panel. Georges Salles, accepting the work on behalf of UNESCO, suggests the title 'The Fall of Icarus'.

The town of Cannes is developed by property speculators, and the villa is surrounded by new buildings. Picasso looks for a quieter place to work and in September buys the château of Vauvenargues, a fourteenth-century building situated at the foot of the Montagne Saint-Victoire, near Aix-en-Provence and various other Cézanne locations.

1959

Beginning of the year: paints 'Seated Nude' (cat.11), either at La Californie or shortly after his move to Vauvenargues.

January: 'Nude under a Pine Tree' (cat.10). Composes a long Spanish poem, *Trozo de piel*, published in Spain in 1961 by the poet Camilo José Cela.

The technique of lino-cutting, which he discovered several years previously in Vallauris at a young printer's, Arnera, had enabled him to make some posters advertising a bullfight in 1956. Thereafter he makes use of it along with the other printmaking techniques: the 'Woman's Bust' after Cranach the Younger, which involves six prints in different colours, is a technical triumph.

Paints several large sculptural nudes (Zervos, XVIII, 321–5).

February: first stay at Vauvenargues.
March: drawings of bullfights with crucifix
(Zervos, XVIII, 342–59).
Back at La Californie, begins 'The Buffet at
Vauvenargues' on 23 March.
'Still-Lifes' with pitcher and mandolin,
Spanish-inspired (Zervos, XVIII, 434–41);
parody of 'El Bobo' after Murillo (Private
Collection; Zervos, XVIII, 484). Several
portraits of Jacqueline, including, on
20 April, the portrait of 'Jacqueline at
Vauvenargues' (Private Collection; Zervos,
XVIII, 452).
5 June: unveiling of the 'Monument to
Apollinaire' in Paris, Saint-Germain-des-
Prés, with the bronze head of Dora Maar of
1941.
Summer: stays at La Californie.
August: at Vauvenargues, beginning of the
variations on Manet's 'Déjeuner sur l'Herbe'
(cats.13, 14), divided into about ten work
stages, from August 1959 to December
1961, and among three studios,
Vauvenargues, La Californie and Mougins.
19 September: opening of the chapel at
Vallauris, decorated with the 'War and
Peace' panels; it becomes a national
museum.
Lino-cuts with Mediterranean themes:
bacchanalia, centaurs, fauns.
Publication of *La Tauromaquia o arte de torear*
by Jose Delgado, alias Pepe Illo (Barcelona,
Gustavo Gili, with one dry-point, twenty-six
aquatints and two further aquatints for the
sequel).
October: with Jacqueline, takes part in the
shooting of Jean Cocteau's film, the
Testament d'Orphée.

1960

Drawings and paintings of women in the
bath or washing their feet.
February: renewed work on the 'Déjeuners'
(Zervos, XIX, 160–8, 376–82).
12 April: at Vauvenargues, paints 'Nude on
the Beach with Spade' (Private Collection;
Zervos, XIX, 236) in which the figures
presage the metal cut-out sculptures of
1961.
15 June–13 July: exhibition of forty-five
lino-cuts at the Galerie Louise Leiris, Paris.
6 July–18 September: 1895–1959
retrospective at the Tate Gallery (270
works). Catalogue by Roland Penrose.
20 August: at Vauvenargues, completes a
version of 'Déjeuner sur l'Herbe', begun on
3 March (Musée Picasso, Paris).

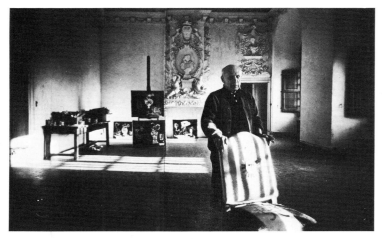

Picasso at Vauvenargues, 1959.
Photo David Douglas Duncan

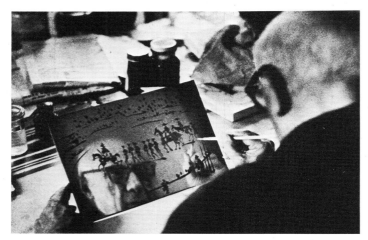

Picasso working on 'Tauromachia', 1959.
Photo David Douglas Duncan

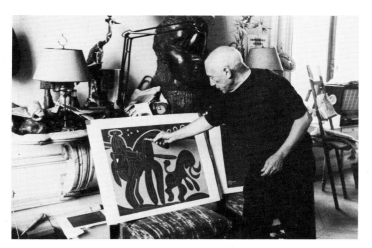

Picasso making a lino-cut, 'Picador and Bull', 1959.
Photo Edward Quinn

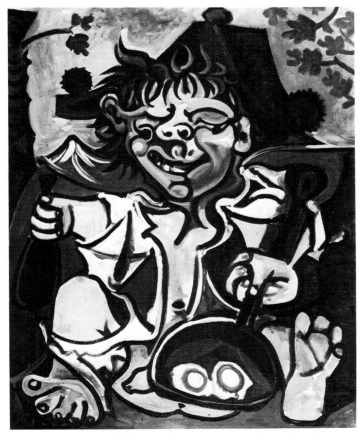

'El Bobo' after Murillo, 14–15 April 1959

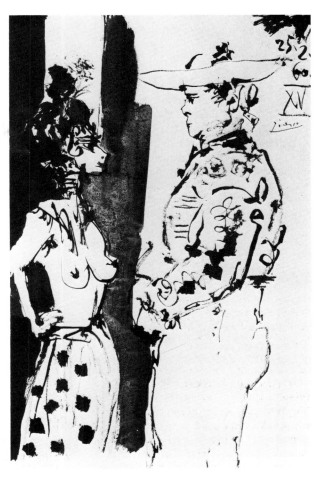

'Picador and Girl', wash, 25 February 1960 (xv)

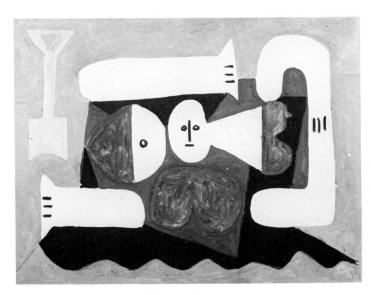

'Nude on the Beach with Spade', 12 April 1960

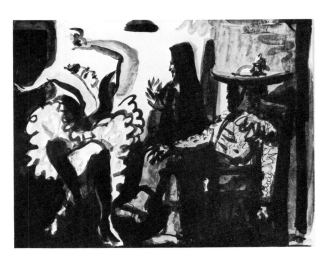

'Dancer and Picador', wash, 6 June 1960 (iv)

Picasso in front of the model for the College of
Architects in Barcelona. Photo Carl Nesjar

'Woman Wearing a Hat' (1961), La Californie.
Photo Edward Quinn

'Woman with Child' (early 1961), La Californie.
Photo André Gomès

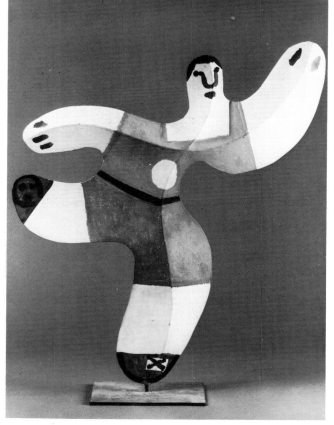

'Footballer', spring 1961

Carl Nesjar standing between the model for 'Woman with Arms
Outstretched' (1961) and the full-scale version at Daniel-Henry
Kahnweiler's house in Saint-Hilaire, 1962.
Photo documentation by Musée Picasso, Paris

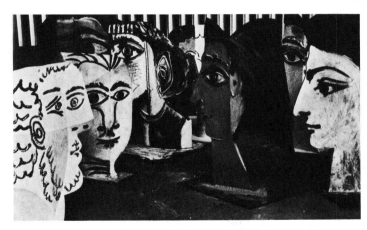

Painted sheet-metal heads, Mougins, 1962.
Photo David Douglas Duncan

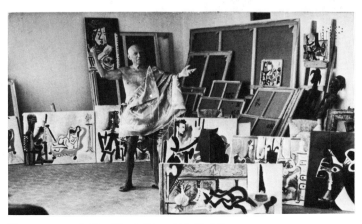

Picasso surrounded by 'The Artist and his Model'
series (1963), Mougins, 1963. Photo Robert Doisneau

15 October: begins the maquettes for the
murals for the architects' college in
Barcelona. The full-scale finished works in
incised concrete will be made by Carl Nesjar
in 1960 and 1961: outside there are two
friezes; inside two murals, one depicting the
sardane, a very popular Catalan dance.
November–December: exhibition at Sala
Gaspar, Barcelona (thirty paintings), and an
exhibition of drawings and washes, made
between 11 July 1959 and 26 June 1960,
around the theme of the picador, at the
Galerie Louise Leiris, Paris.

1961

24 January: preliminary sketch for the
'Rape of the Sabines' (Zervos, XIX, 421).
2 March: marries Jacqueline Roque very
quietly at Vallauris. Works in Cannes on
painted sheet metal cut-outs: 'The Chair',
'Woman with Arms Outstretched', 'Woman
Wearing a Hat', 'Woman with Child',
'Seated Pierrot', 'Footballers' (Musée
Picasso, Paris).
June: moves into the Notre-Dame-de-Vie
farmhouse at Mougins, above Cannes.
Second stage of 'Déjeuner sur l'Herbe'.
25 October: Picasso's 80th birthday
celebrations at Vallauris.
25 October–12 November: 'Happy
Birthday, Mr Picasso' exhibition at the
UCLA Art Gallery, Los Angeles (over 170
works).
David Douglas Duncan, *Picasso's Picassos*,
Paris, Bibliothèque des Arts.
13 December–10 January 1962: 'Woman
and Dog Under a Tree' (Zervos, XX, 160).

1962

2 January: paints 'Seated Woman with
Yellow and Green Hat' (Private Collection;
Zervos, XX, 179).
26 January–24 February: exhibition of
paintings at Vauvenargues (1959–61) at
the Galerie Louise Leiris, Paris.
25 April–12 May: 'Picasso: An American
Tribute', exhibition at the Cordier Warren
Gallery, New York.
1 May: is awarded the Lenin Prize for Peace
for the second time.
Continues work on sheet-metal heads.
Makes seventy portrayals of 'Jacqueline' in
the course of the year: paintings, drawings,
ceramics, prints, twenty-two of these
executed between November and December.
14 May–18 September: *Picasso 80th
Birthday Exhibition: The Museum Collection,*

Present and Future at the Museum of Modern Art, New York.
August: Serge Lifar suggests to Picasso that he should design the set for the ballet 'Icarus', to be staged at the Paris Opera. Makes a gouache for this on 28 August.
23 October: 'Still Life with Cat and Lobster' (cat.20).
24 October: 'Rape of the Sabines'.
4–8 November: 'Rape of the Sabines' (cat.22). 'Woman with Arms Outstretched', cast in concrete by Carl Nesjar (6 metres high), made in the course of the year for Daniel-Henry Kahnweiler's garden at Saint-Hilaire (Spies, 639).

1963

9 January-7 February: 'Rape of the Sabines', Museum of Fine Arts, Boston.
Thirteen variations on Jacqueline right at the beginning of the year.
February: begins 'The Artist and his Model' sequence (cats.23–5).
9 March: opening of the Museu Picasso in Barcelona, calle Montcada, in the fifteenth-century hôtel Aguilar.
26 May: 'Seated Woman' (Musée Picasso, Paris).
May–September: drawings after Rembrandt's 'Bathsheba' (Zervos, XXIII, 241–9).
31 August: death of Braque.
11 October: death of Cocteau.
October: in printmaking, collaborates closely with the Crommelynck brothers, Aldo and Piero, who set up their copper-plate engraving studio at Mougins. Picasso had met Aldo in the 1940s, when the latter was working with Lacouriere. The Crommelyncks will proof the engravings in the great series of Picasso's last years. Develops innovatory techniques and a mixture of methods in two series: from 14–20 October, the 'Embrace' sequence (Bloch, I, 1110–16); from 31 October to 7 December, 'The Artist and his Model' sequence (Bloch, I, 1117–44).
During this year, a series of murals incised by Nesjar is erected at the home of Douglas Cooper, collector, art historian and friend of Picasso, at the château de Castille, at Remoulins.

1964

11 January–16 February: *Picasso and Man* retrospective at the Art Gallery of Toronto.
15 January–15 February: *Peintures*

1962–1963 exhibition at the Galerie Louise Leiris, Paris.
January-May: sequence of about twenty canvases on the theme of 'Nude with Cat', most of which have Jacqueline's face (cat.27).
Spring: Françoise Gilot, collaborating with Carlton Lake, publishes *Life with Picasso*, New York, McGraw-Hill (French edition, Calman Levy, 1965).
23 May–5 July: 1899–1963 retrospective at the National Museum of Modern Art, Tokyo, then at Kyoto and Nagoya. An entire volume of Christian Zervos's catalogue, vol. XXIV, is dedicated to 1964: reproduced in it are female faces and nudes, men's heads in crayon, four self-portrait drawings. 'The Artist and his Model' theme is taken up again in about a hundred canvases executed in the last months of the year (cats.28–30). The printmaking work, interrupted on 8 February, is resumed in August, with use of soft coloured varnish. Makes the maquette for the huge sculpture for the new business district of Chicago, after a 'Woman's Head' of 1962 (Art Institute, Chicago). The finished version, in steel (20 metres high) is completed in 1965 (Chicago, Civic Center) and unveiled in 1967 (Spies, 653). During the year, Brassai's book, *Conversations avec Picasso* (Paris, Gallimard), illustrated with photographs taken by the author, is published.

1965

January: 'The Two Friends'.
February: sequence of tortuous landscapes (Zervos, XXV, 32–6).
March: for the May Salon, presents the composition 'Twelve canvases in One, One canvas in Twelve'. Continues the theme of 'The Artist and his Model'. About thirty canvases on the subject are made in March.
16 April: 'Woman Pissing' (cat.33).
New themes in painting: man carrying a child, the family, man eating water-melon. In the spring, painting and printmaking are very closely linked.
May: new sequence of landscapes (Zervos, XXV, 121–6).
22 June–15 September: *Picasso et le Théâtre* exhibition at the Musée des Augustins in Toulouse, organized by Denis Milhau.
15 July–18 August: exhibition of paintings, tapestries, drawings and prints, at the Sala Gaspar, Barcelona (since 1961 this gallery has mounted an annual show of recent work illustrating various techniques).

October: moves on from the men's heads sequence to a mother and child sequence, which is interrupted by illness, the result of a crisis in his private life. His attempts to prevent the publication in French of Françoise's book, *Vivre avec Picasso*, prove unsuccessful and simply serve to promote the book.
November: operated on in the American hospital in Neuilly. Last stay in Paris. The Tate Gallery purchases 'The Dance' (1925).
Renderings in incised concrete by Carl Nesjar of the figures in the 'Déjeuner sur l'herbe, after Manet' (Spies, 652) and their erection in the garden of the Moderna Museet in Stockholm.

1966

Spring: begins to draw, then paint, again, with the appearance of the musketeers, noblemen from Spain's Golden Age.
August: returns to printmaking About sixty plates, brilliantly executed, are made by spring 1967. They will not be reproduced until after 1975 (cats.109–12).
28 September: death of Breton.
19 November: opening of the 'Hommage à Picasso' exhibition at the Grand Palais and Petit Palais in Paris, by André Malraux, Minister of Culture since 1959. Organized by Jean Leymarie, the exhibition is extremely successful; in particular it reveals to the public for the first time Picasso's sculptures in their entirety: a number of sculptures in the artist's possession had never previously been exhibited.
During the year, *Sable Mouvant*, by Pierre Reverdy, (Paris, Louis Broder, with ten aquatints) is published. *Sable Mouvant* is Reverdy's last poem; he died at Solesmes on 17 June 1960. As a tribute to the poet Picasso agrees to illustrate this posthumous publication. The ten aquatints are selected from the great 'Artist and his Model' series made in winter 1963–4 and February–March 1965.

1967

January: drawings of 'Man Eating Watermelon', 'Man Playing Flute' and 'Man with Sheep' (Zervos, XXV, 267–73).
20 January: some 200 Catalan students and academics pay tribute to Picasso in Barcelona.
Turns down the Légion d'Honneur.

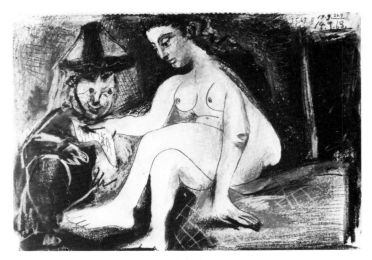

'Seated Nude' after Rembrandt's 'Bathsheba',
3 May (III), 20 September 1963. Pencil and crayon

Model for 'Head' (1962–64) with Picasso's
signature of approval (1966) for the Civic Center,
Chicago. Photo Nedrich-Blessing

Picasso in front of 'Woman Pissing', 16 April 1965.
Photo André Gomès

'Head', 1967. Civic Center, Chicago.
Photo George Kufrin

Spring: Picasso is evicted from his studio in rue des Grands-Augustins.

Continues the 'Heads' of the musketeers series (Zervos, XXV, 278–83, 302–22).

21 May: first foreshortened nude, full frontal, in a sequence which will be developed until October: 'Reclining Nude' (Zervos, XXVII, 26–8).

9 June–13 August: exhibition of sculptures and ceramics at the Tate Gallery, organized by Sir Roland Penrose; the exhibition is then shown at the Museum of Modern Art, New York (11 October–1 January 1968).

14 June: 'Reclining Nude' (cat. 35).

July: numerous wash drawings, one of which is 'Nude in Mirror' (Rosengart Bequest, Lucerne).

October: drawings on the theme of the 'Embrace' and the 'Kiss' (Zervos, XXVII, 129–37, 522 (cat. 80)).

The sculpture for Chicago's Civic Center is erected.

1968

January: pictures on the theme of 'Nude with Bird' (cat. 36).

Drawings on the theme of 'The Turkish Bath' (Zervos, XXVII, 199–209).

13 February: death of Jaime Sabartès (born 1881). In honour of his memory, Picasso donates the 'Meniñas' series (fifty-eight canvases) and a portrait of Sabartès from the Blue Period to the Museu Picasso in Barcelona. Sabartès, who had donated his library to the provincial Museum of Fine Arts in Malaga in 1953, had subsequently donated his collection of works of art to the Museu Picasso in Barcelona, and these formed the basis of the museum's collection.

28 February–23 March: exhibition of drawings from 1966 and 1967 at the Galerie Louise Leiris, Paris.

16 March–5 October: the masterly '347' series (cats. 139–67), made during this period and exhibited in December at the Galerie Louise Leiris, Paris (18 December–1 February 1969). A complex work with a variety of interconnecting themes: circus, bullfight, theatre, commedia dell'arte; the series reaches its climax in a number of erotic scenes tinged with humour, inspired by Ingres's painting, 'Raphael and la Fornarina'. The prints are made by the Crommelynck brothers in their Mougins studio.

Publication of Le Cocu Magnifique, by the engravers' father, Fernand Crommelynck (Paris, Ed. de l'Atelier Crommelynck, seven etchings, four aquatints and etchings, one aquatint, dry point and etching). This book appears two years before the playwright's death: the illustrations belong to the series of sixty-five prints made between 6 November and 19 December 1966.

October: 'Musketeers with Pipe' (Zervos, XXVII, 338–41 and 343–6).

8 October: 'Reclining Nude with Necklace' (cat. 37). A huge bust of 'Sylvette' in concrete is erected at the University of New York (Spies, 658). Publication of the first volume of L'Oeuvre gravé de Picasso by Georges Bloch, Berne, Ed. Kornfeld, and the second volume of L'Oeuvre gravé et lithographié de Picasso by Bernhard Geiser, Lausanne, Ed. Clairefontaine.

1969

Prolific output in painting during the course of the year: intensely staring faces, couples (in particular the theme of the 'Kiss', cat. 49), nudes, men with swords and smoking, still-lifes . . . (cats. 50–4).

April: publication of El Entierro del Conde de Orgaz, with a prologue by Rafael Alberti (Barcelona, Editorial Gustavo Gili, Ed. de la Cameta, with one copper-plate engraving, twelve etchings, three aquatints). This 'literary fantasy' was compiled by Picasso between 6 January 1957 and 20 August 1959, and the engravings were selected from work done during 1966 and 1967.

October: Yvonne and Christian Zervos, following a visit to Mougins, decide to organize an exhibition of recent works, which will take place the following year in the Palais des Papes in Avignon.

1970

January: bequest to the Museu Picasso in Barcelona of the works Picasso left with his family in Spain, works from his early career, made at La Corogne and later at Barcelona, and those made in 1917 during his time with the Ballets Russes.

20 January: death of Yvonne Zervos. Christian Zervos writes the preface for the Palais des Papes exhibition which opens on 1 May, with 167 paintings and 45 drawings. He dies on 12 September.

Picasso continues to paint. 'The Family', 30 September; 'The Matador', 4 October (Musée Picasso, Paris).

12 May: the Bateau-lavoir is destroyed in a fire.

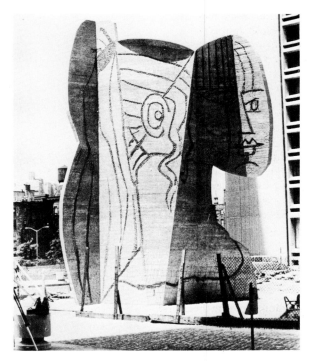

'Sylvette', full-scale version executed by Carl Nesjar
for New York University, 1968. Photo Carl Nesjar

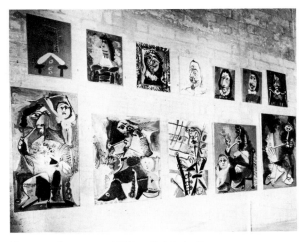

Picasso 1969–1970 exhibition, Palais des Papes,
Avignon, May–September 1970. Photo Atzinger

Sheet of engravings for *La Célestine*, 1971
(Musée Picasso, Paris)

Cover for *The Burial of the Count of Orgaz*, Barcelona,
Ed. Gustavo Gili, 1969

'Woman with Vase' (1933) on Picasso's grave,
Vauvenargues, 1973. Photo André Gomès

1971

23 April – 5 June: exhibition of 194 drawings, made between 15 December 1969 and 12 January 1971, at the Galerie Louise Leiris, Paris.

25 May: gift of fifty-seven drawings made between 31 December 1970 and 4 February 1971 to the Musée Reattu in Arles, where Picasso has enjoyed the bullfights.

30 August: 'Motherhood'.

25 October: Picasso's 90th birthday. To mark the occasion, a selection of works from various French public collections is exhibited in the Grande Galerie in the Louvre. Publication of Fernando de Rojas's *La Célestine* (Paris, Ed. de l'Atelier Crommelynck, sixty-six etchings and aquatints). This narrative drama in twenty-one acts, first published at Burgos in 1499, is one of the major works of Spanish literature. The engravings, dated from 11 April to 18 August 1968, are taken from '347' series.

Winter: Picasso presents the Museum of Modern Art in New York with 'Guitar' of 1912, his first construction in metal.

1972

31 March: 'Landscape' (cat.69).
April: drawings of 'Reclining Nude' (cats.97–8).
26 May: 'Musician' (cat.71).
1 June: 'The Embrace' (cat.72).
June–July: series of self-portrait drawings. The head is sometimes portrayed as a death mask, the eyes starting out of their sockets (cats.101–2).
3 October: drawing of 'Nude in Armchair'

1973

1 December 1972 – 3 January 1973: 172 drawings from 21 November 1971 to 8 August 1972 exhibited at the Galerie Louise Leiris, Paris.

24 January – 24 February: exhibition of 156 prints made between the beginning of 1970 and March 1972 (cats.141–55) at the Galerie Louise Leiris, Paris which, since 1953, has exhibited Picasso's work immediately following its execution, and has played a highly important part in its promotion.

8 April: death of Picasso at Notre-Dame-de-Vie, Mougins.

10 April: burial in the garden of the château de Vauvenargues; Jacqueline places 'Woman with Vase', a bronze made in 1933, on his grave (Spies, 135).

23 May – 23 September: the *Pablo Picasso, 1970–1972* exhibition at the Palais des Papes in Avignon (catalogue with preface by René Char) reveals the final works, which Picasso himself selected for the exhibition.

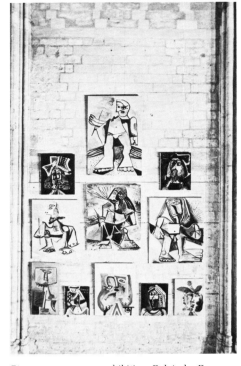

Picasso 1970–1972 exhibition, Palais des Papes, Avignon, 23 May–23 September 1973. Photo Atzinger

Bibliography

Alaminos, Eduardo: 'Picasso en el espacio de "Las Meniñas"', *Batik*, Barcelona, no.64, November–December 1981, pp.29–33.

Alberti, Rafael: *Picasso en Avignon*, Paris, Éd. Cercle d'Art, 1971.

Alberti, Rafael: *Picasso, le rayon inin-terrompu*, Paris, Éd. Cercle d'Art, 1974.

Alloway, Lawrence: 'The Late Picasso', *Art International*, Lugano, vol.VI, no.4, May 1962, pp.47–49.

Alloway, Lawrence: 'Picasso and Periodization', *Art in America*, New York, vol.68, no.10, December 1980, pp.13–15.

Anderson, John: 'Faustus/Velázquez/Picasso', *Arts Canada*, Toronto, no.106, March 1967, pp.17–21.

Ashton, Dore: 'The Late Work: a Postscript', *Arts Canada*, Toronto, no.236/237, September–October 1980, pp.16–18.

Bailly, Derivery, Dupré, Perrot: 'À propos d'un tableau de Picasso de la série des "Femmes d'Alger"', *Matérialisme*, Paris, no.1, 1980, pp.45–52.

Barr-Sharrar, Beryl: 'Some Aspects of Early Autobiographical Imagery in Picasso's "Suite 347"', *The Art Bulletin*, New York, vol.LIV, no.4, December 1972, pp.516–39.

Baumann, Felix Andreas: 'Baiser, 25.10.1969. Von Pablo Picasso', *Jahresbericht Zürcher Kunstgesellschaft*, Zurich, Kunsthaus, 1975, pp.121–23.

Bergamin, José: 'Masque transparent', in Klaus Gallwitz, *Picasso Laureatus: son œuvre depuis 1945*, Lausanne/Paris, La Bibliothèque des Arts, 1971.

Berger, John: 'La réussite et l'échec de Picasso', *Les Lettres Nouvelles*, Paris, Denoël, 1968.

Bernadac, Marie-Laure: 'De Manet à Picasso: l'éternel retour', in cat. *Bonjour Monsieur Manet*, Musée national d'art moderne, Centre Georges Pompidou, Paris, 1983, p.33.

Bernadac, Marie-Laure: 'Picasso et les peintres du passé', in Georges Boudaille, *Picasso*, Paris, Nouvelles Éditions Françaises, 1985, pp.121–46.

Bolliger, Hans: *Picasso, Graphic Works 1955–1965*, London, Thames and Hudson, 1967.

Boudaille, Georges: *Picasso*, Paris, Nouvelles Éditions Françaises, 1985.

Bouret, Blandine: 'La permanence et le triomphe du cuivre', in cat. *Pablo Picasso. L'œuvre gravé 1899–1972*, Paris, Musée des Arts Décoratifs, 1984.

Brassaï: *Conversations avec Picasso*, Paris, Gallimard, 1964, rev. ed. 1986.

Brassaï: 'Picasso 1971', *XXe siècle*, Paris, special issue 'Hommage à Picasso', 1971, pp.134–36.

Cabanne, Pierre: 'Degas chez Picasso', *Connaissance des Arts*, Paris, no.262, December 1973, pp.146–51.

Cabanne, Pierre: *Le Siècle de Picasso*, vol.IV (1955–1973), Paris, Denoël, 1975.

Chabanne, Thierry: 'Illustre Picasso', in *Autour du chef-d'œuvre inconnu de Balzac*, Paris, École nationale des Arts décoratifs, 1985.

Champris, Pierre de: *Ombre et Soleil*, Paris, Gallimard, 1960.

Char, René: 'Picasso sous les vents étésiens' in cat. *Picasso 1970–1972*, Avignon, Palais des Papes 1973.

Chastel, André: *L'Image dans le miroir*, Paris, Gallimard, 1980, pp.334–70.

Cohen, Janie L.: 'Picasso's Exploration of Rembrandt's Art, 1967–1972', *Arts Magazine*, New York, no.2, October 1983, pp.119–26.

Cooper, Douglas: *Pablo Picasso: Les Déjeuners*, Paris, Éd. Cercle d'art, 1962.

Cooper, Douglas: 'Les déjeuners, un changement à vue', in cat. *Picasso. Le Déjeuner sur l'herbe 1960–1961*, Paris, Galerie Louise Leiris, 1962.

Crommelynck, Aldo et Piero: 'Picasso blanc et noir', *Arts Loisirs*, Paris, no.61, 23–29 November 1966, p.38.

Crommelynck, Aldo et Piero: Foreword to cat. *Picasso: 347 gravures*, Chicago/Paris, Art Institute of Chicago/Librairie des Quatre Chemins: Editart, 1968.

Crommelynck, Aldo et Piero: Foreword to cat. *Picasso: linos réhaussés*, Basle, Galerie Beyeler, 1970.

Crommelynck, Aldo et Piero: 'Picasso vu par ses compagnons de gravure', *Nouvelles de l'Estampe*, Paris, no.9, 1973, pp.3–6.

Dagen, Philippe: 'Picasso: 347 gravures', *Peinture*, Paris, nos.18/19, 1985, pp.119–31.

Daix, Pierre: 'Painters are never Better than in the Evening of their Lives', *Art News*, New York, vol.72, September 1973, pp.56–59.

Daix, Pierre: 'L'arrière-saison de Picasso ou l'art de rester à l'avant-garde', *XXe siècle*, Paris, no.41, December 1973, pp.11–16.

Daix, Pierre: Text and reviews, in cat. *Picasso. Œuvres de la dernière période* (Donation Sybil, Angela, Siegfried Rosengart in the city of Lucerne to mark its 800th anniversary). Lucerne, Éd. de la Ville, 1983.

Daix, Pierre: 'Picasso et ses modèles', in cat. *Picasso. Der Maler und Seine Modelle*, Basle, Galerie Beyeler, 1986, pp.9–12 (English/French edition).

Daix Pierre: *Picasso créateur*, Paris, Éd. du Seuil, 1987.

Dominguin, Luis Miguel, Georges Boudaille: *Pablo Picasso, Toros y Toreros*, Paris, Éd. Cercle d'Art, 1962.

Dufour, Pierre: *Picasso 1950–1968*, Geneva, Éd. Albert Skira, 1969.

Feld, Charles: *Picasso, Dessins 27.3.66–15.3.68*, Paris, Éd. Cercle d'Art, 1969. Foreword by René Char.

Fermigier, André: *Picasso*, Librairie générale française, 'Livre de poche' series, 1969.

Francblin, Catherine: 'Le retour au bordel', *Art Press*, Paris, no.50, 1981, pp.14–15.

Gagnebin, Murielle: 'Picasso iconoclaste', *L'Arc*, Aix-en-Provence, 1981, no.82, pp.39–43.

Gagnebin, Murielle: 'La répétition dans la série, "Le Peintre et son modèle" de Picasso', *Création et répétition*, Paris, Éd. Clancier-Guénaud, 1982.

Gagnebin, Murielle: 'Érotique de Picasso', *Esprit*, Paris, January 1982, pp.71–76.

Gallwitz, Klaus: 'Le peintre et ses "Ateliers"', *XXe siècle*, Paris, special issue 'Hommage à Pablo Picasso', 1971, pp.57–61.

Gallwitz, Klaus: 'Zum Spätwerk Picasso' in cat. *Pablo Picasso*, Munich, Haus der Kunst, 1981, pp.181–91.

Gallwitz, Klaus: *Picasso Laureatus: son œuvre depuis 1945*, Lausanne/Paris, La Bibliothèque des Arts, 1971 // *Picasso 1945–1973*, Paris, Denoël, 1985.

Gallwitz, Klaus: *Picasso, The Heroic Years*, New York, Abbeville Press, 1985.

Galy-Carles, Henry: 'Les sources classiques', *XXe siècle*, Paris, special issue, 'Hommage à Pablo Picasso', 1971, pp.62–66.

Gedo, Mary Mathews: *Picasso, Art and Autobiography*, Chicago/London. The University of Chicago Press, 1980.

Geelhaar, Christian: 'Pablo Picasso, 156 graphische Blätter 1970–1972', *Pantheon*, Munich, vol.36, no.3, 1978, pp.288–89.

Geelhaar, Christian: 'Themen 1964–1972', in cat. *Pablo Picasso. Das Spätwerk*, Basle, Kunstmuseum, 1981.

Häsli, Richard: 'Zu zwei Altersradierungen von Picasso', in cat. *Picasso. Das Spätwerk*, Basle, Kunstmuseum, 1981.

Imdahl, Max: 'Picasso. Spätwerk und Tod', in cat. *Picasso Todesthemen*, Bielefeld, Kunsthalle, 1984.

Jardot, Maurice: préface au cat. *Picasso, Peintures (Vauvenargues) 1959–1961*, Paris, Galerie Louise Leiris, 1962.

Jouffroy, Alain: 'Les dernières œuvres graphiques de Picasso: la transparence entre le sexe et la mort', *XXe siècle*, Paris, no.40, June 1973, pp.161–63.

Kahnweiler, D.- H.: 'Huit entretiens avec Picasso', *Le Point*, Colmar, XLII, October 1952, pp.22–30.

Kahnweiler, D.- H.: 'For Picasso's Eightieth Birthday', *Art News*, New York, vol.60, no.6, October 1961, pp.34–36 and 57–58.

Langner, Johannes: '"Der Stuzz des Ikarus", zur Polarität von Tod und Leben bei Picasso', in cat. *Picasso Todesthemen*, Bielefeld, Kunsthalle, 1984, pp.121–36.

Leiris, Michel: 'Picasso et la comédie humaine ou les avatars de Gros Pied', *Verve*, Paris, vol.VIII, no.29–30, 1954.

Leiris, Michel: 'Picasso et les "Ménines" de Velázquez', Foreword to cat. *Picasso: 'Les Ménines', 1957*, Paris, Galerie Louise Leiris, 1959 // *Art Press*, Paris, no.39, 1980, p.11.

Leiris, Michel: 'La peinture est plus forte que moi . . .', Foreword to cat. *Picasso. Peintures 1962–1963*, Paris, Galerie Louise Leiris, 1964.

Leiris, Michel: 'The Artist and his Model', *Picasso in Retrospect*, New York, Praeger, 1973, pp.243–62 (under the directorship of Roland Penrose and John Golding).

Levin, Kim: 'Die Avignon Bilder' in cat. *Pablo Picasso. Das Spätwerk*, Basle, Kunstmuseum, 1981.

Lewis, Windham: 'Relativism and Picasso's Latest Work', *Picasso in Perspective*, Englewood Cliffs (N.J.), Prentice-Hall Inc., 1976, pp.53–55.

Leymarie, Jean: *Picasso. Métamorphoses et unité*, Geneva, Éd. Albert Skira, 1971.

Limbour, Georges: 'Picasso à La Californie', *L'Œil*, Paris, no.30, June 1957, pp.14–23.

Lucas, John: 'Picasso as a Copyist', *Art News*, New York, vol.54, no.7, November 1955, pp.36–39, 53–54 and 56.

Malraux, André: *La Tête d'obsidienne*, Paris, Gallimard, 1974.

Mellow, James R.: 'Picasso: The Artist in his Studio', in cat. Picasso, *The Avignon Paintings*, New York, The Pace Gallery, 1981, pp.3–10.

Meyer, Franz: 'Picasso Aktualität', in cat. *Picasso. Das Spätwerk*, Basle, Kunstmuseum, 1981, pp.85–87.

Otero, Roberto: *Forever Picasso, an Intimate Look at his Last Years*, New York, H. N. Abrams, 1973.

Parmelin, Hélène: *Picasso sur la place*, Paris, Éd. René Julliard, 1959.

Parmelin, Hélène: *Picasso: Les Dames de Mougins*, Paris, Éd. Cercle d'Art, 1964.

Parmelin, Hélène: *Le Peintre et son modèle*, Paris, Éd. Cercle d'Art, 1965.

Parmelin, Hélène: *Picasso. Notre-Dame-de-Vie*, Paris, Éd. Cercle d'Art, 1966.

Parmelin, Hélène: *Picasso dit . . .*, Paris, Éd. Gonthier, 1966.

Parmelin, Hélène: 'Picasso au Palais des Papes', *La Nouvelle Critique*, Paris, special issue 'Avignon 70', 1970, pp.34–43.

Parmelin, Hélène: 'Picasso tel quel', *Jardin des Arts*, Paris, no.200–201, 1971, pp.20–27.

Parmelin, Hélène: *Voyage en Picasso*, Paris, Robert Laffont, 1980.

Passeron, René: 'Quand Picasso s'attaque aux chefs-d'œuvre', *Jardin des Arts*, Paris, no.200–201, 1971, pp.58–64.

Penrose, Roland: 'Dessins récents de Picasso 1966–1967', Paris, *L'Œil*, no.157, January 1968, pp.18–23.

Penrose, Roland: *Picasso*, Paris, Flammarion, 1982.

Perl, Jed: 'Drawing Conclusions', *Art in America*, New York, vol.68, special issue December 1980, pp.148–50.

Perls, Frank: 'The Last Time I Saw Picasso', *Art News*, New York, vol.73, no.4, April 1974, pp.36–42.

Perucchi-Petri, Ursula: *Pablo Picasso, 156 graphische Blätter, 1970–1972*, Zurich, Graphischeskabinett. Kunsthaus, 1978.

Picasso, 90 dessins et œuvres en couleurs (introduction by Horst Keller), Basle, éd. Beyeler, 1971.

Picon, Gaëtan: 'Pablo Picasso, La "Chute d'Icare" au Palais de l'Unesco', Geneva, Éd. Albert Skira, 1971.

Quiñonero, Juan Pedro: 'Las palabras y los dioses', *Cuadernos Hispanoamericanos*, Madrid, nos.277–78, July–August 1973, pp.41–58.

Richardson, John: 'Picasso's Ateliers and other recent works', *Burlington Magazine*, London, no.651, June 1957, pp.183–93.

Richardson, John, foreword to cat. *Hommage to Picasso*, New York, Marlborough Gallery, 1971, pp.9–13.

Richardson, John: 'The Catch in the Late Picasso', *New York Review of Books*, New York, 19 July 1984.

Richardson, John: 'La epoca de Jacqueline', in cat. *Picasso, su ultima decada 1963–1973*, Mexico, Museo Rufino Tamayo, 1984, pp.52–67.

Richardson, John: 'Les dernières années de Picasso: Notre-Dame-de-Vie', in cat. *Pablo Picasso, Rencontre à Montréal*, Montréal, Museum of Fine Arts, 1985, pp.85–107.

Sabartès, Jaime: *Pablo Picasso, Les Ménines et la vie*, Paris, Éd. Cercle d'Art, 1958.

Sabartès, Jaime: '"A los toros" avec Picasso', Monte Carlo, Éd. André Sauret, 1961.

Scarpetta, Guy: 'Le peintre, son philosophe et son peintre', *Art Press*, Paris, no.50, 1981, pp.16–17.

Schiff, Gert: *Picasso in Perspective* (collection of articles), Englewood Cliffs (N.J.) Prentice-Hall Inc., 1976.

Schiff, Gert: 'Picasso "Suite 347", or Painting as an Act of Love', *Picasso in Perspective*, Englewood Cliffs (N.J.) Prentice-Hall Inc., 1976, pp.163–67.

Schiff, Gert: 'The Musketeer and his Theatrum Mundi', in cat. *Picasso, the Last Years 1963–1973*, New York, Solomon R. Guggenheim Museum, 1984 (published by George Braziller, 1983).

Schiff, Gert: 'Les Sabines, 1962', *Je suis le cahier, Les carnets de Picasso*, Paris, Grasset, 1986.

Schiff, Gert: 'Picasso at Work at Home', in cat. *Picasso at Work at Home*, Miami, Center for the Fine Arts, 1986, pp.4–11.

Soavi, Giorgio: 'Grande di Spagna', in cat. *Picasso 347 immagini erotiche*, Milan, Éd. Gabriele Mazzotta, 1982, pp.5–9.

Sollers, Philippe: 'De la virilité considérée comme un des beaux-arts', *Tel Quel*, Paris, no.90, Winter 1981, pp.16–20.

Spies, Werner: *Picasso, pastels, dessins, aquarelles* (original title: *Picasso, Pastelle, Zeichnungen, Aquarele*, Stuttgart, Éd. Gerd Hatje, 1986)//Paris, Éd. Herscher, 1986.

Steinberg, Leo: 'The Skulls of Picasso' et 'Picasso at 90', *Artnews*, New York, vol.70, no.6, October 1971, pp.27–29 and 68–69.

Steinberg, Leo: 'The Algerian Women and Picasso at Large', *Other Criteria*, New York, Oxford University Press, 1972.

Steinberg, Leo: 'A Working Equation or Picasso in the Homestretch', *The Print Collector's Newsletter*, New York, no.5, November-December 1972, pp.102–105.

Steinberg, Leo: 'Picasso's Revealer', *The Print Collector's Newsletter*, New York, vol.VIII, no.5, November–December 1977, pp.140–41.

Sutherland Boggs, Jean: 'The Last Thirty Years', *Picasso in Retrospect*, New York, Praeger, 1973, pp.197–241 (under the directorship of Roland Penrose and John Golding).

Taillandier, Yvon: 'Les profils proliférants', *XXe siècle*, Paris, special issue 'Hommage à Pablo Picasso', 1971, pp.87–92.

Turner, Evan H.: 'Picasso since 1937', in cat. *Picasso and Man*, Toronto/Montreal, The Art Gallery of Toronto/The Montreal Museum of Fine Arts, 1964, pp.18–21.

Verdet, André: 'Les linoléums de Vallauris', *XXe siècle*, Paris, special issue 'Hommage à Pablo Picasso', 1971, pp.93–100.

West, Rebecca: *Verve*, Paris, no.29–30, 1954.

Wilenski, R. H.; Penrose, Roland: *Picasso, Later Years*, London, Faber and Faber, 1961.

Zervos Christian: foreword to cat. *Pablo Picasso 1969–1970*, Avignon, Palais des Papes, 1970.

Picasso as seen by other artists

Chauvet, Jean-Pierre: 'La peinture souveraine', *Art Press*, Paris, no.50, Summer 1981, p.18.

Devade, Marc: 'Picasso, horizon indépassable', *Art Press*, Paris, no.50, Summer 1981, p.19.

Diamonstein, Barbaralee: 'He Gave us What Einstein Gave to Science' (Caro, de Kooning, Indiana, Lichtenstein, Motherwell and Nevelson discuss on Picasso's influence), *Art News*, New York, vol.73, no.4, April 1974, pp.44–46.

Hockney, David: 'Pinteras importantes de la decada de los Sesenta', in cat. *Picasso, su ultima decada 1963–1973*, Mexico, Museo Rufino Tamayo, 1984, pp.80–90.

'Documents sur Picasso aujourd'hui' (texts by Claude Viallat, Susanna Tanger, Dominique Thiolat, Kimber, Smith, Christian Sorg, Judith Reigl, Pierre Nivollet, J. Y. Langlois, Tony Long, Marc Devade, Norbert Cassegrain, Pierre Buraglio, Robert Motherwell), *Documents sur*, Paris, nos.2–3, October 1978.

'Picasso: A Symposium' (interviews by Eric Fischl, Joseph Kosuth, Larry Rivers, Edward Ruscha, Richard Serra . . .), *Art in America*, New York, special issue 'Picasso', December 1980, pp.9–19 and 185–87.

'Pablo Picasso'. *L'Arc*, Aix-en-Provence, no.82, special issue 'Picasso', 1981, with texts by Eduardo Arroyo, Cueco, Jean Hélion, Mario Prassinos, Hervé Télémaque, Gérard Titus-Carmel . . .

Exhibitions

1954
Picasso, 1938–1953, The Lefevre Gallery, London, May.

1955
Picasso. Drawings, Bronzes, Marlborough Fine Art Ltd, New York, May–June.

1957
Picasso. Peintures 1955–1956, Galerie Louise Leiris, Paris, March–April.
Picasso. Paintings 1954–56, Saidenberg Gallery, New York, 30 September– 26 October.

1959
Picasso (especially: 'Les années récentes: 1946–1959), Musée Cantini, Marseille, 11 May–31 July.
Picasso. Les Ménines 1957, Galerie Louise Leiris, Paris, 22 May–27 June.

1960
Picasso (especially: 'Cannes and Vauvenargues 1955–60'), The Tate Gallery, London, 6 July–18 September.
Picasso. Dessins 1959–1960, Galerie Louise Leiris, Paris, 30 November–31 December.

1961
Picasso. Gemälde 1950–60, Galerie Rosengart, Lucerne, Summer.

1962
Picasso. Peintures (Vauvenargues 1959–1961), Galerie Louise Leiris, Paris, 26 January–24 February.
Picasso: an American Tribute. The Fifties, Cordier-Warren Gallery, New York, 25 April–12 May.
Picasso. Le Déjeuner sur l'herbe, 1960–1961, Galerie Louise Leiris, Paris, 6 June–13 July.
Picasso. Les Déjeuners, Galerie Madoura, Cannes, August.

1963
Picasso. Peintures. Deux époques: 1912–27, 1952–61, Galerie Rosengart, Lucerne, Summer.

1964
Pablo Picasso: Picasso and Man, The Art Gallery of Toronto, Toronto, 11 January– 16 February/The Montreal Museum of Fine Arts, Montreal, 28 February–31 March.
Picasso. Peintures 1962–1963, Galerie Louise Leiris, Paris, 15 January– 15 February.
Pablo Picasso, National Museum of Modern Art, Tokyo, 23 May–5 July/National Museum of Modern Art, Kyoto, 10 July– 2 August/Prefectural Museum of Art, Nagoya, 7–18 August.

1965
Picasso. 150 Handzeichnungen aus sieben Jahrzehnten, Kunstverein, Hamburg, 24 July–5 September.
Picasso. Gouache en tekeningen 1959–1964, Galerie d'Eendt, Amsterdam.

1966
Pablo Picasso, Einige Aspekte des Nachkriegsoeuvres, Michael Hertz, Bremen, July–September.
Picasso. Deux époques (peintures 1960–65 et des années 1934, 1937, 1944), Galerie Rosengart, Lucerne, Summer.
Hommage à Pablo Picasso, Grand Palais (paintings), Petit Palais (drawings, sculptures, ceramics), Paris, November 1966–February 1967.
Picasso (works between November 1966 and May 1967), Galerie Beyeler, Basle.
Picasso, Tel-Aviv Museum, Tel-Aviv.

1967
Picasso. Oeuvres récentes, Museum of Unterlinden, Colmar, July–September.
Picasso 1966–1967, Saidenberg Gallery, New York, 11 December 1967–31 January 1968.

1968
Picasso. Dessins 1966–1967, Galerie Louise Leiris, Paris, 28 February–23 March.
Picasso. Pinturas, dibujos, grabados, Sala Gaspar, Barcelona, March.
Pablo Picasso, Österreichisches Museum für angewandte Kunst, Vienna, 24 April– 30 June.
Las Meninas, Museu Picasso, Barcelona, May.
Pablo Picasso, Das Spätwerk. Malerei und Zeichnung seit 1944, Staatliche Kunsthalle, Baden-Baden, 15 July–6 October.

1969
Picasso aujord'hui, oeuvres recentes, Galerie Rosengart, Lucerne, Summer.
Picasso, Dunkelman Gallery, Toronto, 26 November 1969–10 January 1970.

1970
Picasso. Drawings, The Waddington Galleries I, London, 10 February–7 March.
Pablo Picasso 1969–1970, Palais des Papes, Avignon, 1 May–30 September.
Pablo Picasso, Galleria Michelucci, Florence, 4–30 June.
Picasso, 1967–1970, Saidenberg Gallery, New York, 6 October–14 November.

1971
Picasso. Dessins en noir et en couleur (5 décembre 1969–12 janvier 1971), Galerie Louise Leiris, Paris, 23 April–5 June.
Picasso. Dessins du 31.12.70 au 4.2.71, Musée Réattu, Arles, July–September.
Homage to Picasso, Marlborough Gallery Inc, New York, October.
Picasso, 90 dessins et oeuvres en couleur, Kunstmuseum, Winterthur, 9 October– 15 November/Galerie Beyeler, Basle, 20 November 1971–15 January 1972/Wallraf-Richartz Museum, Cologne, 25 January–28 February 1972.
Picasso. Pintura, dibuho, Sala Gaspar, Barcelona, 25 October.
Picasso. 25 oeuvres, 25 années 1947–1971, Galerie Rosengart, Lucerne.

1972
Picasso, Galerie Veranneman, Brussels, 29 January–26 February.
Picasso 172 dessins en noir et en couleur, Galerie Louise Leiris, Paris, 1 December 1972–13 January 1973.

1973
Hommage à Picasso, Musée Réattu, Arles, 12–30 April.
Picasso 1970–1972, 201 peintures, Palais des Papes, Avignon, 23 May– 23 September.
Picasso, dessins 1970–1972, Albrecht Dürer Gesellschaft, Nuremberg, 24 June– 5 August.
Picasso, Festival of Humanities Exhibition organised by the Committee of the Central Party of French Communists and Humanities, Paris, 5–9 September.

Picasso in Hannover: Gemälde, Zeichnungen, Keramik, Kunstverein, Hanover, 21 October – 25 November.
Homage to Picasso 1881 – 1973, R. S. Johnson International Gallery, Chicago, Winter.

1975
Picasso, Ingres Museum, Montauban, 27 June – 7 September.

1976
Las Meninas, Museu Picasso, Barcelona, July – August.

1977
Picasso, City Museum, Tokyo/Central Museum for Architecture and Culture, Fukuoka/National Contemporary Art Museum, Kyoto, 15 October 1977 – 5 March 1978.

1978
Picasso, Eight works from the last 20 years of his life, Am Rhyn Hau, Lucerne, Summer.

1979
Picasso. Oeuvres reçues en paiement des droits de succession, Grand Palais, Paris, 11 October 1979 – January 1980.

1980
Picasso, a Retrospective, New York, Museum of Modern Art, 22 May – 16 September.
Picasso, The Seibu Museum of Art, Tokyo, 1980.

1981
Picasso. The Avignon Paintings, The Pace Gallery, New York, 30 January – 14 March.
Picasso, 1953 – 1973, Anne and Albert Prouvost Foundation, Marcq-en-Baroed, 14 February – 17 May.
Picasso, gouaches, lavis et dessins 1966 – 1972, Galerie Berggruen, Paris, March.
Pablo Picasso. Das Spätwerk. Themen 1964 – 1972, Kunstmuseum, Basle, 6 September – 8 November.
Els Picassos del Mas Manolo a Calder de Montbus, Ajuntament de Calder de Montbus, December 1981 – January 1982.

1982
Picasso. La pié à musique de Mougins, Cultural Centre Marais, Paris.

1983
Picasso, couleurs d'Espagne, couleurs de France, couleurs de vie (chapter III: 'Jacqueline, les portraits de l'amour IV et V'). Dominican Monastery, Toulouse, February – April.

1984
Picasso the Last Years 1963 – 1973, Solomon R. Guggenheim Museum, New York, 2 March – 6 May.
Picasso, su ultima decada, Museo Rufino Tamayo, Mexico, June – July.
Picasso, National Gallery of Victoria, Melbourne, 28 July – 29 September.

1985
Pablo Picasso, rencontre à Montréal, The Montreal Museum of Fine Arts, Montreal, 21 June – 10 November.
Picasso at Work at Home, Center for the Fine Art, Miami (Florida), 19 November – 9 March.

1986
Je suis le cahier. The Sketchbooks of Picasso, (especially: *Sketch book no. 163, Les Sabines, 1962*), The Pace Gallery, New York, 2 May – 1 August/Royal Academy of Arts London 11 September – 23 November.
Picasso. Pastelle, Zeichnungen, Aquarelle. Kunsthalle, Tübingen, 5 April – 11 June/Kunstsammlung Nordrhein-Westfalen, Düsseldorf, 14 June – 27 July.
Picasso. Der Maler und seine Modelle, Galerie Beyeler, Basle, July – October.
Picasso en Madrid (Collection Jacqueline Picasso), Museum of Contemporary Art Madrid, 25 October 1986 – 10 January 1987.

PRINTS

1957
Picasso. Das graphische Werk, Kupferstichkabinett der Saatlichen Museen zu Berlin, Berlin, October – November.

1960
Picasso. Oeuvre gravé, Galerie des Ponchettes Nice, 12 January – 15 March.

1963
Picasso: 42 incisioni su linoleum 1962, Galleria il Segno, Rome, March – April.
Picasso, 28 linographies originales, Galerie Madoura, Vallauris, 4 April – 5 May.
Picasso. 54 Recent Colour Linocuts, Hanover Gallery, London, 30 April – 31 May.
Pablo Picasso. 50 gravures sur linoléum 1958 – 1963, Galerie Gérald Cramer, Geneva. 31 May – 5 July.
Picasso. 15 linoleums recientes, Sala Gaspar, Barcelona.

1964
Pablo Picasso, Museum für Kunst und Gewerbe, Hamburg, 31 January – 22 March.

1965
Picasso, Sala Gaspar, Barcelona, 15 July – 15 August.

1966
Picasso 1959 – 1965, The Israel Museum, Jerusalem, 24 March – 2 May.
Pablo Picasso, le peintre et son modéle. 44 gravures originales 1963 – 1965, Galerie Gérald Cramer, Geneva, 24 November 1966 – 21 January 1967.
Picasso, gravures, Galerie Beyeler, Basle, November 1966 – March 1967.
Pablo Picasso. Druckgraphik, Kunsthalle, Bremen, 11 December 1966 – 22 January 1967.
Grafika Picasso, Pushkin Museum, Moscow.
Pablo Picasso. Gravures, National Library, Paris.

1967
Exposition de gravures de Pablo Picasso, Museum of Contemporary Art, Belgrade. 10 June – 1 August.

1968
1 Picasso Atelie, Malmö Museum, Malmö, September.
Picasso. 347 gravures (16 mars – 5 octobre), Galerie Louise Leiris, Paris/The Art Institute of Chicago, Chicago, 18 December 1968 – 1 February 1969.

1969
Picasso d'aujourd'hui, Musée Réattu, Arles, 4 April – 1 June.
Picasso, 347 graphische Blätter aus dem Jahre 1968, Akademie der Künste, Berlin, 1 – 29 June; Hamburger Kunsthalle, Hamburg, 11 July – 10 August; Kölnischer Kunstverein, Cologne, 7 September 12 October.
Picasso. Gravures récentes, Galerie Madoura, Vallauris, 20 August – 25 September.
Pablo Picasso. Kupfergravüren aus dem Jahre 1968, Michael Hertz, Bremen.

1970
Pablo Picasso, Contemporary Art Museum, Tokyo, 1 February – 15 March.
Picasso. Linos rehaussés, Galerie Beyeler, Basle, March – May.
Picasso Gravures récentes, Galerie Madoura, Vallauris, 6 May – 30 June.
Picasso. Graphik von 1904 bis 1968, Haus der Kunst, Munich, 20 June – 27 September.
347X Picasso graphische Blätter aus dem Jahre 1968, Würtembergischer Kunstverein, Stuttgart, 8 October – 29 November.
Picasso: Master Printmaker, The Museum of Modern Art, New York, 14 October – 29 November.
Picasso. 347 grabados, 16 March – 5 October 1968, Sala Gaspar, Barcelona, December.
Pablo Picasso 1956 bis 1965. Bemalte Linos Ausstellung 1970, Kornfeld und Klipstein, Berne, 1970
Picasso. 347 engravings, 16.3.68 to 5.10.1968, Institute of Contemporary Arts, London, 1970.

1971
Picasso. 150 grabados, Museo de Bellas Artes, Caracas, March.
Pablo Picasso: 347 Radierungen des Sommers 1968, Stuck-Villa, Munich, April – June.
Picasso. Gravures, dessins, Musée de l'Athénée, Geneva, 13 July – 16 October.

1972
Picasso. 347 Engravings, The Waddington Galleries II, London, 13 September – 17 October.

Picasso: gravures 1946 – 1972, Musée d'art et d'histoire, Neuchâtel, 28 October 1972 – 18 February 1973.

1973
Picasso. 156 gravures récentes, Galerie Louise Leiris, Paris, 24 January – 24 February.
Picasso. His Graphic Work in the Israel Museum Collection, Jerusalem, January – March.
Picasso, 51 linocuts 1959 – 1963, Fuji Television Gallery, Tokyo, 15 May – 2 June.
Picasso Graphics, The Waddington Galleries III, London, 18 September – 13 October.

1974
Picasso, Henie-Onstad Kunstsenter, Høvikodden, February – April
Picasso, Contemporary Art Museum, Séoul, 10 August – 22 September

1978
Picasso. Els 156 darrers gravats originals 24.10.68/25.3.72, Sala Gaspar, Barcelona, March – April.
Pablo Picasso, 156 graphische Blätter 1970 – 1972, Kunsthaus, Zurich, 31 March – 16 May.

1979
Picasso erotic, Museu Picasso, Barcelona, 27 February – 18 March.
Pablo Picasso: his Last Etchings: a Selection (1969 – 1972), R. S. Johnson International, Chicago, March.
Picasso. Die letzten graphischen Blätter 1970 – 1973, Kestner-Gesellschaft, Hanover, 4 May – 27 May.

1980
Darrers gravats de Picasso, Museu Picasso, Barcelona, 6 May – 31 July.
Picasso. Letzte graphische Blätter 1970 – 1972, Galerie der Hochschule für Graphik und Buchkunst, Leipzig, 9 May – 20 June.
Picasso Gravats – lithografias, Sala Gaspar, Barcelona, November-December.

1981
Picasso, tout l'oeuvre linogravé, Museum Granet, Aix-en-Provence, 7 March – 6 September.
Pablo Picasso. Die letzten graphischen Blätter aus der Sammlung Ludwig, Aix-la-Chapelle, Kupferstichkabinett der Staatlichen Kunstsammlungen, Dresden, 8 May – 17 July.
Picasso. Obra grafica original 1904 – 1971 (especially the second volume of the

catalogue), Madrid, Salas de exposicionas de la subdirección general de artes plasticas, May – July.
Picasso, 347, Henie – Onstad Kunstsenter, Høvikodden, 23 June – 23 August.
Picasso Druckgraphiik, Westfalisches Landesmuseum für Kunst und Kulturgeschichte, Munster, 4 October – 22 November.
Picasso y los toros, Museo de Bellas Artes, Malaga, October-December.
Picasso Graphics, Institut français, London. Exhibition toured by Arts Council of Great Britain.

1982
Picasso. Rétrospective de l'oeuvre gravé (1947 – 1968), Foundation Capa/Galerie Herbage, Cannes, Summer 1982.
Picasso, 347 immagini erotiche, Milan, November.

1983
Picasso: 117 gravats 1919 – 1968, Museu Picasso, Barcelona, 19 March – 31 May.
Picasso. Collection des linogravures originalses 1958 – 1963, Chez Pernot, Bordeaux, 6 – 27 May.
Picasso the Printmaker: Graphics from the Marina Picasso Collection, Dallas Museum of Art, Dallas, 11 September – 30 October.
Picasso. Liebe, Elefanten Press Galerie, Berlin, 25 November 1983 – 29 January 1984.

1984
Pablo Picasso: the Last Prints Selection from the Series of 156 Etchings, Aldis Browne Fine Arts, New York, 19 April – 29 June.
Pablo Picasso: l'oeuvre gravé, 1899 – 1972, Musée des Arts décoratifs, Paris, 26 September – 29 October.

1985
Picasso, Sidste grafiska arbejder 1970 – 72, Nordjyllands Kunstmuseum, Aalborg, 6 June – 1 September.

1986
Pablo Picasso, Paço Imperial, Rio de Janeiro, 28 May – 6 July.
Mon ami Picasso, Exhibition of drawings, engravings and posters from the Georges Tabaraud collection, Le mareau, Limoges, June.
Picasso, 60 originals, Sala Gaspar, Barcelona.

Lenders

AUSTRALIA
The Art Gallery of New South Wales, Sydney 6

DENMARK
Louisiana Museum of Modern Art, Humlebaek 14

USA
Art Institute of Chicago, Chicago 10
Douglas S. Cramer, Los Angeles 56
Metropolitan Museum of Art, New York 38
Museum of Modern Art, New York 8
Hirschl and Adler Galleries, New York 79, 95
Mrs Victor W. Ganz, New York 3, 4, 5, 7, 11
Dr and Mrs Martin L. Gecht, Chicago 99
Mr and Mrs Morton L. Janklow, New York 29, 65
Mr and Mrs Raymond D. Nasher 16, 62
Paloma Picasso-Lopez 31
Mr and Mrs Daniel Saidenberg 76

FRANCE
Musée Picasso, Paris 1, 57, 69, 71, 73, 74, 108
Galerie Louise Leiris, Paris 17, 32, 68, 85, 103, 109–155
Lionel Prejger 106
Bernard Ruiz-Picasso 35, 46, 54, 61, 66
Maya Ruiz-Picasso 43
Musée National d'Art Moderne, Centre Georges Pompidou,
 Paris 12, 22, 25, 33, 87–94

UK
Tate Gallery, London 37

JAPAN
The Hakone Open-Air Museum 20, 24, 107
Fuji Television Gallery Co. Tokyo 101

NETHERLANDS
Museum Boymans-van Beuningen, Rotterdam 48
Stedelijk Museum, Amsterdam 9

E GERMANY
Nationalgalerie der Staatlichen Museum, Berlin 30

W GERMANY
Museum Ludwig, Cologne 36
Ludwig Collection, Aix-la-Chapelle 30
Staatsgalerie, Stuttgart 13

SWITZERLAND
Collection Marina Picasso, Jan Krugier Galerie, Geneva 23,
 52
Galerie Beyeler, Basle 84
Ernst Beyeler 27, 50, 83
Galerie Rosengart, Lucerne 26, 102
Thomas Ammann Fine Art, Zurich 39
Gilbert de Botton 28, 49, 63

CZECHOSLOVAKIA
Národní Galerie, Prague 19

VENEZUELA
Museo de Arte Contemporáneo, Caracas 44, 98

Private Collections 2, 15, 18, 21, 34, 40, 41, 42, 45, 47, 48,
 51, 53, 55, 58, 59, 60, 64, 67, 70, 72, 75, 77, 78, 80, 81,
 82, 86, 96, 98, 100, 104, 105

Photographic credits

THE FRIENDS OF THE TATE GALLERY

The Friends of the Tate Gallery is a society which aims to help buy works of art that will enrich the collections of the Tate Gallery. It also aims to stimulate interest in all aspects of art.

Although the Tate has an annual purchase grant from the Treasury, this is far short of what is required, so subscriptions and donations from Friends of the Tate are urgently needed to enable the Gallery to improve the National Collection of British painting and keep the Twentieth-Century Collection of painting and sculpture up to date. Since 1958 the Society has raised over £1 million towards the purchase of an impressive list of works of art, and has also received a number of important works from individual donors for presentation to the Gallery.

In 1982 the Patrons of New Art were set up within the Friends' organisation. This group, limited to 200 members, assists the acquisition of works by younger artists for the Tate's Twentieth-Century Collection. A similar group – Patrons of British Art – was formed in late 1986 to assist the acquisition of works for the Collection of British painting of the period up to 1914.

The Friends are governed by a council – an independent body – although the Director of the Gallery is automatically a member. The Society is incorporated as a company limited by guarantee and recognised as a charity.

Advantages of Membership include:

Special entry to the Gallery at times the public are not admitted. Free entry to, and invitations to private views of paying exhibitions at the Gallery. Opportunities to attend lectures, private views at other galleries, films, parties, and of making visits in the United Kingdom and abroad organised by the Society. A 10% discount on all stock in the Tate Gallery shop, apart from books and catalogues, and a 10% discount on current special exhibition catalogues. Use of the Members' Room in the Gallery.

MEMBERSHIP RATES

Any Membership can include husband and wife

Benefactor Life Member £5,000 (single donation)
Patron of New Art £475 annually or £350 if a Deed of Covenant is signed
Patron of British Art £475 annually or £350 if a Deed of Covenant is signed
Corporate £250 annually or £200 if a Deed of Covenant is signed
Associate £65 annually or £50 if a Deed of Covenant is signed
Life Member £1,500 (single donation)
Member £18 annually or £15 if a Deed of Covenant is signed
Educational & Museum £15 annually or £12 if a Deed of Covenant is signed
Young Friends £12 annually.

Subscribing Corporate Bodies as at May 1988

*Agnew & Sons Ltd, Thomas
Alex, Reid & Lefevre Ltd
Allied Irish Banks Plc
American Express Europe Ltd
Art Promotions Services Ltd
†Associated Television Ltd
Bain Clarkson Ltd
Balding + Mansell UK Ltd
†Bankers Trust Company
Barclays Bank International Plc
Baring Foundation, The
Beaufort Hotel
*Benson & Partners Ltd, F.R.
Blackwall Green Jewellery & Fine Art
Bowring & Co. Ltd, C.T.
British Council, The
Bradstock Penrose Forbes Ltd
British Petroleum Co. Plc
Brocklehursts
Bryant Insurance Brokers Ltd, Derek
CCA Stationery Ltd
Cazenove & Co.
Charles Barker Group
*Chartered Consolidated Plc
*Christie, Manson & Woods Ltd
*Christopher Hull Gallery
Citicorp Investment Bank Ltd
Colnaghi & Co. Ltd, P & D
Commercial Union Assurance Plc
Coutts & Company
Crowley Ltd, S.J.
De La Rue Company Plc
Delta Group Plc
Deutsche Bank AG
*Editions Alecto Ltd
Electricity Council, The
Equity & Law Charitable Trust
Esso Petroleum Co. Plc
Farquharson Ltd, Judy
Fine Art Society Ltd
Fischer Fine Art Ltd
Fishburn Boxer & Co.
Fitton Trust, The
*Gimpel Fils Ltd
Greig Fester Ltd
Guinness Peat Group
Hill Samuel Group
IBM United Kingdom Ltd
*Imperial Chemical Industries Plc
ISTD Fine Paper Ltd
Johnson & Higgins
Kiln & Co. Ltd
Kleinwort Benson Ltd
Knoedler Kasmin Ltd
*Leger Galleries Ltd
Lewis & Co. Plc, John
London Weekend Television
*Lumley Cazalet Ltd
Madame Tussauds Ltd
†Manor Charitable Trustees
Marks & Spencer Plc

Marlborough Fine Art Ltd
*Mayor Gallery, The
Minet & Co. Ltd, J.H.
Morgan Bank
Morgan Grenfell Group Plc
National Westminster Bank Plc
Norddeutsche Landesbank
Ocean Transport & Trading Plc
*Ove Arup Partnership
Pateman Underwriting Agencies Ltd
Patrick Underwriting Agencies
Pearson Plc
Peter Moores Foundation
*Phillips Son & Neale
Piccadilly Gallery
Plessey Company Plc, The
Rayne Foundation, The
Redfern Gallery
†Rediffusion Television Ltd
Richard Green Gallery
Roberts & Hiscox Ltd
Roland Browse & Delbanco
Rothschild & Sons Ltd, N.M.
Royal Bank of Scotland Plc
RTZ Services Ltd
Schroder Wagg & Co. Ltd, J. Henry
Schupf, Woltman & Co. Inc
Scott Mathieson Daines Ltd
Seascope Insurance Holdings
*Secretan & Co. Ltd, F.L.P.
Sedgwick Group Plc
*Sinclair Montrose Trust
Smith & Son Ltd, W.H.
Somerville & Simpson Ltd
Sotheby Parke Bernet & Co.
Spink & Son Ltd
Star Assurance Society
Stephenson Harwood
Stewart Wrightson Ltd
Sun Alliance & London Insurance Group
Swan Hellenic Art Treasure Tours
Swire & Sons Ltd, John
*Tate & Lyle Ltd
Thames & Hudson Ltd
†Tramman Trust
*Ultramar Plc
Vickers Ltd
*Waddington Galleries Ltd
Willis Faber Plc
Winsor & Newton Ltd

*By Deed of Covenant
†Life Member

for further information apply to:

The Friends of the Tate Gallery,
Tate Gallery, Millbank, London SW1P 4RG
Telephone 01-821 1313 or 01-834 2742.

[311]